VINCENT VERSACE

WELCOME TO OZ 2.0

A CINEMATIC APPROACH TO

DIGITAL STILL PHOTOGRAPHY WITH PHOTOSHOP

New Riders

VOICES THAT MATTER™

WELCOME TO OZ 2.0
A Cinematic Approach to Digital Still Photography with Photoshop

Vincent Versace

New Riders
1249 Eighth Street
Berkeley, CA 94710
510/524-2178
510/524-2221 (fax)
Find us on the Web at: www.newriders.com

To report errors, please send a note to errata@peachpit.com

New Riders is an imprint of Peachpit, a division of Pearson Education

ISBN 13: 978-0-321-71476-3
ISBN 10: 0-321-71476-8

9 8 7 6 5 4 3 2 1

Printed and bound in the United States of America

To my Father.

Thank you for giving me the childhood you dreamed of.

And

To Tad Z. Danielewski and Sydney Walker.

Thank you for always being the broom that swept clean and thank you for teaching me about the gift of giving.

And

To my brother Lane.

I could not have asked for and gotten a better friend than you. I miss you more than there are words in the universe.

Acknowledgments

From a grain of sand the pearl comes.

—Confucius

Once again, what I have learned is that writing a book is a collaborative process after which I get all the credit. Which is cool, but...

This book simply would not be this book if it were not for the draconian editorial diligence of Edna A. Elfont, Ph. D., and the scientific diligence of Lawrence B. Coleman Ph. D., Professor of Physics at the University of California at Davis. When you read this book and you find that the thoughts are clear, concise, easy to understand, and make sense, trust me: that's all Edna.

If it were not for Professor Coleman's kind and gentle criticisms, his incredible insights and explanations that made me see the light when I was scientifically out of my mind, this book would be far less of a book. This book's scientific strength is powered by a beautiful mind. Thank you, Professor. I know you had better things to do in your free time. Your gift to me is not lost.

I am the photographer I am today because of CJ Elfont. Also, the technical photographic accuracy of this book would not be what it is if it were not for CJ's intervention. Without CJ (and Edna too), I would not be an artist, I would not be a photographer; I would be someone else—certainly not the person who could ever have written this book.

To Sean Dyroff: You truly are a Super Hero with "spidey" powers. You laid out this book, tech edited it, fixed every one of my actions, and answered every one of my Photoshop questions, all while going to graduate school. Bravo!

To Mark Jaress: Thank you for being the person who taught me Photoshop. Thank you, thank you, thank you...

To Fatima Nejame: Thank you for talking me in to teaching, thank you for all of the wonderful places you have asked me to go and teach, and thank you for being my friend. I really like seeing the world through a camera with you.

To Ted Waitt, my editor at Peachpit Press: This book is *finally* done. Thank you for fighting the good fight for me, and thank you for keeping me safe.

To everyone at Peachpit Press: Thank you for your hard work and efforts to make this book happen.

To Bert Monroy, David duChemin and Jay Maisel: Thank you for allowing me to talk you into writing the foreword and afterwords of this book, though I suspect you may have done it simply to shut me up.

To John Paul Caponigro and R. Mac Holbert: Thank you for being the best examples of perfect practice I have ever met. My technique is so much smoother and cleaner because of you.

To Ed Sanchez and Mike Slater of Nik Software: Thank you for keeping the company so alive and on the edge of technology. Thank you for providing three of the "crown jewels" for this book. Your friendship outside of work is cherished.

Nils Kokemohr (the N, i and k of Nik Software): You are the smartest human I know. Your software makes my life and me more creative than I could have ever imagined.

To Josh "the boy wonder" Haftel of Nik Software: You never sleep, and that's a good thing for all of us who use the products you manage.

To Joe Sliger of Wacom: If it were not for you, the tablet presets that are part of this book would not have happened.

To Mike Wong and Dan Harlacher of onOne software: Thank you for providing FocalPoint 2.0 for this book and constantly reiterating Genuine Fractals. Most importantly, thank you for believing that whenever possible, our business meetings must take place at Splash Mountain at Disneyworld.

To Joseph G Hirschberg, Ph. D., Professor Emeritus, University of Miami, Department of Physics: Thank you for sending me down this path. I never would have gotten on this ride were it not for you. Thank you for teaching me the difference between real and virtual, accurate and precise, how to bend light with a spoon, and the conversations we had about the

science of art in Burma. Thank you for asking me "Does light travel in a straight line?" and when I said "Yes," telling me, "Not according to Einstein."

To Dr. Adrian Cohen: You are the standard I try to live up to in all my deeds.

To Challen Cates: Thank you for all the time you spent sitting in front of my camera waiting for me to get it right. As they did in the first book, the images of you make for a much nicer looking book.

To Dave Moser and Scott Kelby: The day you asked me to be a part of the National Association of Photoshop Professionals is the day that led to this book. I never have been more proud to belong to an organization than I am to belong to NAPP.

To Dan Steinhardt of Epson: Thank you again for providing me with your unfailing support even when I was/am a complete pain in the ass. Because of you, once again, another pocket of time was created in which I could create this book.

To Nancy Carr of Kodak; Vincent Park and Anthony Ruotolo of American Photo Magazine; Ed Sanchez and Mike Slater of Nik Software; Peter Poremba of Dyna-Lite; Fabia Ochoa of Epson; Tadashi Nakayama, Makoto "Mike" Kimura, Naoki "Santa Claus" Tomino, Jeff Mitchell, and Mike Corrado of Nikon; Liz Quinlisk and Thomas Kunz of X-Rite, Jeff Cable of Lexar; and Richard Rabinowitz: Without all of your faith and support over the years, I would never have had the career that I do.

To Marc Vanocur of Shout Softly Films: Thank you for making my madness look professional.

To Toby, Sally, Adam, and Jamie Rosenblatt: Were it not for you, I would have stopped being a photographer.

To Chef John Fraser of Dovetail Restaurant in New York City: The week I spent in your kitchen studying reminded me of the importance of being attentive to detail in my work. Everything matters when you create; everything dovetails into everything else. A day has not gone by that I have not reflected on what I learned in your kitchen. Thanks also to your entire staff for so generously sharing their knowledge.

To my sister Eve and my mother, I really did win the relative lottery.

And once again to my wife, Sylvia, who had to suffer through the rewriting of this book. You have kept me calm when I was anything but. I am so lucky that you still have questionable taste in men.

To Vanilla Gelato, Wasa Cinnamon Crackers, and Café Americano: Every section in this book was celebrated by having one of each.

Oh… I almost forgot, Prrrl j. Cat, the fur person. Thank you for sitting on my keyboard and reminding me when it was time to rest.

Contents

Foreword

Through the years, I have come to know Vincent Versace fairly well. We have travelled to foreign lands together and share memories of many good times. I have found that no matter what the subject of conversation is, he has an opinion. He can be funny, sarcastic, and irreverent, but steer the topic towards photography and art and a different Vincent Versace presents himself. He becomes serious and focused. The subject touches a nerve deep within the soul of this man, and Vincent becomes immersed in a passion that easily becomes contagious.

Vincent is a great photographer, but a better description would be—Artist. Give the average couch potato with little drive or ambition the most complete set of brushes, paints, and canvases that money can buy, and what will you get in return? Not much. Give an artist a worn piece of chalk and what will you get? You will get something that will capture your soul. Vincent does not just take a picture, he feels the image. It is obvious when looking at his work that, once he has been inspired, he will go to great lengths to perfect the end result so that it will then inspire you.

Vincent is a talented and gifted artist, but his greatest talent and gift is his ability and desire to teach. It is this side of the man that makes this book such an important piece of work.

Vision is something that lies within all of us. We all possess the ability to be creative. Whether we pursue this creative instinct is a matter of personal choice. There is a rewarding warmth that comforts the soul once you have been inspired and then create something tangible that can be shared with others. In this book, Vinnie teaches you how to transcend the limitations of the photographic medium that keep you from realizing your vision. He teaches you how to create the mood through proper lighting. He shows you how to combine multiple images to create that single, perfect shot. Vincent clearly holds your hand through all the processes necessary to bring your vision to life.

He does this in a way that is highly informative yet easy to understand. You might say it is even entertaining. Vincent riddles the chapters with little insights and bits of information that help you completely grasp the concepts being discussed. Whether the subject is setting up a reflector or combining multiple HDR images, you walk away with the satisfaction of successfully having added a new set of skills to your repertoire.

Each subject is tackled with the same passionate intensity that Vincent Versace employs in the creation of his work. No stone is left unturned. You get every side of the story. You get all the tools you need to do whatever your creative imagination can conjure.

The camera and Photoshop, in the hands of an artist, go far beyond that "worn piece of chalk." We live in a world that has become a media frenzy. We can't walk down the street or pick up a magazine without being bombarded with tons of chaotic imagery, a plethora of images all fighting for attention to sell you this or that—a dizzying array of colors, styles, and subjects that can make you scream! Every now and then something stands out. Something catches your eye and says, "Look at me for a while." What is it about that "something" that makes it different? More often than not it is the fact that the person who created the work had more in mind than just grabbing your attention. They wanted to reach out and touch you—not just capture your attention but hold it for a while. Whether the intent is to soothe you or excite you into action, how that image has been presented makes all the difference in the world.

Take, for example, the fact that there are millions of pictures of flowers out there. What makes one stand out above the rest? Is it the color? Is it the composition? Is it the surroundings? It is all of these things and more. It is the emotion that the flower stirred in the person at the moment of capture. It is how well that person was able to convey that emotion via their image. It is the passion and hard work that the person put into making that final image to share with others. It is the eye and skill of the artist.

This book will train you to see the world through the wide open eyes of an artist. It will then give you the skills that you need to take what your eyes see and convert it into a work of art for the rest of us to enjoy. The skills go far beyond those taught in other books of this genre. Many Photoshop books will teach you what the tools do, but how many teach you when and why to use them?

What do you look for? What does that shot need to make it terrific? How do you plan your workflow? Sound overwhelming? Vincent holds your hand through the entire process. He challenges you while comforting you at the same time. He gives you the means to do great work. All you need to do is read this book and feel the passion and desire to be an artist. Sound easy? No! It is not. But, if you are up to the challenge, if you feel that burning desire to be the best you can be, this book is your ultimate weapon. If you think you are pretty good at what you do, here is your chance to be great.

Learn from a true master of the art. The rest is up to you.

—Bert Monroy

Just Like the Movies: The Pre-Show Entertainment

If we have learned one thing from the history of invention and discovery, it is that, in the long run—and often in the short one—the most daring prophecies seem laughably conservative.

The only way to discover the limits of the possible is to go beyond them into the impossible.

—Arthur C. Clarke

Look at the image to your left and turn the book upside down.

Frequently in photography, as is the case in life, things are not what they appear to be.

When I was asked to revise this book, I decided that, rather than just update the keyboard commands and add a few of the new bells and whistles from CS5 and call it at day, it would be better to practice what I preach, which is that practice does not make perfect. Perfect practice makes perfect. So this book is not a revision. It is a complete re-write. The approach that I took when re-writing was to tell you what I would do today, this moment, with these images, as if I were working on them for the first time. I also felt it important to use a new image, shot with the largest file that I can produce, and show you a large megapixel workflow.

This book is about understanding the middle, the process of producing an image; what you should consider at the point of capture to create the very best print. For me, this is what the technical aspect of photography is all about.

One of the first changes you might notice in this book, is that two complete chapters are absent: the black and white chapter, and the chapter on time. Also, the book is 100 pages longer.

This book is now the first book in what will be a three, possibly four, book series, the first being *Welcome to Oz 2.0: A Cinematic Approach to Digital Still Photography with Photoshop*; the second, *From Oz to Kansas: Almost Every Black and White Conversion Technique Known to Man* (an expansion of the original black and white chapter into its own book); the third, *Return to Oz* (which will contain the chapter on time and will explore the conceptual difference between photographing the movement of time versus the motion of time); and the last book (should I live this long), *Every Picture Tells a Story: Cinematic Digital Still Photography and 21st Century Composition Theory.*

This book is not about how you can make my pretty pictures, it is about learning techniques that I believe will help you make your pretty pictures a closer reflection of the voice inside you. I want you to be able to make your own images, not just make a Xerox of mine.

The conversation that I want to begin with you in this first book of the *Oz* series is one concerning being taken by a photograph; to be so compelled by the image that you see in the viewfinder, to be so completely committed to the moment, that you do not take the image, the image takes you. Those are images that took your breath from you. It was that moment that made you want to convey that feeling to others. This book is about starting that journey.

The More Things Change, the More They Remain the Same: Mostly the Original Introduction

Sometimes you read a book and you understand it, and sometimes you read a book and it understands you.

—Bjork

In the past, when I bought "how-to" books, I bought them by weight. The equation was a simple one: I assumed that the heavier the book, the more knowledge it contained. Over the years I accumulated lots of answers; I just did not know any of the questions. I had the *how*, but no idea of the *why*. What I have discovered is that the *why* is more important than the *how*. If you know what you want to do and why you want to do it, discovering how becomes mere detail.

This book is not intended to teach you how Photoshop works, nor does it offer a "12-steps-to-perfect-photos," one-size-fits-all workflow. Rather, this book is about engaging in a conversation that will lead to teaching yourself to be able to make magic, starting at the point of capture. There is a circularness to photography. Because you are in service of the print (the end) which is your voice, the more you know about image editing (the middle), the more informed your decisions can be when you make your captures (the beginning). We will be traveling in a circle, but we will be doing it in a straight line.

This is a book about exploring how to express your vision. No one can teach you how to become an artist. Art, and being called an artist, are social terms. You do not create art by deciding that is what you are going to do today, and you do not become an artist by proclaiming yourself one. In my eyes, nothing I do is art. For me, it is expression. It becomes art when other people call it so. In the moment that "art" happens for the viewer of my work, I am an artist.

It is of ultimate importance that you create only those images that you find worthy. Others cannot like what you do not. I know that my harshest critic sits in the same chair I do. I offer you this thought—there are enough people in the world who want to beat you up; do not help them. Create images that please you. If you think you have an image with unfulfilled potential, do not discard it as worthless. Determine what about the image should be different and then transform it so it becomes an expression of your voice.

The experience that this book is designed to create is one that mimics, as closely as possible, the real-world experience of image editing. To this end, included with this book, you have received full-resolution, 16-bit source files (not 72-dot-per-inch low-resolution work files) on which to work. Additionally, there is a 100-ppi version of the source file that was created during the writing of each chapter's lesson, so that you can see what these files look like in your environment, that is, on your calibrated monitor on your computer. I assume nothing other than that you believe that the journey is the destination.

What digital photography has shown me is that impossible is just an opinion. For the first time in my creative life, I can realize my vision and express it for others to see. This is the journey on which I wish to take you. It is the reason that I wrote this book.

The Core Concepts of a Cinematic Approach to Digital Still Photography

Though this book's entire focus is on the why and how of developing a cinematic approach to digital still photography with Photoshop, what follows are the core concepts that are the foundation of this approach.

Photoshop is not a verb. It is a noun. It is the means to an end, not the end itself. Photoshop is not the reason you take a picture, it is a tool to help you realize your vision. Photoshop, though one of the most inspired pieces of software ever written, was not meant to be used as a jackhammer; it was intended to be used as an emery board. Should you ever be asked whether or not you altered an image in Photoshop, you want it to be a question, not an accusation.

A still photograph is called a still photograph because the picture does not move, not because the objects in the picture are not in motion. This is the single most important consideration when taking a photograph. What occurs in a properly executed still photograph is that motion is captured with stillness. If we were to take a 35mm movie camera, place a flower that was just beginning to bud in front of it, let the movie camera fire off one frame a minute for two weeks while the flower blossomed, develop the film, and play what we shot at 28 frames per second, we would see the flower open up before our eyes and then the petals drop off. At no time did the flower stop moving; what was stopped was the motion of the flower. Things happen at the speed of life. They do not happen at one frame a second or even 8.5 or 28 frames a second.

RGB is not a color. RGB is a formula to mix color. If you can see it with your eye, it is a color. How you control color is one of the elements that will determine how the viewer's eye moves across a print. From the moment of capture, understanding the formula to mix color will make your images more successful when they are printed.

NOTE: This core concept was originally taught to me by Eric Magnusson, and it is one that we will revisit a number of times in this book.

There are two "eyes" that view an image, the unconscious eye and the conscious eye. The unconscious eye is an amazing biological optical system that "sees" in a predictable manner. By controlling how the unconscious eye moves across an image, you can determine the story that the conscious eye perceives.

If something you see moves you, take a picture of it. Do not hesitate. If you hesitate, the moment is lost. The moments of life happen, they do not re-happen. Viola Spolin said, "In absolute spontaneity, you get absolute truth. You can only be one way when you are spontaneous, and that's truthful." By staying in the moment and allowing the spontaneity of your experience to cause the shutter to be fired, all of your images will have in them the truth of what you felt and saw. If you preconceive what you are going to shoot, the images lose that truth, that reality.

Visualize the finished image in your mind's eye as you are taking the picture and not a moment before. You do this so that when you get to the image editing process, you already have the end in mind. When you approach shooting images this way, you can remove everything that is not your vision. But even though you want to hold a clear vision of what you want the image to be, do not start with preconceptions about what you are going to shoot. Walk into the taking of pictures open to what is out there, without any preconceptions.

Get it right in the camera. If it does not look good through the lens, it will not look good coming out of the printer. Even if you find yourself in a situation that does not

allow you to make the captures as you would have liked, get as much right in camera as you can. Make informed decisions as you shoot, keeping in mind what images you might need when you get to image editing in Photoshop, so that your choices are not compromises.

Compose your images, do not crop them. Cinematographers do not have the luxury of cropping an image in the darkroom or the computer. What they see in the viewfinder is the canvas on which they have to paint. You are responsible for every millimeter of every image frame you create. Fill it! Place your subject in places other than the center of the frame. Bulls-eye composition is great if you are a marksman, but in the creation of a photograph, it is generally not considered to be a preferable style choice.

Workflow starts at the point of capturing the image and is dynamic, not static. No two images are the same, therefore no two workflows are the same. Be adaptive. Always pro-act, do not react. Be willing to improvise, and you will find the impossible within your reach.

In the ensuing chapters, just a few of the subjects we will explore are: light, gesture, shape, color, and the formula to mix color. It is my hope that when you arrive at the last word of the last chapter in this book, you will have attained the same skill set as I have. Your vision is not limited by your skills—only by your imagination. Your skills help you to communicate your vision to others. With that said, we begin.

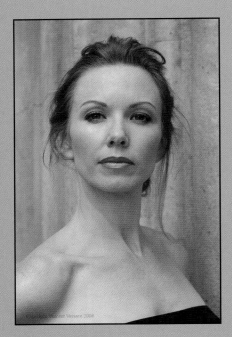

FIGURE 1.0.1 *Before*

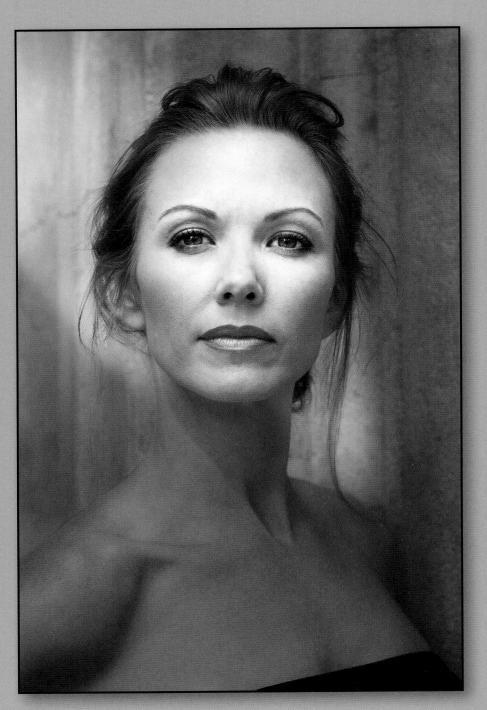

FIGURE 1.0.2 *After*

The Tao of Dynamic Workflow

Practice doesn't make perfect. Perfect practice makes perfect.

You first have to practice at practicing.

—Vince Lombardi

This chapter deals with how to analyze an image and develop a dynamic, image-specific workflow, so that you can achieve in the print, the image as you conceptualized it. I place special focus on image mapping and how to do basic lighting in Photoshop. I also take a broader look at how to approach images and think about them. This lesson is about learning how to practice at practicing and then about how to find the path to perfect practice.

Revisiting Shibumi:
The Art of Perfect Practice

My wish for this book was to make each chapter reflect, as closely as possible, an actual workflow—not some idealized sequence. Because workflow is fluid, and books are static, Acme Educational allowed me to use their high resolution computer screen grabs (frames from their 1200x1600 QuickTime movie) as part of each lesson in this book. But because some of you learn better by reading, some by seeing, and some do best using both, if you wish, you can purchase all the lessons from this book as a video set at www.acmeeducational.com. Both this book and the Acme tutorial are designed to stand alone, but they are mutually supportive.

Of all the lessons in this book, "Shibumi: The Art of Perfect Practice," is the one to which I return again and again. When I originally created the image that I have used in this lesson, I learned a lot of the things that eventually led to the creation of my first book, *Welcome to Oz*. But, perhaps the most important thing that I learned is that impossible is just an opinion.

The image in this chapter is a picture of the actress Challen Cates from a photo shoot that I did in Los Angeles using a single piece of lighting gear, a 6′×3′ diffuser. Why a single piece of lighting gear? Simple—the lighting equipment I

planned to use did not show up when I did. I had planned to use hot lights and reflectors, but when the lights did not show up, I was three hours away from my studio with only the diffuser that I had loaded, as an afterthought, into my assistant's car. My choices were either to react to the situation and call it a day, or be proactive and go ahead with the shoot believing that by adapting and improvising, I would be able to achieve my original vision. Choosing to be proactive, I had my assistant hold the diffuser over Challen's head so that she was evenly lit. Doing this would give me the best possible source file with which to work so that I could later light her properly in the computer. The techniques that I had to develop in order for me to achieve my original vision are the techniques that I want to share with you.

NOTE: Every image in this book marks a significant milestone in the development of my approach to creating images. Each represents a moment of discovery in which I found a new way to create, in print, what my eye had initially determined should be there.

I believe that it is best to approach Photoshop preemptively, to get it right in the camera, and that Photoshop is best used as an emery board and not a jackhammer. Even when the situation does not lend itself to getting it perfect, as in the case of the Challen Cates shoot, at the time of capture you should get as much right as possible.

In order to know how to get it right in the camera, which is the beginning of the process, you must understand the middle and end of the process as well. The middle of the process is the manipulation of the file in Photoshop and its end is the print, which is your voice, your vision.

This lesson will teach you how to analyze an image and optimize it. Image optimization is a process of refinement. First you make broad strokes that you later refine (what I call working from the global to the granular), removing everything that is not your vision, so all that remains is the image that you envisioned. You will also learn how to develop a dynamic, image-specific workflow so that you can achieve in the print the image as you conceptualized it. You will be able to do this because you will gain an understanding of how to maximize capture, so that manipulation of the file in Photoshop will result in the print that you wanted to achieve. Because of the circumstances of the Challen Cates shoot, the image that I had in my head when I captured it was nothing like the image I was forced to take—an image with almost no variation in light, dark, contrast, saturation, focus, or blur. I knew, however, that if I kept my initial vision in my head, using Photoshop, I could create those variations within that picture, so that it would be transformed into what I knew it should become.

IMPORTANT: Before You Begin This Lesson

If you have not downloaded the free plug-ins, the demo plug-ins, and source files from the download site for this lesson, as well as all the other files that are provided for the lessons in this book, go to: http://www.welcome2oz.com. All of the URLs that you need are located there, and you should do this before you go any further.

NOTE: All of the lessons have instructions on how to do them without the demo software, but when it comes to the free plug-ins (except in one instance), there is no alternative approach available in Photoshop. The reason for this is either that there is no way in Photoshop to accomplish what the plug-ins do, or that the plug-in does a better job. Also, the plug-ins are free with this book. One-hundred percent of my images see at least two of the plug-ins you now own. I highly recommend that you try them.

Each source file has two versions for all of the lessons in this book: one that contains all of the image maps that I created, and one that has only the source files. I urge you to use your own image maps, but they are best used if you have a tablet or pen-based display like I do. (I prefer a Wacom Cintiq or an Intuos 4 tablet.) If you have neither, or simply want to get right to the lesson, then use the source files with the image maps that I have provided.

The Secret of Dynamic Workflow

Workflow is a flexible series of steps that one follows to efficiently and accurately realize your vision.

—R. Mac Holbert

No two images are the same, so no two images will ever require the identical workflow, therefore, a standard workflow recipe does not exist. Some images are simply easier to work with than others, but before you begin, you may not know how much difficulty you will encounter. Your workflow must be flexible enough to accommodate any level of complexity.

Workflow is the operational aspect of a work procedure (in this case, producing a final image) and includes: how tasks are structured, their relative order, and how they are synchronized. A dynamic workflow is one in which you allow yourself mental flexibility when you work on an image. It is about figuring out how to process your file in order to create that which you hold in your mind's eye. By approaching workflow dynamically, you not only gain total artistic control, even your

file structure will be flexible, so that as technology and your skills improve, you can return to your files and re-interpret them.

A dynamic workflow is about making things as simple as possible, but no simpler, and working as quickly as possible, but no quicker. If an image is worthy enough to be worked on, then it is worth taking your time and care to create the image that realizes your vision. When you send an image out into the world, it has a life of its own, and if you did your job well, viewers will be moved. But you also have a life and should spend less of it using Photoshop.

To achieve a truly organized, dynamic workflow, you must be adaptable and open to improvisation. It is through such improvisational practice that you overcome obstacles. By practicing at practicing, you can find the way to engage in perfect practice, which is achieved when you unconsciously, and without effort, adapt and improvise in order to overcome obstacles. The Japanese call it "being in Shibumi." This lesson is about learning how to be in Shibumi whenever and wherever you create.

Practicing What I Preach

From the time that I first created this image, I have grown as an artist, both aesthetically and technically. I have gained better understanding of the software now available, and of post-processing technology. I am still on my journey to understand light and how to replicate it, but I have more skills than I did when I first captured Challen's image.

If you read the first version of *Welcome to Oz*, you will notice that my artistic core beliefs have not changed, but there have been some significant changes in the way I do things, as well as the way Challen's image now looks. I believe that through the practice of practicing, you will discover that every experience is new (even reworking an old image) if you bring to that experience an openness to explore.

Setting Up Photoshop for a Non-Destructive Workflow

The negative is everything. The print is all.

—Ansel Adams

The finest images—more specifically, the finest prints—are actually about how well the file was managed, but logic suggests that you should know how the device that does the printing works and what you can do to manipulate it. The issue, however, is that the printer is a default device; you can turn it on and off, put ink in it, and put the paper of your choice into it. Because inkjet printing devices today are so stable, little can or needs to be done to them. High quality prints are produced long before setting up image sizing and making selections in the printer driver. It is your imaging software and what you do to your file that ultimately controls your printer. Your prints will more accurately reflect your photographic vision, if you understand your imaging software.

Before you begin working on Challen's image, you need to have Photoshop set up for a non-destructive workflow. A non-destructive workflow is one in which you may do many manipulations without ever altering or losing the original file data. A typical non-destructive workflow starts when a RAW file is opened in the ProPhoto RGB color space in 16-bit. There is little or no clipping of colors in ProPhoto RGB (**Figure 1.1.1**), because it is such a large color space. It is the only color space that can contain all of the color that your DSLR can create. Files can always be converted later into smaller color spaces like sRGB (**Figure 1.1.2**) for display on the internet, but when a RAW file is opened in a smaller color space like Adobe RGB (**Figure 1.1.3**), colors that could have been printed had you used ProPhoto RGB are no longer in the file. Compare all of the color spaces in the visible spectrum in **Figure 1.1.4**.

NOTE: Once you capture in or convert into a smaller color space, all you have are the colors of that space. So if you have been converting your sRGB captured files into ProPhoto RGB thinking that you maximized the gamut of color, what you really have done is similar to pouring a quart of water into a gallon container; it is still only a quart of water.

Staying in 16-bit vs. 8-bit preserves all the tonal transitions in the RAW capture. Every time you adjust a file in Photoshop, Lightroom, Capture NX, or whatever RAW processor you choose, some information is lost. Staying in 16-bit guards against excessive information loss that could lead to posterization and banding. In the past, many photographers shied away from working in 16-bit due to large files sizes that slowed their workflow and were expensive to store. With dramatic improvements in computer processing power, coupled with equally dramatic decreases in the cost of storage, this is no longer the hurdle it once was. Non-destructive workflow ensures that any image editing can be undone, files stay in ProPhoto RGB 16-bit, and are saved in lossless formats such as .psd, .psb or .tif. Most importantly, this allows for the future growth and improvement of both technology and an individual's technique. The reason for this revision is that, not only have the technologies available today improved, my understanding of how to exploit Photoshop has grown.

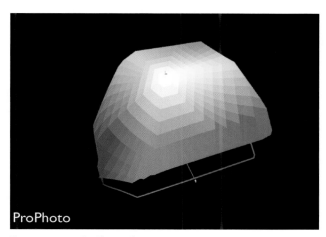

FIGURE 1.1.1 *ProPhoto color space*

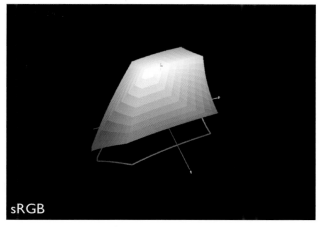

FIGURE 1.1.2 *sRGB color space*

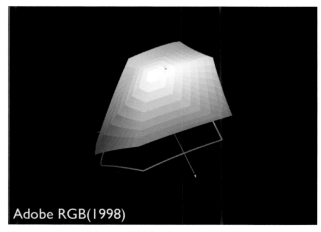

FIGURE 1.1.3 *Adobe RGB(1998) color space*

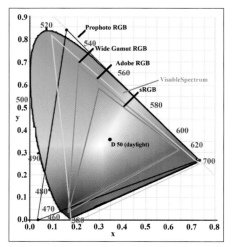

FIGURE 1.1.4 *The visible spectrum and the three color spaces*

Set Up a Non-Destructive Workflow and Create a Custom Workspace

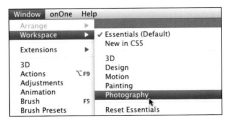

FIGURE 1.2.1

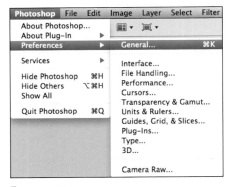

FIGURE 1.2.2

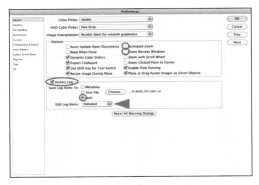

FIGURE 1.2.3 *Turning on the History Log*

Step 1: Photoshop Preferences

Photoshop CS5 ships with a series of preset workspaces, any of which allow you to achieve a non-destructive workflow. I am going to tell you how to fine tune one of them, and then I will have you save this as a custom workspace. The reason for this is one of exit strategy; something you always want to afford yourself whenever you edit an image. You do this so that if anything happens to your settings, your computer crashes, or your menus get moved or closed, all you have to do is click on your custom workspace and you will be back in business.

1. When you open Photoshop after you first install it, it defaults to the Essentials workspace. Go to the Window pull-down menu, select Workspace and then Photography (**Figure 1.2.1**).

2. Go to the Photoshop pull-down menu, select Preferences > General (Command + K for Mac / Control + K for Windows) (**Figure 1.2.2**) and the Photoshop Preferences dialog box will come up.

3. In the General Settings box, leave the Color Picker set to Adobe, and Image Interpolation set to Bicubic. In the Options dialog box, turn off Animated Zoom.

4. Next, click on the History Log and select Both. When the Save dialog box comes up, select New Folder and name that folder PS_IMAGE_TEXT_DOCS. Click Create and then Save in the Save dialog box (**Figure 1.2.3**).

NOTE: I place the PS_IMAGE_TEXT_DOCS folder on the desktop. I also create a folder on the desktop bearing the name of the image on which I am working. Into this folder, I put a copy of the original RAW file, a copy of the modified RAW file, the layered .psd file, and any other files that I create related to that specific image. Make sure to name this folder so that it reflects the specific image to which all the files in it belong.

All of the choices I have had you make here are personal workflow choices. Although all of the features that I have had you turn off are well-executed pieces of code that are visually beautiful, I have disabled them because I find them visually distracting so they slow me down.

I find the History Log to be useful. (The older I get, the more useful I find it.) Its uses are twofold: you have a record of what you have done, which helps in figuring out the bill when you are doing work for someone else, and you have a written record of what you have done in case you want to replicate an effect. If you find you do not need the History Log, come back and turn it off—just be sure to save the changes in the custom workspace.

5. Select Interface from the Preferences dialog box. In the General part of this dialog box, use the default settings. In the Panels & Documents part of the dialog box, however, turn off Open Documents as Tabs and Enable Floating Document Window Docking (both of these features make working with multiple images difficult and add unnecessary steps when you are engaging in an image harvesting workflow) (**Figure 1.2.4**).

6. Select Units & Rulers from the Preferences dialog box. Enter your unit preference (centimeters or inches) and, for new documents, I change the resolution to 360 ppi from 300ppi (**Figure 1.2.5**).

NOTE: Because Epson printers, which I use, produce the best results at resolutions of either 240ppi or 360ppi, I select 360ppi. HP and Canon do best at 300ppi. This is because of the nature of the printer head technology. Epson uses Micro Piezo whereas HP and Canon use a thermal approach. The Epson head is far more accurate with regard to dot placement than either Canon or HP. I use primarily 360ppi because I do a lot of black and white images, and the majority of them are printed on Exhibition Fine Art paper, which is a glossy surface paper that holds dot structure better than any other paper I have used. I sometimes use a resolution of 240ppi when I am printing on fine art, cotton-based papers. This has to do with dot gain or the expansion of the ink dot due to the tooth of the paper.

7. Click OK. You will now set up the next part of Photoshop for an Oz workflow.

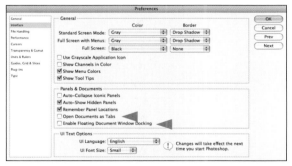

FIGURE 1.2.4 *Disabling the Open Documents as Tabs option*

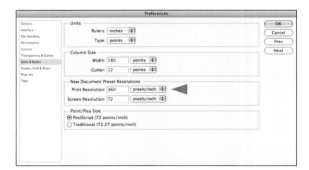

FIGURE 1.2.5 *Setting the default resolution to 300ppi*

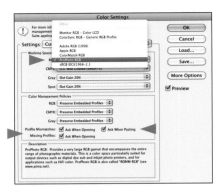

FIGURE 1.3.1

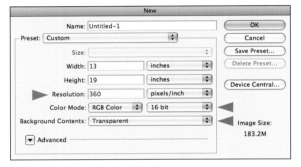

FIGURE 1.3.2 *Setting the New Document preset*

FIGURE 1.3.3 *Creating a New Workspace*

Step 2: Setting Up Photoshop Color Space Preferences and File Bit Depth

1. Go to Edit > Color Settings (Command + Shift + K / Control + Shift + K). The Color Settings dialog box will come up. Its default is North American General Purpose.

2. Select North American Prepress 2. In the Working Spaces part of the dialog box, click on the RGB pull-down menu and select ProPhoto RGB (**Figure 1.3.1**). Click OK.

NOTE: You should do this so that all of the color space warnings are turned on. It is important to remember that once you assign a color space, unless the needs of image editing require that you go from a larger color space to a smaller one, you should use the color space of the file as it is.

Another reason to turn on the color space warnings is so that you are aware of any possible shifts in color that will happen when working with multiple images. Being aware of a possible color shift is important in case you need to address it.

3. Go to File > New File (Command + N / Control + N). Click on the Bit Depth pull-down menu and select 16 bit. For Background Contents, select Transparent (**Figure 1.3.2**), and leave the Width and Height at their default values. Click Save Preset, and then click OK in the New Document Preset dialog box. Click OK in the New File dialog box, and then click Command + W / Control + W to close the file that you just created.

4. Go to Window > Workspace > New Workspace... and save this workspace (**Figure 1.3.3**) in the New Workspace dialog box, naming it Workspace Oz2. Click Save.

Photoshop is now set up and optimized for photographic image editing.

Practicing at Practicing: Image Maps

If a cluttered desk is the sign of a cluttered mind, what is the significance of a clean desk?

—Dr. Laurence J. Peter

Step 1: Using Image Maps

As an optical sensing device, the human eye scans a scene in a predictable sequence. It first goes to patterns it recognizes, then moves from areas of light to dark, high contrast to low contrast, high sharpness to low sharpness, in focus to blur (which is different than high to low sharpness), and high color saturation to low.

In order to make the viewer's eye move across the image in a way that you decide it should, you must manipulate the light and dark areas, their contrast, their sharpness, their degree of focus or blur, and their saturation. So as not to feel overwhelmed when undertaking such a task, you should start by creating a list of the changes you would like to make. This is best done by creating an image map.

An image map is a Photoshop layer that sits on top of the image layer stack, on which you can make notes about what you are planning to do to an image. You can also use it to make notations on the various steps you will take, but what it does best is teach you how to create image-specific workflows. An image map is a planning device that helps you see the trees from the forest.

NOTE: You can download a tutorial QuickTime movie entitled "How to Make an Image Map" from www.welcome2oz. com (the same place you downloaded the source files for all of the lessons in this book). As I noted at the beginning of this chapter, image maps work best if you have a tablet or a pen-based display. Although it is possible to do everything in all the lessons in this book with a mouse, or even the trackpad of a laptop, you will be better served if you use a pen- or tablet-based system.

Keep in mind that image maps are designed to go away. They are the equivalent of training wheels. They are a good way to teach yourself how to organize and see, but you will not need them forever. To practice at practicing, you should do every lesson in this book with them and then again without them.

Another good reason to use image maps is that they allow you to make notes to yourself for retouching when you meet with a client. (I have the client sign the layer, so that there is a record in the file of what he wanted done and so there are no questions when I deliver the final image.) Image mapping also allows me to return to an image and note what I have done while it is still fresh in my mind so that I have accurate notes for the future.

Before you take the first "how to" step toward creating an image map, consider how believable you would like the finished image to appear. In this lesson, you do not want the viewer to know that you did any manipulation in Photoshop; you want to mimic what would have occurred had the model been properly lit in the first place.

A way to explain this can be found in Aristotle's *Poetics*. In this work, he suggested that a believable improbability is better than an improbable believability. I believe this to be true and have extended this concept to define believable probability. What are these concepts and why are they important to digital photography?

The easiest way to understand these concepts is by using examples. Good examples of believable improbability are found in the Star Wars sagas. We do not travel faster than the speed of light, and walking, talking robots with feelings do not yet exist. In spite of this, we are willing to suspend disbelief, because the stories of love, longing, and conflict are believable

even though they are improbable. In contrast, what follows is an example of improbable believability. I buy a lottery ticket in Los Angeles and the jackpot is $100,000. I win! The next day, I fly to New York City, buy another ticket, and win a jackpot of $75,000,000! The next day I fly to Chicago, repeat the process and win again! Although this could happen, you don't believe it because it is so improbable.

The third concept, that of believable probability, can be explained using the Challen Cates image. You will create an image using Photoshop that the viewer will find both probable and believable, because the final image will be lit as though I had had the proper lighting equipment when I made the initial capture.

In order to assure that you create a believable probability rather than an improbable believability, you need to make sure that every choice you make in Photoshop leads to a result that will mimic the reality of proper lighting. For example, if you create a light that appears to shine from above, you need to create corresponding shadows that follow the direction of that light.

There will be images in which you will want to create a believable improbability. (There are some in this book. Try to identify them as you progress through the lessons.) The key to making something believable, no matter how improbable it may be, is to make sure that it conforms to the logic of our reality as much as possible. Once you have defined your goal for a particular image, you can begin to create image maps.

There are three free filter plug-ins from www.niksoftware.com/ozlessons: Tonal Contrast, Contrast Only, and Skylight filter. They will show up in your Filter pull-down menu under Nik Software as the Versace Edition. At the time of writing this book, the Nik Software filters only work in 32-bit in the Macintosh operating system; however, they work in 64-bit in Windows. Nik Software is in the process of updating them, but until then, Mac users will have to run CS5 in 32-bit. You do this by Control-clicking on the CS5

application icon. Select Get Info and click on the Open in 32-bit Mode checkbox. Close the window and start Photoshop.

You will also need to download the free copy of onOne Software's FocalPoint 2.0 from www.ononesoftware.com/ozlessons. This is a fully functional version of the software and you will be a fully licensed user.

Lastly, once you have installed everything, if you are not working in the ProPhoto RGB color space, you need to set Photoshop to ProPhoto RGB. You do this by going to Edit > Color Setting (Command + Shift + K / Control + Shift + K) so that the Color Settings dialog box comes up. Select North American Prepress 2 in the Working Spaces in the RGB pull-down menu and, also, change the setting from Adobe RGB 1998 to ProPhoto RGB. Click OK.

Creating an Image Map

1. Open the image "SHIBUMI_SOURCE_16BIT.tif " (located in the CHAPTER_01 folder that you downloaded from www.welcome2oz.com) in Photoshop.

NOTE: There is also a video on youtube.com where you can watch how I make an image map. The URL is http://www.youtube.com/watch?v=5ki3QhJkw-4.

Make sure that the image is in the neutral gray workspace by pressing the letter F. The gray space is best for making color decisions, because it gives you a color-neutral background. Gray is specifically used to minimize chromatic induction (visual color contamination), and a gray midtone is used to minimize contrast effects. By choosing a gray background, you can make the most informed decisions about changing the color, contrast, and shade of the image with which you are working.

2. View the image in full screen (Command + 0 / Control + 0), and choose the Pencil tool from the tool bar (in the same place as the Brush tool). Double-click on the Set Foreground Color box in the Tools panel (the black and white squares located toward the bottom of the Tools panel). This brings

up the Color Picker dialog box. Select a bright color. (I generally start with red and then work my way down on the color selector.)

3. Make sure the Layers panel is open, and click on the Create a New Layer Group icon (**Figure 1.4.1**). This will create a Layer Set folder in the Layers panel. Name the new layer set IMAGE_MAPS (**Figure 1.4.2**).

4. Create a new layer by clicking on the Create a New Layer icon (**Fig 1.4.3**). Call the new layer L2D_IM (for Light-to-Dark image map) (**Fig 1.4.4**).

FIGURE 1.4.1 *Create a New Layer Group icon*

FIGURE 1.4.2 *Creating the Layer set IMAGE_MAPS*

FIGURE 1.4.3 *Create a New Layer icon*

NOTE: At any level of expertise, giving your layers meaningful file names is an important part of creating an effective workflow. If many months after working on a file, you want to return to it to try a new technique, you will immediately grasp the purpose of each layer on which you originally worked and be able to retrieve the appropriate one on which to try your new approach. Perhaps you made a print or sent a file to a client, and changes are needed. Knowing at a glance what you did to the image will make life a lot easier should you have to go back and redo or undo something. It also makes your practicing at practicing sessions easier. If you get lost, you have an easily readable and retrievable road map.

5. Select a brush size of 25 pixels. (You increase or diminish a brush's size by pressing the square bracket keys, which are on the keyboard next to the letter P. Pressing the left bracket makes the brush smaller; pressing the right bracket makes it bigger.)

NOTE: Correct brush size is determined by the size and resolution of the image, so focus on the visual size of the brush, and not on its pixel size. For example, a 25-pixel brush would be much too large to use on a small, low-resolution image.

FIGURE 1.4.4 *Renaming the layer L2D_IM*

The Relationship of Light to Dark

For the first part of this lesson, I want you to manipulate the variables that I mentioned at the beginning of Step 1: light-to-dark, high-to-low contrast, and in-focus-to-blur. Remember, it is the person creating the image who decides the journey that the viewer's eye will take. And it is that journey that causes the viewer to see the story you wanted to tell.

You control where the viewer's eye will go by manipulating variables such as focus, light, and dark. I contend that when we view anything at all, there is both an unconscious and a conscious element involved. First, our unconscious eye, or the anatomical structure that makes up the eye, scans in the predictable manner I described above. Then, the conscious eye, the mind's eye, interprets the image seen. It is how you control the unconscious eye that determines how the viewer interprets the image. This is a theme to which I will frequently return.

In general, I like to begin manipulating light-to-dark, thereby exploiting the unconscious eye's tendency to move from light areas to dark ones. For this specific image, I want the viewer's eye to go first to the face, then to the torso, then to the rest of the image.

You must first decide what ratio or relationship of light-to-dark to create within this image. I wanted the face to be brightest, so I set it at 100%. As light's circle of illumination increases, its intensity diminishes, so set the hair and torso at 50%. The background should be darker than the face, hair, and torso. The light on the background should go from light to dark as the eye moves from right to left. (I will explain why in a moment.) Set the right side at 25% and the left side at 0%.

NOTE: As you create your image map, keep in mind that these percentages are just notations. You can change them any time. You are working from the global to the granular.

After those values are drawn on the L2D_IM layer, the image will look like this (**Figure 1.5.1**).

Placing Key and Fill Lights

If I had had all my lighting equipment at the photo shoot, I would have started by lighting the background, and I would have cross-lit it from left to right. Then I would have set key lights and fill lights. With a portrait, you usually want the viewer's eye to go first to the subject's eyes, so that is where you should put the key light. Then you might put fill lights on the lips and, to some degree, the torso.

Create a new layer and name it LIGHTING_IM (for Lighting image map). Pick a color other than red from the Tools panel to draw your lighting choices. (I chose blue.)

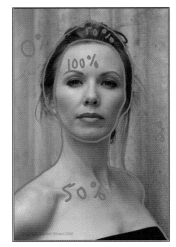 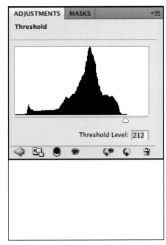

FIGURES 1.5.1 AND 1.5.2 *Light-to-dark image map, and Lighting image map*

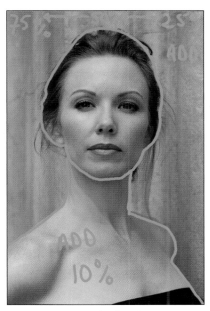

FIGURE 1.5.3 *Depth of Field image map*

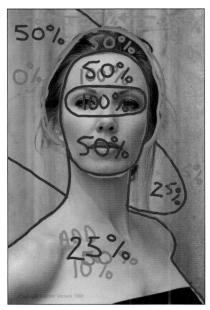

FIGURE 1.5.4 *Combined image maps*

Here is the LIGHTING image map (**Figure 1.5.2**) showing the notation of the percentages I used: eyes: 100%, face: 50%, torso: 25%, and background areas: 50% and 25%.

The Illusion of Depth of Field

When shooting portraits, I find that a shallow depth of field (where only the subject is sharp and the background is out of focus) is visually pleasing. When you focus on the subject's eye that is closest to the camera, the depth of field (the zone of acceptable sharpness) on the face will extend from the tip of the nose to a little past the ear. Generally that means shooting at f/5.6.

Create a new layer and name it D_OF_F (for Depth of Field), and pick a new color to use for your next set of image map notations (I chose light green) (**Figure 1.5.3**).

In this case, the image was shot at f/6.3, with the model standing right against the wall, underneath the diffuser. The result is too much depth of field (DOF), with everything in focus, including the background.

NOTE: One of the issues that occurred during Challen's photo shoot was that in order to evenly light her, I had to place her almost against the wall. I would have preferred that she be some distance away from and at an angle to it. In order to create this illusion in Photoshop, so as to achieve a believable probability, I had to create the correct quantity of in-focus-to-blur that would have occurred had I actually lit her properly and positioned her away from the wall. You also need to apply some degree of blur to her torso. (Since the point of focus is her eye, and one-third forward from that point should be in focus, the area in focus should stop at the tip of her nose. Any areas of her torso that extend past her nose should not be in focus.)

You now have a basic workflow to follow for manipulating the lighting and DOF of the Challen Cates image in Photoshop (**Figure 1.5.4**). (Keep in mind that the values I chose to use

epth of field refers to the area that is in focus both in front and behind the true plane of focus. It has been shown that if the depth of the area that appears to be in focus in front of the true plane of focus is one foot, then the area that appears to be in focus behind the true plane of focus is two feet. This works out to a ratio of one-third in front in focus to two-thirds behind in focus; i.e. twice as much behind as in front.

The absolute distance that appears in focus depends on two factors: the size of the lens aperture and the distance from the camera to the subject. The larger the aperture, the "shallower" or smaller the area that is in focus. The smaller the aperture, the "deeper" or greater the area that is in focus. Additionally, the farther away a subject is from the camera, the greater its depth of field, i.e. the more that will be in focus. Conversely, the closer the subject is to the camera, the less its depth of field, i.e. the less that will be in focus.

In the lighting image map, we made some decisions as to where we would like the viewer's eye to go: first to the face, then the torso, and then the background from right to left. The face and torso are easy to understand, but why right to left? Because we want to create the illusion that the model is farther from the background than she really is (**Figure 1.5.3**).

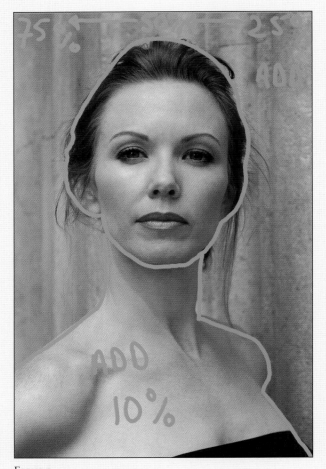

FIGURE 1.5.3

are only approximations and reflect relationships specific to this image.) Starting with a completely flat-lit photograph, you are now well on the way to creating a believable probability.

Make the image maps invisible by clicking off the eyeball of the layer set IMAGE_MAPS. They will be out of the way, but available when needed.

Step 2: Correcting Digital Sensor Color Cast

Now that you have an image roadmap, working from the global to the granular, the next biggest issue is the correction of the image's CCD/CMOS color cast. It is an important issue because it will affect all of the image editing choices you will make from this point on.

All RAW images, from any digital camera, exhibit some form of color cast as a result of the interpolation process that occurs when you bring that image into digital manipulation software such as Photoshop. The Challen Cates image on which you are working has a magenta/yellow haze.

The most effective way to remove this type of color cast is to first define the black and white points of the image. Finding the white point is a bit more problematic than finding the black point—and finding a gray point is even more elusive—but you are going to find all three by using a Threshold adjustment layer.

There are some rules that are important to know when removing color cast caused by the interpolation of the data from a CCD/CMOS sensor. When looking for the black point, select your sample point from an area of "meaningful" black rather than using the first black pixel you see. If you select the very first black pixel that you see, it generally has RGB values that are R:0, G:0, and B:0. If no information was recorded, no color contamination exists. What you are looking for is a black pixel that has RGB information in it.

Finding a white point is completely different. You do not want to select a white point from an area of "meaningful" white. Rather, you want to find the pixels that are closest to pure white, without actually being pure white. (A pure white pixel will have RGB values of R:255, G:255, and B:255, which is of the same usefulness as a black pixel that has RGB values that are zero.) What makes finding a white point so problematic is that, much of the time, visible white and measurable white are two different things. (Measurable white, using the Threshold adjustment layer method, will always be biased to R:30%, G:60%, and B:10%, while visible white generally consists of equal values of RGB and tends to be a lot bluer than measurable white.) In addition, there are instances when there is no white point at all and, occasionally, there may be aspects of the white point color cast correction you may not like, i.e. you may actually like aspects of the color cast. For these reasons, it is a good idea to separate the black and white points into separate Curves adjustment layers, because it gives you options that you will see as this lesson progresses.

NOTE: Looking at this image, visible white is found in the catch light of the subject's eye.

Conceptually, it may be more accurate to view setting a white and black point as setting a light and dark one, because you do not want to use the pure white (R:255, G:255, and B:255) and pure black of an image (R:0, G:0, and B:0); you want to be as close as possible to those values without reaching them.

FIGURE 1.6.1 *Threshold adjustment icon*

FIGURES 1.6.2 AND 1.6.3 *Black and white image with Threshold adjustment applied, and whole image with first meaningful black*

FIGURE 1.6.4

How to Find Black and White Points Using a Threshold Adjustment Layer

1. Make the background layer active. If you are working in CS4 or above, go to the Adjustments panel and select Threshold by clicking on the Threshold adjustment layer icon (**Figure 1.6.1**). (If you are working in CS3 or below, go to the bottom of the Layers panel, click on the Create a Fill or Adjustment Layer icon, and select Threshold.) A black-and-white representation of the image appears (**Figure 1.6.2**).

2. If you are working in CS4 or above, make sure that the Eyedropper tool is selected. (If you are working in CS3 or below, the tool is automatically selected.) Move the triangle slider (located at the bottom of the Threshold dialog box) to the left until the image goes completely white. As you move the slider slowly back toward the right, you will see image detail start to emerge in black. The first meaningful area of black that you see is where you should take your black sample point (**Figures 1.6.3**). (Meaningful black is an area in which you can see "something.")

3. Choose a black point from the top of the model's dress by zooming into this area (Command + Space / Control + Space gives you the Zoom tool) and then by Shift-clicking a sample point (**Figures 1.6.4**).

4. Bring the image back to full screen (Command + 0 / Control + 0), and move the triangle slider all the way to the right. The image will be completely black, but you should see a sample point (your black point) bearing the number 1 in the lower right corner.

NOTE: Even though you see "meaningful" black in areas of the model's hair and eyes, I chose to put my black point in the model's dress, because her dress was actually black. You will notice, however, that the dress's color recorded as dark blue.

5. Move the slider slowly back to the left until the first area of white pixels appear. (I saw this at a Threshold level of 212.) (**Figures 1.6.5**)

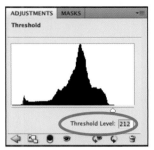

FIGURE 1.6.5 FIGURE 1.6.6

FIGURES 1.6.7 AND 1.6.8 *Three areas of white in Threshold preview, Sample point 2 placed on the white pixels*

NOTE: When choosing a potential white point, get as close as you can to the first white pixel that you see. If that pixel has an RGB value of R:255, G:255, and B:255, just like the a black point that has a RGB value of 0,0,0, it contains nothing to measure. This is why you should get as close as you can to the first white pixel without actually selecting it. To remove a color cast, you must have a pixel that has a variation between the red, green, and blue pixel values.

6. The three areas that come up are on Challen's shoulder, cheek, and forehead. Move the slider to the right so that it is at the very end of the black in the histogram shown in the Threshold dialog box. (For this image, that is a threshold level of 204.) What you should now see is one white square in a field of black (**Figures 1.6.6** and **1.6.7**).

7. Zoom into the area of the white squares above her shoulder. One of these three white squares is going to become your white point. You are going to further define your white point by moving the threshold level upward. Click on the white triangle and slowly move it until only one white square remains, which occurs in this image at a threshold level of 207. Make sure the Eyedropper is selected in the tool bar. Shift-click on the white square, and you should see a sample point appear with the number 2 (**Figure 1.6.8**).

Finding a "Sometimes" Midpoint Using a Threshold Adjustment Layer

Contained within every image is a set of numbers (RGB values) that corresponds with the always-difficult-to-find midpoint value. What follows is the easier of the two ways to find that midpoint; the one that works when the image has easy-to-find neutrals. (Later in this book, you will learn how to find a midpoint value even when you cannot see one.) The concrete wall behind Challen is made up of neutral tones that lend themselves to finding a useful midpoint.

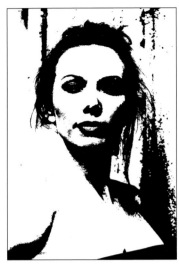

FIGURE 1.6.10 *The Threshold adjustment set to 128*

FIGURE 1.6.9 *The image at a Threshold of 128*

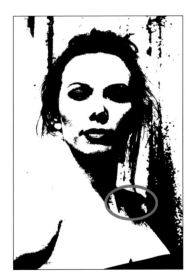

FIGURE 1.6.11 *Zoom into the shoulder*

8. Bring the image back to full screen (Command + 0 / Control + 0), and move the triangle slider until the Threshold Level is at 128 (**Figures 1.6.9** and **1.6.10**). When you turn the Preview Eyeball off on the Threshold adjustment layer located at the bottom of the dialog box, you will see a red line through the Eyeballs. (In Photoshop CS3 and below, click off Preview.)

9. Zoom into the model's right shoulder containing the desired neutral values (**Figure 1.6.11**).

10. Click on the Preview Eyeball of the Threshold adjustment layer. In the Threshold, type 127, and press Return. Command + Z / Control + Z back and forth, and observe where black pixels appear and reappear on the wall. Once you have found an area like this, zoom into it. Repeat toggling back and forth between a threshold level of 127 and 128, and watch where the pixels appear and reappear. When you return to a threshold level of 128, pick a single pixel that reappears, and place your third sample point (**Figure 1.6.12**).

11. Click the Trash Can icon (**Figure 1.6.13**) to discard the Threshold adjustment layer (or select Cancel in the Threshold dialog box if you are working with CS3 or below). This layer was needed only to help you locate the potential white, mid- and black points.

Living in the Land of 2%

Whenever you work on an image, regardless of the RAW processor you use, you clip data that results in the introduction of artifacts. It is extremely important to understand that such artifacting is cumulative and can become multiplicative. Furthermore, the image data that you see when you first open a RAW file (before you do anything to it) is the cleanest it will ever be.

When you decide to manipulate your file, you must decide whether or not to live in the land of 2%. If editing an image brings it 2% closer to your original vision, you must do it, and thus, you are living in the land of 2%. To paraphrase Viola Spolin (internationally renowned theater educator, director,

and actress), the moment you decide something in the creation of your work doesn't matter, is the moment you decide that your work doesn't matter. I believe that everything you do must matter. What becomes your greatest challenge is editing your image so as to remove only those things that are not compatible with your original vision in such a way that you create the smallest amount of artifact possible.

Why and how I do many of the things I do is because I want my image to be 2% closer to my original vision, but I do not want to cause a possible 15–20% quality decrease in my image file due to the cumulative and potentially multiplicative aspects of artifacting. Everything I do is in service of the print, which is in service of my vision, or voice, and I want my voice heard and my vision seen without any detractions.

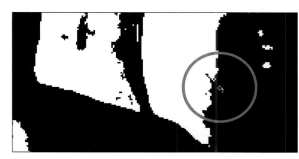

FIGURE 1.6.12 *The third sample point*

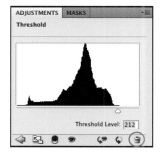

FIGURE 1.6.13 *Discarding the adjustment*

That brings me to another thought. I have been talking about correcting a digital file's color cast, but not all color cast is objectionable, and sometimes, it may merely be aspects of the color cast you do not like.

This is what I know:

1. All images have a color cast.

2. The color cast may be objectionable, or merely aspects of the color cast are objectionable.

3. Aspects of color cast may be usable.

4. The untouched file is the cleanest it will ever be.

5. Anything I do to this file clips data and introduces artifacts.

6. All artifacting is cumulative and may be multiplicative.

7. When working on a image, I want to clip as little data as possible.

8. I want the greatest image control I can get.

9. I always want to be able to undo what I have done.

I want you to apply these thoughts to the task at hand, which is removing the color cast of this image, while sparing the loss of information and maintaining the greatest amount of aesthetic control possible. You will do this is by using separate Curves adjustment layers for setting this image's white point, black point, and midpoint. Because you will make one adjustment per layer, you will minimize the artifacts that you will introduce.

Since I adhere to Albert Einstein's tenet that we should make things as simple as possible and no simpler, why would I want you to use three separate Curves adjustment layers when it would be simpler to do the three points on just one? The reason is that the resultant images are profoundly different. This is what the image looks like when I separate out the black, mid-, and white points onto three separate Curves adjustment layers (**Figure 1.7.1**), and this is what it looks like when I do the three points in just one (**Figure 1.7.2**).

Another reason to use three separate curves is that if you combine the three points into one Curves adjustment layer, you lose control over your image. You cannot return to the image (should you decide or need to) to brush things backward, change opacities, or re-blend the colors. Some photographers use one layer to save space on their hard drive and to simplify their workflow. The result, however, is that they are stuck with what they have done. Trying to make something simpler than it should be can cause many unanticipated problems.

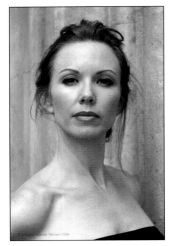

FIGURES 1.7.1 AND 1.7.2 *Comparing the effect of three separate curves adjustments (left) with one (right)*

Another benefit of this approach is that you can control the amount of whatever effect you are using: globally through the use of the layer's opacity (in the Layers panel), and selectively through the use of layer masks for each of the adjustment layers.

Using Multiple Curves Adjustment Layers to Remove Color Cast

In Step 11, under finding a midpoint, you discarded the Threshold adjustment layer. After doing that, the image reappeared in color displaying the three sample points you created: one on the model's cheek, one on the concrete wall, and one on her dress. The series of numbers that appear in the Info panel are the actual color values of each of those points. (Sample point 1—your black point: R:18, G:31, and B:17; Sample point 2—your white point: R:219, G:192, and B:208; and Sample Point 3—your midpoint: R:131, G:129, and B:114.)

NOTE: In CS3 and below, click Cancel to get rid of the Threshold adjustment layer. In CS4 and above, click on the trash can. Be aware, however, that in CS4 and above, if you are using actions or Extension panels, you click Cancel the same way you would if you were using CS3 and below.

If your numbers do not exactly match mine, it simply means that we picked slightly different sample points. Notice that the area you clicked on for your white point was not located in the area of the eye. In this instance, visible white is different from measurable white. For the purpose of demonstration, I placed a white sample point (and named it Sample Point 4) in the specular highlight of the eye. This is the whitest, visible white point in the image.

1. Make sure the Layers panel is open, and click on the Create a New Layer Group icon (**Figure 1.8.1**). This will create a Layer Set folder in the Layers panel. Name the new layer set BP/WP/MP.

2. Making sure that you are in the BP/WP/MP layer set and turn Caps Lock on; the pointer becomes the crosshairs cursor. If you are in CS3 or below, go to the bottom of the Layers panel, and click on the Create New Fill or Adjustment Layer

FIGURE 1.8.1 *Create a New Layer Group icon*

FIGURE 1.8.2 *The black eyedropper in the Curves adjustment*

FIGURE 1.8.3 *Setting new values for the black eyedropper*

radial button. (It is the third radial button from the left and is a half-white, half-black circle). Select Curves from the fly-out menu. You will now create the first of three Curves adjustment layers. If you are in CS4 or above, you can either create a Curves adjustment layer this way or you can use the Adjustment panel.

3. When the Curves dialog box comes up, click the black eyedropper to set the threshold at which you want the black eyedropper to sample (**Figure 1.8.2**). Now, double-click on the black eyedropper that is located in the lower right corner of the dialog box. The Color Picker dialog box will come up. In the RGB values part of the dialog box, type 7 in the R, 7 in the G, and 7 in the B. Click OK (**Figure 1.8.3**).

4. Zoom into the area of sample point 1. Select the black eyedropper, which is the leftmost eyedropper of the three in the Curves adjustment layer dialog box, and you will see a circle with two crosshairs. Line the crosshairs up until it appears that there is only one, and click. Notice how the color changes (**Figures 1.8.4** and **1.8.5**).

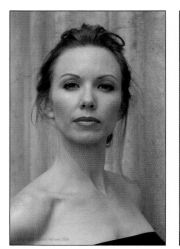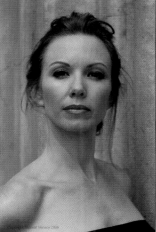

FIGURES 1.8.4 AND 1.8.5 *Before the BP Curves adjustment and after the BP Curves adjustment*

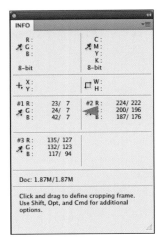

FIGURE 1.8.6 *Equal RGB values for the black point*

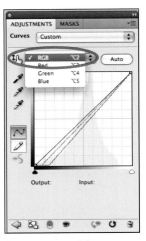

FIGURE 1.8.7 *Selecting the Red channel*

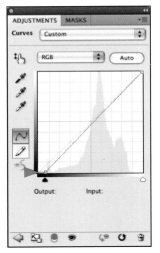

FIGURE 1.8.8 *Fine tuning the anchor point*

NOTE: The RGB values of R:7, G:7, B:7 approximate the beginning of what is known as Zone II (textured black) in the Zone system, as developed by Ansel Adams and Minor White. For further discussion of the Zone System, see *The Zone System Manual* by Minor White.

When you define the white point, you will set the white point eyedropper for the upper end of Zone IX (textured white), because in a fine art print, you are looking for 100% ink coverage in the highlights (no place where the paper shows through the ink) and shadows that have detail throughout. In other words, you want no paper showing and no ink wasted.

If Photoshop asks, "Want to save the new target colors as default?" click Yes for both the black and white point curves.

Because you are addressing issues of color (color cast), you are going to leave the blend mode of this Curves adjustment layer, as well as the one you are about to create, as Normal.

You will now see that, in the Info panel, sample point 1 has changed from values of R:19, G:17, and B:31 to values of R:9, G:9, and B:9. Your next task is to fine tune each of the RGB channels in your Curves adjustment layer to R:7, G:7, and B:7 (**Figure 1.8.6**). In so doing, you will recover some more data that may be potentially clipped in the course of removing color cast, as well as to remove the color cast from the black aspect of your image.

5. From the Modify Individual Channels pull-down menu, select the Red channel and click on the anchor point at the bottom of the channel (**Figures 1.8.7** and **1.8.8**). Using the directional arrows on your keyboard (for this image, it is the right arrow), move the anchor point to the right until the number in the Info panel moves from 9 to 7. (For me, it was 2 clicks for all three channels.) Repeat this process for the green and blue channels. In the Info panel, all the RGB values should now equal 7. By redefining the black point, you have also removed the CCD/CMOS color cast from the black parts of the image (**Figures 1.8.9** and **1.8.10**). In the Layers panel, name

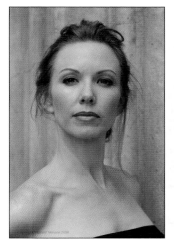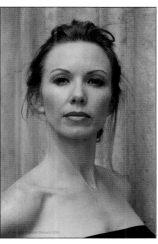

FIGURES 1.8.9 AND 1.8.10 *Before the BP Curves adjustment and after fine tuning the BP Curves adjustment*

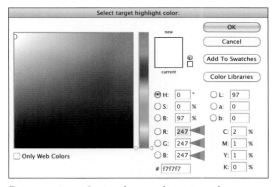

FIGURE 1.8.11 *Setting the new white point values*

FIGURE 1.8.12

this layer BP (for Black Point) and turn its eyeball off. You should repeat this process for the white and midpoints.

6. Repeat the steps for creating a Curves adjustment layer. To set the threshold of the white eyedropper, select the white eyedropper, double-click on the white eyedropper and set the RGB values to R:247, G:247, and B:247. (This approximates the upper end of Zone IX) (**Figure 1.8.11**). Click OK. Zoom into the area of sample point 2, align the crosshairs, click, and then click OK. You have set the white point. In the Info panel, sample point 2 (the white point) should have changed from R:219, G:208, and B:192 to R:247, G:247, and B:247.

7. From the Modify Individual Channels pull-down menu, select the Red channel, and click on the anchor point at the top of the channel. Using the directional arrows on your keyboard (the right arrow for this image), move the anchor point to the right until the number in the Info panel moves from 253 to 247. (For me, it was 5 clicks to the right.) Repeat this process for the green and blue channels. (For me, the green channel was 5 clicks to the right, and the blue was 7 clicks to the left.) The RGB values in the Info panel should now equal 247 (**Figure 1.8.12**). In the Layers panel, name this layer WP (for White Point) and turn its eyeball off. Compare before (**Figure 1.8.13**) and after (**Figure 1.8.14**).

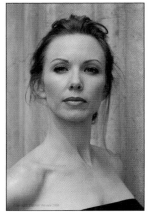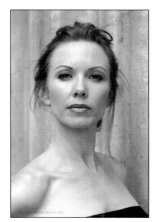

FIGURE 1.8.13 *Before the WP adjustment*　　FIGURE 1.8.14 *After the WP adjustment*

Adjustment Layers vs.
Image > Adjustment Commands

When you use the Image > Adjustment commands approach to editing your images, you are making permanent changes to the pixels on the active layer. On the other hand, an adjustment layer is a layer of math that sits above the layer stack and, though it affects the image the same way as using an Image > Adjustment command, it does not make permanent changes to the pixels of the active layer.

It is a better idea to use adjustment layers rather than adjustment commands because:

1. An adjustment layer can be re-opened and the settings changed by double-clicking the left-hand thumbnail.

2. An adjustment layer can be hidden to temporarily remove its effect or it can be deleted to permanently remove the adjustment.

3. When using a layer mask, an adjustment layer can be selectively applied to various parts of the image.

4. An adjustment layer can be used to apply an adjustment to all of the layers below it in the Layers panel.

5. An adjustment layer can be "clipped" to a single layer by Option- / Alt- clicking on the line in the Layers panel between the adjustment layer and the layer immediately below. This restricts the adjustment to the single layer.

6. An adjustment layer can be applied to some layers in the Layers panel. To do this, add the layers to which you want to apply the adjustment to a Layer Group, place the adjustment layer within the Group at the top, and change the Group's blend mode from Pass Through to Normal.

8. For the last time, repeat the steps for creating a Curves adjustment layer. Select the Set Graypoint eyedropper. (Do not worry about double-clicking on the gray-point eyedropper; the RGB values are already set to R:128, G:128, and B:128.) Zoom into the area of sample point 3, align the crosshairs, click, and then click OK. You have set the midpoint or gray point. The Info panel for sample point 3 should have changed from R:131, G:129, and B:114 to R:124, G:124, and B:124.

9. Once again, from the Modify Individual Channels pull-down menu, select the Red channel and click on the anchor point in the middle of the channel. Using the directional arrows on your keyboard (the left arrow for this image), move the anchor point to the left until the number in the Info panel moves from 124 to 128. (For me, it was 4 clicks to the left.) Repeat this process for the green and blue channels. (For me, the green and blue channels were both 4 clicks to the left.) The RGB values in the Info panel should now equal 128. In the Layers panel, name this layer MP (for Midpoint). Compare before the MP adjustment (**Figure 1.8.15**) and after (**Figure 1.8.16**).

10. Now that you have dialed in each of the three correction curves, turn on the eyes of the BP and MP Curves adjustment layers. With all the layers on, the image should look like this: before and after (**Figures 1.8.17** and **1.8.18**).

You have successfully removed the CCD/CMOS color cast from the white, mid, and black aspects of the image, thereby eliminating the color contamination inherent in the process of converting RAW files to any usable file format.

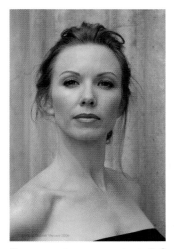
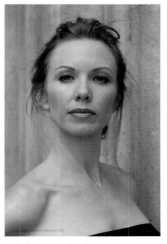

FIGURES 1.8.15 AND 1.8.16 *Before and after the MP adjustment*

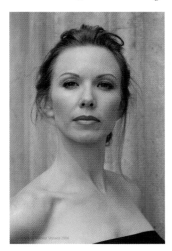
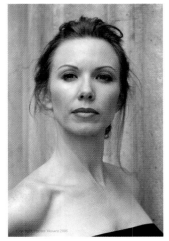

FIGURES 1.8.17 AND 1.8.18 *Before and after the CCD/CMOS color correction*

Making Lemonade from Lemons: Selectively Using File Color Cast to Your Advantage

When you create images that reflect your vision of the world, the only rule is that there are no rules. No one cares what you did to the image to make it look the way it does; they care only that your image moves them. The viewer wants so much to believe in your image that he or she is willing to suspend all disbelief to take the journey. What viewers do not want to see are the chalk marks of your post-processing, for if those are evident, their willing suspension of disbelief ceases. So when your image has some lemons, make lemonade; just do it so that no one can see the peels.

When trying to create a believable probability, you need to pay attention to the way people naturally perceive things. For example, painters are taught that warm colors appear to move forward in an image while cool colors move backwards. What is true for them is also true for photographers, which means that the closer an object is to the camera, the more warm, or yellow and red, it will appear. If the object is further away, it will appear cool or blue. Also, shadows tend to be bluer or cooler than areas that are lit, which tend to be warm. What this means is that if you are trying to create the illusion of DOF in the Challen image, in addition to making her look like she was lit with appropriate lights, you need to pay attention to the colors of things. (That attention needs to be paid from the very moment you open the file and choose to change something, because everything you do must be about mini-mizing artifact. You must also endeavor to create a workflow that makes things as simple as possible, but no simpler.)

One of the reasons that I wanted you to separate the black, white, and midpoint color cast corrections is so that you can have complete control over the colors of all objects in any of your images. You may decide that you want to use all three color cast corrections, but you may want to use just one or two, or none at all. You may also want to change the order of your three correction curves, as well as the individual opaci-ties of each layer. Lastly, you may choose to selectively adjust

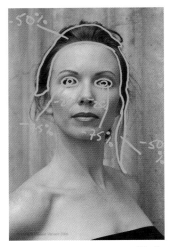
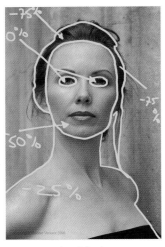

FIGURES 1.9.1 AND 1.9.2 *Black point correction brush back image map and white point correction brush back image map*

FIGURES 1.9.3 AND 1.9.4 *Before and after the BP adjustment*

the color of one or more of the smallest of areas by using layer masks. So even though all files you capture have varying levels of color cast, you will be able to use any part of that cast to your advantage.

Looking Before You Leap

Before you move on and do any brushwork, assess each of your color cast correction layers for what you do and do not like about each. At each point along the way to creating an image, you should re-evaluate what you have already done.

My first observation when I re-evaluate this image is that I do not like the overall color cast before correction. I do not, however, like the coolness of the image once the color cast is removed. I do like some of the warmth of the black point correction, but I do not like what it does to Challen's eyes and hair. I like the overall effect of the white point correction, but not what it does to her face and hair. I like aspects of the original, uncorrected image, specifically the tones of her hair, and I am happy with the midpoint correction. With all these observations in mind, here are the first image maps that I drew: black point correction brush back (**Figure 1.9.1**) and white point correction brush back (**Figure 1.9.2**).

Fine Tuning the Color Cast on the Curves Adjustment Layers to Set the Stage for the Creation of the Illusion of Depth of Field

With the global color correction behind you, the granular color correction is next. Begin by thinking through what steps you want to take.

I chose to begin on the BP and to brush back the model's eyes in this layer, because there are aspects here that I like. Look at this before the black point correction (**Figure 1.9.3**) and after (**Figure 1.9.4**).

Then, look at the image before the white point correction (**Figure 1.9.3**) and after (**Figure 1.9.5**), and you can see that this correction cools the image and removes some of the color cast from her hair.

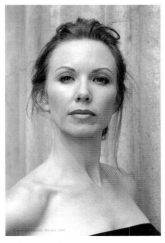

FIGURES 1.9.3 AND 1.9.5 *Before and after WP adjustment*

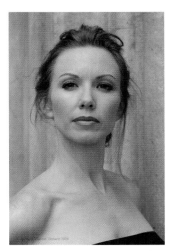
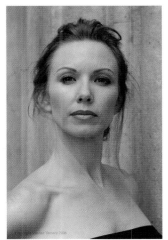

FIGURES 1.9.3 AND 1.9.6 *Before and after MP adjustment*

If you look at the image before the midpoint correction (**Figure 1.9.3**), and then after (**Figure 1.9.6**), the image is even cooler than it was before you did the midpoint correction. When you put all three together, you get what the image looked like when I shot it, but it is not yet what I want it to become. Look at the image before the correction (**Figure 1.9.3**) and after the black, white and midpoint corrections (**Figure 1.9.7**).

In order to make this image match my initial vision of it, I must create the illusion of DOF. In order to do this, you will use color to your advantage. Since you now know that warm colors appear to move forward in an image, and cool colors appear to recede, if you make Challen's face the warmest part of the image, her body the second warmest, and the background the coolest, you will begin to create the illusion that there is a greater separation of Challen from the background than there really was.

There are many things that you could do to this image to affect its color cast. You could individually look at the black, the white, or the midpoint; you could put them together as seen in **Figure 1.9.7**, or you could lower the opacity of each of the layers. But what I would like you to do, after looking at this Black point brush back image map (**Figure 1.9.1**), is to brush back the areas that I have drawn in and keep the areas with no notations: that means brushing back the pupils of her eyes, brushing back the whites of her eyes, and then her hair.

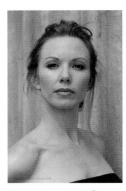
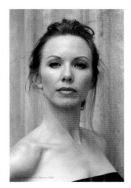

FIGURE 1.9.3 *Before any corrections*

FIGURE 1.9.7 *After all corrections*

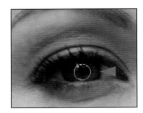

FIGURES 1.10.1 *Setting the brush size*

FIGURES 1.10.2 *Fade effect dialog box*

FIGURES 1.10.3 *Fade set to more than 50%*

FIGURES 1.10.4 *Fade set to less than 50%*

FIGURES 1.10.5 *Fade set to 69%*

Finding the Gray Areas:
Step 1: Fine Tuning the Black Point Curves Adjustment Layer

1. Turn off the Black Point image map, and zoom into Challen's face and hair. Make the layer mask active on the Black Point (BP) Curves adjustment layer.

2. Select the Brush tool (keyboard shortcut B), and zoom in to her face. Set the opacity to 50% by pressing 5.

3. Start with her eyes. Select the Brush tool (making sure that Caps Lock is off) and shrink it until it is just a bit smaller than her eye (**Figure 1.10.1**).

4. Make sure that the foreground color is black. (Use the keyboard shortcut D to reset the foreground and background color. To reverse the foreground and background color, use the keyboard shortcut X.) You will paint with black, because the layer mask is white. Black conceals, white reveals. (See the sidebar Unmasking Layer Masks and the 80/20 Rule.) Start by brushing just the pupil of her eye.

5. Bring up the Fade effect tool by using keyboard Command + Shift + F / Control + Shift + F (**Figure 1.10.2**) or go to the Edit menu. Look at the effect at more than 50% (**Figure 1.10.3**) and at less than 50% (**Figure 1.10.4**). I selected 69% (**Figure 1.10.5**) because I liked concealing more of the correction. Click OK.

6. Hold the space bar down to bring up the Move tool and move the image over to her right eye (**Figure 1.10.6**). Brush over her right pupil as you did on her left eye. Next, bring up the Fade effect tool (Command + Shift + F / Control+ Shift + F). Type in 69% and click OK. You know it is going to be 69%, because it was 69% on her left eye and they should match (**Figure 1.10.7**).

7. Shrink the brush size by using the bracket keys located next to the letter P. The left bracket key makes the brush smaller, while the right bracket key makes it larger. The brush should fit in the area where her tear duct and her eyelid meet (about 20 pixels) (**Figure 1.10.8**).

FIGURE 1.10.6 *Move to her right eye*

FIGURE 1.10.7 *Fade the brushwork to 69%*

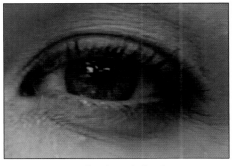

FIGURE 1.10.8 *Shrinking the brush size again*

8. Brush in the whites of her eyes at 50%.

NOTE: Although there is an unwanted overlap in the layer mask from inadvertently brushing over the same area, this is easily corrected. (See the sidebar Error-Free Layer Masks.)

9. Once you have fixed the layer mask using one of the techniques discussed in the Error-Free Layer Masks sidebar (Approach 1 is the best choice for this image), use keyboard command D to reset the foreground and background colors to black and white. Next, select a brush opacity of 50%. (Keyboard shortcut 5 gives you an opacity of 50%.)

The Power of 50%

Three things to remember when working with opacity and layer masks. 1) The scale for working on a brush is zero to 100%. 2) What ever you are going to do, it is either going to be more or less than 50%, or exactly 50%. 3) There is no way you can precisely know what the percentage is going to be for you to get the desired effect. You need to use your eye to dial in the exact amount you desire. The key is to use the Fade effect command (Command + Shift + F / Control + Shift + F).

NOTE: This approach was created by John Paul Caponigro and it has saved me hundreds of hours of work.

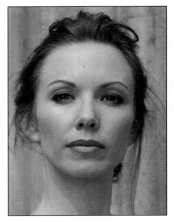

FIGURE 1.10.9 *Before the brushback*

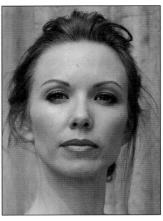

FIGURE 1.10.10 *After the brushback*

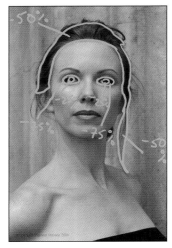

FIGURE 1.10.11 *The brushback image map*

FIGURE 1.10.12 *The resulting layer mask*

10. Zoom out so that Challen's face fills the screen. Using the right bracket key, increase the brush size to 90 pixels and brush back all of Challen's hair. After that, bring up the Fade effect dialog box (Command + Shift + F / Control + Shift + F), and set it to 81% using the slider. Compare the before (**Figure 1.10.9**), and after (**Figure 1.10.10**), and look at the image map (**Figure 1.10.11**) and the final layer mask (**Figure 1.10.12**).

NOTE: You do not have to be precise with the layer mask, because you can later return to and refine it using one of the approaches discussed in the Error-Free Layer Masks sidebar. Also, located at www.welcome2oz.com, there is a QuickTime presentation that you can watch on how to do this. Simply go to the source files for this lesson.

11. Once you have brushed Challen's hair back, Option- / Alt-click on the layer mask to display it. With the Brush tool still selected, set its opacity to 100% (keyboard shortcut 0). Then, Option- / Alt-click on the gray part of the mask. (Option- / Alt-clicking on a layer mask brings up the sample eyedropper.)

A Faster Layer and a More Accurate, Error-Free, Masking Workflow

Before you go further, I want to tell you how you can avoid some of the problems that can arise when you re-brush. In my opinion, the only way to find the right amount of gray for which you are looking is through the use of opacity. However, depending on whether the layer mask on which you are working is filled with black (for concealing the effect) or with white (for revealing the effect), using opacity may be problematic when you are trying to refine a layer mask created by using varying opacities of white and black. (See the 80/20 Rule sidebar.) The reason is that if I brushed on my layer mask at 50% and missed a spot that I later touched up and that overlaps my original brushing, that overlap would now be at 75%. (Fifty percent of fifty percent is twenty-five percent.) Just because my color may appear to be 50% gray, it is really still black. At 50% opacity, however, it will produce a 50% gray. So if I re-brush over anything on which I have already worked,

it will be as if I was brushing at 75%. The outcome is the creation of a halo that is both undesirable and visible in the final image. If, however, I go to 100% opacity, and sample and paint with the grays that I created, I get to have my creative cake and eat it too. I no longer have to worry about creating halos, because all I am doing is painting with the same color gray that surrounds the area I originally missed. When you tightened up the eye aspect of this layer mask, you got a little taste of how useful this technique can be.

1. Click on 0 (zero) to set the brush opacity to 100% opacity. Option- / Alt-click on the gray part of the layer mask. (Holding down the Option / Alt on a layer mask brings up the sample eyedropper. Clicking on it while holding down the Option / Alt key samples the color.) In the Tools panel, the color gray will show up in the foreground box. Brush in the white

area and touch it up. The beauty of this approach is that it does not matter how many times you paint over the same area, because it is the same density of gray as the area that you sampled.

2. Another advantage of working this way, is that once you have established the amount of density you want for Challen's hair, you can keep painting with the same color, and you will get the same density of gray in your layer mask in those areas in which you have not yet done brushwork. Brush in the rest of the area that you mapped in your image map. Look at the layer mask and the image after refining the layer mask (**Figures 1.10.13** and **1.10.14**).

You have completed fine tuning the Black Point Curves adjustment layer. Next, you will turn your attention to fine tuning the White Point Curves adjustment layer.

FIGURE 1.10.13 *Refined layer mask*

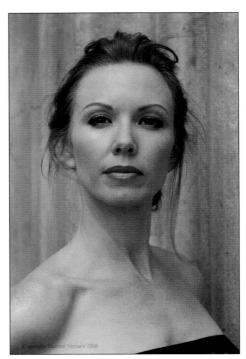

FIGURE 1.10.14 *The image after refining the layer mask*

Layer masks are a powerful Photoshop tool and an important way to control the aesthetics of an image. A layer mask works by allowing you to completely or partially hide or reveal filter effects, adjustment layer corrections, or anything else you want to selectively control.

The best way to remember how to work on a layer mask is by remembering this simple mnemonic: "Black conceals and white reveals." That means that black will block the visibility of the effect that you are creating, whereas white will allow the effect to be visible.

A good way to ensure an efficient workflow is to use what is referred to as the "80/20 rule." If you want to reveal 80% and conceal 20% of the layer, create a white mask and paint with black to conceal. If you want to conceal 80% and reveal 20%, start with a black mask and paint the areas you want to reveal with white.

Since you are working in grayscale when you are working on a layer mask, varying the levels of black or white opacity determines how much of the effect on that layer you will allow to be seen. In other words, if you are working on a white layer mask, the darker the gray, the less that is revealed, and when you are working on a black layer mask, the lighter the gray, the more that is revealed.

0521 Rule

I have found that there is a relationship between 100%, 50%, 25% and 10% opacity. The 0521 rule is based on this observation. The way the rule works is this: 50% of 50% is 25%. So if you're working at 50% opacity, and you want to increase the effect of the thing on which you are working, you will generally want to increase it about 25%.

In the same way, 20% of 20% is 4%. So if you are working at 20%, you will want to increase the effect about 4%. And if you want a little more, then 20% of 24% is approximately 5%, and so on. The keyboard commands for changing opacity of a brush are: 100% opacity is 0, 50% is 5, 20% is 2, and 10% is 1. (Hence the name 0521 Rule).

Being in Two Places at Once

What follows is a way to have both the image on which you are working and the layer mask of that image visible at full size on the screen at the same time:

Go to Window > Arrange > and select the New Window for (image name) from the bottom of the menu to open a new window of the same image that is "live." After each stroke, that window will be updated so you can see the effect of each change you make.

Put the two images side by side (or if you use dual monitors, put one image on each monitor), and Option- / Alt-click on the layer mask of whichever of the images has the layer mask that you want to show. Depending on whether you want to work on the image or the layer mask, make that image active, and you will be able to see what happens as you do your brush work.

Figure 1.11.1 *Before*

Figure 1.11.2 *After*

Now that you have a layer mask, this is the way to have one that has no missed areas or unwanted overlaps.

As I discussed in the 80/20 Rule, when you are working on a layer mask, you are working in grayscale. This means that when you change the opacity of white or black (depending on whether you are revealing or concealing), you are changing the density of the color with which you are working. That change in density manifests itself as shades of gray on the layer mask.

When you are working with opacity on a layer mask, you might miss an area. Because brushing is cumulative, it is almost impossible to match up the areas you missed with the areas that you didn't. Rather than try the conventional approach to brushing, treat the layer mask as a color: the color gray.

Approach 1: Make the layer mask visible at full screen (see the Being in Two Places at Once section of the previous sidebar), and make the layer mask active. Select the Brush tool and set the brush opacity at 100%. Option- / Alt-click on the area that you want to sample (the Option / Alt key brings up the sample tool eyedropper when you are in the Brush tool), and brush over the area you missed or in which you have an unwanted overlap. (Remember, you are painting with gray.)

Approach 2: Set the brush opacity to 100%. Option- / Alt-click on the area that you want to sample. Select the Polygonal lasso tool. (The keyboard command is the letter L. If you want to scroll through any tool set, hold down the Shift key and click on the tool's letter until the desired tool appears.) Click around the area and, when you have the desired area selected, Option + Delete / Alt + Backspace to fill with the foreground color.

Approach 3: (The Peter Bauer Method)
1. In order to make the layer (rather than the mask) active, click on the layer thumbnail to the left in the Layers panel.
2. Layer > Layer Style > Stroke. (Use the default color of red unless the image has a lot of red in it.) Increase the stroke width to 10 or 15 pixels.
3. Click OK in the Layer Style dialog box.
4. Click on the layer mask thumbnail to the right in the Layers panel.
5. Where you see blobs of red in the image, there are stray black or white areas, so (with the layer mask active) simply paint over the red spots with the appropriate color and watch them go away.
6. After cleaning up the mask, delete (or hide) the Stroke layer style.

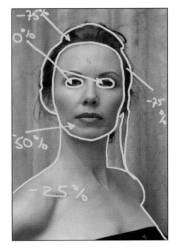

FIGURE 1.12.1 *WP Brush Back image map before the correction*

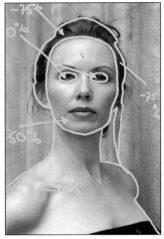

FIGURE 1.12.2 *The same image map after the WP correction*

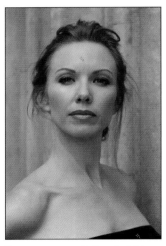

FIGURE 1.12.3 *Before the WP correction*

FIGURES 1.12.4 *After the WP correction*

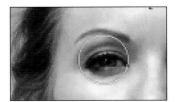

FIGURE 1.12.5 *Adjusting the brush size*

Step 2: Fine Tuning the White Point Curves Adjustment Layer

It is time to address the remaining granular adjustments of the white point. Before you begin, look at the White Point Brush Back image map before the adjustment (**Figure 1.12.1**), as well as the image map after the white point correction (**Figure 1.12.2**). Also, review the image before and after without the image map (**Figures 1.12.3** and **1.12.4**).

When the white point correction is applied, the image cools down. In Challen's image, you are trying to create the illusion of DOF, as well as create the illusion that the image was actually lit with hot lights. While doing this, you must ensure that you stay as close as you can to the original file. With this in mind, look at the original image map.

I suggest leaving her eyes alone, but brushing about 75% of the white point correction back into her hair, 25% into her body, and 50% into her face. This allows more of the image's warmth to bleed through. (Warm colors appear to move forward in an image and cool colors recede, so the background in this image appears to be further away than it actually was.)

1. Make sure that the White Point Layer Mask is the active layer. Select the Brush tool (keyboard shortcut B) and make sure that the foreground color is black and the background color is white (keyboard shortcut D). Set the brush opacity to 50% (keyboard shortcut 5) and make your brush is about the size of Challen's eye socket, which is about 300 pixels (**Figure 1.12.5**).

2. Brush in the whole area of her face. (At this moment, disregard her eyes.) Compare before the brushwork (**Figure 1.12.4**) and after brushwork (**Figure 1.12.6**).

3. Bring up the Fade effect dialog box (Command + Shift + F / Control + Shift + F). Move the slider first to the left, and then to the right to see if you want less or more effect. For this image, I chose 63%. Click OK. Compare before the brushwork (**Figure 1.12.4**) and after (**Figure 1.12.7**).

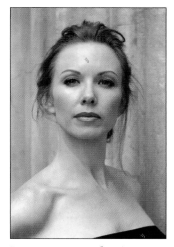

FIGURE 1.12.4 *Before the brushwork*

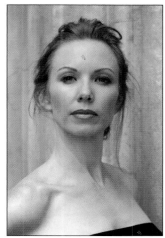

FIGURE 1.12.6 *After the brushwork*

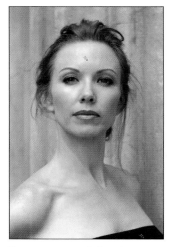

FIGURE 1.12.4 *Before the brushwork*

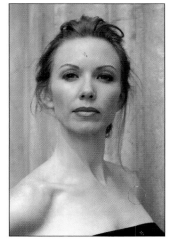

FIGURE 1.12.7 *After brushwork on her face*

FIGURE 1.12.8 *Focusing on her eyes*

4. Next, zoom into her eyes by holding down the Command + Space / Control + Space keys and, starting at the upper left part of her face, just above her eyebrow, drag the magnifying glass (in Windows it is a white dot with a + in it) to the lower right part of her face, just under her eye (**Figures 1.12.8**).

5. Press the D key, for default (the foreground color is black and the background white), and then the X key (to switch the foreground and background colors), so that you have the foreground color in white. Press the number 0 to set the brush opacity to 100%. Click the left bracket key and set the brush size to 40 pixels. Brush back just Challen's eyes, specifically their whites and her pupils, and take a look at the layer mask (**Figures 1.12.9** and **1.12.10**).

NOTE: I did the adjustment described above in this manner, because is it is easier to brush back the smaller area than it is to work around it. I always work from the global to the granular.

NOTE: Remember to tighten up the layer mask using the same techniques that you used in the previous section when you fine tuned the layer mask on the Black Point Curves adjustment layer.

FIGURE 1.12.9 *The eyes afer cleaning up the brushwork*

FIGURE 1.12.10
The layer mask

FIGURE 1.12.11

FIGURE 1.12.12 *Sampling the gray*

FIGURE 1.12.13 *The final layer mask*

6. Bring the image back to full screen (Command + 0 / Control + 0) and look at your layer mask. You still need to do brushwork on her body and hair. Set your brush to an opacity of 50% (keyboard command 5). Increasing the size of your brush to a diameter of 200 pixels (right bracket key), brush just the outline of her body, and a little in its center. (Again, it is not yet important to be exact.) Bring up the Fade effect dialog (Command + Shift + F / Control + Shift + F) and move the slider left and right to see if you want more or less of the effect. In this case, I chose 32%.

7. Option- / Alt-click on the White Point Layer Mask (**Figure 1.12.11**) and then on the light gray area of Challen's chest (the area in which you just brushed) to sample the color (**Figure 1.12.12**). Press the number 0 to set the brush to 100% opacity, and brush in the areas that were missed, tightening up the edges as you go (**Figure 1.12.13**). This is the quickest, most efficient way that I know to make a layer mask.

8. Next, take care of her hair. Click on the forward slash key (located next to the right bracket key) to bring the image back with the image map layer visible. The White Point layer should still be active, as should the layer mask. Click on the D key to set the foreground/background colors to default, and then click the X key to switch the colors. (The foreground should be black and the background white in the Tools dialog box.) Click the 5 key to set the opacity to 50%, and then the B key for Brush, making sure your layer mask is active. Now paint Challen's hair according to what you mapped. Once that is done, bring up the Fade effect dialog box (Command + Shift + F / Control + Shift + F) moving the slider right and left to see if you want more or less of the effect. In this case, I chose 50% more. Also, I chose 88% opacity for this part of the image brush back.

9. Zoom into the tendrils of her hair on the right side of the image (**Figure 1.12.14**). Using the left bracket key, shrink the brush size to 40 pixels and brush in the tendrils. Bring up the Fade effect dialog box (Command + Shift + F / Control + Shift + F), and type in 88%.

That takes care of the white point.

I did not touch the Midpoint Curves adjustment layer, because I liked what that did in this image. That may not be the case in other images, which is why I had you separate the three points into three different adjustment layers—complete control.

FIGURE 1.12.14 *Brushing in the tendrils of her hair*

Getting the Red Out

The last part of the granular adjustment of this image is to remove the redness from Challen's eyes (especially where there are blood vessels that show) and to add coolness to the background wall so that it will appear farther back. You will do all this with one Hue and Saturation adjustment layer.

Look at the image map (**Figure 1.13.1**). You will brush back the right side of the wall, and then the whites of her eyes.

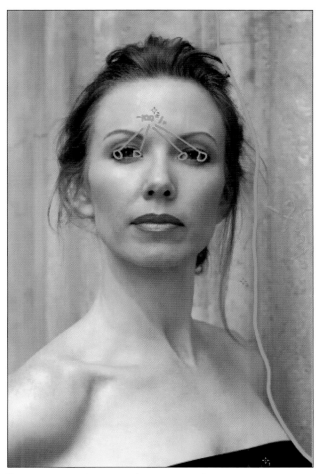

FIGURE 1.13.1 *Image map for removing red*

FIGURE 1.13.2
Hue/Saturation adjustment

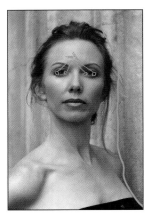

FIGURE 1.13.4 *Setting the Saturation to −100%*

FIGURE 1.13.4 *Gray image after the Hue/Saturation adjustment*

1. Create a Hue and Saturation adjustment layer (**Figure 1.13.2**), and name it EYE/WALL_CORRECTION. If you are using CS4 or above, you can do that with the Adjustments panel. If you are using any version of Photoshop, you can click on the Adjustment Layers icon located at the bottom of the Layers panel (fourth icon from the left—the half black and half white circle). Move the Saturation slider all the way to the left (−100%), which completely removes the color from the image (**Figures 1.13.3** and **1.13.4**). Next, move the Lightness slider to +5, and fill the Hue and Saturation adjustment layer mask with black.

2. Making sure that the layer mask is active, select the Brush tool (keyboard shortcut B). Expand the brush diameter to 600 pixels and set the opacity to 50%. Starting at the top of the image about halfway in, brush to the right, down the right side of the wall, making sure not to do any brushwork on Challen (**Figure 1.13.5**). Bring up the Fade effect dialog box, and move the slider right and left to see if you want more or less of the effect. I chose 38% (**Figure 1.13.6**).

NOTE: I chose an amount that is actually less than I notated. Remember that image maps are only guides. Your final choices will be made as you view and work on an image.

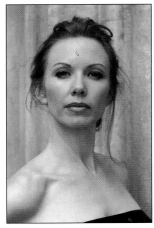

FIGURES 1.13.5 AND 1.13.6 *Brushwork on right wall and then fading the effect with the Fade effect command*

3. Zoom into Challen's face, around her eyes (**Figure 1.13.7**). Reduce the brush to 20 pixels and make sure that the brush opacity is set to 100%. Brush in all of the white in both of her eyes. You will notice that this is actually a bit too much, but I chose to do this because I wanted the desaturation to be greater in her eyes than in the wall. Also, I wanted to have some color bleed back into her image. One of the many advantages to using adjustment layers is that you can decrease opacity using the Opacity slider located at the top of the Layers panel. I chose 60% for this image. Examine the close-up of her eyes after the adjustment (**Figure 1.13.8**). Next, color back in the wall (**Figure 1.13.9**).

FIGURE 1.13.7 *Zooming into Challen's face*

FIGURE 1.13.8 *The eyes after the adjustment*

FIGURE 1.13.9 *Brushing in the back wall*

4. Move the Hue and Saturation adjustment layer above the Midpoint Curves adjustment layer and turn the Midpoint Curves adjustment layer on.

The first part of the granular correction is done. You can see how an image-specific, dynamic workflow is developing. Throughout the course of this book, you should also be aware of how certain decision-making processes allow you to stay as close to the originally captured image data as possible, so as to minimize the cumulative aspects of artifacting, while allowing you to re-create your original vision.

Step 3: Merging Layers in "The Move"

You will now merge the copies of the layers that you have created thus far into a single new layer, while preserving the individual layers that you created earlier. Adobe Photoshop refers to this as Merge Stamp Visible. I prefer to refer to it as doing "The Move." Note that you are merging the layers into one without flattening the image. This is an important distinction, because if you just merge layers, you also flatten the resultant image and lose all the original layers. This leaves you no exit strategy, and you will be unable to practice at practicing.

Make sure you are at the top of the layer heap by making the topmost visible layer active. Or, if you are working with a layer set, as you are in this image, make the layer set active. In this case, the layer set to make active is BP/WP/MP. For CS3 and above, press and hold Command + Option + Shift + E / Control + Alt + Shift + E. For CS2 and below, press Command + Option + Shift / Control + Alt + Shift, then type N, and then type E.

NOTE: Do not forget that when doing The Move, all layers that are turned on will be merged into one, both above and below the layer that is active. If after you do The Move, you notice that you have twice the effect that you had before you did it, you had adjustment layers turned on above the active layer or layer set. This is why you want the top layer, or top layer set, to be the active one.

Blend Modes

Blend modes are algorithms assigned to layers (or tools) which affect how they interact with other layers. The blend mode assigned to a layer (the "blend" color layer) determines how the colors of the pixels on that layer interact with the colors of the pixels on the base color layer or layers below. The result of that interaction is know as the "result color." When working with tools, the blend mode of the tool affects how that tool will alter the pixels on every layer below.

You now have a base image layer on which you can start to work to make other aesthetically pleasing changes. Name it MASTER_1. Click Save As (Command + Shift + S / Control + Shift + S) and name the file SHIBUMI_16BIT. Save the image as a Photoshop document (.psd).

NOTE: I have a system for saving and naming files. I always save the layered files with which I am working as Photoshop documents (.psd). I save all of the files that I use for printing as Tiff files (.tif), but I do not save layered Tiffs. Not all programs that can open Tiffs can read layered Tiffs, and sometimes layered Tiffs can cause programs that cannot read them to crash. Also, the Windows operating system (OS) does not show thumbnails of either layered files or any file on the desktop, except for Genuine Fractal files (.stn). Because I will eventually scale all of my files, I save them as Genuine Fractal lossless files. Once they are scaled, I save the scaled file as a Genuine Fractal visually lossless file.

So that I can recognize how I saved a file, I add 16Bit or 8Bit to the filename. For Tiffs, I add the canvas size. For example, SHIBUMI_13x19.tif would mean that its canvas size is 13 by 19 inches. The reason that I use underscores instead of spaces is to guarantee that every OS can see and open the file. SHIBUMI.stn would mean that this is a saved Genuine Fractal lossless version of the file saved in its native resolution (the resolution in the original capture). SHIBUMI_24x30 _VL.stn would mean that the canvas is 24x30 inches and that it is a Genuine Fractal, visually lossless file that has been scaled to 24x30 inches. Genuine Fractals is the best way I know to scale an image, both up and down, and is a great way to losslessly compress an image so that it can travel with you. Always give your layers and files meaningful names, and always give yourself an exit strategy as you develop your personal approach to workflow.

If you are using a pen-based workflow with either a graphics tablet like the Wacom Intuos or pen display like the Wacom Cintiq, you can program any set of keystrokes into the pop-up menu, express keys, or Radial dial menu depending on which flavor of the device driver you are using. All you will have to do is click a button, and voilà — "The Move" will happen.

Creating the Illusion of DOF on Pixel Layers

In order to create the illusion of DOF, you are going to use three free third-party plug-ins, two from Nik Software (Skylight and Contrast Only) and one from onOne Software (FocalPoint 2.0).

The Skylight filter will be used to add warmth to the image by selectively brushing in those areas you want to appear to be in the foreground. (Warm colors create the illusion of moving the object forward in the composition.) Those areas that are not brushed in will appear to move backwards in the composition, because they will be cooler than those in the brushed-in areas. (Cool colors appear to recede.)

This goes back to creating a believable probability. In the real world, shadows tend to be bluer (cooler) than areas that are well lit. Areas that are lit tend to be red or yellow (warm). Generally, people tend to look better warmer than cooler. Thus, what you will do is create selective warmth in the image so that it follows the roadmap that you defined in your initial image maps. Now look at the L2D image map (**Figure 1.14.1**), the Lighting image map (**Figure 1.14.2**) and the Combined L2D and Lighting image maps (**Figure 1.14.3**).

Nik Software's Contrast Only filter will be used to selectively add contrast to both aid in the replication of the way a lens would create DOF and to control how the viewer's eyes moves through the image.

Before I talk about bokeh, you should know that when an optical lens is focused on an object, there is a direct relationship between the sharpness of the image and its contrast. Contrast is about "surface texture" while sharpness (resolving power) is about the distinctness of edges. As the surface textures of adjacent areas become more distinct, the boundary between them (the sharpness) increases.

A good lens will sharpen an image if certain characteristics are built into the glass, i.e., contrast and resolution capability. Some lenses are better than others because of these characteristics. In optics, as sharpness and contrast decrease, blur increases. When purchasing a lens, its ability to go from sharpness (focus) to blur (out-of-focus) is an often overlooked quality. This quality is called bokeh (pronounced BO-KAY). The term comes from the Japanese word, boke (pronounced BO–KA), which means blur, and aji (pronounced AE), which means quality.

In photography, bokeh is the aesthetic quality of the blur in out-of-focus areas of an image, or the way the lens renders out-of-focus points of light. When deciding what lens to buy or use, strongly consider one that exhibits excellent, aesthetic bokeh. Much has been written about bokeh, and I encourage you to read more about this concept.

What you will do in the next series of steps is to create three layers, which, when combined, will replicate a lovely and subtle bokeh. In the image of Challen, I wanted to create the illusion that she is farther away from the wall than she actually was. I am going to have you do this by, first, warming up the image, then by building up the image's contrast, and, finally, by introducing blur.

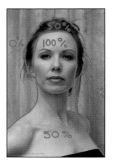 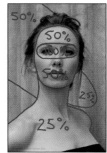 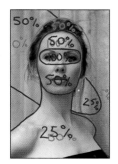

FIGURE 1.14.1 FIGURE 1.14.2 FIGURE 1.14.3

Step 1: Getting the Red In: Correcting for the Blue Color Cast with Nik's Skylight Filter

Up to this point, you have used adjustment layers, which are simply layers of math over your image, and have not actually altered the pixels. This is about to change. Previously, you created your first layer, MASTER_1, which was the culmination of all of the work you did on the Black, White, and Midpoint Hue/Saturation adjustment layers.

Whenever possible, I try to come up with a "Photoshop" way of doing things, and I am successful most of the time. But what makes Photoshop such a unique software package is that Adobe designed a way for us to use add-ons (called plug-ins) without affecting the core of the program. In my pursuit of a smoother workflow, I have become an advocate of the filters made by Nik Software.

NOTE: If you have not already downloaded the free versions of the Nik Software Skylight, Tonal Contrast, and Contrast Only filters, you can find them at www.welcome2oz.com. You will need to install these plug-ins for this next part of the lesson.

A Skylight filter can correct for the fact that shade and shadow light tends to be bluer than direct light, and direct light tends to be bluer than early morning and late afternoon light. The filter scans the image and determines how much, and where, red needs to be added to counteract any blue cast.

1. Duplicate the MASTER_1 layer (Command + J / Control + J).

2. Go to Filter > Convert for Smart Filters (Photoshop will make the layer you just duplicated into a Smart Filter) (**Figure 1.15.1**).

3. Duplicate the MASTER_1 copy layer twice (Command + J / Control + J). You should now have three Smart Filter layers.

NOTE: A quick way to duplicate a layer is to use Command + J / Control + J. Although this is the command for duplicating a selection, you can also use it to duplicate a layer.

Now that you have created your first Smart Layer, or Smart Filter, you may have been surprised at how quick and easy it was. Smart Filters take a while to make, but not to duplicate. If I know that I am going to use different effects or multiple filters, but I do not want to work on just one layer or on the same master layer, I will make several duplicates and throw away the ones I do not need when I am finished.

If you use CS3 or above, you should use Smart Filters (if you do not already) because they contribute to creating a non-destructive workflow, and because you can undo whatever you may have done. Even after you have made a print, all you have to do is go back to that Smart Layer and adjust it if you want to sharpen differently, change the lighting effects, or the color. The only down side it that Smart Filters make the file bigger. Regardless, I believe that Smart Filters and Smart Objects are the future of image editing.

4. Make the layer MASTER_1 copy three, the active layer, and rename it SKYLIGHT.

5. Choose Filter > Nik Software > Color Efex Pro 3.0: Versace Edition > Skylight Filter. When the dialog box comes up, select Skylight (**Figure 1.15.2**). Zoom out to see the full image. Leave the default at 25%, which is usually the correct amount, and click OK. Compare the before (**Figure 1.15.3**) and after (**Figure 1.15.4**).

You should see that the blue cast has been removed from this entire image so that it appears warm, which is wonderful for Challen's face, but not for her body, and definitely not for the background. You want the background to appear to be in shadow, which requires a blue cast. In addition to trying to create DOF, you are also trying to create an image that appears to have been lit with "hot" or tungsten lights. In order to create this believable probability, you must pay attention to the areas that must be lightened. As you go about the business of building this image, each step must build upon the last in a way that minimizes artifacts.

FIGURE 1.15.1

FIGURE 1.15.2 *Applying the Skylight filter*

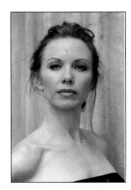

FIGURE 1.15.3 *Before the Skylight filter*

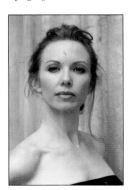

FIGURE 1.15.4 *After the Skylight filter*

6. Create a layer mask on the SKYLIGHT layer and fill it with black.

NOTE: You are filling the layer mask with black, because you want to conceal more than you want to reveal (see 80/20 rule sidebar.)

To create a layer mask, go to the bottom of the Layers panel. Holding down the Alt / Option key, click on the Add Layer Mask button (the third from the left). This is the one-click way to create a layer mask and fill it with black.

7. Make the L2D IM and LIGHTING IM layers visible so that you can analyze how to selectively warm this image (**Figure 1.15.5**).

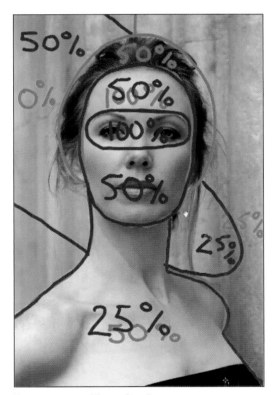

FIGURE 1.15.5 *The combined image maps*

FIGURE 1.15.6 *Set the Amount to 61%*

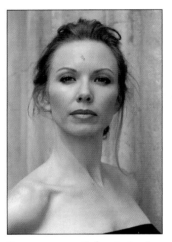

FIGURE 1.15.7 *Before the brushwork and Fade effect*

FIGURE 1.15.8 *After the brushwork and Fade effect*

For a moment, review your lighting decisions. The model's eye should be the most brightly lit, less on her face, then her hair, and the area on the wall should receive the least light.

Take a moment to conceptualize this task. Because you are working with a layer mask filled with black, but you are painting with white, you are dealing with a negative image as you would in a black-and-white darkroom. Therefore, you are working in reverse.

You are aiming to build up different levels of warmth (the warmth that you just created using the Skylight filter), and since you want the eyes to be brightest, start by brushing that area. (Remember, all brushwork is cumulative.)

8. Choose a very soft brush, roughly the size of the eye socket (400 pixels), but big enough to sweep across her eyes. (That is where the key light is going to go.) Start with an opacity of 50% (keyboard shortcut 5), and brush across her eyes.

NOTE: The keyboard command to change a brush's opacity is simple. Just type in the number value of the opacity percentage you want: 0=100%, 5=50%, 2=20%, and so on.

9. Bring up the Fade effect dialog box (Command + Shift + F / Control + Shift + F). This is the area to get the greatest Skylight filter effect, so move the slider to the right until you reach 61%, the value I chose. Click OK (**Figure 1.15.6**).

10. Increase the brush size (the right bracket key) to 700 pixels, and, following your image map, brush in her face and hair.

11. Bring up the Fade effect dialog box (Command + Shift + F / Control + Shift + F) and move the slider to the right to 65%. Click OK. Compare the before (**Figure 1.15.7**) and after (**Figure 1.15.8**).

12. Bring up the Fade effect dialog box (Command + Shift + F / Control + Shift + F), move the slider to the left, and lower it to an opacity of 34% (**Figure 1.15.9**). Paint in a small area of her body and examine the effect (**Figure 1.15.10**).

FIGURE 1.15.9 *Setting the Fade effect to 34%*

FIGURE 1.15.10 *Brushing in the effect on her body*

FIGURE 1.15.11 *The Skylight filter before the layer mask*

FIGURE 1.15.12 *The Skylight filter applied selectively with the layer mask*

The last thing to do is to brush in the area where you will place your background light.

13. Following the image map and using a 700 pixel diameter soft brush, brush on a diagonal from the upper left corner of the whole image to the area just above Challen's shoulder and neck. Leaving that area at 50% opacity, brush in the area just above her right shoulder, bring up the Fade effect dialog box (Command + Shift + F / Control + Shift + F) and move the slider leftward to an opacity of 34%. Compare the image before adding the layer mask (**Figure 1.15.11**) and after the layer mask (**Figure 1.15.12**).

NOTE: There are several areas of gaps and overlap in the layer mask. Using the technique that you learned in the previous section, tighten them up.

Step 2: Creating Selective Contrast with Nik Software's Contrast Only Plug-In to Replicate Realistic Lens Bokeh

When referring to how optical lenses record images, it can be said that contrast and blur are directly related. This may not be true when you create blur in a image using image editing software. Computer manipulation allows you to apply both contrast and blur to your image file, so they are not interdependent as they are if the blur was created by a lens. Although you can increase contrast with the brightness and contrast filters in Photoshop—or even better, with a Curves adjustment layer—Nik Software's Contrast Only plug-in does a better job than either of these and, not only offers significantly greater control, it comes free with this book.

FIGURE 1.16.1 *Opening Color Efex Pro 3.0*

FIGURE 1.16.2 *Moving the Contrast slider to 55%*

1. Go to Filter > Nik Software > Color Efex Pro 3.0 Versace Edition (**Figure 1.16.1**). When the Plug-in dialog box comes up, select Contrast Only.

Begin by adjusting the contrast of Challen's face. Because the contrast of her face is the critical part of this image, you should bias your aesthetic decisions in that direction.

2. Click on the Contrast slider. (The default is 50%.) Move the slider to the right to increase the contrast. Move it to 64%, which is too much, and then come back to 55%, a reasonable setting (**Figure 1.16.2**).

3. Click on the Brightness slider. Move the slider to the left to diminish the brightness. (The default is 50%.) Move the slider to 35%, which is too much, and then retreat to 41%, a usable position (**Figure 1.16.3**).

You have completed a global adjustment of the contrast and brightness. Although there are still some blocked shadows and overly bright highlights, you will address them in a moment. A bigger issue, however, is that when you compare the before and after aspects of the image in the Contrast Only dialog box, you now have some issues with image saturation. Specifically, you lost some of it and will have to correct that.

Thus far, the adjustments you have made to brightness and contrast could have been done in Photoshop, but the following steps will more elegantly and easily be done using Nik's Contrast Only filter.

4. Click on the Saturation slider, and move it to the right, until you match the saturation to the before side of the image in the preview area of the plug-in dialog box, which for this image occurs at 16% (**Figure 1.16.4**).

It is time for you to address the more granular issues that were produced after you introduced contrast into this image: blocked up shadows and loss of image detail. The method that I will have you use to correct these problems (the Protect Shadows and Protect Highlights sliders in the Contrast Only plug-in) allows you to control how much of the shadows and

FIGURE 1.16.3 *Moving the Brightness slider to 41%*

FIGURE 1.16.4 *Moving the Saturation slider to 16%*

highlights you affect (see the Protect Shadows and Protect Highlights sidebar for how this works.)

5. Click on the Protect Shadows slider and move it to the right until the shadow is no longer blocked up. Compare the before (**Figure 1.16.5**) and after (**Figure 1.16.6**).

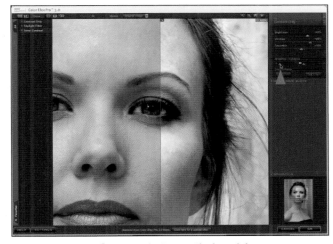

FIGURE 1.16.5 *Before using the Protect Shadows slider*

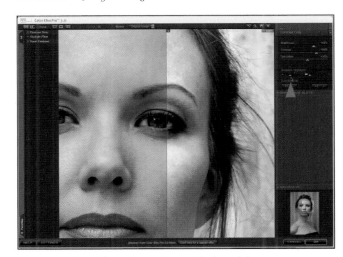

FIGURE 1.16.6 *After using the Protect Shadows slider*

The Protect Shadows and Protect Highlights sliders help you protect image details at both ends of the tonal range (from pure white with no texture to pure black with no detail) (**Figure 1.16.7**). The controls take advantage of the TrueLight™ function in Color Efex Pro 3.0. and appear on the Advanced tab in Color Efex Pro 2.0. When collapsed, this section displays one slider for protecting shadows and one for protecting highlights. As you click and drag either slider to the right or left to increase or decrease protection, notice the change in the details in the image. When expanded, this section displays not only the sliders, but also a histogram representing the full tonal range of the active image after the current enhancement has been applied. The histogram changes in real time as you adjust the filter controls and Protect Shadows/Protect Highlights sliders. The colored areas at both ends of the histogram help identify potential problems. The top and bottom 2.5% of tonal values (representing Shadows without Detail on the left and Highlights without Detail on the right) appear in red. The next 2.5% of the shadows and highlights (indicating Shadows with Detail on the left and Highlights with Detail on the right) appear in green. Connected to each of the four colored areas (Shadows without Detail, Shadows with Detail, Highlights without Detail, Highlights with Detail) are numerical call-outs displaying the percentage of pixels from the active image in each of those four areas after the enhancement has been applied.

The Protect Shadows and Protect Highlights sliders help you keep your image details from falling into these areas. For best results, keep the greater part of the image between the green areas (Shadows with Detail and Highlights with Detail) of the histogram. Portions of the image in Shadows without Detail will likely print pure black; those in Highlights without Detail will likely print as paper white. Click and drag the Protect Shadows slider to the right to adjust the filter's effect and prevent details from being moved into the Shadows without Detail area. Click and drag the Protect Highlights slider to the right to adjust the filter's effect and prevent details from being "blown out" or being moved into the Highlights without Detail area.

NOTE: In general, it is best to maintain the histogram in the region between the Shadows with Details and the Highlights with Details sections. Nevertheless, many good images have spectral values in those areas of the histogram (e.g., a highlight on a chrome bumper).

FIGURE 1.16.7 *The Protect Shadows and Highlights sliders*

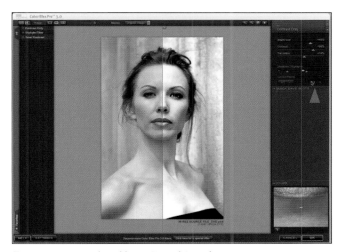

FIGURE 1.16.8 *The Additive Control Point button*

FIGURE 1.16.9 *Placing an Additive Control Point on her forehead*

I am going to introduce you to one of the most powerful functions of the Contrast Only plug-in: Control Points. (See sidebar for detailed information.) Control Points allow you to create an effect in an isolated object within a photograph. After you place a Control Point, the software analyzes its color, tonality, detail, and location, and applies the desired effect. There are two types of Control Points: Additive and Subtractive.

6. Click on the Additive Control Point (**Figure 1.16.8**), and place it on the middle of Challen's forehead by clicking on that area (**Figure 1.16.9**).

Once you have initially placed your Control Point, you can fine tune its effect by moving it. When you move a Control Point, it will update in real time. You can also control the size of the area that you want the Control Point to influence.

7. Click on the Control Point and drag it to the area between her eyes at the top of the bridge of her nose (**Figure 1.16.10**).

FIGURE 1.16.10 *Moving the Control Point between her eyes*

Control Point automatically isolates objects based on their unique characteristics and permits you to easily apply enhancements using sliders. This is done with simple click and drag functionality, so there is no need to create complex selections, masks, or layers found in most conventional editing tools. Rather, changes can be made using a single, easy-to-use method that greatly expands your image editing capabilities. Using U Point® powered Control Points, you simply start by identifying an object, area, or region in a photo that you wish to enhance, and then you drag and drop a Control Point onto the image. Once a Control Point is placed, the Control Point automatically:

1. reads RGB and location values for each Control Point that is placed on the image.
2. calculates additional values of hue, saturation, brightness (lightness), and image detail to create a complete and unique set of U Point Pixel Characteristics.
3. incorporates the U Point Pixel Characteristics into a central, intelligent, blending function. U Point technology's central blending function enables you to adjust the entire range of parameters that control color and light (including, Red, Green, Blue, hue, saturation, brightness, contrast, and warmth, as well as the size of the area to be controlled) using a set of sliders associated with each Control Point.

When an additional Control Point is placed on the image, U Point Pixel Characteristics for that specific Control Point are calculated and are then factored into the central blending function. As more Control Points are placed on the image, the central blending function becomes more intelligent, enabling you to make even more refined and precise changes in the image. You control color, light, contrast, and tonality.

The Control Points are interdependent and communicate to combine and blend enhancements naturally. They can be easily adjusted or undone at any time, regardless of the order in which the change was made or the sequence in which the points were placed (**Fig.1.16.11**).

FIGURE 1.16.11

FIGURE 1.16.12 *The Subtractive Control Point button*

FIGURE 1.16.13 *Placing a Subtractive Control Point on the wall*

You can either increase or decrease the amount of the effect with the Opacity handle, the bottom one, or you can increase or decrease the size of the area that will be affected with the Radius handle, the top one.

8. Click on the Radius handle and move it inward so that the outer edge of the circle is touching her hair. Then, further fine tune the effect by moving the Control Point to the red dividing line that runs down the center of the image.

9. Click on the Subtractive Control Point (**Figure 1.16.12**) and drag it to upper right corner of the wall that is in the background (**Figure 1.16.13**). Click on the Radius handle and extend it to 67%.

10. Create a second Subtractive Control Point, and move it to the lower right of the wall above Challen's shoulder. Adjust it to the same radius as the first Subtractive Control Point that you placed (**Figure 1.16.14**).

FIGURE 1.16.14 *Placing a second Subtractive Control Point*

FIGURE 1.16.15 *Placing a third Subtractive Control Point on the wall to the left of Challen*

FIGURE 1.16.16 *Placing a fourth Subtractive Control Point on the upper left wall*

11. Create a third Subtractive Control Point and move it to the lower left of the wall above Challen's shoulder. Adjust it to the same radius as the first Subtractive Control Point that you placed (**Figure 1.16.15**).

12. Create a fourth Subtractive Control Point and move it to the upper left of the wall next to Challen's head. Adjust it to the same radius as the first Subtractive Control Point that you placed (**Figure 1.16.16**).

The result of using Additive and Subtractive Control Points is that the background has no contrast, but the model's face does.

13. If you would like to increase the contrast, move the Contrast slider to 73%.

14. Click OK.

Compare the image before the Contrast Only filter (**Figure 1.16.17**) and after the Contrast Only filter (**Figure 1.16.18**).

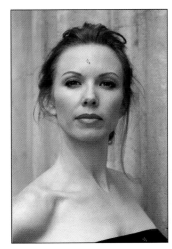

FIGURE 1.16.17 *Before the Contrast Only filter*

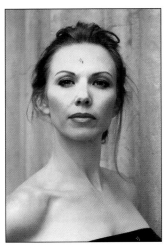

FIGURE 1.16.18 *After the Contrast Only filter*

15. Duplicate the SKYLIGHT layer mask and drag it down to the CONTRAST layer mask. You do that by holding down the Option / Alt key, clicking on the SKYLIGHT layer mask, and dragging it down to the Contrast layer. Once finished, you should see in the Layers panel that the Contrast and Skylight layers have the same layer mask (**Figure 1.16.19**). The image now looks like it does in **Figure 1.16.20**.

You now have some options to consider. You could move the Contrast layer above the Skylight layer, or you could leave it where it is beneath the Skylight layer. For this image, I prefer to have the Skylight layer on top and the Contrast layer just beneath it.

Another option is to lower the amount of the Skylight or Contrast layer to further dial in the effect. For this image, I chose to reduce the Skylight layer to an opacity of 70% (**Figures 1.16.21**).

You should notice that the model's image is beginning to appear forward from its real position. Once you introduce blur, you will have completed the illusion of DOF.

FIGURE 1.16.19

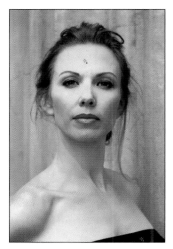

FIGURE 1.16.20 *The image after duplicating the layer mask*

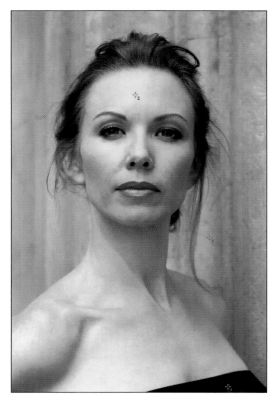

FIGURE 1.16.21 *The image after reducing the Skylight layer opacity to 70%*

Step 3: Creating Selective DOF Using onOne Software's FocalPoint 2.0 to Replicate Realistic Lens Bokeh and DOF

The definition of a Circle of Confusion: A bunch of photographers sitting around a table trying to explain Depth of Field.

—Michael Reichmann

As I briefly discussed earlier in this chapter, computer manipulation allows you to apply both contrast and blur to your image file, so they are not interdependent as they would be if the blur was created by a lens. This distinction is important because in a digital image file you can apply blur without diminishing contrast.

The model's image is beginning to appear forward from its real position because you have introduced selective warmth, using the Nik Software Skylight and Contrast Only filters on her face and torso, while leaving the background unaffected. Because your aim is to create a probable believability, while keeping your workflow dynamic and non-destructive, you want the viewer's eye to move through your image so that they are unaware of the journey. This will happen once you introduce realistic, selective blur, the focus of the next step.

Plumbing the Depths of DOF

DOF generally refers to the area that is in focus both in front and behind the true plane of focus. Actually, it is best conceptualized as the area of acceptable out-of-focus outside of the plane of focus. DOF varies depending on camera type, recording media (film or digital), aperture, and focusing distance. Even print size and viewing distance influences our perception of DOF.

When you consider DOF, there is no abrupt change from the area of sharp focus to areas of un-sharp focus; the change is a gradual one. One of the many common misconceptions about DOF is that its area encompasses everything that is in focus. Not true. According to optical physics, there is only one plane that is in focus in a photograph, that plane on which the lens is physically focused (the plane of critical focus). Everything else is less sharp; our eyes may simply not perceive it.

What we perceive to be in focus has a lot to do with the resolving characteristics of lenses, film, and silver-based photographic papers. A good or great lens can resolve an image of 200 line pairs (LP), or 200 pairs of black and white lines per centimeter. Black and white silver-based films can resolve approximately 175 LP, color film approximately 150, and photographic papers between 50 and 75. In other words, the final resolution is no better than the paper's ability to record it. Fortunately, the human eye will not detect blur until the resolution falls below 50 to 75 LP, so even though anything that was captured and recorded above 75 LP is lost in the printing process, we remain blissfully unaware of it.

Digital photography and inkjet printing has changed all of this. Lenses and sensors both resolve 200 LP, and consumer inkjet printers can print 150 LP—twice to three times the resolution of silver-based papers. Additionally, professional inkjet printers can resolve upwards of 300 LP—even more than lenses, CCDs, and CMOS sensors can resolve. What this means is that if you want three elements in an image to be in focus, rather than stopping the lens down in traditional wet photography methods, in digital, you will need to take three separate images of the three elements you want in focus to ensure that you get the detail you want in each. (You will explore this further in Chapter Three of this book.)

In any image, there is much more blur than there is focus. And blur is not simply a measurement of what is not in focus. Blur has a quality, a bokeh. This is an important aesthetic element and should be considered in every image. (More in a moment.)

Because the point at which focus transitions to out-of-focus is a difficult one to perceive, the term "circle of confusion" is used to define how much a point needs to be blurred in order to be perceived as not sharp. As well stated in Sean McHugh's discussion of DOF (http://www.cambridgeincolour.com), "When the circle of confusion becomes perceptible to our eyes, this region is said to be outside the DOF and thus no longer acceptably sharp."

What Is a Circle of Confusion?

The Glossary of Digital Photography (John Blair, Rocky Nook Inc., 2008) defines a circle of confusion this way: "When a lens is operating properly, subjects that are perfectly in focus should come to a point at the plane of the sensor. This is known as the focal point of the lens. Subjects closer or farther away will not be in as good of focus as the main subject. Instead of coming to a point at the sensor, the subjects create a small circle or other shape depending on the lens and aperture configuration. If the circle is sufficiently small, the subject is considered to be in focus. As the circle grows larger, due to subject distance from the lens, it becomes more noticeable. This circle is known as a circle of confusion. The range of distances of the subject from the lens when the circle is small enough not to be noticeable is known as the DOF. The largest circle of confusion still considered acceptably small, such that the subject is in focus, is known as the maximum permissible circle of confusion." (Real lenses do not focus all rays perfectly, so that a point is imaged as a spot rather than a point. The smallest such spot that a lens can produce is often referred to as the circle of least confusion.)

In the description above, note the relationship of DOF and the circle of confusion (COC). In photography, a rudimentary understanding of COC is essential to your understanding of DOF.

As I discussed earlier in the Depth of Field sidebar, "It has been shown that if the depth of the area that appears to be in focus in front of the true plane of focus is one foot, then the area that appears to be in focus behind the true plane of focus is two feet. This works out to a ratio of one-third in front in focus to two-thirds behind, i.e., twice as much behind will be in focus as in front."

The distance that appears to be in focus depends on two factors: the size of the lens aperture and the distance from the camera to the subject. The larger the aperture, the shallower the area that appears to be in focus; the smaller the aperture, the greater the area that appears to be in focus. Additionally, the farther away a subject is from the camera, the greater the DOF, i.e., the more that will appear to be in focus. Conversely, the closer the subject is to the camera, the shallower the DOF, i.e., the less that will appear to be in focus.

What No Focal Length?

Many photographers have the mistaken belief that shorter focal length lenses have a greater DOF than longer focal length lenses. Telephoto lenses appear to have a much shallower DOF, because they are most often used to make the subject appear larger when you cannot get physically as close to the subject as you might like. Sean McHugh of Cambridge Colour states, "If the subject occupies the same fraction of the viewfinder (constant magnification) for both a telephoto and a wide angle lens, the total DOF is virtually constant with focal length!" This means that it is the angle of view, and not the focal length, that determines DOF. I will illustrate why this misunderstanding exists with the following example. If I set up a tripod and shoot a scene using a 200mm lens, and then change to a 35mm lens at the same position without changing the aperture, the 35mm frame will appear to have a greater DOF. This occurs, however, only because the 35mm lens has a much larger field of view. To accurately compare the DOF of the 200mm lens to the 35mm lens, I must move in with the 35mm lens until the field of view exactly matches the field of view I had with the 200mm lens at the original position. When the resulting images are compared, the DOF for the two lenses will be exactly the same.

Compare the DOF images that were shot with a 35mm lens, a 70mm lens and a 135mm lens of the Golden Gate Bridge. (**Figures 1.17.1**, **1.17.2**, and **1.17.3**)

FIGURE 1.17.1 *Shot with a 35mm lens*

FIGURE 1.17.2 *Shot with a 70mm lens*

FIGURE 1.17.3 *Shot with a 135mm lens*

NOTE: Some of the best examples of this concept can be found in Michael Reichmann's landscape article, "Do Wide Angle Lenses Really Have Greater Depth of Field Than Telephotos?" (http://www.luminous-landscape.com/tutorials/dof2.shtml). See also Sean McHugh's discussion of DOF (http://www.cambridgeincolour.com/tutorials/depth-of-field.htm).

The Bouquet of Bokeh

For me, DOF is more about the quality of the blur, the bokeh, than it is about what is actually in focus. This is because everything that is not in the plane of focus is at varying levels of acceptable out-of-focus. Thus, most of your image is affected by bokeh. Bokeh is an immeasurable quality. It describes the feel of the blur, its smoothness. It is inherent in how an optical system bends the light and handles those rays of light that are not in focus and which blurs the object's edges in an aesthetically, visually, appealing way. Good bokeh consists of a gentle smoothness where the blur gradually occurs in a subtle way.

Effing the Ineffable

Good bokeh is not necessarily inherent in lens design, but different lenses produce different bokehs. A lens is defined simply as "a transparent optical device used to converge or diverge transmitted light and to form images." The image resulting from an excellent lens will be one where the edges of objects are extremely well-defined with little gradual blur. A technically perfect lens, however, does not necessarily produce a good bokeh. In fact, that technically perfect lens might render out-of-focus points of light with sharply defined edges rather than with the smoothness that you may find more visually appealing and desirable. It is the imperfections, the peccadilloes of design, that give a lens uniqueness. The finished image often owes its beauty to these imperfections.

Bokeh can be compared to the crazing on an old piece of porcelain that has hundreds of random, minute cracks that occur over time due to an imperfect glazing process and thermal

FIGURE 1.17.4 *24–70mm lens*

FIGURE 1.17.5 *24–120mm lens*

FIGURE 1.17.6 *70–200mm lens*

stresses. The result is a vase or cup that is beautiful because of its imperfections. Although you may know what causes these imperfections, there are no measurements or rules that allow you to control it. It occurs in a random and beautiful way.

No one knows why one lens design produces better bokeh than another. What matters is that you are aware that this phenomenon occurs, and that you should pay attention to its presence or absence when choosing your glass. Among the things that affect lens bokeh are: the number of blades in the aperture diaphragm; the shape of the diaphragm opening; the number, configuration, and grouping of lens elements; the length of the lens barrel; the types of lens aberrations; the coatings on and the type of glass used in the lens, the speed of the lens; and more. This is why the same image shot with a 24–70mm zoom, a 24–120mm zoom, and a 70–200mm zoom lens, all at a focal length of 70mm, would look different. It is up to the photographer to test his or her lenses and decide which ones impart the illusive quality that he or she seeks to any particular subject matter. See **Figures 1.17.4, 1.17.5,** and **1.17.6**.

I am having you consider bokeh in this lesson, because you are trying to replicate the reality of a shallower DOF than you have, so that Challen appears to be standing farther away from the background than she actually was. If you understand that a lens is more about blur than focus, and that the blur that you are trying replicate has a unique quality that is lens specific, then this understanding will help you decide how to best create the believable probability that this image was shot at a shallower DOF than it really was.

NOTE: Two very good explanations and discussions of bokeh are Harold Merklinger's at http://www.luminous-landscape.com/essays/Bokeh.shtml and Ken Rockwell's at http://www.kenrockwell.com/tech/bokeh.htm

FIGURE 1.17.7 *Good bokeh: The blur is completely undefined.*

FIGURE 1.17.8 *Neutral bokeh: The blur circle is even and its edges retain definition even though the light circle is blurred. (This is the way most modern lenses are designed.)*

FIGURE 1.17.9 *Bad bokeh: The blur circle's edge is overly defined and there is a ring around the center that is darker than the center.*

Focusing in on FocalPoint 2.0

To my knowledge, there is no better way to create realistic lens blur, and either enhance the existing bokeh of a lens or replicate lens bokeh, than by using the FocalPoint 2.0 plug-in.

First, there are two parts to the user interface (UI): FocusBug (**Figure 1.18.1**) and its slider controls (**Figure 1.18.2**). You will probably need only the FocusBug, but the sliders provide fine tuning should you need it.

FIGURE 1.18.1 *The FocalPoint UI*

FIGURE 1.18.3

FIGURE 1.18.4

FIGURE 1.18.2

Take a look at the Panels side of the UI.

1. **Navigator Panel**: displays an overview of the entire image along with a red box marking the area displayed in the preview area (**Figure 1.18.3**).

2. **Aperture Panel**: contains controls for type of aperture, round or planar, as well as its feather and opacity functions (**Figure 1.18.4**).

The Aperture Panel lies just below the Navigator and contains controls for aperture shape as well as its feather and opacity functions. Feather and opacity can also be adjusted with the FocusBug.

Aperture Shape

This pop-up allows you to control the shape of the sweet-spot. You can select between round (default) or planar. The Focus-Bug tool changes appearance from a round body (the default creates a round or oblong sweet-spot) to a square body. The round body is similar to using a selective focus lens and its blur extends to all sides of the image. (The sweet-spot is the area that is not affected by blur and is in focus.)

The second shape, planar, simulates a tilt-shift or view camera appearance. It creates a sweet-spot that slices through the image from one side to another.

Feather

Feather controls how hard the edge of the sweet-spot will be. The harder the edge, the more obvious the transition will be between the sweet-spot and the blur. Generally, a setting of 25–50 is used. Feather also controls the angle of the right antenna.

Opacity

This controls the sweet-spot's opacity. At 100%, the sweet-spot is completely protected from blur. As the opacity is decreased, the sweet-spot begins to blur. In most cases, you

will want the opacity to remain at 100%. The opacity is also controlled with the left antenna.

3. Blur Panel: contains controls for the amount and type of blur, both of which can be adjusted with the FocusBug (**Figure 1.18.5**).

Amount

This slider controls the amount of blur, and is typically set between 25–75%. The amount can also be controlled with the right antenna.

Motion

The Motion slider controls the amount of motion or distortion in the blur. At the minimum setting, the blur appears uniform. As you increase the angle (amount), the blur will appear to have more motion. This simulates the edge of an image circle where the blur becomes more distorted and is useful for a more dramatic look or simulating the bokeh of certain lenses.

4. Vignette Panel: contains controls for the amount and brightness, as well as the midpoint of the vignette (**Figure 1.18.6**).

The Vignette panel is located under the Blur panel and contains the controls for adding realistic vignettes to an image.

Adding a vignette is a classic method for focusing the viewer's eye on the subject. The shape of the vignette is always round and will follow the sweet-spot.

Lightness

The Lightness slider controls the amount and brightness of the vignette. At the neutral position (in the slider's middle), there is no vignette. Moving the slider to the right yields a dark vignette, while moving it to the right yields a light one.

Midpoint

The Midpoint slider controls the relative size of the vignette in relation to the sweet-spot. Low values add a large vignette that is tight around the sweet-spot, while large values add a smaller vignette that affects only the image's edge.

5. Presets Panel: lists the categories and presets and allows for their creation and loading (**Figure 1.18.7**).

6. FocusBug: The main control for FocalPoint 2.0, the Focus-Bug controls the size, position, and shape of the sweet-spot. Its antennae adjust the controls for the Aperture and Blur panels as well (**Figure 1.18.8**).

7. Guide Grid: The guide grid shows the size and shape of the sweet-spot and can be used to control its 3D tilt (**Figure 1.18.9**).

FIGURE 1.18.5 *Blur panel*

FIGURE 1.18.6
Vignette panel

FIGURE 1.18.7 *Presets panel*

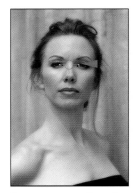

FIGURE 1.18.8 *FocusBug* FIGURE 1.18.9 *Guide grid*

8. **Toolbar**: contains the Zoom and Pan tool for navigating the image. It also contains the FocusBug tool for adjusting the FocusBug and contains the preview on/off toggle (**Figure 1.18.10**).

9. **Masking Options**: adds a layer mask to the results in Photoshop allowing the selective application of effects.

10. **Film Grain Panel**: controls the addition of simulated film grain (**Figure 1.18.11**).

The Film Grain panel is located under the Vignette panel and contains the controls for adding film grain, or noise to the blur. Adding film grain can replace grain lost during the blurring process so that a realistic image is maintained. It is also useful to prevent posterization during printing. To toggle the Film Grain effect on and off, use the toggle on the right side of the panel title bar.

Amount

The Amount slider controls the amount, or opacity, of the film grain. It is a good idea to zoom into 1:1 (100%) when adjusting the amount.

Getting Buggy: Using the FocusBug

The FocusBug is the main control for using FocalPoint 2.0. It appears as a wireframe representation of an insect with a body, legs, and antennae. The FocusBug controls many features of the sweet-spot: its position; size; shape; the amount and type of blur; its feather and opacity.

FIGURE 1.18.10 *Toolbar*

FIGURE 1.18.11
Film Grain panel

FocusBug Shapes

Already discussed, the FocusBug has two shapes, round (default) and planar, and is controlled in the aperture panel from the shape pop-up.

Adjusting Size, Shape, and Position

The FocusBug controls the position, size, and shape of the sweet-spot. To position the FocusBug, make sure you have it selected from the toolbar. Then click inside the body of the bug, hold, and drag it into the middle of the area that you want to keep in focus (the sweet-spot). In order to control the size and shape of the sweet-spot, you will need to manipulate the FocusBug's legs, the shorter appendages that extend out of the FocusBug body. On the round FocusBug there will be four legs; on the planar, only two. To adjust a leg, click, hold, and drag it with your mouse. If the end of a leg glows blue when your mouse pointer approaches it, you can select it. The length of the legs control the size and shape of the sweet-spot. You can also rotate the legs around the body to change the angle of rotation of the sweet-spot (**Figure 1.18.12**).

NOTE: It is often useful to turn on the grid when adjusting the FocusBug. This will allow you to see the exact size, shape, and position of the sweet-spot. You can turn on the grid by going to View > FocusBug Grid and selecting Auto or On.

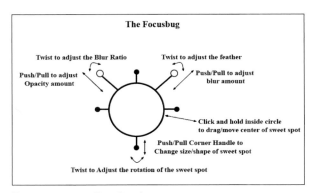

FIGURE 1.18.12 *FocusBug diagram*

Using the Antennae

The antennae of the FocusBug control the amount and type of blur as well as the feather and opacity of the sweet-spot. You adjust the antennae as you did the legs. Click, hold, and drag the antenna you wish to adjust. The right antenna controls the amount and type of blur. The longer the antenna, the more blur you will get. The angle of the antenna in relation to the body controls the feather or the transition between the sweet-spot and the blur. It is best to set the amount to 100% by pulling the right antenna to its longest position and then adjusting the feather at this setting. This will make the feather more obvious while you adjust it. Once the feather is set you may readjust the amount.

NOTE: Locking the antenna allows adjustment of only one variable at a time. By holding down the Shift key while adjusting an antenna, it will be locked to adjust only the antenna length. You may hold down Shift + Command / Shift + Control to adjust the angle instead.

The left antenna controls the type, or mix of blurs, as well as the opacity of the sweet-spot. The angle of the left antenna controls the type or mix of blurs. This is analogous to the Motion slider in the Blur panel. At the minimum setting, the blur will appear to be uniform. As you increase the angle (amount), the blur will appear to have more motion, which is useful when you want a more dramatic look or are trying to simulate certain lenses. The length (of the left antenna) controls the opacity of the sweet-spot, which in most cases you will want to set to 100%. This protects the sweet-spot from any blur.

Adjusting 3D Tilt

You can also use the FocusBug to tilt the plane of focus just like using a view camera. This will vary the blur on each side of the sweet-spot. To control the tilt, click and hold the Option / Alt key, and then click and drag inside the body of the FocusBug. A grid will appear, and as you move your cursor inside the FocusBug's body, the grid will tilt in three dimensions. You can reset the tilt by holding Option / Alt and double-clicking inside the FocusBug's body.

NOTE: Unlike a tilt-shift lens or view camera movements, FocalPoint 2.0 can only reduce the amount of sharpness, not improve it.

Mask View

Using Mask View will enable a black and white mask view of the sweet-spot. This can help you to see the bounds of the sweet-spot as well as understand the effects of the 3D tilt. To enable the Mask View, go to the View menu and select Show / Hide Mask. You can toggle it on and off with Command + M / Control + M. Mask View has no effect on the results of FocalPoint 2.0; it is just a view mode to assist you in configuring the FocalPoint 2.0 controls.

Adjusting the FocusBug Opacity

The opacity of the FocusBug can be controlled to minimize its interference with the preview image. To adjust this, go to the View menu and select FocusBug Opacity. (This is different than the aperture.)

The FocusBug has a really intuitive UI, but like all new things, it takes practice to master. I suggest that you play with it before diving in.

Bugging Out of Focus

It is time to start blurring this image by working with FocusBug.

1. Turn off the SKYLIGHT and CONTRAST layers, and make active the layer that you want to blur, which is the original MASTER_1 layer. This is most important.

FIGURE 1.19.1 *Accessing FocalPoint 2*

FIGURE 1.19.2 *Select the Round option*

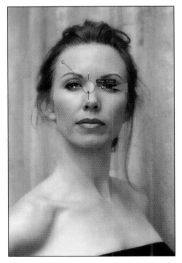

FIGURE 1.19.3 *Move the FocusBug to the center of her face*

NOTE: You have to make sure that the layer to which you want to apply blur is active, and that anything above it is turned off, because of the way the filter works.

2. Go to Filter > onOne > FocalPoint 2 > FocalPoint 2… (**Figure 1.19.1**).

3. In the Aperture dialog box, select Round (**Figure 1.19.2**).

4. Click on the FocusBug and center it onto Challen's face. (**Figure 1.19.3**).

5. Holding down the Shift key, which locks the FocusBug in place, click on the vertical sizing handle (located at the bottom of the FocusBug). Move the vertical sizing handle until it is just into her hair. I chose a height of 1454 pixels (**Figure 1.19.4**).

NOTE: The width should be 980 pixels, which you have not yet changed, and the angle –360, because you are holding the space bar down to lock it in place.

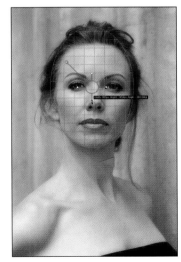

FIGURE 1.19.4 *Moving the vertical size handle to 1454 pixels*

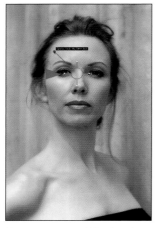

FIGURE 1.19.5 *Adjusting the horizontal handle*

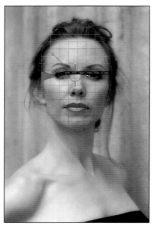

FIGURE 1.19.6 *Changing the height to 1502 pixels*

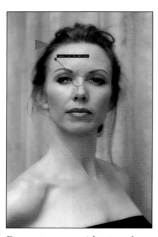

FIGURE 1.19.7 *Adjusting the Opacity handle*

FIGURE 1.19.8 *The mask of the blur*

6. Holding down the Shift key, which locks the FocusBug in place to ensure that there is no unwanted rotation of the blur effect, click on the horizontal sizing handle (located at the left of the FocusBug) (**Figure 1.19.5**). Move the vertical sizing handle until it is just into her hair. I chose a width of 982 pixels and my height changed to 1502 pixels (**Figure 1.19.6**).

7. Click on the Opacity antennae, which I will now refer to as handles (the handle is on a 45° angle located in the upper left of the FocusBug) (**Figure 1.19.7**). Move the Opacity handle downward until it cannot move anymore, but make sure that it is at its full extension as you do this. You want the Feather amount at 30%. The mask will now look like **Figure 1.19.8**, and the image looks like **Figure 1.19.9**.

NOTE: In addition to controlling opacity, by moving the opacity handle up or down you can control the amount of motion in the blur.

To see the mask that you have created, use Command + M / Control + M. To return to the image, repeat the keyboard command.

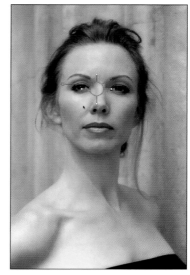

FIGURE 1.19.9 *The image after the initial setup of the FocusBug*

Once you have the blur circle almost as you want it, you should change the angle and direction from which the blur comes so that it mimics what would have occurred if this was optically created at capture. You could blur the image in post-processing software. You could even create a ratio of 1/3 forward, 2/3 behind the focus plane, but the blur would not look realistic, because it would lack the directional component. Thus, you would create an improbable believability rather than the believable probability that should be your goal.

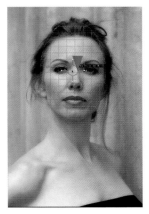

FIGURE 1.19.10 *Show the grid by holding Option/Alt*

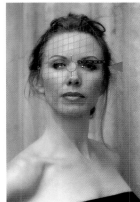

FIGURE 1.19.11 *Drag the grid to the right*

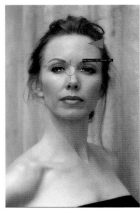

FIGURE 1.19.12 *Adjust the Blur handle*

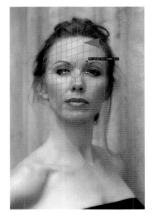

FIGURE 1.19.13 *Move the Blur handle to a blur of 42% and a feather of 47%*

8. Click in the center of the FocusBug, holding down the Option / Alt key, and the FocusBug grid will come up (**Figure 1.19.10**). Drag the cursor to the right side of the FocusBug grid, slightly below the Opacity handle (**Figure 1.19.11**).

Once you have defined the direction of the blur, you will define the amount. Then you will fine tune the FocalPoint Blur layer by doing some brushwork on a layer mask.

9. Click on the Blur handle in the upper right of the Focus-Bug at a 45° angle to it (**Figure 1.19.12**). You will now determine how much blur and feather you want. Move the Blur handle in, and slightly downward, until you get a blur of 42% and a feather of 47% (**Figure 1.19.13**). Click Apply. Compare the before (**Figure 1.19.14**) and after (**Figure 1.19.15**).

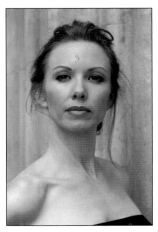

FIGURE 1.19.14 *Before Focal-Point 2*

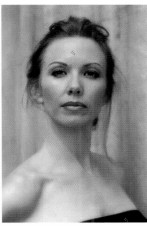

FIGURE 1.19.15 *After Focal-Point 2*

10. Hold down Option + D / Alt + D, and click on the Create Layer Mask icon at the bottom of the Layers panel (filling the layer mask with black) in order to add a layer mask to the FocalPoint layer.

11. Click D on the Tool bar to get the default colors of white for the foreground and black for Background. Select the Brush tool (keyboard command B) and set the opacity to 50%. (Keyboard command 5 yields an opacity of 50%.) Using the right bracket key (]), increase the brush size to 500 pixels.

FIGURE 1.19.16 *Sampling the gray*

FIGURE 1.19.17 *Painting in her neck and chest*

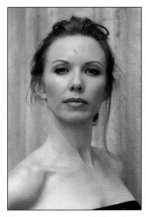

FIGURE 1.19.18 *Before the layer mask*

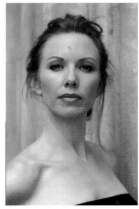

FIGURE 1.19.19 *After the layer mask*

12. Brush in the entire background, not touching Challen. Bring up the Fade effect dialog box (Command + Shift + F / Control + Shift + F). Lower the amount to 24%. Click OK.

13. Starting at the right of the image, just above Challen's shoulder, brush in the background wall. (Avoid her head and shoulder as much as possible.) Bring up the Fade effect dialog box (Command + Shift + F / Control + Shift + F) and reduce the opacity to 24%. Starting at the top center of the image, brush in the left side of the background wall (still avoiding her head and shoulder). Bring up the Fade effect dialog box and increase the opacity to 75%.

Once you have added angled blur using the FocalPoint software, it is time to add blur to the foreground to mimic what would have occurred if, at the time of capture, you had had a shallow DOF and your focus point had been her eyes.

14. Using the left bracket key ([), reduce the brush size to 100 pixels. Brush in just the outline of her neck and shoulders, and then a little in her body.

15. Bring up the Fade effect dialog box and lower the opacity to 44%.

16. Hold down Option / Alt and click on the layer mask. Sample the color of the area that you have just brushed by Option- / Alt-clicking on that area (**Figure 1.19.16**). Click on the zero key to give your brush 100% opacity, increase the size of your brush (right bracket key) to 300 pixels, and paint in her neck and chest area (**Figure 1.19.17**). Compare the image before the layer mask (**Figure 1.19.18**) and after (**Figure 1.19.19**).

17. It is time to re-introduce contrast. Turn on the eyeball of the CONTRAST layer (Blur + Contrast) (**Figure 1.19.20**).

18. You should now re-introduce warmth. Turn on the eyeball of the SKYLIGHT layer (Blur + Contrast + Skylight) (**Figure 1.19.21**).

Challen should appear to have moved forward in the image and the wall appeared to move backward.

19. Make sure that the top or SKYLIGHT layer is active. Hold down the Shift key and click on the FocalPoint layer. (This will select everything in between these layers.) Make the bottom layer active, and Shift-drag it to the Create a New Layer set. Name the new layer set D_of_F for DOF. Create a master layer, name it MASTER_2 (making sure that MASTER_2 is active), and turn the layer set off.

20. Save the file.

NOTE: When using Smart Filters, it is a good idea to group them in to layer sets, especially when you are using multiple Smart Filters to create a desired effect. When you are done, you can create master layers.

The reason for this is that when opening and saving a file, Photoshop will try to render any Smart Filter that is turned on. This means that you will spend a significant amount of time watching the Technicolor beach ball spin.

By creating a master layer of the combined contents of a layer set, you have a snapshot of everything you have done, and the file will open quite rapidly. The only down side is that you have increased the file's size.

When I talked about creating the image map for DOF, one of the issues I addressed was that I wanted the back wall to appear lit as if it was positioned well behind the subject. What I actually photographed was a subject standing up against the wall. If I could have cross-lit the background, I would have positioned the subject about five feet away from it. To create a believable probability, I had to add the illusion of optical depth. You will do that by creating a layer of blur between two layers of sharpness.

Everything that you have done thus far is in preparation for working with Render Lighting Effects and Curves in order to lighten and/or darken the image. This will finally create the lighting that I had originally envisioned when I first decided to shoot Challen.

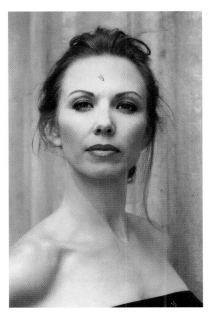

FIGURE 1.19.20 *Turning the CONTRAST layer on in combination with the blur*

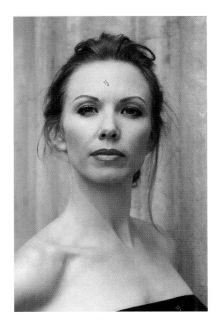

FIGURE 1.19.21 *Turning the SKYLIGHT layer on*

Light Changes Ahead

Up to this point, you have made significant modifications to Challen's image, but their appearance is subtle. From here on, they will become more dramatic. By selectively removing such issues as color cast, which would otherwise be problematic throughout the image editing process, you have created an image with which you can more easily work. In other words, you have been working from global to granular.

Now it is time to start building the "lighting" of this image. Because the changes you make to an image must be transparent to the viewer, you must pay attention to the way light manifests itself in the real world. Light has a direction, and so do any shadows it casts. Fail to respect that physical law, and the result will look like those mass-produced paintings of snow-covered cottages with light shining from 17 different places at once.

You will start by using a Curves adjustment layer to create a full tonal range from light to dark. Then you will use the Render Lighting Effects filter in Photoshop. This filter is likely one of the most forgotten, yet one of the most powerful and useful, pieces of software within Photoshop, and I am going to show you the magic that you can do with it.

Step 1: Creating Light-to-Dark Using Curves Adjustment Layers

By now you can see that all of your work on this image is cumulative, one modification building on the last. This next step in the lighting process addresses the light-to-dark aspect of how the eye sees an image.

As a practical matter, it makes sense to tackle the DOF problem, as you have just done, before manipulating light-to-dark. Because it is a lot easier to see the effect of DOF while the image is light, you can use aspects of the warming tendencies

of interpolation artifacting to work to your advantage (warm colors appear to move forward), and creating the illusion of DOF makes the lighting look realistic.

The first step in "lighting" the image in Photoshop is to use the Curves adjustment layer to get 90% of the correction you seek. This allows you to work in the ProPhoto color space and in 16-bit, a less destructive, less artifact producing way to work than in 8-bit, a smaller color space. Also, by using a Curves adjustment lighting layer, you can make better decisions on how to place your "lights" when you later use the Render Lighting Effects filter to complete the remaining 10% of the correction.

Because the Render Lighting Effects filter does not work in 16-bit (something I hope that Adobe will address in the next version of Photoshop), you will have to change both the bit depth and the color space when you use it. I will soon discuss this in depth.

Removing Everything That Is Not

1. Duplicate the MASTER_2 layer and make it into a Smart Filter layer (Filter > Convert to Smart Filters).

2. Create a Curves adjustment layer above the MASTER_2 layer. (You can create one by going either to the Adjustments Panel if you are using CS4 or above, or at the bottom of the Layers panel, which you can do in every version of Photoshop that is Adjustment layer capable.)

3. Click the center point of the line that runs across the Curves dialog box and drag the point diagonally down. (Do not flatten or clip the bottom part of the curve.) Select the Luminosity blend mode (**Figures 1.20.1** and **1.20.2**). This is what the image looked like before the Curves adjustment (**Figure 1.20.3**), and this is after (**Figure 1.20.4**). **Figure 1.20.5** shows the image after switching blend modes.

FIGURE 1.20.1 *Placing a point on the curve*

FIGURE 1.20.2 *Moving the curve downward*

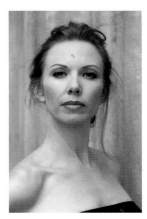

FIGURE 1.20.3 *Before the Curves adjustment*

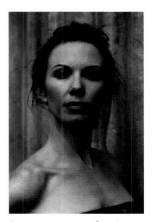

FIGURE 1.20.4 *After the Curves adjustment*

NOTE: Option- / Alt + click to get small gridlines, which give you a finer degree of control.

Unlike the Normal blend mode, the Luminosity blend mode deals only with the light-to-dark aspect, or luminance, of the image and leaves the colors alone. When you darken an image in the Normal blend mode, you increase color saturation, which is something to avoid since you just spent a lot of time addressing the file's color issues.

NOTE: If you prefer to increase color saturation, you can leave the blend mode in Normal. Your vision must dictate that decision.

4. Name the Curves adjustment layer L_2_D_LUM for Light-to-Dark Luminosity.

NOTE: It is important to give your layers meaningful names when you create them, so that you can easily understand the purpose of each.

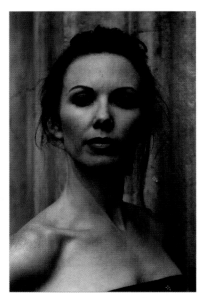

FIGURE 1.20.5 *The image after switching the blend mode to Luminosity*

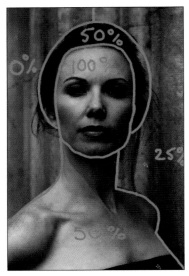

FIGURE 1.20.6 *The L2D image map with the Curves adjustment active*

5. Turn on the L2D image map (**Figure 1.20.6**) and make sure that both the Curves adjustment layer and the layer mask attached to it are active. Click on the D key to set the foreground and background colors to their defaults (foreground is white and background is black), and then click the X key to switch them. Select the Brush tool (keyboard command B) and set the brush size to 300 pixels at 100% opacity (keyboard command 0). Paint in the area of Challen's face that you want lightest (**Figure 1.20.7**).

Set the brush opacity to 50% (keyboard command 5) and repeat the process with her hair (**Figure 1.20.8**). Bring up the Fade effect dialog box (Command + Option + Shift + F / Control + Alt + Shift + F), bring the opacity to 48%, and click OK. Compare the image before (**Figure 1.20.3**) and after (**Figure 1.20.9**).

NOTE: If you are not 100% accurate with your brushwork, you can always tighten up the layer mask later by going to 100% opacity, sampling the different color grays, and touching it up.

FIGURE 1.20.7 *Painting in Challen's face*

FIGURE 1.20.8 *Brushing in her hair*

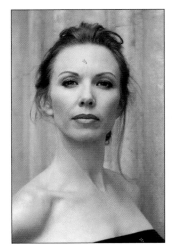

FIGURE 1.20.3 *Before the Curves adjustment*

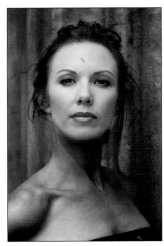

FIGURE 1.20.9 *After the brushwork*

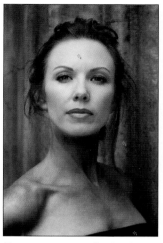
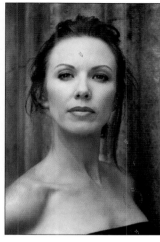

FIGURE 1.20.9 *Before brushing in her torso*

FIGURE 1.20.10 *After brushing in her torso*

6. Making sure that your brush opacity is still at 50% and your brush size is still at 300 pixels, start to brush in her neck and torso. Compare the image before (**Figure 1.20.9**) and after (**Figure 1.20.10**).

7. Increase your brush size to 800 pixels (the left bracket key) and, with the brush opacity still set at 50%, brush in the right side of the background wall. Follow the image map. Start at the top of her head and brush the wall around her moving to the bottom right of her shoulder. Bring up the Fade effect dialog box (Command + Option + Shift + F / Control + Alt + Shift + F), lower the opacity to 31%, and click OK. Look at the image after the Fade effect (**Figure 1.20.11**).

8. Go back and tighten up the layer mask using the techniques that you have already learned. Compare the layer mask before fine tuning (**Figure 1.20.12**) and after (**Figure 1.20.13**).

9. Save the image.

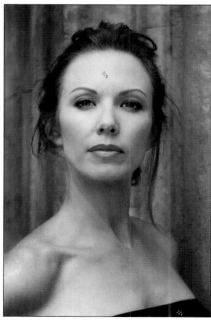

FIGURE 1.20.11 *The image after all brush-work on the L2D Curves adjustment*

FIGURE 1.20.12 *The initial layer mask*

FIGURE 1.20.13 *The layer mask cleaned up*

As you move through the next phase of the lighting correction, you will slowly lower the opacity of the light-to-dark layer so that, when you are done, it may not be at 100%. The quickest way to get an idea of what the completed image may look like is to use a Curves adjustment layer, a technique with which you should now be familiar. Using Curves adjustment layers is probably the least destructive way to effect adjustments and gives you the greatest control over color and luminosity, both at the same time. So if you have been using Levels, I suggest you change.

You are now ready to move into Render Lighting Effects.

Before moving on, compare the image after adding the light-to-dark adjustments (**Figure 1.20.5**) and then after the final brushwork and layer mask fine tuning (**Figure 1.20.11**).

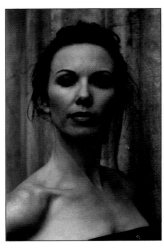 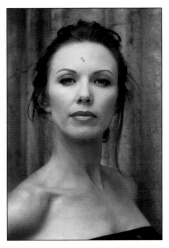

FIGURE 1.20.5 *The adjustment without fine tuning*

FIGURE 1.20.11 *After fine tuning the layer mask*

Step 2: Lighting the Image with Render > Lighting Effects

Every time you do something in Photoshop, you are dumping or clipping data and creating artifacts. If you shoot in the RAW file format, the original file contains the least artifacted, cleanest data it will ever have.

Because artifacts are cumulative, and may be multiplicative, your workflow should employ an approach that minimizes them and affords you an exit strategy. As I have already discussed, two ways to minimize artifacts is to do as much work as possible in 16-bit and to work in the ProPhoto color space because of its massive size. The next corrections to be done on this image, however, require that you convert the file to 8-bit. The payoff? Whatever artifacts you have created will be lost or minimized in the conversion process.

You will first convert the file from ProPhoto RGB to Adobe RGB because ProPhoto does not play as well in 8-bit as does Adobe RGB. Then you will go from 16-bit to 8-bit. (You want to do the color space conversion in the bigger color space first, and then to go to the smaller bit depth so as to minimize any color artifacts that might occur in the conversion process.)

Converting Color Spaces and Bit Depths

1. Go to Edit > Convert to Profile (**Figure 1.21.1**) to get that dialog box and click on the Destination space (**Figure 1.21.2**). Once the Destination Profile list comes up, select Adobe RGB 1998 (**Figure 1.21.3**) and Relative Colormetric as the rendering intent. Turn on Black Point Compensation (**Figure 1.21.4**) and click OK. When the Changing Document Profile dialog box comes up, select Don't Rasterize (**Figure 1.21.5**). You will see that nothing has changed. (That is a good thing.)

NOTE: You selected Don't Rasterize in the Changing Document Profile dialog box so as to keep all your layers intact. If you were to select Rasterize, Photoshop would flatten all the layers into one during the conversion process.

FIGURE 1.21.1

FIGURE 1.21.2

FIGURE 1.21.3

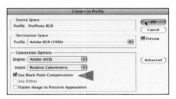

FIGURE 1.21.4

FIGURE 1.21.5

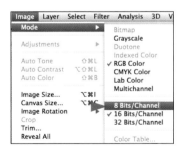

FIGURE 1.21.6

2. Press Save As and rename the file (Command + Shift + S / Control + Shift + S). Just change the name so that it ends with 8_ bit just before the file type (.tif, .psd, etc.), e.g., SHIBUMI_16_BIT.psd would become SHIBUMI_8_BIT.psd. This way, you always have an exit strategy.

3. Go to Image > Mode > 8 Bits/Channel (**Figure 1.21.6**).

4. Save the file.

You have converted the file's color space and bit depth. It is now time to start working with the Render Lighting Effects plug-in.

Using the Render Lighting Effects Filter

You are going to work with the Render Lighting Effects filter to make the image look as if you had used the appropriate lighting when the image was first captured. You will light the background, and then the subject, using key lights and then fill light. Once the lights are placed, you will adjust their intensity.

Because this is a filter that you will use in almost every chapter of this book, you should understand how it is set up before you begin.

NOTE: To view this filter go to Filter > Render > Lighting Effects (**Figure 1.21.7**).

FIGURE 1.21.7

The Render Lighting Effects Dialog Box

On the right side of the dialog box (**Figure 1.21.8**), at the top, is the Style pull-down menu. This menu contains 16 presets—ranging from the default, which is Spotlight, to multiple lights like Five Down and colored lighting effects like RGB. The list ends with Triple Spot.

NOTE: The styles, such as Soft Spotlight and Soft Omni, are presets that use specific settings. Interestingly, re-creating those settings to get the same effect requires a very deft touch. I have found it is better to start with a preset and then adjust it, or add more lights, as each image requires.

Following the Style pull-down menu is the Light Type menu, the two of which work in tandem. In the Light Type menu, you can choose three types of light: Spotlight, Omni, and Directional.

NOTE: The best way to conceptualize these three types of light is this:

Spotlight throws an elliptical beam whose direction, focus, intensity, and size you can control and whose intensity diminishes as the light gets farther from the source.

Omni is omni-directional light; the type of light you see when there is a bare bulb hanging over a poker table.

Directional is a distant light with parallel rays. (Like sunlight, the light does not diffuse over distance, so the light angle remains constant.)

In general, I have found that using Omni or Spotlight creates studio lighting effects that most closely replicate a believable probability. Usually, you either want a downwardly directed light source (Omni) or you want an angled beam (Spotlight). However, when I am trying replicate the look and feel of natural sunlight, Directional gives a result that looks like sun shining through a window.

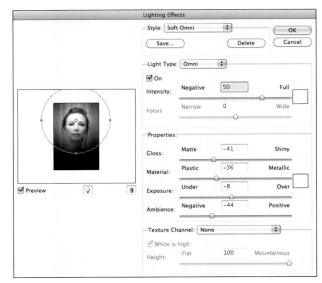

FIGURE 1.21.8 *The Render Lighting Effects dialog box*

In addition to the pull-down menu, this dialog box has two sliders:

Intensity moves from Negative to Full in order to increase or decrease the brightness of the light source that you adjust.

Focus (used only with the Spotlight option) determines how much of the elliptical area is filled with light. (When the Spotlight area is round, 50% fills half the diameter.) When the Spotlight area is elliptical, the center of the "light" lies halfway along the line from the center to the light source, and the value determines how much of that area is filled. This slider defines the width of the light that you adjust.

Moving down the right side of the dialog box, the next area of the Render Lighting Effects dialog box is the Properties section, which has four sliders.

Gloss ranges from Matte to Shiny. The Gloss slider determines the apparent reflectivity of the surface onto which you apply the filter. Matte means that it is less reflective and Shiny means that it is more.

Material ranges from Plastic to Metallic. The Material slider determines what will be reflected, the light or the surface. Plastic uses the light's color in the reflection, while Metallic uses the object's.

The last two sliders, **Exposure** and **Ambience**, are properties of the surface upon which your created light is falling.

Exposure addresses the general brightness of the image and determines how bright or dark the objects to which you apply the Render Lighting Effects filter will be.

Ambience determines how much lighting exists in the scene other than your added light, i.e., how much light is allowed into the background. Another way to think about Ambience is that it governs the light outside of the ellipse or circle.

NOTE: For both the Light Type and the Exposure menus, there is a white box located to the right of the sliders. If you double-click on a swatch, you will open the Color Picker. This allows you to change the color of either the light source or background light (Light Type), as well as of the ambient light (Properties). You will use this in Chapter 2.

The **Light Color** box is found in both the Light Type and Properties parts of the Render Lighting Effects dialog box. When you double-click on this box, you bring up the Color Picker as described above.

To change the position of a light, click on the center dot of the light and drag it to the desired position.

Change the size or shape of a light by clicking on one of its four anchor points, or dots, and dragging them to bring about your desired change. (You can also rotate the position of the light by clicking on one of these points and rotating the light in the direction of choice.)

To create a new light, click on the light bulb (located centrally beneath the image preview), and drag it to the area that you want. Then, in the Light type pull-down menu, select either Spotlight, Omni, or Directional.

To make a light active, click on the center point of the light on which you want to work.

To remove a light, make the light you want to remove active and drag it to the Trash Can icon, located next to the Create a New Light icon (the light bulb).

To duplicate a light, Option- / Alt-click on the center of the light and drag the new light to the desired position. Remember this because it allows you to match lighting.

Let There Be Render Light

Look at the lighting image map (**Figure 1.22**).

You want to light Challen's eyes and face with key lights, and then add light to the background. The workflow sequence is to, first, light her eyes and face on one layer, and then light the background on another.

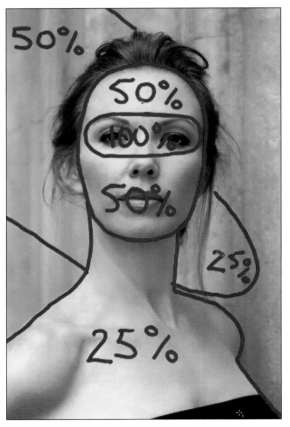

FIGURE 1.22 *Lighting image map*

Placing the Key Lights

1. Turn off the L_2_D_LUM Curves adjustment layer (click the eyeball).

2. Duplicate the MASTER_ 2 layer, make it a Smart Filter. Then duplicate the layer twice (Command + J / Control + J). The result should be three Smart Filter layers, one named MASTER_ 2 copy, MASTER_ 2copy 2 and MASTER_ 2 copy3. Turn off MASTER_ 2 copy3. Change the name of MASTER_ 2copy 2 to KEY_LIGHT and MASTER_ 2 copy to BG_LIGHT.

NOTE: Smart Filters take some time to create, but no time to duplicate or discard. Because you can discard extra layers when you are done, it is a good idea to make one more than you anticipate needing.

3. Make the KEY_LIGHT layer the active one, and go to Filter > Render > Lighting Effects. In the Style menu, when the Render Lighting Effects dialog box opens from the Style pull-down, select Soft Omni (**Figure 1.22.1**). Click the center point of this light, and move it so that it is between the top of her left eyelid and her eyebrow (**Figure 1.22.2**). Click on the outer left anchor point and reduce the circle until its outer edge is on the outer part of the subject's hair (**Figure 1.22.3**).

NOTE: You should use Soft Omni instead of Soft Spotlight so that you can obtain a softer, more diffused light that is not directional. Also, you want the light to appear as if it is in front of, and slightly above, the subject.

NOTE: If you have a version of Photoshop that does not allow you to make Smart Filters, make the light look the way you want it to and save it so that you can come back and adjust it should you need to. One of the problems with Render Lighting Effects is that its UI is very small, so it is difficult see what you are doing and you may have to tweak it a little later.

FIGURE 1.22.1 *Select Soft Omni*

4. Holding down the Option / Alt key, click on the center point of the light you have just placed to duplicate it, and drag it just above the model's right eye and just below her eyebrow (**Figure 1.22.4**). You now have two identical lights, with the same intensity. Once again, holding down the Option / Alt key, click on the center point of the light and move it to the top, middle of her forehead. Again, hold down the Option / Alt key, click on the center point of the light, and move it to just below the center of her lower lip. The image now has five lights (**Figure 1.22.5**).

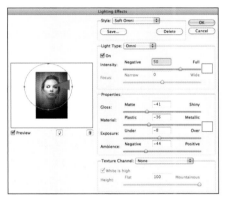

FIGURE 1.22.2 *Move the light above her left eye*

FIGURE 1.22.4 *Duplicate the light and place it above her right eye*

FIGURE 1.22.3 *Reduce the light size*

FIGURE 1.22.5 *All five lights on the model*

FIGURE 1.22.6 *Moving her forehead light*

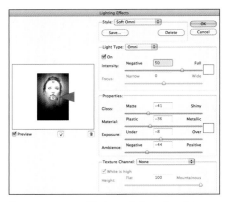

FIGURE 1.22.7 *Moving a light to her chin*

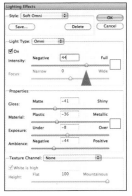

FIGURE 1.22.8 *Lower the Intensity to 44*

Now that you have created and placed the lights, you can define a more exact placement, fine tune their size, and set their intensity. For example, when you first placed the light on this image, the light was on her forehead. It was then moved closer to her scalp line and to the left, and the lower light was moved closer to her chin. Once you have placed the lights where you want them, you can move to the next step: sizing the lights.

5. Click on the upper anchor point of the forehead light, and move it so that it is just inside her upper hairline (**Figure 1.22.6**). Click on the lower anchor point of the light on Challen's chin and move it to just under her chin (**Figure 1.22.7**).

Once the lights have been placed and sized, it is time to adjust their intensity.

6. Click on the center anchor point of the light in Challen's left eye to make it active. Then, click on the Intensity slider and move it from 50 to 44 (**Figure 1.22.8**). Click on the center anchor point of the light in Challen's right eye to make it active. Click on the Intensity slider and change it from 50 to 44 by just typing 44.

7. Click on the center anchor point of the light on Challen's forehead to make it active. Click on the Intensity slider and move it from 50 to 24. Notice how the areas influenced by the individual lights are getting smaller while the background is getting darker (**Figure 1.22.9**).

8. Click on the center anchor point of her chin light to make it active. Click on the Intensity slider and move it from 50 to 36 (**Figure 1.22.10**).

Creating the Quality of the Key Lights

With the lights in place, it is time to blend and shape them (working within the Properties dialog box) so that they aesthetically please you. You will do this by learning how to, for lack of a better word, dance with the properties metallic, material, and gloss.

Up to this point, everything you have done to this image has been about its colors, specifically, using its warmer aspects to create the illusion that Challen is further away from the background than she was at the time of capture. However, you did not select the Color Picker to change the color aspect of the light you chose, but I am sure that you would agree that the most important color aspect in this image is the color of the object (the model), not the light.

Therefore, I suggest that you start with the Material slider, which ranges from Plastic to Metallic. As previously described, Plastic uses the light's color in the reflection, while Metallic uses the object's.

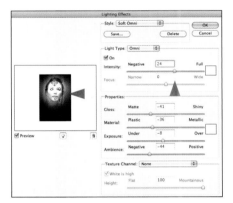

FIGURE 1.22.9 *Lower the Intensity to 24*

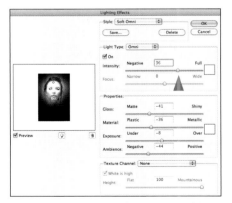

FIGURE 1.22.10 *Lower the Intensity to 36*

Once you have found the blend that you like between Plastic and Metallic, move to the Gloss part of the Render Lighting Effects filter. Because you want to create the illusion of a diffused light in front of and above the subject, you will move more to Matte than Shiny.

Then it will be time to manipulate the qualities of Exposure and Ambience.

So let's dance.

Sliding, Not Tripping, the Light Fantastic

9. Click on the center handle of the right eye light. Click on the Material slider and move it to the right, starting from –36 and ending where it looks best to you. For this image, I chose 60 (**Figure 1.22.11**).

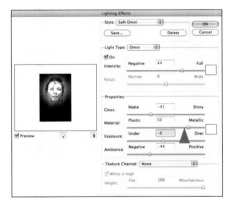

FIGURE 1.22.11 *Move the Material slider to 60*

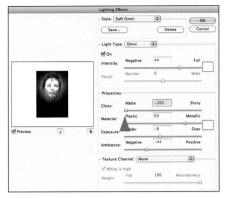

FIGURE 1.22.12 *Move the Gloss slider to −100*

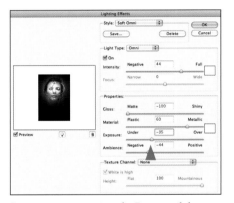

FIGURE 1.22.13 *Move the Exposure slider to −35*

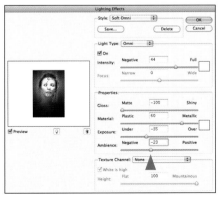

FIGURE 1.22.14 *Move the Ambience slider to −23*

10. Click on the Gloss slider and move it to the left, from −41 to where it looks best to you. For this image, I chose −100 or completely Matte (**Figure 1.22.12**).

How you will work with the Exposure and Ambience sliders is different from how you used the other sliders. The other sliders worked individually, but Exposure and Ambience work in tandem. This means that you will move one, then the other, and then return to the first to readjust. You may have to repeat this part of the Light Dance several times. Click on the Exposure slider and move it to the left, from −8 to −35 (**Figure 1.22.13**).

11. Click on the Ambience slider and move it to the right, from −44 to −23 (**Figure 1.22.14**).

12. Click again on the Exposure slider and move it to the left, from −35 to −37 (**Figure 1.22.15**).

13. Click OK.

Examine the image with the key light adjustment after using Render Lighting Effects (**Figure 1.22.16**).

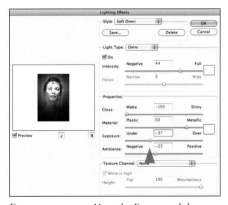

FIGURE 1.22.15 *Move the Exposure slider to −37*

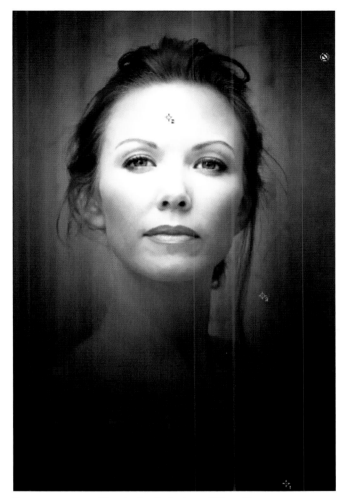

FIGURE 1.22.16 *After the Render Lighting Effects filter*

Brushing in the Key Light and Further Refining Light Positions Using Smart Filters

Although this image is not yet optimally lit, you have another piece of magic you can use, one that did not exist when I wrote the first edition of this book. You have Smart Filters. Before Smart Filters existed, once you clicked OK, that was it. With the advent of Smart Filters, you can re-open a filter if you do not like what you have done and this approach fits well into a non-destructive workflow. In addition, you will use a layer mask brush to brush in only the aspects of light you wish to keep from the image as it now exists.

NOTE: Look to your image map for ideas of the direction you want to take, i.e., which areas need to be brighter or darker than others.

14. Turn on the Lighting image map layer (LIGHTING_IM) (**Figure 1.22.17**).

15. Create a layer mask on the KEY_LIGHT layer and fill that layer mask with black.

16. Select the Brush tool, and set its opacity to 50% and its brush size to 300 pixels.

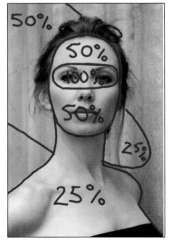

FIGURE 1.22.17 *The Lighting image map*

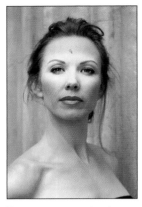

FIGURE 1.22.18 *Brushing in her eyes*

FIGURE 1.22.19 *The layer mask for her eyes*

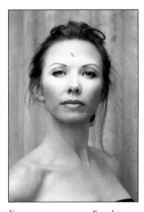

FIGURE 1.22.20 *Brushing in her face*

FIGURE 1.22.21 *The layer mask for her face*

FIGURE 1.22.22 *Lowering the Intensity to 31%*

17. Making sure that layer mask is active on the KEY_LIGHT layer, brush across Challen's eye area (the 100% area of the image map) at 50% (**Figures 1.22.18** and **1.22.19**).

18. Brush in her entire face including the eye area that you have just brushed (**Figures 1.22.20** and **1.22.21**).

You have finished the primary brushwork on this layer. Next, you will use Smart Filters to fine tune the lighting. You will do this by re-opening up the Render Lighting Effects filter that you made into a Smart Filter at the beginning of this set of steps.

19. On the KEY_LIGHT layer, double-click on Lighting Effects.

20. Once the Render Lighting Effects dialog box opens, click on the center handle of the left eye to make it active. Click on the Intensity slider and lower the Intensity to 31% (**Figure 1.22.22**). Then, move the light slightly to the left, just under where her left eyebrow ends.

FIGURE 1.22.23 *Move the light to the right*

21. Click on the center handle of the light in her right eye to make it active. Move the light slightly to the right, under where her right eyebrow ends (**Figure 1.22.23**).

22. Click on the center handle of her chin light to make it active, and then click on the lower handle and make the light a little bigger (**Figure 1.22.24**).

23. Click on the center handle of her forehead light to make it active, and make the light a little bigger (**Figure 1.22.25**). Bring the Intensity to 27 to restore detail and color (**Figure 1.22.26**).

24. Click OK.

FIGURE 1.22.24 *Increase the size of the light*

FIGURE 1.22.25 *Increase the size of the light*

Compare the image before (**Figure 1.22.27**) and after (**Figure 1.22.28**)

You can see that the power of using Smart Filters is that you can re-tweak an image at will. You never have to start from scratch if something does not work the way you envisioned.

There is still a bit of brushwork to do.

FIGURE 1.22.26 *Lower the Intensity to 27*

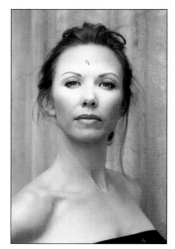

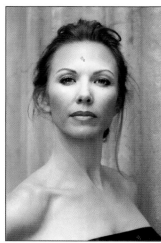

FIGURE 1.22.27 *Before the adjusted Render Lighting Effects* FIGURE 1.22.28 *After the adjusted Render Lighting Effects*

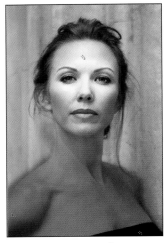

FIGURE 1.22.29 *Brush in her neck*

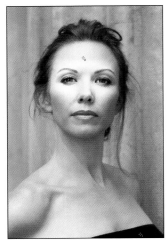

FIGURE 1.22.30 *Fade the brush-work to 31%*

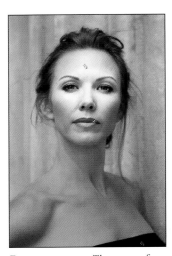

FIGURE 1.22.31 *The image after tightening up the layer mask*

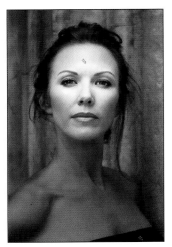

FIGURE 1.22.32 *Turning on the L_2_D_LUM layer*

Brushing Off the Brush

25. Select the Brush tool, set its opacity to 50%, and its brush size to 300 pixels, making sure that layer mask is active on the KEY_LIGHT layer. Brush in the model's neck and torso at 50% (**Figure 1.22.29**). Bring up the Fade effect dialog box, lower it to 31%, and click OK (**Figure 1.22.30**). Now, tighten up the layer mask using the techniques that you previously learned (**Figure 1.22.31**).

26. Turn on the L_2_D_LUM Curves adjustment layer (**Figure 1.22.32**) and lower its opacity to 67%. (**Figure 1.22.33**).

27. Turn off the L_2_D_LUM Curves adjustment layer.

28. Turn off the KEY_LIGHT Smart Filter layer.

29. Save the file.

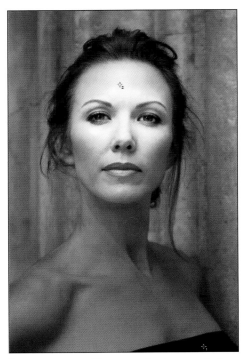

FIGURE 1.22.33 *The image after lowering the layer opacity to 67%*

Creating the Background Lights

You have placed the key lights and created the light-to-dark visual pathway using the L_2_LUM Curves adjustment layer, so the image is really taking shape. Hopefully, you are impressed with how Smart Filters play a key role in making workflow truly dynamic and in creating a non-destructive exit strategy.

Now it is time to place the background lights. The reason that I had you turn off both the KEY_LIGHT and L_2D_LUM layers is so that, when you affect changes to the placement and qualities of the background lights, you do not change any of the other lights. Once you have made the changes to the background lights, you will blend all of the lights together using opacity and layer masking.

Even more than placing the key lights, placing background lights is a dance. This is because of the subtley that you will want in them and because of the type of light you will use—Soft Spotlight instead of Soft Omni lights. These lights, however, are what will make this image visually unique and interesting.

You will be using Soft Spotlights for the background lights because their elliptical beam appears to diminish with distance from the light source, creating a 3D appearance. Also, you can better control this light's direction, focus, intensity, edge appearance, and size. On the other hand, Soft Omni lights impart a soft, radial, directional light, perfect for key lighting.

Again, just because you place something, the dance is not over until you make the next master layer. I cannot reinforce this enough—rely on what looks or, more importantly, feels right to you.

1. Make the BG_LIGHT Smart Filter layer, the active one, and make sure it is turned on. (Click the eyeball.)

2. Go to Filter > Render > Lighting Effects. When the Render Lighting Effects dialog box opens, from the Style pull-down menu, select Soft Spotlight (**Figure 1.23.1**).

3. Click on the center anchor point of the default light in the dialog box and move it to the upper left corner. When you release the light, it will look like **Figure 1.23.2**.

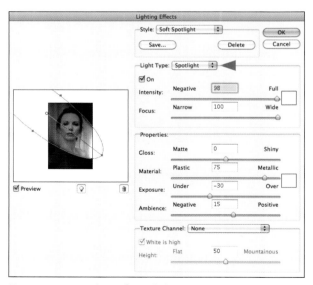

FIGURE 1.23.1 *Select Soft Spotlight*

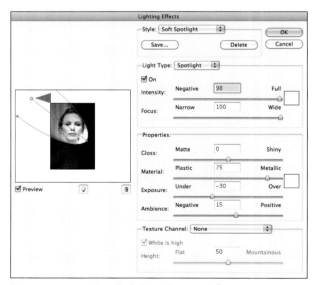

FIGURE 1.23.2 *Move the light to the upper left*

4. Because you want this first light to be a fairly large, sweeping one, click on the lower handle located at the left edge of the image preview, and move it a little less than one half inch downward (**Figure 1.23.3**).

5. Click again on the center handle of the default light, and readjust it by moving it higher up in the upper left corner. (**Figure 1.23.4**).

NOTE: Do not worry if the lights that you are placing affect Challen's face; you are concerned only with the background wall.

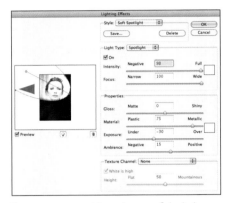

FIGURE 1.23.3 *Adjust the size of the light*

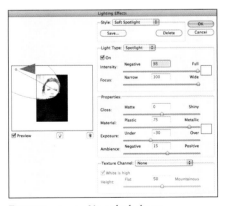

FIGURE 1.23.4 *Move the light up*

The first background light is more or less placed, so it is time to do the initial adjustments to the light qualities that you want this light to possess.

6. Click on the Intensity slider and lower it from the default of 98 to 51.

7. Click again on the center handle of the default light and readjust it by moving it so that it is almost in the farthest upper left corner. (**Figure 1.23.5**).

8. Click on the Focus slider and lower it from the default of 98 to 59.

9. In the Properties section, move the Gloss slider to Shiny or 100%, so that you get the appearance of a surface reflecting light (**Figure 1.23.6**).

10. In the Properties section, move the Materials slider to Plastic or –100% because you want use the light's color in the reflection (**Figure 1.23.7**).

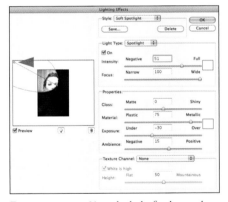

FIGURE 1.23.5 *Move the light further to the upper left*

FIGURE 1.23.6 *Adjust the Gloss slider to 100%*

FIGURE 1.23.7 *Move the Materials slider to −100%*

FIGURE 1.23.8 *Adjust the Exposure slider to −39*

You now have a diffused, soft light on the background wall, so it is time to address the ambient nature of the light and the exposure. In general, it is best to first set the quality of the light and then to adjust the ambience and exposure. Because Ambience determines how much lighting exists in the scene other than the light you have added, and Exposure addresses the general brightness of the image, set the Ambience first and then adjust the Exposure.

11. Click on the Ambience slider, and increase the ambience from 15 to 30.

12. Click on the Exposure slider, and decrease the exposure from 30 to −39. The image should now look like **Figure 1.23.8**.

You have set the base qualities of the first of the background lights, and it is time to place the second. Remember that this is a dance, so after you place the second light, you will need to come back and adjust the first, because the more lights you add, the brighter everything becomes. Every time you add a light, you need to adjust one or more of the variables of those already placed.

13. Click on the light bulb icon (located directly under the image preview), and place it at the top corner of the left side of the image, just outside of the image preview (**Figure 1.23.9**).

FIGURE 1.23.9 *Add another light to the top corner*

FIGURE 1.23.10 *Expand the width of the light*

FIGURE 1.23.11 *Expand the length of the light*

FIGURE 1.23.12 *Adjust the sliders*

14. Click on the lower handle and expand the width of the light (**Figure 1.23.10**).

15. Click on the front handle and expand the length of the light (**Figure 1.23.11**).

16. Lower the intensity to 23, lower the focus to –15, increase the ambience to 37, and set the exposure to –44 (**Figure 1.23.12**).

17. Click on the center handle of the first light to make it active, and lower the intensity to 41.

18. Click on the light bulb icon (located directly under the image preview) to create the third background light, and place it halfway down the left side of the image, just outside of the image preview (**Figure 1.23.13**).

19. Click on the lower handle and expand the width of the light (**Figure 1.23.14**).

20. Click on the front handle and expand the length of the light (**Figure 1.23.15**).

21. Click on the center handle of the third light and reposition it so that the center handle is about a half inch from the edge of the image (**Figure 1.23.16**).

FIGURE 1.23.13 *Add a third light*

FIGURE 1.23.14 *Expand the width of the light*

FIGURE 1.23.15 *Expand the length of the light*

FIGURE 1.23.16 *Move the light left*

NOTE: If you find that you need to expand or contract the length and/or width of the beam as you are working, just do it. Nothing is set until you click OK, and even then, if you are using Smart Filters, you can come back and change things.

22. Lower the intensity of the third light to 23, and lower the focus to –24.

23. Click on the center handle of the first light to make it active, and lower the intensity to 27.

24. Click on the center handle of the second light to make it active, and lower the exposure to 35.

25. Click on the center handle of the third light to make it active, and lower the ambience to 32.

Review the adjustments you just made (**Figure 1.23.17**).

NOTE: You may find that you need to reposition the lights as you make these adjustments, because hot and dark spots may appear. What you are trying to create is the appearance of a single streak of light by overlapping one light with another. Just as it would be in real life, when placing multiple lights to create a desired effect, adjustments are often necessary.

FIGURE 1.23.17 *Review the adjustments*

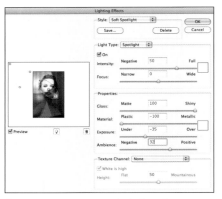

FIGURE 1.23.18 *Move the light to her nose*

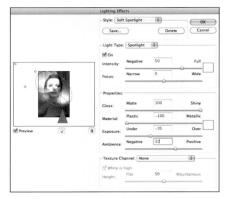

FIGURE 1.23.19 *Expand the light*

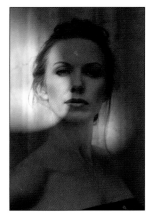

FIGURE 1.23.20 *The image after Render Lighting Effects*

26. Click on the light bulb icon (located directly under the image preview) to create the fourth background light, and place it so that the center handle is more or less on the tip of Challen's nose (**Figure 1.23.18**).

27. Click on the top handle to expand its width and click on the front handle to expand its length (**Figure 1.23.19**).

28. Lower the intensity to 29, and the focus to −27.

29. Click OK (**Figure 1.23.20**).

30. Save the file.

Brushing in the Background Lights

You can see that the light you created on the background wall is quite good, while that on Challen's face is most unattractive—and this is why I had you create two separate lighting layers. (You pro-acted rather than re-acted.) The filter is limited; it can do only one type of light modification at a time well, i.e. Soft Spotlight or Soft Omni. So, knowing that you had to pro-act, you worked around the limitations of the filter to get the desired result.

One of the best things about Adobe Photoshop is that, designed into the software, is the ability to make infinite modifications through the use of layers, layer masks, adjustment layers, Smart Filters, and opacity.

1. Create a layer mask on the BG_LIGHT layer, make the sure that the foreground color is white and the background is black, make the layer mask active, and fill the layer mask with black.

NOTE: For all of the layer mask work that you will be doing in this book, it is easier to have both the image and the layer mask visible and active at the same time. To see how to do this, refer to the Unmasking Layer Masks sidebar earlier in this chapter.

2. Select the Brush tool, and set the brush opacity to 50%.

3. (This step is optional.) Turn on the LIGHTING_IM layer (the lighting image map) (**Figure 1.24.1**) and brush in the background light.

NOTE: You may or may not want to turn the image map on to do your brushwork. I frequently turn on the image map layer.

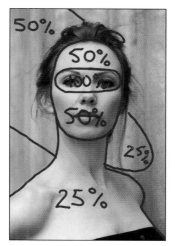

FIGURE 1.24.1 *Lighting image map*

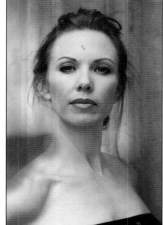

FIGURE 1.24.2 *Brush in the background*

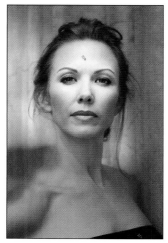

FIGURE 1.24.3 *The KEY_LIGHT layer on*

4. Brush in the background behind Challen at 50% so that it ends up looking something like this (**Figure 1.24.2**).

5. Turn on the KEY_LIGHT layer (**Figure 1.24.3**).

There are still issues to be addressed. Some background lights need to be replaced, and there is some unappealing overlap of layer masks. Frequently, you cannot see what needs to be done until you have completed the layer mask brushwork. Because you are using Smart Filters and a dynamic workflow, readjusting the image will be fairly easy.

Keeping the idea of working global to granular in mind, do you think the layer mask overlap or the light placement issue is the bigger of the two problems? I believe that the bigger issue is the light placement.

6. Double-click on Lighting Effects in the BG_LIGHTS layer to reopen the Render Lighting Effects dialog box.

7. Click the center handle of the lower light, and move it slightly downward and forward (**Figure 1.24.4**).

FIGURE 1.24.4 *Move the light down*

FIGURE 1.24.5 *Widening the light*

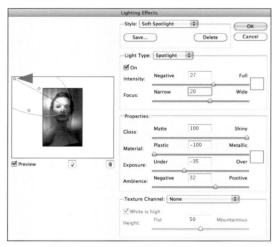

FIGURE 1.24.6 *Narrow the Focus to 20*

8. Click on the lower handle and open it up until the handle touches the edge of the dialog box (**Figure 1.24.5**). Narrow the focus to –23, and you will notice that the light's edge is now smoother.

9. Click on the second, or middle, light's center handle to make it active (**Figure 1.24.6**), narrow the Focus to 20, and click OK.

You should see a smoother line of light (**Figure 1.24.7**). Now it is time to refine the layer mask.

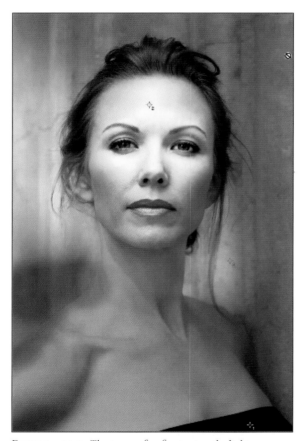

FIGURE 1.24.7 *The image after fine tuning the light*

10. Make the BG_LIGHT layer mask active, select the Brush tool with a brush width of 400 pixels, make the foreground color black and the background white, set the brush opacity to 50%, and brush back the area above Challen's shoulder. This is what you should have when you are finished (**Figure 1.24.8**).

11. Double-click on Lighting Effects in the BG_LIGHTS layer to reopen the Render Lighting Effects dialog box.

12. Click on the center handle of the upper-most light, move it slightly upward and forward, and increase the focus to −23. Click OK. This is what it should now look like (**Figure 1.24.9**).

13. Save the file.

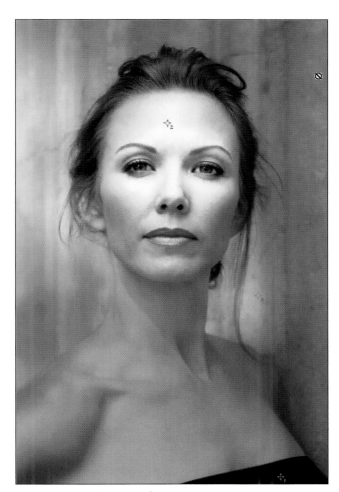

FIGURE 1.24.9 *The image after adjusting the upper-most light*

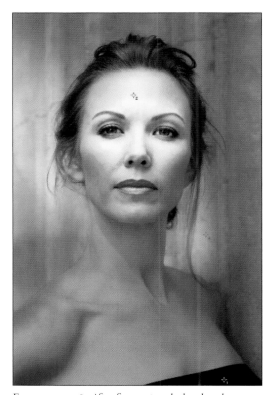

FIGURE 1.24.8 *After fine tuning the brushwork*

Traveling at the Speed of Dark

Light thinks it travels faster than anything, but it is wrong. No matter how fast light travels, it finds the darkness has always got there first, and is waiting for it.

—Sir Terry Pratchett

In the known universe, it is true that light moves faster than anything else, but dark is always there first. I think that there is an artistic truth in Sir Terry Pratchett's words and, in photography, dark is as important as light. Obviously, if an image is evenly lit, it is flat and will not hold anyone's interest.

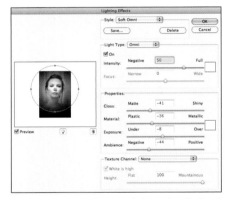

FIGURE 1.25.1 *Placing a light on her forehead*

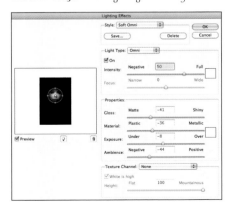

FIGURE 1.25.2 *Shrinking the light*

In the last set of steps, you created lighting layers with the Render Lighting Effects filter. Now you will create darkening layers, and you will use Render Lighting Effects in a way that the designers of Photoshop never intended, because Render Lighting Effects generates the most beautiful gray blur, a blur whose density and directionality you can control.

There is a fundamental principle here—do not let yourself be limited by the obvious. When you work with any tool, be open to everything that happens when you use that tool. Play with it. You may be surprised that there is more to the tool at hand than the designers of that tool had in mind.

1. Make the MASTER_ 2 copy layer active and rename it DRKN_BG.

2. Select Render > Lighting Effects from the Filter pull-down menu.

3. Select Soft Omni from the Style pull-down menu.

4. Click on the center handle and move the light from its default position (in the middle of Challen's forehead) to the middle of her face (**Figure 1.25.1**).

5. Click on the upper handle and move it downward until the outer circle is just above her eyebrows (**Figure 1.25.2**).

6. Click on the Ambience slider and increase it to 9. Click on the Exposure slider and lower it to –13. (Notice how even and nice the gray is in the dialog box.)

7. Click on the Intensity slider and lower it to 35 where only the very center of her face is lit.

8. Click OK (**Figure 1.25.3**).

9. Create a layer mask, fill it with black, and select the Brush tool with a brush width of 400 pixels and an opacity of 50%. Brush in the area just below the background light and the entirety of Challen's torso, beginning just under her chin. Compare the image before the brushwork (**Figure 1.25.4**) and after the brushwork (**Figure 1.25.5**). Bring up the Fade effect dialog box and fade back to 39% (**Figure 1.25.6**).

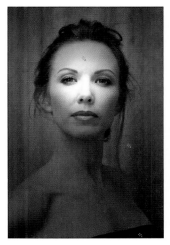

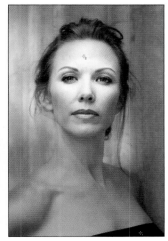

FIGURE 1.25.3 *After the Render Lighting Effects filter*

FIGURE 1.25.4 *Before the brushwork*

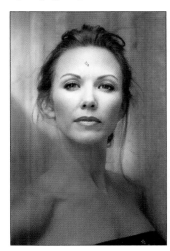

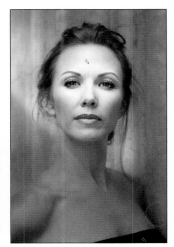

FIGURE 1.25.5 *After the brushwork*

FIGURE 1.25.6 *After fading the brushwork to 39%*

10. Starting at the top of the image in the middle on the other edge of the background light beam, brush in the background all the way down the right side, including Challen's torso and neck (**Figure 1.25.7**). Bring up the Fade effect dialog box and adjust it to 24% (**Figure 1.25.8**). Look at the final layer mask to see if it needs to be tightened up (**Figure 1.25.9**).

11. Save the file.

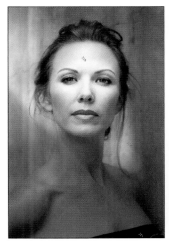

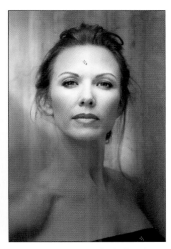

FIGURE 1.25.7 *Brush in her torso*

FIGURE 1.25.8 *Fade the brushwork to 24%*

FIGURE 1.25.9 *The resulting layer mask*

Step 3: Bending, Not Breaking, Pixels: Addressing the Sins of Our Artifacts

Whenever you do anything in Photoshop, you alter the data. When the data is altered, some of it is clipped or dropped, and forever lost. That is how artifacts are created. As I have already discussed, artifacting is cumulative, and if you accumulate enough artifacts, you will see them in your image. In other words, you have performed so many manipulations that you have bent the pixels to the point of breaking them.

The goal of anything you do in Photoshop is to make it look like you did not do anything at all. If someone asks, "Did you do something in Photoshop?" you want it to be a question rather than an accusation. You want to use Photoshop as an emery board and not a jackhammer. However, there are times when no amount of care can prevent artifact formation. Step 3 is about how to address blown-out areas (a type of artifacting) that sometimes result from using the Render Lighting Effects filter. The area of the image that is at issue is the key light area in the center of Challen's face.

If you follow Einstein's thought that we should make things as simple as possible but no simpler, you could go back to the KEY_LIGHT Smart Filter layer and readjust it. Another approach would be to ask the question, "What don't I like about this image?" The answer is that her face is blown out and there is a loss of detail when compared to the original image. It is in this answer that you will find your solution. You need to bring back the detail.

You are striving for an efficient workflow, one that allows you to find the quickest way to achieve your goals yet causes the least amount of artifacting. So rather than readjusting all the lights yet again, go back to the base layer that you first started lighting.

1. Duplicate the original MASTER_ 2 layer and move it above the DRKN_BG layer. Rename this layer FACE_CORRECT.

2. Create a layer mask, and fill it with black. Select the Brush tool, and reduce it to the width of her nose (90 pixels) with the opacity set at 50%.

3. Brush in the area of the bridge of her nose and under her left eye. Bring up the Fade effect dialog box and lower it to 40%. The layer mask will look like **Figure 1.26.1**.

4. Next, brush in her forehead above her right eye. Bring up the Fade effect dialog box and lower the opacity to 20%. The layer mask will look like **Figure 1.26.2**.

5. Turn on the L_2_D_LUM Curves adjustment layer and lower the opacity from 67% to 40%. Compare the image before lowering the opacity (**Figure 1.26.3**) and after lowering the opacity (**Figure 1.26.4**).

6. Turn off the L_2D_LUM Curves adjustment layer.

7. Make the LIGHTING layer set active.

8. Create a Master Layer (Command + Option + Shift + E / Control + Alt + Shift + E) and name it MASTER_3.

9. Create a new layer set and name it EXPRESSION_CORRECT.

10. Drag MASTER _3 into the EXPRESSION_CORRECT layer set folder.

11. Save the file.

Now that you have finished lighting the image, you must create a realistic shadow, and add coolness back in. Then you will correct the lens distortion that widens faces, and finally, you will enhance Challen's expression. You will make her smile.

FIGURE 1.26.1 *Brush in her nose*

FIGURE 1.26.2 *Brush in her forehead and above her right eye*

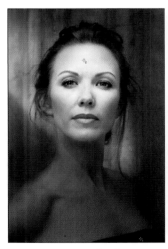

FIGURE 1.26.3 *Before lowering the opacity*

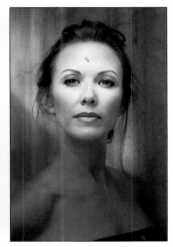

FIGURE 1.26.4 *After lowering the opacity*

Plastic Surgery Without a Scalpel: Facial Rearrangements

While there is perhaps a province in which the photograph can tell us nothing more than what we see with our own eyes, there is another in which it proves to us how little our eyes permit us to see.

—Dorothea Lange

The image now resembles what it might have been had it originally been properly lit. Lighting the image before retouching it may seem contrary to the global to granular approach I advocate, because, at first, the biggest issues seem to be with Challen's face. The reason I had you light it first has to do with one of the pillars of an adaptive, dynamic, non-destructive work flow: alter your image in ways that minimize artifacts.

A lot of what will happen to Challen's face when you retouch it is dependent on how you light it, specifically, where the shadows will fall and the angle of those shadows. Also, if you were to have originally lit her with real lights, you would be retouching the lit image, not the unlit one. So, retouching her face is your next concern. The more you understand about the interactions of your workflow steps, the more informed your decisions can be throughout the entire process of working with any image.

In this next step, you will deal with issues of lens distortion, specifically, how a lens widens a face. Then you will go on to straightening her nose, as well as some other issues of facial expression and symmetry.

The Importance of Image Maps Every Step of the Way

Not only do I use image maps when I meet with a client, I also use them to make notations to myself both before and, sometimes, after I make an adjustment. As I have mentioned before, you do not have to use image maps for every image, but if you want or need to return to an image to make further adjustments, they are invaluable. I started using image maps in my professional portrait work, but I found them useful in my landscapes as well.

This is the image map that I created for Challen's facial expression correction (**Figure 1.27.1**). You are going to shrink Challen's face, thin her nose and even it out, and add smile lines using Liquify. When changing a facial expression, keep in mind that for every action there is a reaction; if you move the edges of her lips upward, aspects of the rest of her face will need to be moved as well.

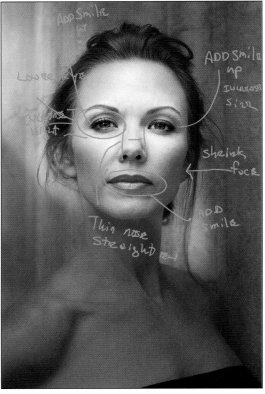

FIGURE 1.27.1 *Image map for facial correction*

Correcting Facial Widening Due to Lens Distortion

1. Select the Marquee tool (keyboard command M). Its default is the rectangular tool, which is the one you want for this step.

2. Starting in the upper left-hand corner of the image, click and drag the Marquee tool to the lower right-hand corner (**Figure 1.27.2**).

3. Copy the selected area to its own layer (Command + J / Control + J).

4. Name this layer FACE_SHRINK.

5. Bring up the Free Transform box (Command + T / Control + T).

6. Holding the Option key down, click on the middle handle on the left side of the Free Transform box (**Figure 1.27.3**) and move it towards the center until you have reduced it to 95.9%. Click on the Hand tool to bring up the Apply dialog box and click Apply. Compare the image before (**Figure 1.27.4**) and after (**Figure 1.27.5**).

FIGURE 1.27.2 *Use the Marquee tool to select her face*

FIGURE 1.27.3 *Move the handle on the left side of the Free Transform box*

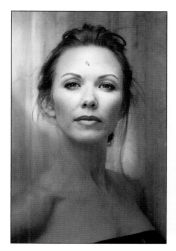

FIGURE 1.27.4 *Before the Free Transform adjustment*

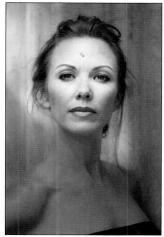

FIGURE 1.27.5 *After the Free Transform adjustment*

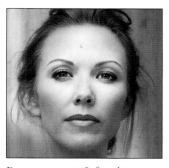

FIGURE 1.27.6 *Before the brushwork*

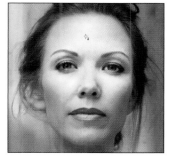

FIGURE 1.27.7 *After the brushwork*

NOTE: Holding down the Option key causes the Free Transform box to uniformly expand or shrink. If you do not hold down the Option key, you will affect only the side of the box on which you are working.

7. Create a layer mask and fill it with black.

8. Select the Brush tool, make the foreground color white and the background black, set the opacity to 100%, and the brush width to 100 pixels.

9. Starting at the top right side of Challen's face, brush in, following the entire outline of her hairline and face. Compare the image before brushwork (**Figure 1.27.6**) and after brushwork (**Figure 1.27.7**).

NOTE: Whenever I do this type of retouching, I create a new layer and fill it with white to see if I missed anything or if there are unwanted gaps. If I see any problems, I fix the layer mask using the techniques I discussed previously.

Be aware that even though the layer mask may appear perfect, things you do not see on the screen may show up in the print. The reason for this is that your screen probably has a resolution of 72 dpi and your printer is likely to have one that ranges from 1440 dpi to 5760 dpi. So what you see is not always what you get. By creating a solid white layer (that I can toggle on and off) beneath the area in which I have just done brushwork, I can better see if I missed something and can fix it before I print it.

With just a brush stroke, you have removed the five pounds Challen seemed to have gain because the lens did not treat her fairly. Now that you have reduced her face and made any necessary refinements to the layer mask, it is time to realign and retouch her nose.

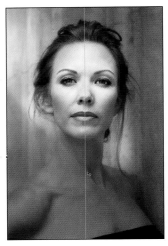

FIGURE 1.27.8 *Adding a vertical guide*

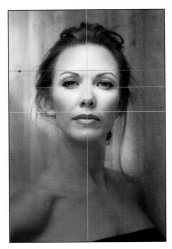

FIGURE 1.27.9 *Adding horizontal guides*

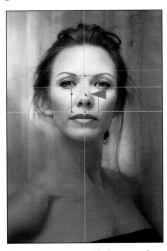

FIGURE 1.27.10 *Clicking on the Reference Point*

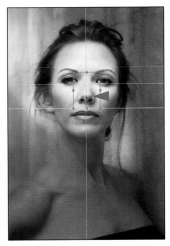

FIGURE 1.27.11 *Move the Reference Point to the center of her nose*

Correcting Nose Size Due to Lens Distortion and Adjusting Alignment

10. Make the MASTER_3 layer active.

11. If you have not already done so, bring up the Rulers (Command + R / Control + R). Select the Move tool (keyboard command V), click on the left Ruler, and drag the guide line until it locks in the center of the image. This is the image's horizontal center (**Figure 1.27.8**).

12. Click on the top Ruler and drag down a guide until it locks in place. This is the image's vertical center.

13. Click again on the top Ruler and drag a guide down until it lines up just below her right eye. Click on the top Ruler again and drag another guide so that it is just above her left eye brow (**Figure 1.27.9**).

You will notice that her left eye is a bit higher than her right eye and her nose is a little crooked and slightly off center.

14. Select the Marquee tool and, starting just below her left eyebrow, click and drag it to just above the right corner of her mouth.

15. Copy the selection to its own layer (Command + J / Control + J).

16. Name this layer NOSE.

17. Bring up the Free Transform box (Command + T / Control + T).

18. Click on the Reference Point (**Figure 1.27.10**) and move it to the center tip of her nose, right on the center vertical guide line (**Figure 1.27.11**).

NOTE: The Reference Point, also referred to as the Center Point of Rotation (or the Center Anchor Point if you work in Adobe After Effects), is an important and frequently overlooked function within Free Transform. To quote Adobe, "All transforms are performed around a fixed point called the reference point." Therefore, if you move the Reference

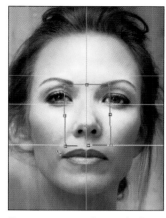

FIGURE 1.27.12 *Rotate the Free Transform box*

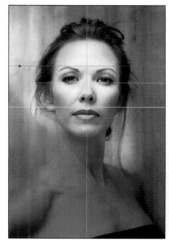

FIGURE 1.27.13 *Before the Free Transform adjustment*

FIGURE 1.27.14 *After straightening the nose*

Point up, down, or even outside of the Free Transform box, the transformations you do will be done based on where this point is placed. Because of its importance, carefully consider its placement every time you bring up Free Transform.

19. Move the cursor to just outside the Free Transform box until you get rotation arrows. Click and drag the Free Transform box counter clockwise until you have an angle of –1.6, which is enough rotation to straighten out her nose. (**Figure 1.27.12**)

20. Holding the Option key down, click on the middle handle on the left side of the Free Transform box and move it towards the center until you have reduced it to 98.4%. Click on the Hand tool to bring up the Apply dialog box and click Apply. Compare the image before (**Figure 1.27.13**) and after (**Figure 1.27.14**).

21. Create a layer mask, fill it with black, hide the guides (Command + H / Control + H), select the Brush tool, set the opacity to 100%, the brush width to 100 pixels, and brush in just her nose. Compare the image before (**Figure 1.27.15**) and after straightening the nose (**Figure 1.27.16**).

FIGURE 1.27.15 *Before*

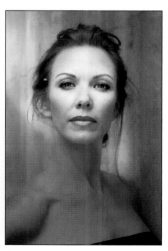

FIGURE 1.27.16 *After*

Refining the Eye So the Eyes Have It

You have successfully made Challen's face a bit more symmetrical and compensated for lens distortion. Now you will even out her eyes, since one appears higher than the other.

1. Make the MASTER_3 layer active.

2. Select the Marquee tool, and, from slightly above the upper guide line (above her left eye), drag the Marquee tool downward to the center guide. Copy that selection to its own layer (Command + J / Control + J). Here is the selected area (**Figure 1.28.1**).

3. Making sure that the Marquee tool is still active, switch to the Move tool and click with the down arrow key until the bottom of her left eye lines up with the guide that you have set beneath her right eye (**Figure 1.28.2**).

FIGURE 1.28.1 *The selected area*

FIGURE 1.28.2 *Move her left eye*

4. Next, you will slightly increase her left eye's vertical height. Select Free Transform (Command + T / Control + T), and type 3% in the Height dialog box. Click on the Hand tool to bring up the Apply dialog box, and click Apply (**Figure 1.28.3**).

NOTE: Increasing the size (height and width) of the eye is a classic Hollywood/Glamour/Beauty retouching trick and is applied to most magazine images you see today.

5. Make the MASTER_3 layer active.

6. Select the Marquee tool.

7. From slightly above the upper guide line, above her right eye, drag the Marquee tool downward to just above her right ear and copy that selection to its own layer (Command + J / Control + J) (**Figure 1.28.4**).

8. Select Free Transform (Command + T / Control + T) and type 3% in the Height dialog box. Click on the Hand tool to bring up the Apply dialog box, click Apply, and select the Move tool. Making sure that the Marquee tool is still active, click on the down arrow key until the bottom of her left eye lines up with the guide. **Figure 1.28.5** shows everything you have already done to this image.

9. Make active the layer into which you copied her left eye. (It should be above the layer into which you copied her right eye.) Merge the one with her left eye (Command + E / Control + E) into the layer with her right eye and name it EYE_ADJUST.

10. If the EYE_ADJUST layer is not already below the NOSE and FACE_SHRINK layers, move it there.

NOTE: The NOSE and FACE_SHRINK layers should be above the EYE_ADJUST layer because the latter contains elements of the other two that have not yet been corrected.

11. Create a layer mask, fill it with black, make the foreground color white and the background black, select the Brush tool,

FIGURE 1.28.3 *Apply the Free Transform*

FIGURE 1.28.4 *Select her right eye*

FIGURE 1.28.5 *Mover her left eye*

set the opacity to 100%, and brush in just the area of both her eyes and her eyebrows (not the bridge of her nose). The areas that you have just brushed in should look like **Figure 1.28.6**.

12. Make the MASTER_3 layer active.

13. Select the Marquee tool.

14. From slightly above the horizontal middle guide line (the guide closest to the bottom of the image and just above the left part of her mouth, drag the Marquee tool downward and copy that selection to its own layer (Command + J / Control + J) (**Figure 1.28.7**).

FIGURE 1.28.6 *After the brushwork*

FIGURE 1.28.7 *Select her mouth area*

FIGURE 1.28.8 *Before the mouth brushwork*

FIGURE 1.28.9 *The brushed in area*

FIGURE 1.28.10 *The lips after the brushwork*

15. Select Free Transform (Command + T / Control + T) and increase the Height to 103.8%. (This will add fullness to her lips.) In order to make it more symmetrical, rotate her mouth counter-clockwise to an angle of –1.7. Click on the Hand tool to bring up the Apply dialog box, and click Apply.

16. Create a layer mask, fill it with black, make the foreground color white and the background black, select the Brush tool, set the opacity to 100%, and brush in the area of just her mouth. Examine the image before (**Figure 1.28.8**), the brushed in area (**Figure 1.28.9**), and after (**Figure 1.28.10**). Name this layer LIPS.

17. Save the file.

Compare the image before (**1.28.11**) and after (**Figure 1.28.12**).

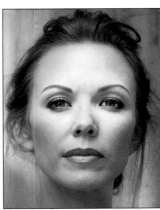

FIGURE 1.28.11 *Before* FIGURE 1.28.12 *After*

Final Fine Tuning Color Corrections and Adjustments

It is time to move into the final aspects of this image: correcting Challen's eye color, removing some of the ruddiness from her skin, adding coolness and blueness into the background, adding warmth into her face, and adding a shadow beneath her nose.

Correcting Eye Color with the Vibrance Tool

Begin with the issues of diminished saturation of her eye color. You will do this using one of my favorite filters in Photoshop, the Vibrance tool.

The Vibrance adjustment tool was new to CS4, but has been a part of ACR (Adobe Camera Raw) and Lightroom for a while. It is located in the second row of the Adjustments panel. Vibrance adds color saturation into the colors that need it, while leaving other colors alone. One of the benefits of using it as an alternative to Hue/Saturation is that Vibrance affects blues and greens more than yellows and reds, and because of this, tends to leave skin tones untouched. Because you will be working on eyes that are green/blue, Vibrance is the ideal tool to use.

NOTE: If you have CS3 or below, there is no Vibrance, so skip to the next section, Removing Ruddiness…

1. Select the Vibrance tool from the Adjustment panel. Name this layer EYE_BOOST (**Figure 1.29.1**).

2. Zoom into her left eye.

3. Boost the Vibrance slider to 100% and the Saturation slider to 18% (**Figure 1.29.2**).

4. Fill the Vibrance adjustment layer's layer mask with black.

5. Select the Brush tool, make sure the foreground color is white and the background is black, set the brush opacity to 50%, make the brush size 50 pixels, and brush in the iris and pupil of her left eye.

6. Bring up the Fade effect dialog box (Command + Shift + F / Control + Shift + F) and increase it to 70%. Compare the image before the Fade effect (**Figure 1.29.3**) and after the Fade effect (**Figure 1.29.4**).

7. Brush the iris and pupil of her right eye, bring up the Fade effect tool, and increase the amount to 70%.

8. To further fine tune Challen's eye color, lower the overall layer opacity to 49%. (**Figure 1.29.5**).

You have enhanced the greens and blues of her irises while maintaining the whites of her eyes.

FIGURE 1.29.1 *Vibrance tool*

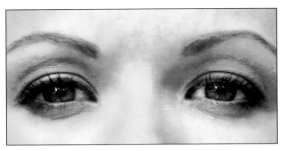

FIGURE 1.29.2 *Increase the Vibrance and Saturation sliders*

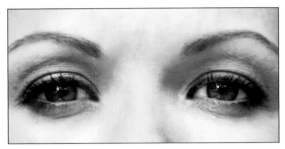

FIGURE 1.29.3 *Before the Fade effect*

FIGURE 1.29.4 *After the Fade Effect*

FIGURE 1.29.5 *Lower the layer opacity to 49%*

Removing Ruddiness from Skin Tone Using a Hue and Saturation Adjustment Layer

Next, you will remove the ruddiness of her skin due to sunburn.

NOTE: There is a video on youtube.com where you can watch me do this. The URL is http://www.youtube.com/watch?v=5ki3QhJkw-4.

1. Create a Hue and Saturation adjustment layer and name it RED_CORRECT.

2. Because you want to remove the redness from her skin, select Reds from the Colors pull-down menu (**Figure 1.30.1**).

3. Select the Positive or Additive Eyedropper correction, which is the default setting when you select a color from the Colors pull-down menu (**Figure 1.30.2**).

FIGURE 1.30.1 *Select the Reds from the Colors pull-down menu*

FIGURE 1.30.2 *Select the Positive eyedropper*

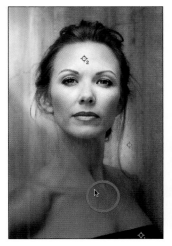

FIGURE 1.30.3 *Selecting the skin color with the eyedropper*

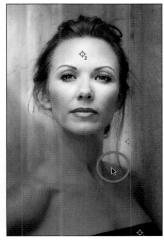

FIGURE 1.30.4 *The acceptable skin tone on her shoulder*

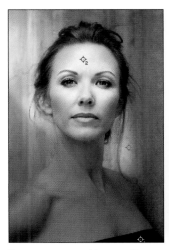

FIGURE 1.30.5 *Adjusting Hue and Lightness slider*

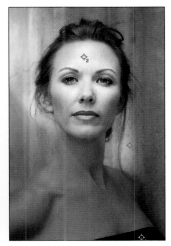

FIGURE 1.30.6 *Brushing in the adjustment to her torso*

4. Click the eyedropper on an area of unacceptable skin tone, in this case, the middle of her chest. You should notice that the area between the white triangles and the vertical line (below the color bar) has expanded. Look at the sample point area (**Figure 1.30.3**).

5. Select the Negative or Subtractive eyedropper which is to the right of the Positive or Additive eyedropper.

6. Click the eyedropper on an area of acceptable skin tone, in this case, the upper right part of her shoulder. You should notice that the area between the white triangles and the vertical line (below the color bar) has contracted. Look at the sample point area (**Figure 1.30.4**).

7. Click on the Hue and Saturation slider. Move it to –17, which is to your right and in the direction of yellow. Click on the Lightness slider and move it to +21. (**Figure 1.30.5**)

NOTE: The trick to removing ruddiness is to get the areas from which you want to remove color to closely match the acceptable areas surrounding them. After you are finished, if the overall skin cast is not exactly as you would like it, remember, you will soon be using a layer mask and brushing in the areas that you want.

Though not necessary for this image, you can further fine tune the correction by moving in the end points of the sample area. This will be further explored in a future book in this series. The chapter will be called "How to Retouch a Portrait in 15 minutes." You can find this now in the Acme Educational tutorial DVD of the same name.

8. Make the Hue and Saturation adjustment layer's layer mask active and fill it with black.

9. Select the Brush tool, and set it to 500 pixels at an opacity of 50%. Brush in just her torso; do not let your brushwork go above her chin. Bring up the Fade effect dialog box and increase it to 74.%. Where you just did the brushwork, the color of her chest has cooled, and you no longer have ruddiness. (**Figure 1.30.6**).

Warm Colors Move Forward, Cool Colors Recede: Adding Coolness and Warmth to Further Enhance the Illusion of Realistic DOF

Using Photoshop's Photo Filters to Add Coolness and Warmth

Inside of Photoshop are a set of filters that replicate actual photographic color correction filters so that you can set the white balance in your digital camera. You are going to use these filters in a way that was not originally intended in order to introduce coolness into the background.

1. In CS4 and above, go to the Adjustments panel and select Photo Filters to bring up a Photo Filters Adjustment layer (in CS3 or below, select Photo Filters from the Adjustment layers icon at the bottom of the layers palette/panel) (**Figure 1.31.1**).

2. From the Filter pull-down menu, select Blue (**Figure 1.31.2**). The image now has a blue cast (**Figure 1.31.3**).

FIGURE 1.31.2 *Selecting Blue*

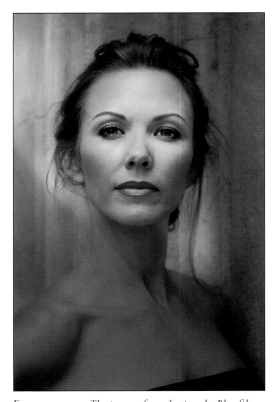

FIGURE 1.31.3 *The image after selecting the Blue filter*

FIGURE 1.31.1 *Photo Filters*

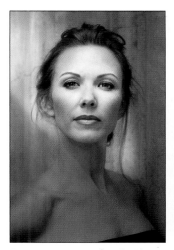

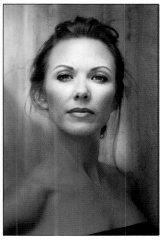

FIGURE 1.31.4 *Before the Blue filter on her torso*

FIGURE 1.31.5 *After the Blue filter on her torso*

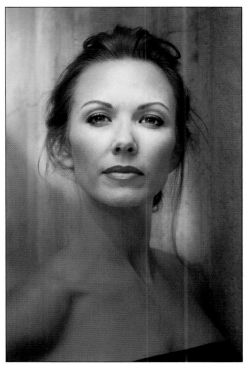

FIGURE 1.31.6 *After adding an Orange filter to her*

3. Make sure that the Blue Photo Filter Adjustment layer that you have just created is above the RED_CORRECT adjustment layer. Fill the layer mask with black, set the brush opacity to 50%, and the pixel width to 500. Brush in the region between the area just above her left shoulder and the background light. Bring up the Fade effect dialog box and type in 65% to further fine tune the intensity. Now, brush in every area that is not "lit." In the background of the image, bring up the Fade effect dialog box and type in 65%. Next, brush in her torso (below her neck and her shoulders and chest). Bring up the Fade effect dialog box and lower it to 30%. Challen should appear to have moved forward from the background. Compare the before (**Figure 1.31.4**) and after (**Figure 1.31.5**).

4. Name this layer COOL.

5. Save the file.

NOTE: Rather than paint a large area, which is time consuming, I had you begin with a small one so that you could more efficiently determine the optimal amount you would later use on the larger area. To achieve an efficient workflow, think about the fastest way to get the best result.

Challen's torso is at a lower percentage than the wall, because her torso is closer to the camera and you have been creating the illusion that the subject is further from the wall. Because shadows tend to have a blue cast and since her torso is in shadow, it should be bluer (cooler) than the areas around it that are well lit.

Now that you have added coolness to the background and the areas of her body that are in shadow, it is time to add warmth into the area of the background light.

6. Go to the Adjustments panel and select Photo Filters to bring up a Photo Filters Adjustment layer. (In CS3 or below, select Photo Filters from the Adjustment Layers icon at the bottom of the layers palette/panel.) From the Filter pull-down menu, select Orange and the image takes on a very warm color cast (**Figure 1.31.6**).

7. Make sure that the Orange Photo Filter Adjustment layer that you have just created is above the RED_CORRECT adjustment layer. Fill the layer mask with black, set the brush opacity to 50%, and choose a pixel width of 500.

8. Paint in the area to the right of Challen, bring up the Fade effect dialog box and increase the amount to 75%. Paint in the larger area of the background light, and once again, bring up the Fade effect dialog box and type in 75% (**Figure 1.31.7**).

9. Name this layer WARM.

10. Save the file.

You now have the right colors and shadow, and everything is balanced. The last touch, which will make your observer believe that the image they see was in the original capture, is a shadow underneath Challen's nose.

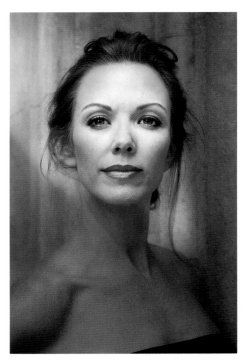

FIGURE 1.31.7 *After fine tuning the WARM layer*

Creating a Realistic Shadow

This next step makes the image a believable probability. It is something so simple—a shadow. The most common way to make a drop shadow is to make a new layer, create a selection, feather that selection, fill that selection with black, zap it with Gaussian blur, and then lower the opacity. This works for things like fonts, but when you work with three-dimensional objects, the result may not look real. A major consideration when putting a shadow into your composition is recognizing the direction from which the light is striking your subject. This will influence the size and position of the shadow that you would expect to see. If you don't take this into account, you run the risk of creating unrealistic images in which the light may appear to be coming from several different directions at once. In this step, you will create a realistic-looking shadow.

1. Zoom in on the model's nose and mouth. Select the Eyedropper tool, and sample the color of the shadow just below the right side of her nose, so that the foreground color reflects the color of the shadow (**Figures 1.32.1** and **1.32.2**).

Notice that the color of the sample box in the tool bar is anything but gray. Rather, the color of the shadow is a darker variant of the colors around it.

FIGURES 1.32.1 AND 1.32.2 *Sampling the shadow color just below her nose*

FIGURE 1.32.3 *Make a selection*

FIGURE 1.32.4 *Feather the selection*

FIGURE 1.32.5 *Apply a Gaussian Blur*

FIGURE 1.32.6 *Select the Warp command*

2. Create a new layer and name it SHADOW.

3. With the Polygonal Lasso tool, select a lock point that starts at the edge of the shadow below her nose. Click a selection (**Figure 1.32.3**). Go to Select > Feather, select an 11-pixel radius, and click OK. This will cause the selection to even out (**Figure 1.32.4**). Fill the selection with the foreground color (Alt + Backspace / Option + Delete), and deselect the selection. (Click on the layer.) Make the layer a Smart Filter, then open the Gaussian Blur filter, and choose a radius of 27 pixels. Click OK and the image will look like **Figure 1.32.5**.

NOTE: The radius of the feather should be in direct proportion to the size of the area being feathered, as well as to the size and resolution of the file. The bigger the file or the area selected, the bigger the radius.

4. Bring up the Free Transform dialog box (Command + T / Control + T). Holding down the Control key, click on the Free Transform dialog box and select the Warp tool from the pop-up menu (**Figure 1.32.6**).

NOTE: When using Free Transform on a layer that is a Smart Filter, you will get the following warning, "Smart Filters applied to this layer will be turned off temporarily while the transform is being previewed. They will be applied after committing the Transform." There is a "Don't show me again" option that you can check if you prefer that this not reappear. Click OK.

5. Click on the center square (**Figure 1.32.7**) and, keeping your finger depressed on the left mouse button, click and drag it downward (**Figure 1.32.8**) to fit the dip in her nose. Then, on the right side of the shadow, move the grid line upward to create the right side of the shadow contour (**Figure 1.32.9**). Repeat the same process on the left side of the nose shadow. Click on the Hand tool in the tool bar to bring up the Placement dialog box. Click Place (**Figure 1.32.10**).

6. Create a layer mask.

7. Lower the layer opacity to 82% (for this image) in order to match the nose color that you previously sampled. Make the foreground color black and the background white, select the Brush tool, and set the opacity to 50%. At a brush width of 125 pixels, gently ride the edge of the nose shadow with the edge of the brush to form the proper shape (**Figure 1.32.11**).

8. Lower the layer opacity (49% for this image) until you can see the contours under Challen's nose (**Figure 1.32.12**).

9. Turn the L2D_LUM Curves adjustment layer back on, and lower the opacity (13% for this image) until you get the exact balance that you want (**Figure 1.32.13**).

10. Create a Master layer and name it FINAL.

11. Save the file.

FIGURE 1.32.7 *Click on the center square*

FIGURE 1.32.8 *Drag it downward*

FIGURE 1.32.9 *Move the gridline upward*

FIGURE 1.32.10 *Place the transformation*

FIGURE 1.32.11 *Brush in the proper shape*

FIGURE 1.32.12 *Lower the layer opacity to 49%*

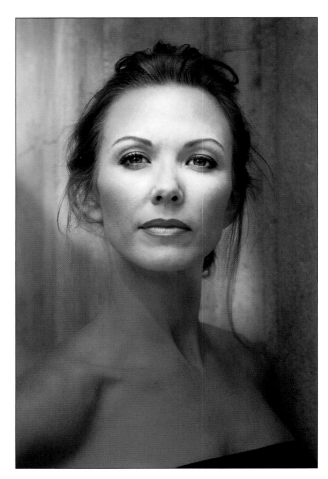

FIGURE 1.32.13 *Final image*

The Transformation Is Complete

This lesson has been about learning how to be in Shibumi whenever and wherever you create, and about developing a dynamic, proactive way of thinking about workflow. What you should have seen in this workflow is that everything was done to minimize artifact and replicate the reality of light.

As I discussed at the beginning of this chapter, practice doesn't make perfect; perfect practice makes perfect. What you need to do is practice at practicing. So before you move on to the next chapter, I suggest you begin with the original image and repeat the entire process described in this lesson. Then try to do it without referring to the lesson. Lastly, try it without using image maps, and see how fast and accurate you can be. What I have found on my journey as an artist is that simple repetition was not the path to mastery. Rather, you need to engage in exercising variations of what you repeat. In that way, your technique evolves and grows. In other words, you need to engage in the exercise of repetition until you are in Shibumi, and with Shibumi comes mastery and the achievement of perfect practice.

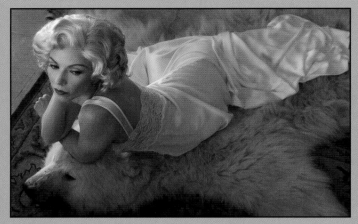

FIGURE 2.0.1 *Before*

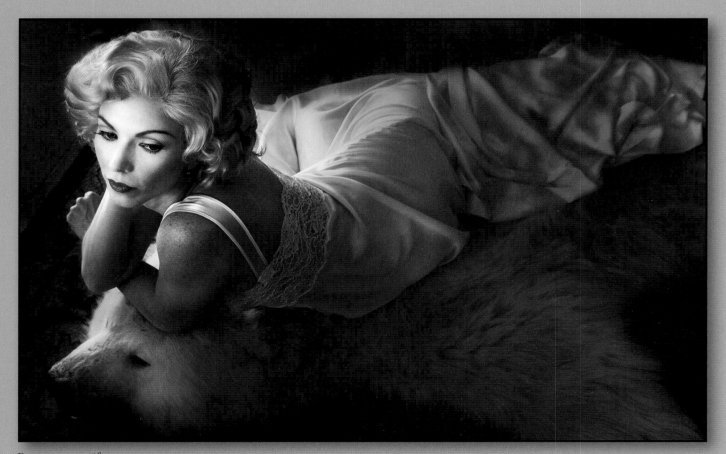

FIGURE 2.0.2 *After*

Classic Studio Lighting

What's the best type of light? Why that would be available light…

and by available light I mean any damn light that is available.

—W. Eugene Smith

In this chapter, building on what you learned in Chapter 1, you will use Photoshop to emulate the look of a classic Hollywood glamour photograph lit with studio "hot" lights and shot on an 8x10 view camera. You will be working with an image that I have entitled *Stardust*.

Creating *Stardust*

When most people think of movie-star images from the 1930s and '40s, George Hurrell's classic 8x10 view camera photographs come to mind. With his iconic portraits of Greta Garbo, Jean Harlow, and Gary Cooper, Hurrell invented the Hollywood glamour photograph, and his dramatic use of light was second to none.

Hurrell most often used two focusable light sources, that he diffused and placed above and on either side of his subject. This type of lighting became known as "butterfly lighting" because of the hallmark shadow it produced under the subject's nose.

He lit his famous subjects with tungsten movie or hot lights, not strobes, and photographed them with an 8x10 view camera, not an SLR. He didn't have the luxury of roll film or CompactFlash cards. Nor did he have the ability to "fix it in Photoshop." For him, Photoshop was the wet darkroom. He had to get it right in the camera, because he had no room for exposure error. He would engage his actor subjects in dialogue, and from time to time, he would click the shutter. The images he captured were the result of those experiences.

NOTE: This chapter was originally Chapter 4 in the first *Welcome to Oz*. An even earlier version of this chapter appeared in *The PhotoshopWorld Dream Team Book, Vol. 1* (New Riders, 2005). I invite you to compare this chapter to both the PDF copy of the original *Welcome to Oz* chapter, which you can download with the source files for this lesson. The more important lesson is to be found in seeing the evolution of thought and technique.

In Stardust, the model on the bearskin was lit naturally with reflected sunlight. This takes advantage of the unique characteristic of sunlight to be both directional and ambient. The technique selected to light the base capture image is called "board-to-board reflecting." It is used to get light from someplace other than a point light source (in this case, the sun), or to make the light source appear to be farther from the subject than it actually is. (See the sidebar Casting Light on the Stardust Model.) That technique was the best way to evenly light the subject with the best type of light—reflected sunlight.

NOTE: The reason that I prefer to use reflected, natural light is that it has a glowing quality that is unique. Also, when doing environmental portraiture, this approach gives me light that is simultaneously directional and ambient: directional because the reflector provides a point light source, ambient because the light is naturally present. This allows the subject more freedom of movement, which typically produces a more spontaneous photograph. I have found that the poses people naturally assume are often far more interesting than those I suggest.

While the image in Chapter 1 was a proactive solution to a difficult situation, the image in this chapter is lit in Photoshop by choice. I chose this lighting technique, not only for aesthetic reasons, but to save time and money. All I needed were two light stands with light disk holders, and two reflectors. Setup and breakdown times were insignificant, and the reflected sunlight was a bonus; again, the more you know about the middle, the more informed your choices can be at the beginning.

Measure Twice, Cut Once

Step 1: Analyzing the Image and Creating image maps

In order to avoid the feeling of being overwhelmed by the amount of work to be done on any image, whether simple or complex, it is best to break the task into manageable steps and attack them one at a time. The first step is to map the image. Next, define the issues you must resolve and decide how you want to approach them. Always work from global to granular. For me, the issues in the Stardust image are:

- Remove the sensor color cast.
- Create areas of selective DOF.
- Remove the blue color cast from the sunlight.
- Light the image.

With these issues in mind, I will show you how to create image maps and begin to develop a workflow specific to this image. Included in the folder that has the work files for this chapter is a source file that contains all of the image maps that I created, as well as a source file that is just the base file should you want to try your hand at making image maps.

Step 2: Removing Sensor Color Cast
Finding the Black and White Points

The first thing you are going to do before you begin lighting this image is to remove the color cast. I have already retouched it so that you do not need to repeat the steps you did in Chapter 1. (For this image, retouching should be done before removing the color cast because retouching may affect it.) Remember, there may be aspects of the digital color cast that you may want to use in the lighting of this image. Because I always work global to granular (solve the biggest problems first), my biggest problem is with the color cast removal. (From this point forward, I will refer you to subjects previously covered rather than re-describing them.)

1. Using the Threshold adjustment layer method, as described in Chapter 1, identify the black point. You are looking for "meaningful" black. For the white point, choose a point as close to the first white pixel as you can get, whether or not you can recognize shape or structure within it.

NOTE: To find the black point, start by moving the slider all the way to the left, then gradually to the right. For the white point, move the slider all the way to the right, then gradually to the left. Be sure to discard the Threshold adjustment layer once you have found the black and white points.

Once the white and black points are established, mark them with color samplers. The black and white color samplers are visible in this image as crosshair targets #1 and #2. The threshold level for the black sampler is 11, while the white sampler threshold level is 252 (**Figure 2.1.1**).

Figure 2.1.1 *The two sample points found for BP & WP correction*

FIGURE 2.2.1 *Edit > Fill*

FIGURE 2.2.2 *50% Gray*

Finding the Midpoint Using the Difference Blend Mode

Unlike the image in Chapter 1, there is no easily identifiable neutral or midpoint. In this step, you will learn to find a midpoint in spite of this.

NOTE: This is one of those ideas I wish had been mine, but credit for this creative technique goes to Dave Cross.

2. Create a new layer.

3. Go to Edit > Fill, select 50% Gray from the Contents dropdown menu, and click OK. You should see a completely gray screen (**Figures 2.2.1** and **2.2.2**).

4. Select the Difference blend mode. You should see this (**Figures 2.2.3** and **2.2.4**).

5. Select the Threshold adjustment layer and move the slider all the way to the left.

6. Move the slider to the right (a threshold range of 6) until you see something (black pixels). (**Figure 2.2.5**).

FIGURES 2.2.3 AND 2.2.4 *The image after changing the blend mode to Difference*

FIGURE 2.2.5 *The image with a Threshold adjustment of 6*

FIGURE 2.2.6 *Place sample point 3*

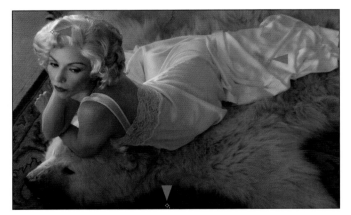

FIGURE 2.2.7 *All three sample points for the BP, WP and MP corrections that will be made to correct for digital sensor color cast*

FIGURE 2.2.8

FIGURE 2.2.9

7. Begin entering progressively smaller numbers into the Threshold Range dialog box until you get the smallest number (as close as you can get to 1) of black pixels. For this image, the number is 3. Zoom into that area and place a sample point (**Figures 2.2.6**).

8. Discard the Threshold adjustment layer.

9. Discard the 50% Gray Difference blend mode layer.

You should have an image with three sample points: a black, white, and mid-point (**Figure 2.2.7**).

Creating Three Curves Adjustment Layers to Neutralize Sensor Color

Having defined black, white, and mid-points, it is time to create the three Curves adjustment layers that you need to remove the sensor color cast.

1. Create a layer set (as you did in Chapter 1) and name it BP/WP/MP.

2. Create a Curves adjustment layer and name it BP. Zoom into the part of the image that has the first sample point. Click on Caps lock. (This sets the cursor to Precise mode.) You should see crosshairs. Click on the sample point.

NOTE: Make sure that the black eyedropper's sample threshold is set to R:7, G:7, B:7 and the white eyedropper's sample threshold is set to R:247, G:247, B:247. See Chapter 1 for more detail.

3. You are going to fine tune the individual channels of the Black Point Curves adjustment layer. As you did in Chapter 1, click on the Red channel from the Curves adjustment layer pull-down menu (**Figure 2.2.8**). Click on the lower anchor point of the curve (**Figure 2.2.9**). Adjust the curve using the arrow keys until the number in the Info dialog box for sample point 1 is 7. Repeat this process for the Blue and Green channels, so that when you are finished, you have three 7s in the Info dialog box.

4. Repeat the steps of this process for the white point using sample point 2 and the white eyedropper.

5. Repeat the steps of this process for the mid-point using sample point 3 and the midpoint eyedropper.

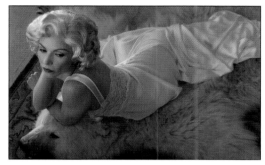

FIGURE 2.2.10 *Before*

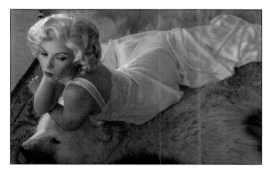

FIGURE 2.2.11 *BP adjustment*

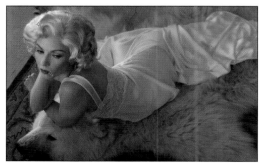

FIGURE 2.2.12 *WP adjustment*

Granular Fine-Tuning the Individual Curves Adjustment Layers by Using Layer Masks

Now that you have globally removed the color cast from this image, the next step is to determine what you like and don't like about it and how you are going to fine tune each layer. Compare the image before the adjustments (**Figure 2.2.10**), the BP adjustment (**Figure 2.2.11**), the WP adjustment (**Figure 2.2.12**), the MP adjustment (**Figure 2.2.13**), and all three adjustments together (**Figure 2.2.14**).

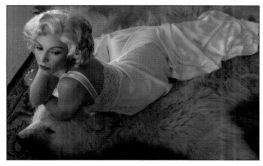

FIGURE 2.2.13 *MP adjustment*

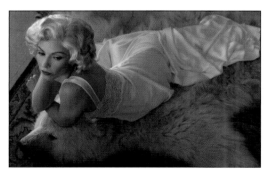

FIGURE 2.2.14 *All three adjustments applied*

Look at your individual adjustments and analyze what you like and do not like about each, keeping your analysis as simple as possible. Remember that by practicing at practicing, you will discover how to do things that might not yet be part of your skill set so that you can free the image you envision from the file that you have in front of you. Also keep in mind that the file on which you are working is not a finished image. When you look at any given point in the process, it is a tree in the forest of things that will be done to make the finished image one that most closely reflects your vision and your voice—what you want to say to the world with the image that you saw.

For example, when you look at the black, white, and mid-point corrections together, you neutralize the overall color cast, which is the goal. However, there may be aspects of each correction that you like individually and which are lost when the three layers are combined. In this image, after looking at the three individually, I like the warmth of the white point and some aspects of the black point. When I look at all three together, the image is quite cool.

Before each step that you take in any workflow, you must keep your goal in mind. In this lesson, your goal is to create two illusions: first, that the model was lit as she would have been in a Hollywood glamour portrait, and second, that she was shot with a view camera that allows you to change the plane of focus and thus modify the DOF.

You must continually consider how light and color work in the real world, so that you can use Photoshop to merge the reality of what you see with what you imagine. There is a reason why Photoshop is capitalized. It is not a verb; it is a noun. It is a tool and you are the creative energy that drives it. Not the other way around.

When I look at all the adjustment layers together and observe what they do and how they interact, I form a direction for my workflow. As discussed in the first chapter, warm colors appear to move forward in an image, cool ones appear to

recede, and shadows are cooler than areas that are lit. When beginning color correction for this (or any) image, it is that knowledge that determines many of the choices I make, even though this has little or nothing to do with the mechanics of Photoshop.

If you look at the three Curves adjustments individually, the white point is warmest. When you look at the black and white ones together, and then add the mid–point, the entire image becomes bluer, or cooler. The first thing to do, therefore, is to brush back some of the black point correction in Challen's face and arms, and brush back all of her skin to allow the colors in these areas to be more affected by the white point. You should also brush back the head of the bear. The reason for brushing back these areas is that these will be directly hit by the "lights" that you will place using Curves adjustments layers and the Render Lighting Effects plug-in. This way you will use the color cast of the original source file to your advantage.

NOTE: Unless otherwise directed, whenever a lesson asks you to select a brush, use a feathered one. Using feathered brushes, rather than hard-edged ones, produces a more natural look as well as creating layer masks that better blend into the image.

Also, from this point forward in the book, you should use the techniques for refining a layer mask discussed in Chapter 1 whenever you do any brushwork on a layer mask.

Here is the image map of the areas for the black point that you should brush back (**Figure 2.2.15**).

1. Select the Brush tool, and set it to 50% opacity, with the foreground color black and the background white. Make the brush width 300 pixels and brush in only the model's face and arms. Bring up the Fade effect dialog box and adjust the opacity to visual taste, which for me was 67% (**Figure 2.2.16**).

NOTE: Remember that the percentages that you put in your image maps are approximations. You may find that you choose to use amounts different than those that I chose. Let your eye and your personal aesthetic decide how little or how much to do to any image element.

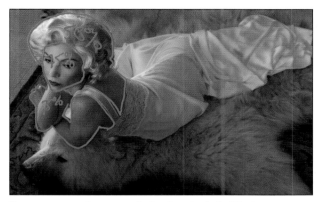

FIGURE 2.2.15 *Image map for brushing back the BP adjustment*

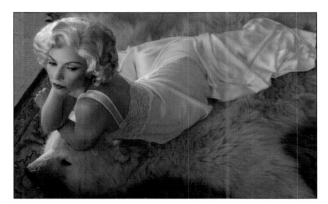

FIGURE 2.2.16

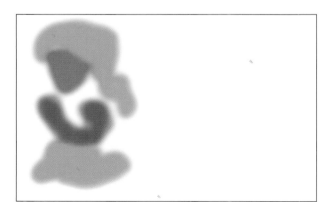

FIGURE 2.2.17 *The final layer mask for the BP adjustment*

2. Brush in the model's hair and the back of her body at 50%.

3. Brush in the face of the bear's head at 50%.

This is what the layer mask should look like when you are finished. (**Figure 2.2.17**).

Now do the brushwork on the Midpoint Curves adjustment layer. You should see that when you add the mid-point adjustment to this image, it cools the colors. Because you are trying to replicate the DOF and bokeh of an 8x10 view camera, as well as light this image, you will use the coolness or blueness of this adjustment to your advantage. Warm colors move forward, cool ones recede, and shadows tend to be a bit bluer than areas that are lit. It is this bit of knowledge that will inform the choices that you make for this image.

Here is the image map of the areas for the midpoint that you will be brushing back (**Figure 2.2.18**).

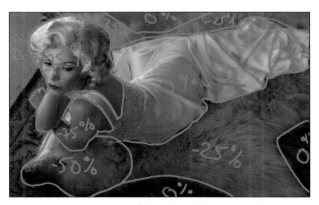

FIGURE 2.2.18 *Image map for brushing back the MP adjustment*

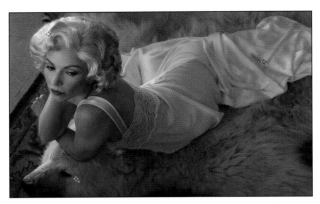

FIGURE 2.2.19 *The image after the beginning MP brushwork*

FIGURE 2.2.20 *The layer mask for the MP adjustment*

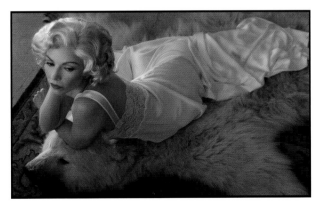

FIGURE 2.2.21 *The image after the brushwork for all adjustments*

4. Select the Brush tool, and set it to 50% opacity, with the foreground color black and the background white. Make the brush width 300 pixels and brush in just her face, arms, hair, and back. Bring up the Fade effect dialog box, and adjust the opacity to your visual taste, which for me was 73% (**Figure 2.2.19**).

5. Brush in the face of the bear's head at 50%. Bring up the Fade effect dialog box and adjust the opacity. I chose 17%. Then, brush in the rest of the bear skin rug at 50%. Be sure to brush the upper part of the rug as well. Look at the layer mask (**Figure 2.2.20**) and then all three adjustment layers together after the brushwork (**Figure 2.2.21**).

6. Create a master layer, as you did in Chapter 1 (Control + Alt + Shift + E / Command + Option + Shift + E) and name it MASTER_1.

7. Save the file using Save as and name it HOLLYWOOD_16BIT.

Now that you have fine tuned the image's color cast adjustment layers, you are going to create the illusion of selective focus DOF—specifically, the illusion of the tilt and shift qualities of an 8x10 view camera. Although you may not be able to increase the selective focus as you could if you had shot this using a large format camera (see The Correct Perspective of Swings and Tilts: SLR vs. View Cameras sidebar), you can replicate the quality of a view camera's selective blur.

The lighting technique used in creating this image is often referred to as board-to-board reflecting. The model was lit by bouncing sunlight off of two 36-inch reflectors. The first one, a Photoflex Silver reflector, directed light onto the second reflector, which reflected light onto the subject. The combination created a slightly warm light. See **Figure 2.2.22** for the lighting setup.

This type of light is referred to as "long light"—the kind that occurs in the Northern Hemisphere during late afternoons in February and October, when the sun is close to the horizon. At this time, because the light passes through the thickest part of the atmosphere, more blue light is scattered (making the sky blue), and therefore increasing the amount of the longer wavelength (warmer) colors in the sunlight shining on your subject. This type of light produces long shadows and, generally, warm tones.

Reflector #1: 36-inch Silver LiteDisc attached to an Articulating LiteDisc Holder. The distance from the top of the reflector to the floor was approximately 10 feet. Silver increases the specular highlights and yields a high-contrast image. (This reflector was angled slightly upward and was the lower of the two.)

Reflector #2: 36-inch Soft Gold LiteDisc attached to an Articulating LiteDisc Holder. The distance from the top of the reflector to the floor was approximately 7 feet. Soft Gold combines gold and silver in a zigzag pattern, giving a warm tone to the light it reflects. (This reflector was angled slightly downward onto the subject and was the higher of the two.)

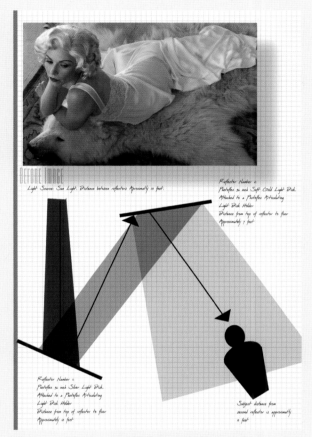

FIGURE 2.2.22 *The diagram for the "long light" technique*

<small>FIGURE 2.2.23 *D3x DSLR*</small>

<small>FIGURE 2.2.24 *Cambo 4×5*</small>

The difference between SLR cameras and view cameras is a simple but profound one. With a SLR, the lens and sensor plane are always parallel to each other. As a result of this design, there will always be distortions to the image (bent buildings, bowed faces, weird lines, etc.) and, most importantly, subjects at different distances from the lens will never all be critically in focus at one time. Therefore, you may have to develop techniques that allow you to use these limitations as aesthetic choices.

NOTE: Tilt shift (TS) and perspective correcting (PC) lenses are a very expensive exception to this. These lenses are designed to afford you some of the control inherent in a view camera.

With view, field, or monorail cameras, the lens plane and sensor plane are designed to move independently from each other. These movements (described below) allow many changes to perspective, as well as the ability to increase or decrease the area of critical sharpness known as selective focus. It is how you use these adjustments that determines what is in focus and the amount of blur.

NOTE: These movements have other effects, but for the sake of brevity I am discussing only the aspects of focus and blur.

Camera Design

A typical large format view camera has a lens that mounts on a board that fits in a frame called a "standard." The rear of the camera also contains a standard that houses an etched plate of glass upon which you focus. The image appears upside down on that glass and is fairly dim in available light, which is why photographers use a hood.

A flexible bellows connects the two standards. Since the standards can move independently of each other, the photographer can control sharpness and perspective by shifting or rotating the optical axes of the two standards as described on the next page. To avoid distortion, the rear standard should always be perpendicular to the surface of the earth.

Swing Movements: (**Figure 2.2.25**)

Swings twist the lens or sensor plane on the vertical axis ether separately or in tandem with each other. When you use both front and back swings, you can increase or decrease the area of critical focus, or selectively focus by increasing or decreasing the DOF.

Tilt Movements: (**Figure 2.2.26**)

Tilts pivot the lens and sensor planes on the horizontal axis. (In some field cameras, the tilts occur at the bottom of the standard and not through the horizontal axis.) When you use both front and back tilts, you can increase or decrease the area of critical focus, or selectively focus by increasing or decreasing the DOF.

Shift Movements: Horizontal Shift (**Figure 2.2.27**) Vertical Shift (**Figure 2.2.28**)

Shift movements move the lens plane and/or sensor plane up and down or side, to side which causes the front and rear of the camera to be out of direct alignment to each other. For example, when you shift the front of the camera up, the image will move downward because the lens will have a greater coverage area of focus than the sensor area.

The Scheimpflug Principle: (**Figure 2.2.29**)

The plane of focus can be changed or adjusted by the swings and tilts. Focus will be achieved for a subject plane when the lens plane, the film plane, and the subject plane intersect along a common line. This means that when the subject plane, the lens plane, and the sensor plane all meet in a line, the entire subject plane will be sharp at any aperture.

FIGURE 2.2.25 *Swing Movements*

FIGURE 2.2.26 *Tilt Movements*

FIGURE 2.2.27 *Horizontal Shift Movements*

FIGURE 2.2.28 *Vertical Shift Movements*

FIGURE 2.2.29 *Scheimpflug Principle*

Step 3: Creating Selective DOF to Replicate Optical Lens Blur and Optical Lens Contrast

Because you are trying to create a probable believability, you have to make sure that all of your choices mimic reality as captured with a glass lens and a camera that has the ability to swing and tilt the lens. Granted you cannot increase the area of focus—that is set in pixels when the image was captured—but you can replicate the blur of an 8x10 view camera. And as I discussed in Chapter One, an image is more about what is blurred than what is in focus.

When you use a lens on a view camera, the effects are optically, and not digitally, created. One of these effects is that as blur increases, there is a tendency for contrast to diminish. This does not occur in Photoshop when blurring the image with Gaussian Blur or using the Lens Blur tool. Step 3 will illustrate how to realistically replicate true optical lens blur.

When you use a perspective-correcting camera or lens, like a view camera or a tilt shift lens, you can affect the area of blur as well as the perspective that blur will have. With these

considerations in mind, you will work with two aspects of controlling the unconscious eye (which I will discuss at greater length in Chapter 3), specifically: in focus to blur, and high-contrast-to-low-contrast. Because you want the viewer's eye to move from the model's face to the front of her body, then to the bear's face, and finally to the upper background, her face should be the central point of focus while the background should have the most blur. Also, you want the model's body to appear to move forward, so blur and contrast go hand in hand for this image.

You are going to do things a little differently than you did in the last lesson. In the last lesson, you used the Skylight filter first, then attended to contrast, and then to blur. Now you will first attend to blur, then contrast, and you will use the Skylight filter last. You will do this because you will use both the Round and Planar types of blur on this particular image. Below are the Planar image map (**Figure 2.3.1**) and the Round image map (**Figure 2.3.2**). After completing the blur, you will generate the contrast layer mask from the layer mask that you created with the two blur layers.

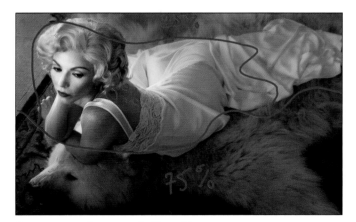

FIGURE 2.3.1 *Image map for Planar blur*

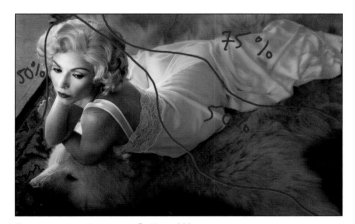

FIGURE 2.3.2 *Image map for Round blur*

FIGURE 2.3.3 *The FocalPoint interface*

FIGURE 2.3.4 *The FocusBug on the model's face*

FIGURE 2.3.5 *The Height handle at 1768 pixels, and moved between her lips and cheek*

1. Duplicate the MASTER_1 layer, add a layer mask, then duplicate the MASTER_1 copy 1 layer (with the layer mask) (Command + J / Control + J).

2. Just as you did in Chapter One, Shift-click onto these newly created layers, and drag them to the Create New Group icon at the bottom of the layers panel. Name this new layer set D_OF_F.

3. Turn off the MASTER_1 copy 2 and make MASTER_1 copy 1 the active layer. Name this layer R:FOCALPOINT.

4. Go to onOne > FocalPoint 2.0 and the FocalPoint 2.0 dialog box will come up (**Figure 2.3.3**).

5. Go to the Aperture panel. You will first use the round aperture, and then, in a second adjustment layer, the planar one.

NOTE: Before I begin working with FocalPoint, I always reset the pallete. To do this click Command + Option + Z / Control + Alt + Z. The only time I will not reset the pallete is if I know that I am going to be redoing the same type of blur with the same values over and over again; then I would save it as a preset.

6. Click on the FocusBug and move it to the center of the model's face (**Figure 2.3.4**).

7. Holding down the Shift key (this causes the handle to lock in position), click on the Height control handle and move it downward until you have a height of 1768 pixels. Move the FocusBug to the right, just between Challen's lips and cheek (**Figure 2.3.5**).

FIGURE 2.3.6 *The Width handle set to 991 pixels, and moved just below her cheek*

FIGURE 2.3.7 *The mask of the FocusBug*

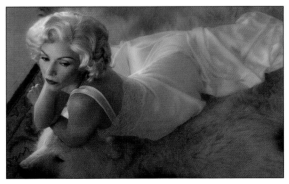

FIGURE 2.3.8 *The image after applying the Round blur*

8. Holding down the Shift key, click on the Width handle and move it inward to a width of 991 pixels. Move the FocusBug to the right, just below her cheek (**Figure 2.3.6**). The mask should look like **Figure 2.3.7**. (To see the actual mask, the keyboard command is Command + M / Control + M.)

NOTE: Make sure that the focus oval that you have created includes the area from the tip of her head to her lower body. Be open to refining your choices as you go through an image.

9. Set the Motion Amount slider to zero (because you are not using that type of blur). Click on the Opacity/Blur control handle and move it upward so that the opacity is 85% and the blur blend is 50%. Click Apply. Look at the image with the Round blur applied (**Figure 2.3.8**).

FIGURE 2.3.9 *Select Planar for Blur type*

FIGURE 2.3.10 *Showing the grid and rotating 90 degrees*

10. Turn off the R:FOCALPOINT layer. Make MASTER_1 copy 2 the active layer and re-name it P:FOCALPOINT. Go to onOne > FocalPoint 2.0. When the FocalPoint 2.0 dialog box comes up, reset the plug-in (Command + Option + Z / Control + Alt + Z). Select Planar (**Figure 2.3.9**).

11. Click on the left control handle, and the work grid will come up. Rotate the control handle (and the grid) 90 degrees (**Figure 2.3.10**).

FIGURE 2.3.11 *Moving the FocusBug to her gown*

FIGURE 2.3.12 *Adjusting the size of the focus area to 527 pixels*

12. Click on the center of the Planar FocusBug and move it to just below the midpoint of her gown (**Figure 2.3.11**).

NOTE: The reason for this repositioning is that you want to replicate the type of selective focus blur that can be created by a forward tilt of the front standard of a large format camera when the camera is positioned above the subject.

13. Adjust the size of the focus area by clicking on the lower handle (the one that you rotated 90 degrees) while holding down the Shift key. (This locks the FocusBug into whatever position you have placed it, just as it does when you are in Photoshop.) Move the control handle inward to a width of 527 pixels (**Figure 2.3.12**).

14. Set the Motion blur to 0% and the Opacity to 100%.

15. Click on the upper right control handle and adjust the amount of blur to 73%. (Move it toward the upper right corner.) Adjust the feather (the softness of the edge of the mask that the FocalPoint plug-in generates) by moving the control handle left to 52% (**Figure 2.3.13**).

FIGURE 2.3.13 *The image after adjusting the amount of blur and the feather of the blur*

FIGURE 2.3.14 *Adjusting the tilt of the blur*

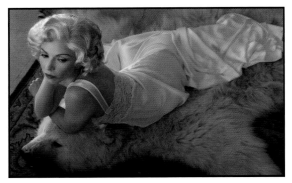

FIGURE 2.3.15 *The image before the Planar blur*

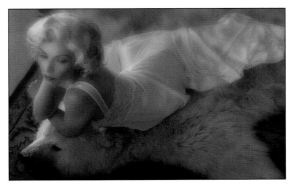

FIGURE 2.3.16 *The image after the Planar blur*

16. Click on the center of the Planar FocusBug, and holding down the Option / Alt key, click and drag it upward so that you can tilt the blur (**Figure 2.3.14**). Click OK.

17. Save the file.

Compare the image before the Planar blur (**Figure 2.3.15**) and after the Planar blur (**Figure 2.3.16**).

DOF Blur Brush In: Doing the Layer Mask Brushwork on the Round and Planar Blur Layers

Using Round blur on the body and Planar blur on the foreground and background, you have created the blurs needed to create the sweeping look of an 8x10 view camera. In this next step, you will create two layer masks, and you will brush in the effect of the Round and the Planar blurs to create the final look of selective focus. Once done, you will attend to the contrast. You will do these things a little differently than you did in Chapter One, but no two images and, therefore, no two workflows are the same. Workflow is dynamic and everything you do builds on everything that you have already done.

Before beginning your brushwork, look at the image maps for each layer mask on the Round (R:FOCALPOINT) blur layer (**Figure 2.3.2**). You want the area of Challen's face, hair, and torso to be in focus. Move along the length of her body so that it gradually moves out of focus. With the Planar (P:FOCALPOINT) blur layer (**Figure 2.3.1**), you do not want to brush blur into her hair, face, or body, but you do want to brush in the foreground more than the background.

1. Turn on the Round blur image map, and, making sure that the P:FOCALPOINT layer is turned off, make the R:FOCALPOINT layer the active one. Click on the eyeball to make it visible. Click on the layer mask of the R:FOCALPOINT layer and fill it with black.

2. Select the Brush tool (making sure that you are using a feathered brush), set the pixel width to 300, and set the foreground color to white and the background to black. Set the opacity to 50%, and brush in both the areas that are 50% and 75% on the image map.

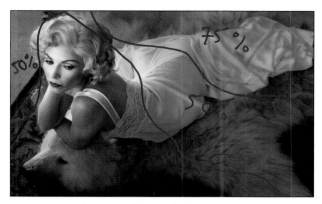

FIGURE 2.3.2 *Image map for Round blur*

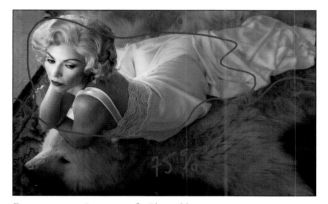

FIGURE 2.3.1 *Image map for Planar blur*

FIGURE 2.3.17 *Layer mask for the Round blur layer*

3. Now, brush in just the 75% area (again at 50% opacity), and bring up the Fade effect dialog box (Command + Shift + F / Control + Shift + F) and move the slider upward to 79%. Look at the layer mask after the brushwork (**Figure 2.3.17**) and the R:FOCALPOINT layer after brushwork (**Figure 2.3.18**).

NOTE: When you brush over an area using the same opacity with which you started, each successive brush stroke increases the opacity by the selected percentage. For example, if you brush over an area at 50% opacity, then re-brush it with an opacity of 50%, since 50% of 50% is 25, it is as if you brushed it at 75% opacity. Similarly, if you begin with an opacity of 40%, and rebrush at 40%, since 40% of 40% is 16, it is as if you brushed it at 56%.

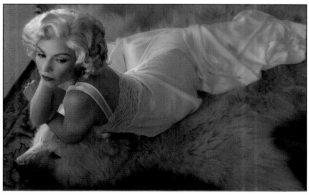

FIGURE 2.3.18 *Image after the brushwork on the Round blur layer*

FIGURE 2.3.19 *Layer mask on the Planar blur layer*

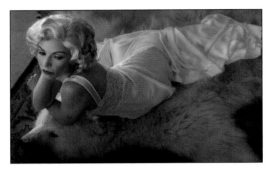

FIGURE 2.3.20 *Image after brushwork on the Planar blur*

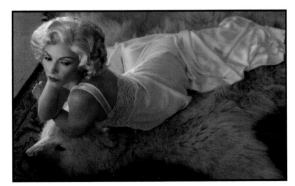

FIGURE 2.3.21 *Before any blur applied*

4. Turn off the Round blur image map and turn on the Planar blur image map. Making sure that the R:FOCALPOINT layer is turned off, make the P:FOCALPOINT layer the active one. Click on the eyeball to make it visible. Then, click on the layer mask of the R:FOCALPOINT layer and fill it with black.

5. Select the Brush tool (a feathered brush), set the pixel width to 200, and set the foreground color to white and the background to black. Set the opacity to 50% and brush in both the areas that are 75% and 25% on the image map.

6. Bring up the Fade effect dialog box (Command+ Shift + F / Control + Shift + F) and move the slider downward to 28%.

NOTE: You should be paying attention to what the background, not the foreground, looks like when you do this adjustment.

7. Brush in just the 75% area (at 50% opacity), bring up the Fade effect dialog box (Command+ Shift + F / Control + Shift + F) and move the slider upward to 70%. Compare the layer mask after brushwork (**Figure 2.3.19**) and the P:FOCALPOINT layer after brushwork (**Figure 2.3.20**).

8. Turn on the R:FOCALPOINT layer. Combine the R:FOCALPOINT and P:FOCALPOINT layers. Compare the image before (**Figure 2.3.21**) and after (**Figure 2.3.22**).

Now that you have created the blur aspect of selective focus, it is time to create the contrast aspect.

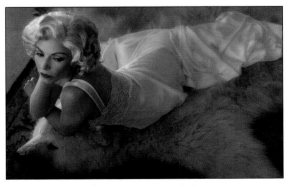

FIGURE 2.3.22 *After the blurs are applied*

FIGURE 2.4.1 *Select Contrast Only*

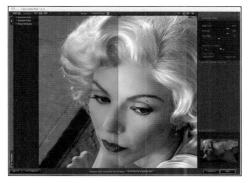

FIGURE 2.4.2 *Move her face to the middle of the preview area*

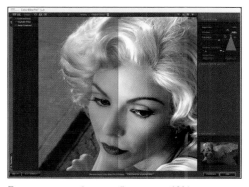

FIGURE 2.4.3 *Increase Contrast to 68%*

Creating Realistic Optical Lens Contrast

1. Make sure that the foreground color is black and the background is white.

2. Duplicate the MASTER_1 once again, convert it to a Smart Filter, and name it R:CONTRAST.

NOTE: When I am working with an image, I tend to duplicate the master layer when I convert to Smart Filters, even though it increases file size. My reasoning is that hard drive space is cheap, my time is not. Also, keeping master layers that have not been touched offers me both exit strategy and workflow efficiency. Should I need to go back to a previous step, most of the time I have only to duplicate the master layer, which takes just a second regardless of the size of the file. Creating a master layer can take tens of seconds to upwards of a minute should there be Smart Filter layers involved.

3. Go to Filter > Nik Software > Color Efex Pro 3.0 Versace Edition. Select Contrast Only from the plug-in's three options (**Figure 2.4.1**).

4. Move Challen's face using the Hand tool so that the before-after center line runs down its middle. (**Figure 2.4.2**) (To select this type of view, if it is not already selected, click on the Spilt view icon in the upper left corner of the Color Efex Pro 3.0 Versace Edition dialog box.)

5. Click on the Contrast slider and move it to the right to increase the amount of contrast to 68% (**Figure 2.4.3**).

Although the contrast is where you want it, the image has darkened, the shadows have blocked up, and the color saturation is not where you want it to be. To correct these issues, you will first lighten the image, then dial in the saturation using the Saturation slider, and lastly, you will use the Protect Shadow functionality of the Contrast Only plug-in.

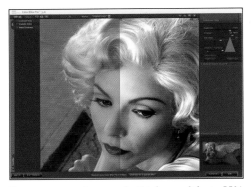

FIGURE 2.4.4 *Increase the Brightness slider to 55%*

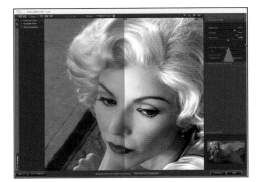

FIGURE 2.4.5 *Move Saturation to 17%*

FIGURE 2.4.6 *Increase the Protect Shadows slider*

6. Click on the Brightness slider and move it to the right to 55% (for this image), matching the brightness of the left, or before, side of the split view screen (**Figure 2.4.4**).

7. Click on the Saturation slider and move it to the right to 17% (for this image), again attempting to match the saturation of the left, or before, side of the split view screen (**Figure 2.4.5**).

8. Click on the Protect Shadows slider and move it to the right until the shadows open up, which for this image is about halfway along the slider (**Figure 2.4.6**).

9. Click OK.

Now compare the image before (**Figure 2.4.7**) and after the contrast correction (**Figure 2.4.8**).

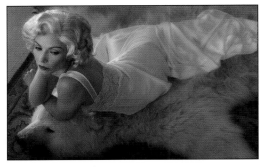

FIGURE 2.4.7 *Before the contrast correction*

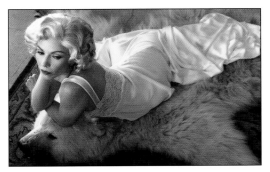

FIGURE 2.4.8 *After the contrast correction*

10. Duplicate the R:CONTRAST layer and name the newly duplicated layer P:CONTRAST. Turn the P:CONTRAST layer off and make the R:CONTRAST layer active. Click on the layer mask to make it active

11. Command- / Control-click on the layer mask of the R:FOCALPOINT layer. (This will make a selection of the layer mask.)

12. Next, you will invert the selection. Go to Select > Inverse or Command + Shift + I / Control + Shift + I.

13. Click on the Make Layer Mask icon and add a layer mask to the R:CONTRAST layer (which should be the active layer). The layer should fill the layer mask with black.

Look at the R:CONTRAST layer mask (**Figure 2.4.9**) and the R:CONTRAST layer with the mask applied (**Figure 2.4.10**).

14. Make the P:CONTRAST layer active.

15. Command- / Control-click on the layer mask of the P:FOCALPOINT layer. (This will make a selection of the layer mask.)

16. Invert the selection. Go to Select > Inverse or Command + Shift + I / Control + Shift + I.

17. Click on the Make Layer Mask icon to add a layer mask to the P:CONTRAST layer (**Figure 2.4.11**). Look at the resulting image (**Figure 2.4.12**).

FIGURE 2.4.9 *The R:CONTRAST layer mask*

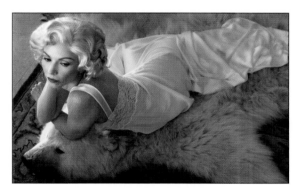

FIGURE 2.4.10 *The R:CONTRAST layer with the mask applied*

FIGURE 2.4.11 *The P:CONTRAST layer mask*

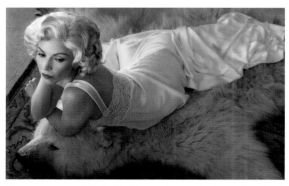

FIGURE 2.4.12 *The P:CONTRAST layer with the mask applied*

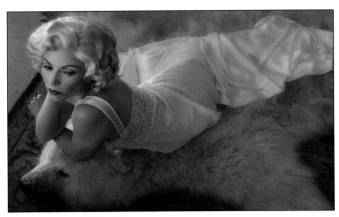

FIGURE 2.4.13 *Before the contrast correction*

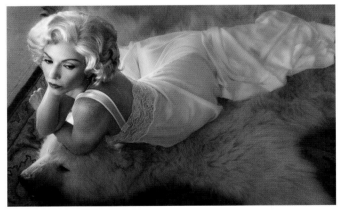

FIGURE 2.4.14 *After the contrast correction*

18. Shift click on both the R:CONTRAST and P:CONTRAST layers and drag them to the Create New Group icon on the Layers panel. Name this new group CONTRAST. Place this layer group beneath the Focal Point blur layers

19. Now you will fine tune the contrast by lowering the layer opacity of the layer group. Click on the Opacity slider located at the upper right of the Layers panel and lower it to 55%.

NOTE: It is a good habit to place the contrast layers, if there are more than one, in a layer group folder, because if you need to lower the contrast via opacity, it is easier to do it this way. You may not always want to equally reduce the contrast in all your contrast layers, but it is helpful when doing these kinds of multiple blurs. Using layer groups and reducing contrast this way also makes it easier to rework the image at a later date.

Compare the image before (**Figure 2.4.13**) and after the contrast adjustments (**Figure 2.4.14**).

Using the Nik Skylight Filter to Add Selective Warmth
You have worked with the blur and contrast aspects of this image; now is the time to work with its color. As I have discussed before, warm colors appear to move forward in an image while cool colors appear to recede. Also, lit areas tend to be warm in color and shadow areas tend to be cool. In this step, you are going to use the Skylight filter to add selective warmth to the image. Using Render Lighting Effects, you will choose where to add different amounts of the Skylight filter based on where the "lights" are going to be placed. You will also use Curves adjustment layers to add dark and light.

Here is the image map of the areas that you are going to brush in (**Figure 2.4.15**).

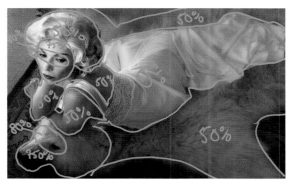

FIGURE 2.4.15 *Image map for selective warmth*

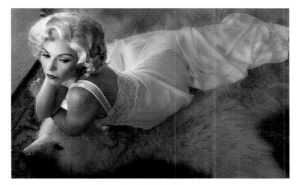

FIGURE 2.4.16 *Before the Skylight filter*

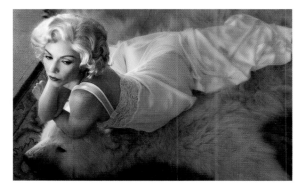

FIGURE 2.4.17 *After the Skylight filter*

1. Create a master layer (Command + Option + Shift + E / Control + Option + Shift + E). Make this layer a Smart Filter, and name it SKYLIGHT.

2. Go to Filter > Nik Software > Color Efex Pro 3.0 Versace Edition. Select Skylight from the three plug-in options and click OK. For this image, the default of 25% appears to be the best. Compare the image before the Skylight filter (**Figure 2.4.16**) and after (**Figure 2.4.17**).

3. Create a layer mask and fill it with black

You are now going to selectively brush in the Skylight filter. You want to create the illusion of light hitting the model's face, so her eyes need to be warmer than her face. (This is where you will be placing the the "key" light.) You also want her face warmer than her hair and torso. In addition, you will want to add some warmth into the face of the bear to create the illusion that light is falling on its eyes and face. Finally, you will want a bit of warmth in the bear skin rug to build the illusion that light falls off there.

4. With a feathered brush of 150 pixels and a brush opacity of 50%, brush in the area of the model's eyes. (Remember, all brushwork is cumulative.)

5. Increase the brush width to 400 pixels and brush in her face. Bring up the Fade effect dialog box (Command + Shift + F / Control + Shift + F) and increase the amount to 75%.

6. With the same 400-pixel brush, brush in her hair at 50% opacity.

7. Reduce the brush width to 175 pixels and brush in her arms, hands, and back.

8. Brush in the bear's eye area at 50%.

9. Brush in the bear's face at 50%. Bring up the Fade effect dialog box (Command + Shift + F / Control + Shift + F) and increase the amount to 78%.

FIGURE 2.4.18 *The layer mask after fine tuning*

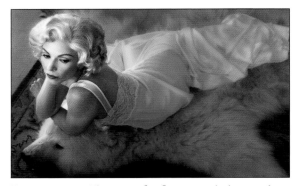

FIGURE 2.4.19 *The image after fine tuning the layer mask*

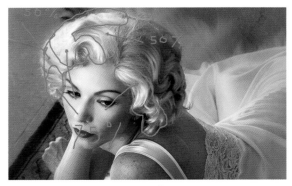

FIGURE 2.4.20 *The image map for brushing in her hair*

10. Brush in the front and back of the bear skin rug at 50%.

Before moving on, you should fine tune the image, because the next step addresses the issues of too much of a good thing—the blown out areas in Challen's hair. When you boosted the contrast, you also lost some hair detail. This is a good example of why you should always have an exit strategy and why you do not throw anything away until you are sure that the image is complete. Look at the layer mask after fine tuning (**Figure 2.4.18**) and the image after fine tuning the layer mask (**Figure 2.4.19**).

11. Duplicate the master layer and move it above the SKY-LIGHT layer.

12. Apply the Skylight filter using Apply last filter, (Command + F / Control + F). Create a layer mask and fill it with black.

Because you are re-using the last filter, it will already be set to the amount most recently selected. Also, because you are trying to match the same color, there is no need to make this a Smart Filter. Lastly, you will use the MASTER_1 layer, because no filters have yet been applied to it, and it was the contrast layers that caused the loss of detail in her hair. Look at the Hair Brush Back image map (**Figure 2.4.20**).

13. Select the Brush tool with a pixel width of 90 and an opacity of 50%. Brush in both areas that are outlined, including the areas that are marked at 75% on the image map.

14. Again at 50%, brush in the areas that are marked on the image map at 75%. (Remember, all brushwork is cumulative when working at an opacity of less than 100%.)

Compare the image before the hair brush back (**Figure 2.4.21**) and after (**Figure 2.4.22**).

15. Make the D_OF_F layer set active, create a Master layer, name that layer MASTER_2, and save the file.

Step 4: Traveling at the Speed of Dark: Using Curves to Create Dark-to-Light Areas

That dark is as important to an image as is light is frequently overlooked. It is the dance between light and dark that makes an image compelling. Without dark, there is no drama; there is also no place to which the eye can retreat when viewing an image. It is how you use darkness in an image that makes the lighted parts more interesting.

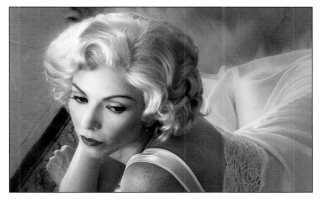

FIGURE 2.4.21 *The image before brushing in her hair*

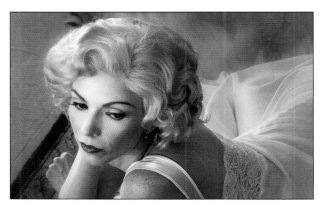

FIGURE 2.4.22 *The image after brushing in her hair*

Now that you have created the desired DOF and a more realistic relationship between in-focus-to-blur and contrast, it is time to start building up the image's light-to-dark/dark-to-light relationship. The issue that you face is that there is not enough variation of light in the image as it now exists; it is too uniformly light. This happened because the base image was shot using reflected sunlight, my favorite type of light. (Light can be refracted, reflected, absorbed, and/or scattered.) I prefer to work with reflected sunlight because it has the ability to be both directional and ambient at the same time. It is this quality of light that I am going to have you modify in the following section.

The key concept to keep in mind is that you want to remove from this image everything that is not your vision. This is not a new idea; it is the way Michelangelo approached sculpture. He removed everything from the rock which was not the sculpture; he freed the sculpture from the rock. In this image, you will remove some light so that there will be more dark. There also needs to be greater contrast. In the section that follows, I will describe how to use the power of Curves to light this image so that you can achieve about 85% of your lighting goals.

You want the unconscious eye (which I will fully discuss in Chapter 3), to move from the model's face to the left side of her body, and then to the right. Here are the image maps of what you will be doing: The combination of the first three (**Figure 2.5.1**), D2L_LUM image map (**Figure 2.5.2**), L2D_image map (**Figure 2.5.3**), L2D_SOFTLIGHT image map (**Figure 2.5.4**), L2D_SCREEN image map (**Figure 2.5.5**), and the L2D_FACE image map (**Figure 2.5.6**).

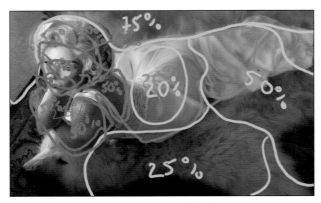

FIGURE 2.5.1 *All three image maps combined*

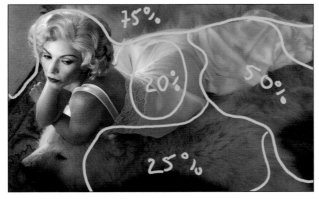

FIGURE 2.5.2 *D2L_LUM image map*

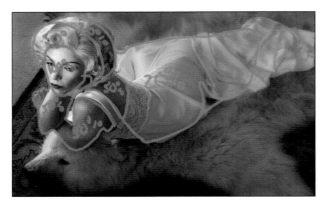

FIGURE 2.5.3 *L2D image map*

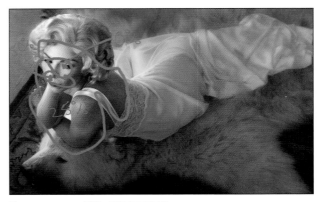

FIGURE 2.5.4 *L2D_SOFTLIGHT image map*

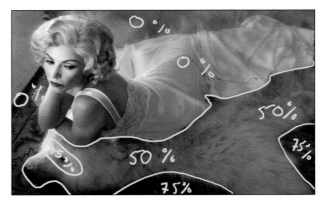

FIGURE 2.5.5 *L2D_SCREEN image map*

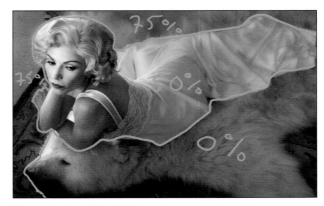

FIGURE 2.5.6 *L2D_FACE image map*

1. Turn off the layer set D_OF_F and make MASTER_2 active.

2. Create a new layer set and name it L2D_D2L, for light-to-dark/dark-to-light.

3. Using either the Adjustment panel or the Make Adjustment Layer icon located at the bottom of the Layers panel, create the first of three Curves adjustment layers in the L2D_D2L layer set, and name it D2L_LUM for dark to light luminosity.

 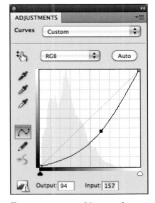

FIGURE 2.5.7 *Adding a point to the center of the curve*

FIGURE 2.5.8 *Moving the center point downward*

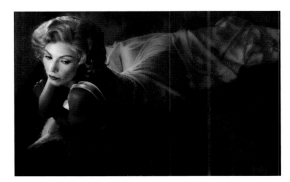

FIGURE 2.5.9 *Image after the Curves adjustment layer*

4. Click on the center of the curve (**Figure 2.5.7**) and drag it downward towards the lower right corner (**Figure 2.5.8**). (The output should read 94 and the input should read 154.) Set the Blend mode to Luminosity.

NOTE: You find the appropriate level of darkness by clicking on the center part of the curve line and moving it around until you get the maximum darkness that you think you will need. Always approach your choices by going to an extreme and then, by using opacity and layer masks, retreat to a setting that you find optimal.

If you look at the image for this aspect of the edit process (**Figure 2.5.9**), there is a lot of "dark" that needs to be removed. Because you are adding "dark" and not light to this image, you will name this layer "D_2_L." Because you have already made decisions about the image's colors; you want only to darken them, not increase their saturation. To accomplish this, use the Blend mode Luminosity, which does just this.

5. Leaving the layer mask filled with white (the default setting for layer masks), select the Brush tool and set it to 100% opacity with a pixel width of 300 pixels, making sure that the foreground color is black and the background white.

NOTE: You are doing this instead of setting the opacity to 50% because you want to completely block the effect of the Curves adjustment on her face.

6. Brush her face at 100% opacity. Look at the image after the brushwork (**Figure 2.5.10**) and the layer mask (**Figure 2.5.11**).

7. Set the brush opacity to 50%. Following the image map, brush in all of her hair. Bring up the Fade effect dialog box and lower the opacity to 19%.

8. Following the image map, brush in just the front part of her hair at 50%. Compare the image after the brushwork (**Figure 2.5.12**) and the layer mask (**Figure 2.5.13**).

NOTE: You will brush this way in order to create the illusion of light fall-off.

9. At an opacity of 50%, brush in her arms and back. Compare the image after the brushwork (**Figure 2.5.14**) and the layer mask (**Figure 2.5.15**).

10. Following the image map, brush in the back part of Challen's gown. Bring up the Fade effect dialog box and lower the opacity to 24%. Compare the image before any brushwork, (**Figure 2.5.16**) after the brushwork (**Figure 2.5.17**) and the layer mask (**Figure 2.5.18**).

11. Save the file.

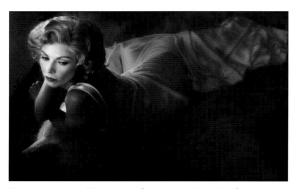

FIGURE 2.5.10 *The image after brushwork on her face*

FIGURE 2.5.11 *The layer mask of her face*

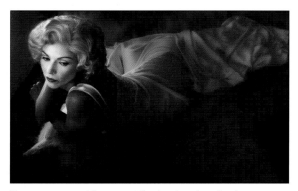

FIGURE 2.5.12 *The image after brushwork on her hair*

FIGURE 2.5.13 *The layer mask of her face and hair*

Step 4.1: Breaking the 11th Commandment: Thou Shalt Not Clip a Curve

What you are endeavoring to do with this image is to replicate, using sunlight, aspects of the warmth of tungsten lights and the way that focused hot lights fall off. One of the advantages of working in the computer is that impossible is merely an opinion, and it may be held by the person sitting in the same chair as you are. You decide what is impossible, and little is. In this image, you can control sunlight as if it were hot lights.

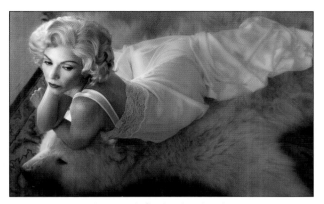

FIGURE 2.5.16 *The image before brushwork on her gown*

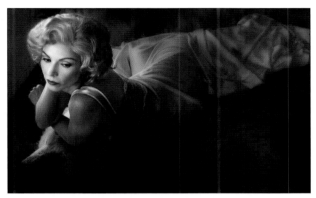

FIGURE 2.5.14 *The image after brushwork on her arms and back*

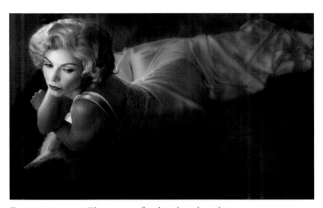

FIGURE 2.5.17 *The image after brushwork on her gown*

FIGURE 2.5.15 *The layer mask after brushwork on her arms and back*

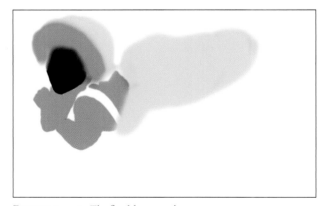

FIGURE 2.5.18 *The final layer mask*

Next, in order to introduce more darkness into this image, you are going to break the 11th commandment—Thou Shalt Not Clip a Curve. You will do this in order to diminish the contrast, which you will then use to create the look of atmospheric haze. You will then darken the haze and introduce it into the image. And you will do all this using only Curves. As always, the goal is to do things as non-destructively as possible, and adjustment layers are just layers of math sitting over the pixels; you are not changing any of the pixels beneath them.

1. Turn off the D2L_LUM adjustment layer.

2. Create a new Curves adjustment layer (above the D2L_LUM adjustment layer) and set its blend mode to Luminosity. Name this adjustment layer L2D_LWR_CNTRST_LUM for "Light-to-Dark Lower Contrast Luminosity."

NOTE: You will name this layer Light-to-Dark rather than Dark-to-Light, as you did in the previous step, because you will be adding dark into a layer that is light. In the previous step, you removed darkness. This naming convention makes it easier for you to know what you did should you need to readjust this image in the future.

3. Click on the upper right of the curve and drag it downward. For this image, drag it three grid lines (**Figure 2.6.1**).

4. Then, click on the center of the curve and drag it slightly downward so that the output reads 84 and the input reads 148 (**Figure 2.6.2**). You should see that the image has acquired a gray cast as well as become a bit darker, for you have lowered the contrast as well as darkened it (**Figure 2.6.3**).

5. As you can see from the L2D_IM layer image map (**Figure 2.6.4**), you do not want to add any darkness or grayness to the model's face or body or to the bear's face. Also, you want the light to appear to come from a high angle, above and from the left, to focus on the model and the bear's faces.

6. Select the brush tool at a diameter of 700 and an opacity of 50%. Make sure that the foreground color is white and the background is black. Fill the layer mask with black.

7. Brush in the lower part of the rug, bring up the Fade effect dialog box, and lower the opacity to 19% (**Figure 2.6.5**). Look at the layer mask after the brush work (**Figure 2.6.6**).

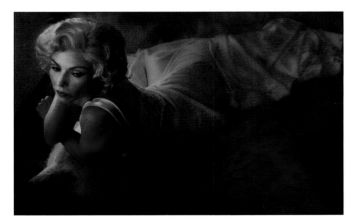

FIGURE 2.6.3 *The image after the Curves adjustment*

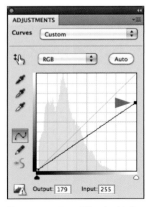

FIGURE 2.6.1 *Clip the highlights of the curve*

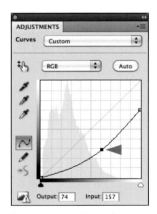

FIGURE 2.6.2 *Drag the center down*

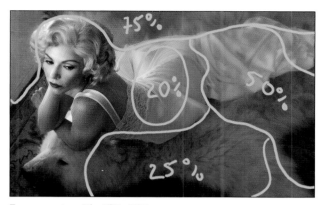

FIGURE 2.6.4 *The L2D_IM image map*

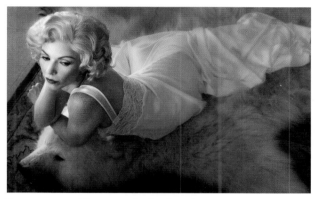

FIGURE 2.6.5 *The image after brush work*

FIGURE 2.6.6 *The layer mask after brush work*

8. Brush in the area above where you just brushed the rug and also brush in the back of her nightgown. Bring up the Fade effect dialog box and lower the opacity to 39%. Look at the image after the brushwork (**Figure 2.6.7**) and the resulting layer mask (**Figure 2.6.8**).

9. Brush in the area above the model's head and the back part of the rug. Bring up the Fade effect dialog box and increase the opacity to 74%.

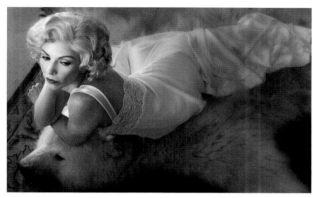

FIGURE 2.6.7 *The image after brush work*

FIGURE 2.6.8 *The layer mask after further brush work*

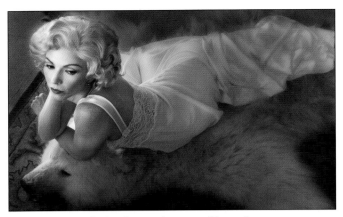

FIGURE 2.6.9 *After brushing in the center of her nightgown*

FIGURE 2.6.10 *The layer mask after brushing the center of her nightgown*

10. Brush in the center area of her nightgown, bring up the Fade effect dialog box and decrease the opacity to 24%. Look at the image after the brushwork (**Figure 2.6.9**) and the resulting layer mask (**Figure 2.6.10**).

11. Turn on the D2L_LUM adjustment layer and make it active. Using the Opacity slider in the upper left of the Layers panel, fine tune the layer to 48%. Compare the image before the opacity adjustment (**Figure 2.6.11**) and after (**Figure 2.6.12**).

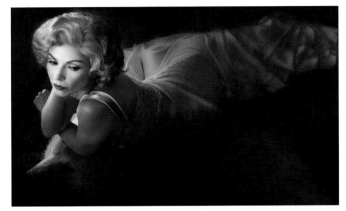

FIGURE 2.6.11 *Before the opacity adjustments and fine tuning*

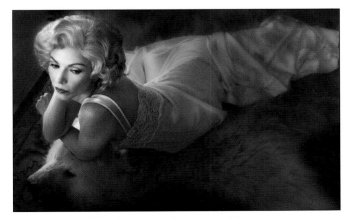

FIGURE 2.6.12 *After the opacity adjustment and fine tuning*

Overlay vs. Soft Light

Frequently, photographers turn to the Overlay blend mode when manipulating images for the enhancement of light and dark. However, if you compare the Overlay and Soft Light (**Figures 2.7.1** and **2.7.2**) blend modes, you will find that the Overlay blend mode yields results that are considerably harder looking on color images than are achieved with Soft Light. This occurs because Overlay is a combination of the blend modes Screen and Multiply. This means that at middle (50%) gray (R:128, G:128, B:128), anything above will be screened and anything below will be multiplied. I prefer using Soft Light, which is much gentler on the image. Therefore, the areas in which Screen and Multiply switch occurs a little bit higher or lower on the scale.

FIGURE 2.7.1 *Overlay*

FIGURE 2.7.2 *Soft Light*

Step 4.2: Killing Two Birds with One Stone: Using the Screen and Soft Light Blend Modes to Enhance Contrast and Selectively Increase Dark and Light.

Now that you have worked on the dark aspect of the image, the next step is to play with the light aspect using two blend modes, Screen and Soft Light.

As discussed in Chapter 1, contrast is the difference in brightness between the light and dark areas of a picture. If there is a large difference between the light and dark areas, then the result is an image with high contrast.

In Step 3 of this lesson, you increased and decreased contrast in relationship to DOF. In Step 4.1, you addressed creating areas of dark-to-light by adding "darkness" to the image.

In this next step, you will further reinforce the movement of the unconscious eye from light to dark by selectively changing the contrast of the image. (You have already created the relationship you like between light-to-dark and high-to-low contrast.) You will do this by creating two Curves adjustment layers: one that will address the image's overall lightness and another that will address its overall darkness.

1. Create a Curves adjustment layer and name it D2L_SOFT-LIGHT. Select Soft Light from the Blend Mode pull-down menu. Before moving on, look at the Soft Light image map. (**Figure 2.7.3**).

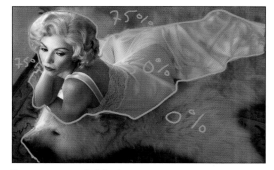

FIGURE 2.7.3 *Soft Light image map*

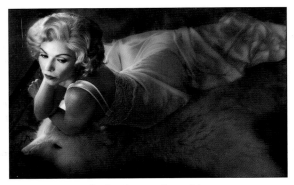

FIGURE 2.7.4 *After brushing in the model*

FIGURE 2.7.5 *The layer mask after brushing in the model*

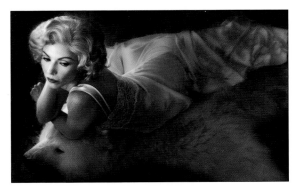

FIGURE 2.7.6 *After brushing in the background area*

2. Fill the layer mask with black, select the Brush tool, set the brush opacity to 50% with a brush width of 650 pixels (making sure the foreground color is white and the background black), and brush in just the model. Bring up the Fade effect dialog box and adjust the opacity to 42%. Look at the image after brushwork (**Figure 2.7.4**) and the resulting layer mask (**Figure 2.7.5**).

NOTE: Now the image's contrast is greater than it was, the light areas are gently lightened, and the dark areas are slightly darkened.

3. Brush in the area behind the model. Then, bring up the Fade effect dialog box and increase the opacity to 68%. Again, look at the image after the brushwork (**Figure 2.7.6**) and the resulting layer mask (**Figure 2.7.7**).

4. Next, you will selectively add "light" using the Screen blend mode, which works by halving the density of the image. (In contrast, the Multiply blend mode doubles the density.)

5. Create a Curves adjustment layer, and name it L2D_SS-CREEN. Select the Screen blend mode from the Blend Mode pull-down menu.

FIGURE 2.7.7 *The resulting layer mask*

The next illusion to create is that there was a light that hit the face of the bear. Before continuing, look at the Screen image map (**Figure 2.7.8**).

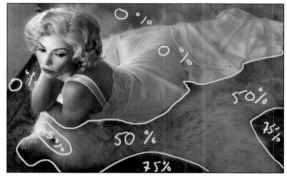
FIGURE 2.7.8 *The L2D_SCREEN image map*

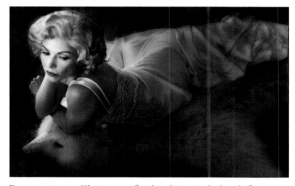
FIGURE 2.7.9 *The image after brushing in the bear's face*

FIGURE 2.7.10 *The resulting layer mask*

6. Fill the layer mask with black, select the brush tool, set the brush opacity to 50% with a brush width of 250 pixels (making sure that the foreground color is white and the background black), and brush in just the bear's eyes. Look at the image after the brushwork (**Figure 2.7.9**) and the resulting layer mask (**Figure 2.7.10**).

7. Now, brush in the face and body of the bear skin rug. When you are finished, bring up the Fade effect dialog box and decrease the opacity to 41%. Again, look at the image after the brushwork (**Figure 2.7.11**) and the resulting layer mask (**Figure 2.7.12**).

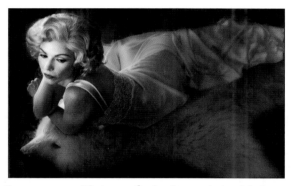
FIGURE 2.7.11 *The image after brushing in the bear's body*

FIGURE 2.7.12 *The resulting layer mask*

8. Brush in the front of the rug behind the bear's head and its front paw. Then, bring up the Fade effect dialog box, increase the opacity to 88%, and brush behind the bear's front paw. Bring up the Fade effect dialog box and increase the opacity to 72%. Look at the image after the final brushwork (**Figure 2.7.13**) and the resulting layer mask (**Figure 2.7.14**)

9. Save the file.

You have created the majority of the illusion that you wanted for this image. The advantage of the approach I described is that, although you started with reflected sunlight as your light source, you could modify the image to make it appear as if it had been lit with "hot" lights. All this was done nondestructively by using Curves adjustment layers and blend modes. Now it is time to fine tune the lighting using the Render Lighting Effects filter that is part of Adobe Photoshop.

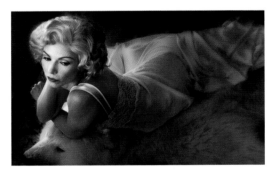

FIGURE 2.7.13 *The image after final brushwork*

FIGURE 2.7.14 *The final layer mask after fine tuning*

Step 5: Lighting Without Lights: Placing Lights with the Render Lighting Effects Filter

You are at the point of no return. You have done everything with the lighting in 16–bit that you can. You must go to 8–bit to continue, so if you have not already done so, save the file.

1. Turn off the layer set D_OF_F.

NOTE: You turn this layer set off because D_OF_F is full of Smart Filters. The problem with Smart Filters is that they each have to convert the file to pixels (referred to as rasterizing in Photoshop) when you open up or save one, which is very time consuming. Turning them off saves you time, and since you made a master layer, you have a layer that contains everything that is in the layer set. The trade off is increased file size, but I think it is better to have a larger file than to have the file open very slowly.

2. Turn off the layer set L2D_D2L.

3. Convert from ProPhoto to Adobe RGB (Edit > Convert to Profile). When the Convert to Profile dialog box appears, select Adobe RGB from the Destination Space menu, and turn off Flatten Image to Preserve Appearance (**Figure 2.8.1**).

4. Convert from 16-bit to 8-bit (Image > Mode > 8-bit). Click OK and select Don't Rasterize.

5. Select Save As (Command + Shift + S / Control + Shift + S) and rename it by changing 16_BIT in the file name to 8_BIT.

NOTE: The reasons for converting from 16-bit to 8-bit are discussed in Chapter 1 "Lighting the Image with Render Lighting Effects."

6. Create a new layer set below the L2D_D2L layer set and above the MASTER_2 layer, and name it LIGHTING/SHARPEN/NOSE.

7. Duplicate the MASTER_2 layer (Command + J / Control + J) and convert it into a Smart Filter layer (Filter > Convert to Smart Filters). Add a layer mask to this layer and put it in the LIGHTING/SHARPEN/NOSE layer set.

FIGURE 2.8.1 *Converting the profile to Adobe RGB (1998)*

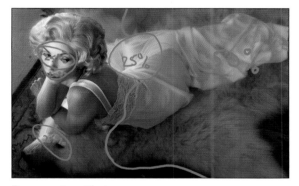

FIGURE 2.8.2 *The image map*

FIGURE 2.8.3 *A sample point just near the bear's eye*

FIGURE 2.8.4

8. Duplicate the newly created Smart Filter layer (the one you just placed in the layer set) four times.

9. Rename MASTER_2_copy1 to LIGHTING and turn off all of the other copies of MASTER_2.

You will use a threefold approach to lighting this image using the Render Lighting Effects filter. First, you will use the filter to do the key lighting as if there had been focusable lighting instruments at the shoot. (Challen's eyes will get the most light, her face a little less, and her arms less than that.) The second approach is to use the Render Lighting Effects filter to add color to the light (which is different from how you used it in Chapter 1), and the third approach is to use it for the quality of "dark" that it creates so that you can further enhance the lighting you have already done. Your file is sheet music, but the image that you create is the symphony such that the sum becomes greater than the parts. Before moving forward look at the image map (**Figure 2.8.2**).

Because you want to make the light reminiscent of the warmth of hot lights, you are going to pick a color from the image and use that to color the "lights" that you place when you launch the filter. For this image, I picked a warm color, which is Info Point 4.

10. Select the sample eyedropper from the Tools panel.

11. Place a sample point on the color you want to use, which for this image is just to the right of the bear's eye (**Figure 2.8.3**). In the Info panel, the RGB values for sample point 4 when I sampled the image were R:179, G:104, and B:149 (**Figure 2.8.4**).

NOTE: Do not be concerned if your numbers are different from mine. The chances that you picked the same pixel that I did are slim.

12. Making sure that you have the LIGHTING layer active, go to Filter > Render > Lighting Effects.

The User Interface (UI) of the Render Lighting Effects filter appears very small on the screen so it can be hard to use. This UI has not changed since its introduction to Photoshop in Version 2. (Photoshop CS5 is actually version 12 of Photoshop.) There are some ways, however, to get around this obstacle.

To do this in the Mac OS:

Go to the Apple pull-down menu and select Preferences and then Universal Access (**Figure 2.8.5**). Click the On radial button in the Zoom In part of the Universal Access dialog box (**Figure 2.8.6**). When you hold both the Command + Option and the + keys down together, you can zoom into the area of the screen where you placed the cursor. To zoom out, press Command + Option and the – key.

To do this in Windows 7: (Unfortunately, this functionality does not exist in Windows XP or Vista.)

FIGURE 2.8.5

FIGURE 2.8.6

Press This Key:

- The Windows Logo Key + Plus Sign (+) or Minus Sign (–)
- Ctrl + Alt + Spacebar
- Ctrl + Alt + F
- Ctrl + Alt + L
- Ctrl + Alt + D
- Ctrl + Alt + I
- Ctrl + Alt + arrow keys
- Ctrl + Alt + R
- Windows Logo Key + Esc

To Do This:

- To zoom in or out

- Preview the Desktop in full-screen mode
- Switch to full-screen mode
- Switch to lens mode
- Switch to docked mode
- Invert colors
- Pan in the direction of the arrows keys
- Resize the lens
- Exit Magnifier

FIGURE 2.8.7 *Choose Soft Omni*

FIGURE 2.8.8 *Selecting the color*

FIGURE 2.8.9 *Lightening the color slightly*

13. When the Render Lighting Effects dialog box comes up, select Soft Omni from the Lighting styles pull-down menu (**Figure 2.8.7**).

14. Double-click on the light color box that is located to the right of the Intensity slider located in the Light Type part of the Render Lighting Effects dialog box. When you do this, the Color Picker will come up.

15. In the RGB part of the Color Picker dialog box, type in the RGB values of the sample point (4) that you chose to be the color of the light (R:179, G:149, and B:104). You should see that the "new" part of the color box has changed (**Figure 2.8.8**).

16. Now, the color is correct, but is too dark. You can change that by clicking on a lighter part of the Color Picker. When you do that, the color should get lighter in the new color box (**Figure 2.8.9**). Click OK. You will see that the light's color has dramatically changed (**Figure 2.8.10**).

FIGURE 2.8.10 *The color of the light has changed*

FIGURE 2.8.11 *Move the light to the left*

FIGURE 2.8.12 *Duplicate a nwe light to her eye*

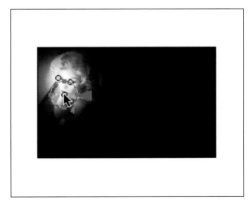

FIGURE 2.8.13 *Move the new light to her lips*

17. Click on the center handle of the Soft Omni light and place it above the model's left eye and below her left eyebrow. Click on the lower anchor point and move it inward (**Figure 2.8.11**).

18. Holding down the Option / Alt key, click on the center handle of the light you just created. (This duplicates the light and a light bulb icon appears.) Move the newly created light to the inside of her right eye (**Figure 2.8.12**).

19. Again, holding down the Option / Alt key, click on the center handle of the light you just created. Move the newly created light to the model's bottom lip (**Figure 2.8.13**).

20. Starting with the left light, further fine tune the size of the light by clicking on the left handle and moving it inward towards its center to shrink its size.

NOTE: Leave yourself open to the possibility that, as you adjust the size of the light, you may also want to change the light's position and further refine its color. Everything you do when creating an image should reflect your vision.

21. Further fine tune the size of the right light by clicking on the left handle and moving it inward towards its center to shrink its size (**Figure 2.8.14**).

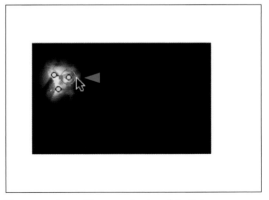

FIGURE 2.8.14 *Fine tune the size of the light*

FIGURE 2.8.15 *Increase the Ambience to 2*

FIGURE 2.8.16 *Lower the Exposure to −56*

FIGURE 2.8.17 *Lower the Intensity to 38*

Once you have placed and sized the lights, it is time to adjust their quality.

22. Make the first light that you placed (the left light) active by clicking on the center handle. Start by adjusting the Ambience. Open it (move the slider right) to a setting of 2 (**Figure 2.8.15**).

23. Adjust the Exposure by lowering it (move the slider left) to a setting of −56 (**Figure 2.8.16**).

24. Make the second light that you placed (the right light) active by clicking on the center handle. Start by adjusting the Intensity of the light, and lower it (move the slider left) to a setting of 38 (**Figure 2.8.17**).

25. Make the third light that you placed (the lower light) active by clicking on the center handle. Start by adjusting the Intensity of the light, and lower it (move the slider left) to a setting of 28 (**Figure 2.8.18**).

FIGURE 2.8.18 *Lower the Intensity to 28*

FIGURE 2.8.19 *Add a new light on the gown*

FIGURE 2.8.20 *Expand the light outward*

FIGURE 2.8.21 *Increase the Intensity to 40*

26. Add a new light by Option-clicking on the light that is on the model's lip (the third light you placed), and drag the new light to the upper part of the white gown, just behind the model's head (**Figure 2.8.19**).

27. Click on the lower handle of the newly placed light and expand it outward (**Figure 2.8.20**).

28. Adjust the Intensity of the light by increasing it (move the slider right) to a setting of 40 (**Figure 2.8.21**).

29. Click OK. This is the image with the Render Lighting Effects applied (**Figure 2.8.22**).

30. Turn on the L2D_D2L layer set.

31. Turn off the LIGHTING layer.

Before you did anything with the Render Lighting Effects filter, you were almost where you needed to be. By using the filter, you not only lit Challen's face, you also lit the bear's face. Now, you are going to use the Render Lighting Effects filter layer to selectively fine tune the lighting of the model's face as well as to add the illusion of "atmospheric distance" to the image. The Render Lighting Effects filter creates the dark aspect of the lighting effect that can be used to add dimensionality to the atmospheric effects that light sometimes exhibits in real life and that cannot be achieved by using only curves.

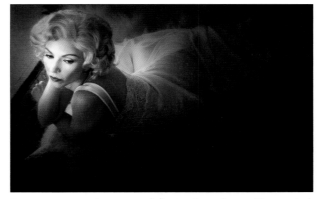

FIGURE 2.8.22 *The image with the Render Lighting Effects applied*

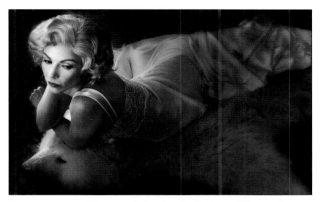

FIGURE 2.8.23 *The image before Render Lighting Effects with the L2D/D2L layer set on*

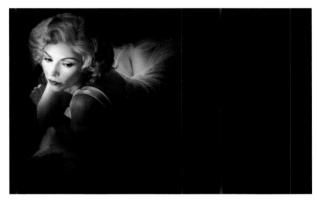

FIGURE 2.8.24 *The image with Render Lighting Effects and the L2D/D2L layer set on*

FIGURE 2.8.25 *The image map for brushing back the Render Lighting Effects layer*

Before continuing, look at the image before the Render Lighting Effects with the L2D/D2L layer set on (**Figure 2.8.23**), the image after the Render Lighting Effects with the L2D/D2L layer set on (**Figure 2.8.24**), and the image map of the brush back areas of the Render Lighting Effects layer (**Figure 2.8.25**).

32. Turn on the LIGHTING layer. Create a layer mask and fill it with black. With the foreground color set to black and the background set to white, select the brush tool with a pixel width of 250 and a Brush opacity of 50%, and brush in the area of Challen's eyes.

33. Brush her face. (The brushing of her eyes and face are two separate actions. This is so you can create the "key" light.) Bring up the Fade effect dialog box and reduce the opacity to 35%. Increase the brush size to 600 pixels and brush in her whole head, including her face (which you have just brushed) and hair. Bring up the Fade effect dialog box and reduce the opacity to 35%. Look at the image after the brushwork (**Figure 2.8.26**) and the resulting layer mask (**Figure 2.8.27**).

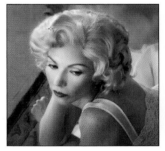

FIGURE 2.8.26 *The image after the brushwork on her face*

FIGURE 2.8.27 *The layer mask after the brushwork*

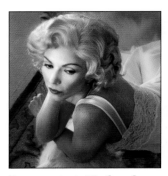

FIGURE 2.8.28 *The face after the brushwork*

FIGURE 2.8.29 *The layer mask after the brushwork*

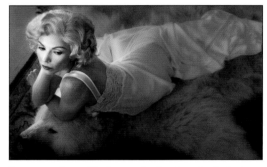

FIGURE 2.8.30 *The image after brushing in the background and body*

FIGURE 2.8.31 *The layer mask after fine tuning the brushwork*

34. With a brush width of 200 pixels (foreground color white, brush opacity set to 50%), brush in her arms and back. Bring up the Fade effect dialog box and reduce the opacity to 29%. Look at the image after the brushwork (**Figure 2.8.28**) and the resulting layer mask (**Figure 2.8.29**).

35. Increase the brush size to 1100 pixels (foreground color white, brush opacity of 50%). Brush in the background, starting from the back right of the bear's head, and go all the way around to the left side of the bear's nose. (Be sure not to brush into any of the areas in which you have already done brushwork.) When finished, bring up the Fade effect dialog box and increase the opacity to 66%. At 50% opacity, brush in the lower left area of the rug, just behind the bear's head and before its paw (**Figure 2.8.30**). Look at the resulting layer mask (**Figure 2.8.31**).

NOTE: At this point in the production of the final image— the color was still too dark for my taste. (You can see the color change occur in the tutorial DVD.) Therefore, I further fine tuned the color of the lights by re-opening the Smart Filter and changing its color values to R:248, G:222, and B:185. You can do that by clicking on the center handle of each "light", then clicking on the color picker square. When the Color Picker dialog box comes up, type in the new color values. These changes are reflected in the 100ppi example file for this lesson.

You separated out the Light-to-Dark Lighting Effects layer so that you could use the Light-to-Dark, Dark-to-Light (L2D_D2L) layer group over which you can have greater control. You can further fine tune a layer, layers, or layer set through the use of opacity. Also, by creating the Light-to-Dark and the Dark-to-Light Curves adjustment layers, you can make more informed decisions about selective contrast, render lighting, and selective sharpening of the image.

36. Turn on the L2D_D2L layer set.

37. Lower the opacity of the Render Lighting Effects layer (**Figure 2.8.32**).

38. Save the file.

The only thing left to do is to selectively move the "unconscious" eye a bit more by using a little sharpness and tonal contrast.

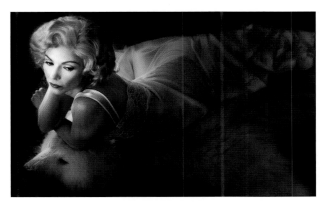

FIGURE 2.8.32 *The image after adjusting the opacity of the Render Lighting Effects layer*

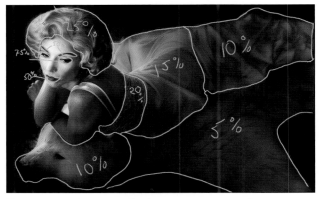

FIGURE 2.9.1 *Image map for the TONAL_CONTRAST layer*

Step 6: Selectively Increasing Midtone Image Structure Using Tonal Contrast

By using contrast, you can further refine how the unconscious eye moves across the image. When you look at a person's image, your eye goes first to their face. Therefore, the first areas on which to focus are Challen's eyes, her mouth, and her eyebrows. After adjusting these, you will add tonal contrast to the bear's face, Challen's gown, and finally the rug. In order to accomplish this in this image, I will have you use a specific type of contrast: Tonal Contrast. (This is one of the three free plug-ins from Nik Software.) The simplest way to describe Tonal Contrast is that it is the Clarity tool on steroids. It is everything you wanted in the Clarity tool but do not have, and it is also things you did not even know that you wanted.

The Clarity tool is an inspired addition to Photoshop (based on Mac Holbert's Midtone contrast approach to printing). The Clarity tool in Photoshop is a one-size-fits-all approach to applying contrast that locally targets midtone image structure by using the highpass filter. Tonal Contrast, however, allows you to selectively adjust not only the midtones, but the highlight and shadow areas as well. It also allows you to increase or decrease saturation, and protect highlights and shadows. Take a look at the image map (**Figure 2.9.1**).

1. Make MASTER_2_copy2 and rename it TONAL_CONTRAST.

NOTE: Because you do not want to impact the color of the image, you are not going to use a master layer or merge stamped layer that contains the Render Lighting Effects layers.

2. Select Filter > Nik Software > Color Efex Pro 3.0 Versace Edition. In the Nik Filter dialog box, select Tonal Contrast, which is located in the upper left-hand corner and is the bottom-most of the three plug-ins.

I use Tonal Contrast on 100% of my images, because it allows me to control the contrast of highlights, midtones, or shadows without affecting the rest of the image. It works by breaking an image into its component parts (such as sky, clouds, foreground, etc.) and then allowing you to increase the contrast of fine details within those component parts without affecting any others. This leads to a more natural look without the introduction of artifacts or halos. For those interested in more technical information, this plug-in is based on the LSC (Local Statistics Convolution) algorithm which provides a unique approach to increasing fine details in an image.

There are four controls in this plug-in. They are shown in **Figure 2.9.2**:

1) **Highlight Contrast**—Controls the degree of contrast added to only the highlights (brightest objects) of the image.
2) **Midtone Contrast** —Controls the degree of contrast added to only the midtones of the image.
3) **Shadow Contrast**—Controls the degree of contrast added to only the shadows of the image.
4) **Saturation**—Controls the overall vibrancy of colors by increasing or decreasing saturation throughout the image.

FIGURE 2.9.2 *Tonal Contrast filter*

FIGURE 2.9.3 *Increasing the Midtone Contrast slider to 61%*

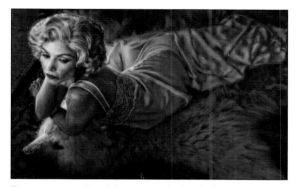

FIGURE 2.9.4 *Tonal Contrast applied globally*

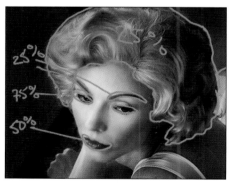

FIGURE 2.9.5 *Zoomed into her face with the image map visible*

3. With the Hand tool, move the image so that the model's face is filling the preview box and so that the split view line (before is to the left, after is to the right) runs down the middle of her face.

4. Start this adjustment by moving the Midtone Contrast slider to the right (this increases the amount) until you reach 61% (**Figure 2.9.3**).

5. For this image, you will leave the Shadow and Highlight sliders at their defaults of 30% and the saturation at its default of 20%. Shadow Protection and Highlight Protection are also good, so leave them at their default as well.

6. Click OK. Look at the image after Tonal Contrast is applied globally (**Figure 2.9.4**).

NOTE: Do not be disturbed by the less than visually appealing, pseudo-HDR grunge look. Remember, always go to an extreme and retreat to a useable position.

7. Make the layer mask of the TONAL_CONTRAST layer active, and fill it with black.

8. Zoom in on Challen's face (**Figure 2.9.5**). Select the Brush tool, and set the opacity to 50% at a pixel width of 35. With the foreground color set to white and the background set to black, brush in just her left eye. Bring up the Fade effect dialog box (Command + Shift + F / Control + Shift + F), increase the opacity to 70%, and brush in her right eye. Again, bring up the Fade effect dialog box and type in 70%. (You want her eyes to be equal.) Brush in her mouth and right eyebrow at 50%. Bring up the Fade effect dialog box, lower the opacity to 24%, and brush in her left eyebrow. Bring up the Fade effect dialog box and type in 24%.

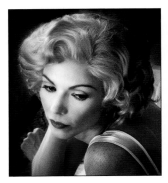

FIGURE 2.9.6 *The face after brushwork*

FIGURE 2.9.7 *The layer mask after brushwork*

FIGURE 2.9.8 *The bear's head after brushwork*

FIGURE 2.9.9 *The layer mask*

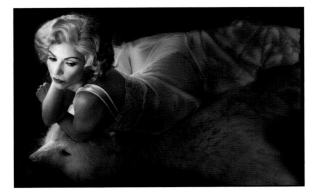

FIGURE 2.9.10 *The image after brushwork on the bear's body*

9. Increase the brush size to 100 pixels, and brush in her hair. Bring up the Fade effect dialog box and reduce the opacity to 36%. Look at the image after the inital brushwork (**Figure 2.9.6**) and the resulting layer mask (**Figure 2.9.7**).

10. With a brush width of 500 pixels, brush in the bear's face and head. Bring up the Fade effect dialog box and reduce the opacity to 36%. Look at the image after the brushwork (**Figure 2.9.8**) and the resulting layer mask (**Figure 2.9.9**).

11. Still using a brush width of 500 pixels, brush in the bear's face and head and the lower part of the bear skin rug. Bring up the Fade effect dialog box and reduce the opacity to 15%. Look at the image after the brushwork on the bear (**Figure 2.9.10**) and the resulting layer mask (**Figure 2.9.11**).

12. Using a brush width of 125 pixels, brush in the lace of the model's gown. Bring up the Fade effect dialog box and reduce the opacity to 13%.

13. Increase the brush size to 400 pixels and brush in the entire gown (including the lace you just did). Bring up the Fade effect dialog box and reduce the opacity to 14%.

FIGURE 2.9.11 *The layer mask after brushwork on the bear's body*

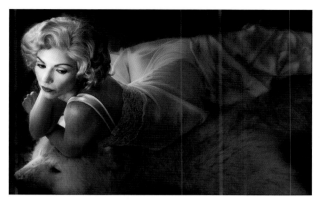

FIGURE 2.9.12 *Before adding Tonal Contrast*

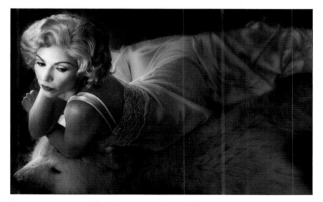

FIGURE 2.9.13 *After brushing in Tonal Contrast*

FIGURE 2.9.14 *The final layer mask*

14. Keeping a brush size of 400 pixels, brush in the center part of the gown (including the lace you just did). Bring up the Fade effect dialog box and reduce the opacity to 10%.

Now, compare the image before brushing in Tonal Contrast (**Figure 2.9.12**), the image after brushing in Tonal Contrast (**Figure 2.9.13**), and the final layer mask (**Figure 2.9.14**).

15. Throw away the Smart Filter layers that you did not use.

16. Save the file.

It is time to add the whipped cream and cherry on top of this image sundae. You will add coolness to the shadows and a realistic butterfly shadow under Challen's nose.

FIGURE 2.10.1 *Sampling the shadow color under her nose*

FIGURE 2.10.2 *Making a selection with the Polygonal Lasso tool*

FIGURE 2.10.3 *Feathering the selection*

FIGURE 2.10.4 *Filling the selection with the sampled color*

FIGURE 2.10.5 *Applying the Gaussian Blur*

FIGURE 2.10.6 *A halo under the nose*

Step 7: The Whipped Cream and Cherry: Adding Shadow Coolness and a Butterfly Shadow

It is time to bring this picture home and put it to bed. You need to add the little touch of reality that will make this image a believable probability, one the viewer will believe was originally lit the way it appears. You will accomplish this is by creating a shadow underneath Challen's nose and by adding the appropriate amount of blueness into the shadow areas.

Creating a Realistic Butterfly Nose Shadow

NOTE: When adding shadowing to images, it is a common mistake to overlook the color of the shadow. See also "Creating a Realistic Shadow" in Chapter 1.

1. Zoom in on the area of the model's nose and mouth. With the eyedropper, sample the color of the shadow just below her nose (**Figure 2.10.1**). The foreground color now reflects the color of the shadow.

2. Create a new layer and name it NOSE_SHADOW. Select the Polygonal Lasso and make a selection like the one shown (**Figure 2.10.2**). Go to Select > Modify > Feather and select a feather of 11 pixels. Notice that the edges of your selection are rounded out (**Figure 2.10.3**). Fill the selection (Option + Delete / Alt + Backspace) with the foreground color (**Figure 2.10.4**).

NOTE: The marching-ants border indicates the pixels that are at least 50% selected.

3. Deselect the feathered selection. (Select the Crop tool and click anywhere on the image.) Convert the layer to a Smart Filter, and go to Blur > Gaussian Blur. Move the slider to the right until you get a blur that you find appealing. I chose 5.3 pixels. Click OK (**Figure 2.10.5**).

4. If you look closely, you will see that you created a bit of a halo beneath her nose (**Figure 2.10.6**). Select the Move tool and, with the up arrow key, move the shadow upward until the halo is gone and the shadow fits beneath her nose (**Figure 2.10.7**).

FIGURE 2.10.7 *Moving the shadow to remove the halo*

FIGURE 2.10.8

FIGURE 2.10.9 *Pulling the center of the grid down*

FIGURE 2.10.10 *Moving the left middle section upward and inward*

FIGURE 2.10.11 *Moving the right middle section upward and inward*

FIGURE 2.10.12 *Moving the upper middle control point upward and to the right*

5. Go to Window > Arrange > New Window and then to Full screen mode. (If you are in the gray space, press the F key twice.) Arrange the windows so that you can see both of them. Make the window with the enlarged nose shadow active.

6. Bring up the Free Transform dialog box (Command + T / Control + T), and click on the Free Transform dialog box while holding the Control key / right-click. This will bring up the Free Transform Options dialog box. Select Warp (**Figure 2.10.8**).

NOTE: You created a new window and arranged it the way that you did so that you could eliminate the Warp grid and better see what you were doing.

Next, you will warp the shadow to follow the contours of her philtrum (the midline groove in the upper lip that runs from the top of the lip to the nose) so that you give dimension to the nose shadow.

7. Click on the center portion of the grid and pull it slightly downward (**Figure 2.10.9**).

8. Click on the left middle section of the Warp grid and move it slightly up and inward (**Figure 2.10.10**).

9. Click on the right middle section of the Warp grid and move it slightly up and inward (**Figure 2.10.11**).

NOTE: Be open to fine tuning what you have already done.

10. Click on the upper middle control corner point and move it upward and to the right (**Figure 2.10.12**).

FIGURE 2.10.13 *Moving the upper left control upward and to the right*

FIGURE 2.10.14 *Moving the middle left control downward and to the right*

FIGURE 2.10.15 *Moving the lower left control downward and to the right*

FIGURE 2.10.16 *Brushing the edge of the shadow*

FIGURE 2.10.17 *The shadow after the final brushwork*

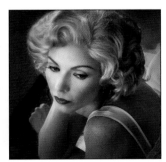

FIGURE 2.10.18 *The face after reducing the opacity of the shadow layer*

11. Click on the upper left control corner point and move it upward and to the right (**Figure 2.10.13**).

12. Click on the lower middle left control corner point and move it downward and to the right (**Figure 2.10.14**).

13. Click on the lower left control corner point and move it downward and to the right (**Figure 2.10.15**).

14. Once you have adjusted the nose shadow to follow the contours of her philtrum, click on the Hand tool and click Place.

15. Close the smaller version of the image; the one you created without the Warp dialog box.

16. Go to the gray space. (Press the F key once.)

17. Lower the layer's opacity to 73%.

18. Create a layer mask, select the Brush tool, set the opacity to 100%, set the foreground color to black, and brush around the shadow with a 40-pixel brush (starting at the top of Challen's nose) (**Figure 2.10.16**) until you are happy with the shadow's size. (Remember to use the edge of the brush.) When you are finished with your brushwork, it should look like **Figure 2.10.17**. Reduce the opacity of the layer until it looks realistic; 33% is about right (**Figure 2.10.18**).

19. Turn off the L2D_D2L layer set (if it is not already turned off).

20. Create a master layer and name it MASTER_3.

21. Turn off the LIGHTING/TONAL/NOSE layer set.

22. Save the file.

Adding Realistic Coolness to the Shadow Areas

You separated out Light-to-Dark and Dark-to-Light adjustment layers so that you could control the opacity should you want to decrease the effective darkness. You did this so that you would have an exit strategy, and so that you would not be married to the darkness that you have created. This separation also allows you to move into or out of any layer group

FIGURE 2.11.1 *Select Cooling Filter 82 from the pull-down menu*

FIGURE 2.11.2 *Leave the Density at 25%*

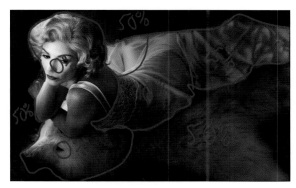

FIGURE 2.11.3 *The image map for the cooling effect*

FIGURE 2.11.4 *The final layer mask for the cooling effect*

and to add things to them as the look of the image develops. In this final step, you are going to cool the shadows of this image using one of Photoshop's built-in photo filters.

1. Turn on the L2D_D2L layer set and open it.

2. Make the L2D_SCREEN Curves adjustment layer active.

3. Click on the Adjustment Layers icon located at the bottom of the Layers panel and select Photo Filter.

4. After the Photo Filter dialog box comes up, select Cooling Filter 82 from the Filter pull-down menu (**Figure 2.11.1**).

5. Leave the filter at its default density of 25% (**Figure 2.11.2**).

6. Fill the layer mask with black.

Look at the image map diagram for this layer's cooling filter (**Figure 2.11.3**). You want to leave the faces of the model and the bear alone, but you want to put a little coolness into the area of the gown onto which the light directly falls. You want to add increasing coolness as the light falls away down the back of the gown. In the area of the rug (both in front and behind), you want to apply a lot of coolness, because this is the area of the deepest shadow.

7. Set your Brush tool at an opacity of 50%, the foreground color to white, and the brush width to 500 pixels. Starting from just behind the bear's head, brush in the entire area around the model ending at the top part of the bear's head. Bring up the Fade effect dialog box and increase the opacity to 77%.

8. Brush in the whole gown at 50%. (Include the front area onto which the light is falling.) Bring up the Fade effect dialog box and reduce the opacity to 26%. Brush in only the back of the gown. Bring up the Fade effect dialog box and lower the opacity to 24%. Look at the final layer mask (**Figure 2.11.4**).

9. Make a master layer and name it FINAL.

10. Save the file.

The Die Is Cast

Gone is the day that the movie moguls taught actors the importance of posing all day for a photograph.

— George Hurrell

You have reached the conclusion of this chapter's main focus, creating classic glamour lighting and replicating the DOF and bokeh of an 8x10 view camera using Photoshop (**Figures 2.12.1** and **2.12.2**). In Chapter 3, I will further discuss the concept of the conscious and unconscious eye and how to control how the viewer "sees" your image.

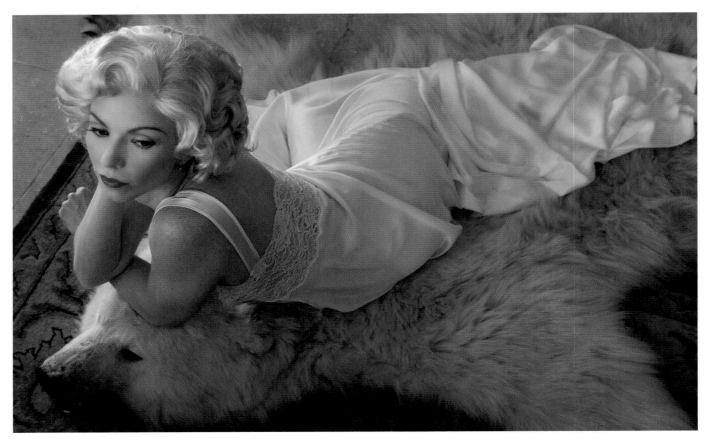

FIGURE 2.12.1 *The original image*

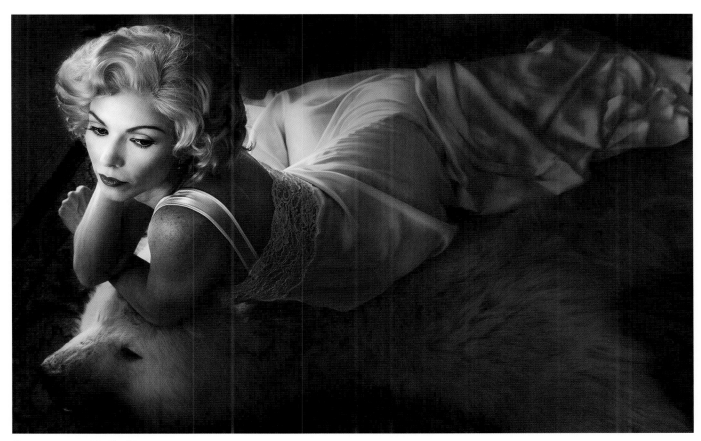

FIGURE 2.12.2 *The final image*

FIGURE 3.0.1 *Before*

FIGURE 3.0.2 *After*

Image Harvesting

Precision does not mean accuracy. Accuracy is how well precision reflects reality.

—Lane H. Decker

In this chapter, I will explore the concept and teach you the techniques of image harvesting. This is the practice of shooting multiple images of the same subject while changing not only the exposure, but the shutter speed, focus point, and image structures. This practice guarantees that your source files will contain the optimum aesthetic aspects of exposure, DOF, bokeh, and focus, so that you can later combine the best of each to create a single, final image.

Recreating What the Eye Saw

The human eye is an amazing biological optical system. It can discern detail in light as dim as moonlight and as bright as noon's direct sunlight at the equator. It also acts as a motion sensor, sees events as they happen, and changes focus so rapidly that everything, near to far, appears in focus, all while adjusting for changes in the light intensity.

A digital still camera, on the other hand, does not have all the capabilities of the human eye. It is simply an image-capturing device that records a very small part of what we see. It records only fractions of seconds, while the majority of what we see is witnessed in unlimited motion. The human eye has the ability to see multiple objects at different distances and see them all in focus. A digital still camera cannot. If you are using a fixed lens system, like a SLR, where the film/sensor plane and the lens are permanently locked into a relationship with each other, you simply cannot have two objects that are at different distances be in focus. No amount of stopping the lens down will change this.

The human eye is capable of adjusting for changes in light and has the ability to determine detail in both extremely low and high light situations. Cameras, on the other hand, always seek to expose for 18% gray. This means that if you take a picture of a white wall and then a black wall, when viewed, neither image would be black or white; they would both be 18% gray. Additionally, no matter how sensitive the light meter in the camera, it cannot determine what area of the image is the most important. Only the photographer can do that.

So how do you replicate what you saw with a device that does not record the image the way you experienced it when you saw and shot it? The answer is this: rather than shoot one image and hope for the best, consider harvesting many images and combining them into one. This is the best way I know to create an image that looks like what the eye saw—not just what the camera captured.

Practicing Preemptive Photoshop

An interesting plainness is the most difficult thing to achieve.

—Ludwig Mies van der Rohe

The image that will be the outcome of this lesson, Hearing the Whisper of the Green Fairy (**Figure 3.0.2**), was harvested rather than captured in one image. It is also the first time that

I went beyond mere High Dynamic Range (HDR) capture and moved into exploring Extended Dynamic Range (ExDR) photography, although I did not know it at the time.

I decided that while revisiting this image harvesting chapter, I should mention that I believe that the importance of expanding dynamic ranges may be being missed in the rush to use HDR imagery to simply make images look strange. I believe that HDR photography is frequently over-used, mis-used, and abused. I read a blog that said that if you do not like HDR images then you do not understand Photoshop. You should not have to understand the technology used to create an image (even though you may) to appreciate it. If an image is simply strange, and does not move you, you know that it is not the culmination of the photographer's vision; it is simply manipulation.

The High of Dynamic Range Thinking

If you don't like change, you're going to like irrelevance even less.
—General Eric Shinseki

Though HDR traditionally refers to widening the range of exposure by shooting multiple images, there is more to this concept than merely using tonemapping software to create the "grunge" look. I believe that shooting multiple images for exposure is just a small part of the high of dynamic range thinking.

When *Welcome to Oz* was first published, there were some critics who thought image harvesting unnecessary, too time consuming, or irrelevant. Now, software exists (Helicon Focus, CS4, and CS5) that creates one completely focused image from several partially focused ones by combining the focused areas of each. In addition, Photoshop automatically aligns multiple images, and there is tonemapping software for assembling images based on exposure (HDRSoft's very aggressive Photomatix and Nik Software's kinder, gentler HDR Efex

Pro). Obviously, the concept of harvesting multiple images for specific needs has taken hold and entered the mainstream of digital processing techniques.

As you work through the chapters in this book, keep in mind that you are not limited by the medium in which you work; you are limited only by your imagination and your personal vision. As you have seen in the first two chapters, and you are about to see in this and the next chapter, owning a fast lens cannot solve problems of selective focus, and stopping the lens down in a fixed lens/capture plane system (such as an SLR) cannot bring objects at different distances from the sensor plane into focus all at once. That is simply physics.

From HDR to XDR to ExDR

My wish for you is that you capture images because you are so taken by what you see that you have no choice but to press the shutter. And I understand how frustrating it is when the limitations of the technology keep you from achieving the fulfillment that you realize when you know that your voice has been heard. Because what you see with your eyes is not what your camera sees when you capture an image, I invite you to extend the dynamic range of those images in such a way that no one will be aware of the manipulation when you are done.

The term XDR was coined by John Paul Caponigro when he and I produced an Acme Educational tutorial DVD to teach his techniques and belief that there were many ways to extend the exposure range (XDR) of an image. What I have observed, through the course of my creative work, is that we should be going beyond extending only exposure range and should be looking to extend the dynamic range of all that makes up image structure: time, specific focus points, multiple objects in focus, blur, color, etc. I call that ExDR. In the next two chapters, you will be exploring this concept.

When I first encountered the subject of Hearing the Whisper of the Green Fairy, I stared at those leaves for an hour,

captured 87 images, and out of those, I chose to use only four. I made so many captures because I shot some at different exposures, some at different focus points, and some were a combination of both. When capturing those images, I was practicing "preemptive Photoshop"—making informed decisions about the way I was shooting (different exposures, focus points, DOF, etc.) so that I got it right in the camera at the time of capture. This allowed me a large number of options when I sat down later at my computer. Remember to approach Photoshop as a noun and not a verb. You cannot always fix it in Photoshop. Photoshop is only a means to an end. Although your goal should always be to get it right in the camera, when the camera cannot give you your vision, adapt to the situation and give yourself as many choices as you can when you are taking the picture, so that later you are not limited by captures you lack.

I have found that real pixels are infinitely better than artificially generated ones. The image that I chose as the main, or base, image for this lesson was one in which I liked the relationship between its main point of focus—the leaf in the upper part of the picture—and the overall image. From the three other captures, I took those parts that I felt resolved areas in the base image that were issues to me. The issue areas were the leaf in the foreground, the cluster of other leaves in the mid-ground, and the absence of interesting detail in the background. After making the composite, I enhanced it as if it were a single image.

Before you dive into all that follows, think about whether you are creating a believable improbability or a believable probability. Ponder this as you work your way through this lesson.

Photoshop Setup and Workflow

As with any image, the first steps are to analyze the image, determine which problems need to be addressed, and decide on the appropriate workflow. As discussed earlier, workflow is a dynamic thing and is specific to each image. In image harvesting, you must first choose the images you will use, then:

- fix any problems with the base image.
- combine the desired elements taken from the other images.
- do color correction and aesthetic image manipulation.

It is wise to solve the biggest problems first. Here, for example, the biggest issue is not correcting the color cast of all four images; it is getting one image from the four. It is easier to color correct one final image than to do each separately.

Try to develop a workflow that minimizes artifacting. Every time you do something in Photoshop, you clip or dump some data, and that causes artifacts. While some of these are visually appealing, some are not. And, as I have previously mentioned, all artifacting is cumulative and can be multiplicative. One way to minimize this is to work in 16-bit and in the ProPhoto color space. This image's workflow is approached with that in mind.

Here are the four harvested images that make up the palette for this lesson:

- Image 1: This is the base image and contains the central focus point of the final image, the large leaf at the top (the primary focus area) (**Figure 3.1.1**).
- Image 2: A nearly identical photo with the focus on a cluster of leaves beneath the large leaf at the top (the secondary focus area) (**Figure 3.1.2**).
- Image 3: A slightly different image, where a single leaf below the cluster is in focus (the tertiary focus area) (**Figure 3.1.3**).
- Image 4: An image taken from a different angle that contains three leaves in focus and a nice pattern for the background (**Figure 3.1.4**). (See the Image Harvesting sidebar)

This is the image map of what you will be doing (**Figure 3.1.5**).

FIGURE 3.1.1 *Image 1: the base image*

FIGURE 3.1.2 *Image 2: focus on the leaf cluster*

FIGURE 3.1.3 *Image 3: focus on a single leaf*

FIGURE 3.1.4 *Image 4: interesting background*

FIGURE 3.1.5 *Image map of combining images*

To extend the dynamic range of an image, whether it is to simply extend the exposure or to move into the more complex extensions of time, image structure, focus, color, or blur, you must know what needs to be done to harvest multiple images in such a way that will later allow you to make one out of many.

When you harvest images, it is most important that the angle and distance of the object to the sensor plane should not change. It was with Hearing the Whisper of the Green Fairy that I learned this lesson and I urge you to follow this advice. However, I will teach you the consequence of changing the object-to-sensor-plane relationship by going through what you must do to correct for it if you must change it in order to achieve your vision. In order to maintain the object-to-sensor-plane relationship, you must have a very stable platform for your camera, which means having a really good tripod, tripod head, mounting system, and cable release. If you do, it will not matter how many times you change the angle of view, or if you use zooms or switch lenses, because as long as the sensor plane remains in the same relationship to the subject, everything will line up later when you begin your Photoshop manipulation. A good tripod, tripod head, and camera mounting system are as important as the quality of your lenses and camera. You should not try to economize on these beyond finding the best price.

To buy the best tripod for you, find one that allows the eyepiece of the camera to be at your eye level when its legs are fully extended and the tripod head and camera are attached. You *never* want to extend the center pole of the tripod to reach your eye level. A camera on a tripod is always at its most stable when it is closest to the tripod's base. Extending above that base introduces shake and wobble that may translate into motion blur in your image, the very thing you are trying to negate by using a tripod.

Be aware that the smaller in diameter the legs of your tripod, the less weight the tripod can handle and the less stable it will be. I think that the best tripods are carbon fiber. They are the most ridgid, the strongest, and the lightest weight. In my opinion, as of publication date, Gitzo and Induro make the best on the market. The major difference between them is that Gitzo tends to be twice as expensive as Induro. (I presently own an Induro C414.)

In my opinion, as of publication date, the best type of tripod head for still photography is a ball head with the Arca Swiss mount, and the best of these are made by Really Right Stuff. The best way to mount your camera to a ball head that employs the Arca Swiss mount is to use an L bracket that is specifically designed for your camera. There are two companies that make high quality brackets: Kirk and Really Right Stuff. The L bracket allows you to mount a camera both vertically and horizontally and completely neutralizes "head creeping." Head creep is the downward movement of the camera due to gravity when the camera is mounted perpendicularly to the ground. It occurs when the screw that holds the tripod plate to the camera body becomes loosened. This creep translates into motion blur.

Lastly, if your lens has a foot for attaching it to the tripod, use it. Not only does a foot remove any stress on the camera's bayonet mount where the lens attaches to the camera, it makes for easier orientation changes (e.g., vertical to horizontal), and allows you to place the nodal point of the lens over the center point of the tripod, which is important if you are shooting panoramas.

From Many to One: Creating the Composite Image

There are numerous reasons for creating a composite image and they range from duplicating the reality of what you originally saw to creating an image of something that exists only in your mind's eye. For instance, if you want a shallow DOF because you like the bokeh at 2.8, and your vision of the image includes having the objects in front of the focus point to also be in focus, you will need to combine multiple images into one. Also, you need to combine multiple images if you want multiple objects that are at different distances from the sensor plane to be in focus. It is this last goal that I had in mind for Hearing the Whisper of the Green Fairy.

Step 1: Combining the Four Images into One

When combining multiple images into one, keep in mind:

- All of the image manipulation decisions you make should be made based on the way the eye works when it "sees." As I discussed in Chapter 1, the eye goes to patterns that it recognizes first: areas of light to areas of dark, high contrast to low contrast, high sharpness to low sharpness, in-focus to blur (which is different from high sharpness to low sharpness), and high saturation of color to low saturation of color.
- You cannot simply combine captures taken with different f-stops to put multiple objects in focus that are at different distances from the sensor plane. (See Chapters 1 and 2.) If you want to do this, then you need to have a common point of focus in each image that will be used in the composite.
- It is in the digital domain, both at capture and in the digital darkroom, that impossible is just an opinion. You are limited only by your ingenuity and imagination.
- Most importantly, always solve the biggest problems first and work down to the smallest, i.e., correct from global to granular.

1. Go to the folder CH_03_OZ_3.0 that you downloaded from www.welcome2oz.com. Using BANFF0274.tif as the base file, double-click on the background layer, and rename it BASE IMAGE. One at a time, Shift-click and drag the image icon in the Layers panel from the three harvested images to the base image.

By using the Shift-click method, the copied image will pin register with the base image. In other words, Photoshop will place the copied image exactly on top of the base image. Here is the layer order, from the bottom up:

- BASE IMAGE: This was BANFF0274.tif.
- MID LEAVES: This was BANFF0273.tif.
- FG LEAF: This was BANFF0277.tif.
- BG PARTS: This was BANFF0269.tif.

2. Close the BANFF0273.tif, BANFF0277.tif, and BANFF0269.tif files. They are no longer needed.

3. Save the file (Shift + Command + S / Shift + Control + S) as a Photoshop or PSD, file (not as a layered TIFF) and name it GREEN_LEAVES_16BIT.

NOTE: Photoshop should be set to Snap To Guides (on the View > Snap To menu), and the viewing mode should be set to Full Screen with Menu Bar. Keyboard shortcut F displays the image on top of a neutral gray background.

Step 2: Removing Unwanted Elements from the Base Image

In the base image, the viewer's eye is drawn away from the main leaf by a distracting branch. This is the biggest problem, because it will show up in everything that you do until you remove it. Prior to CS5, the only way to do this was by using the Patch tool. CS5 has something better: Content-Aware Fill. (Quite a moniker!) It works by removing a selected element and filling it with detail that matches the surrounding area. It can seamlessly generate bushes, trees, clouds, etc., and fill the selected area so that, for the most part, you will be hard pressed to see that something has been done.

Working global to granular, the biggest issues in this image, besides making four images into one, are the sins of our base image—specifically, the unwanted branches and dead leaves (**Figure 3.2.1**).

FIGURE 3.2.1 *The image map for removing unwanted elements*

Content-Aware Fill

1. Make a copy of the BASE IMAGE layer (Control + J / Command + J) and name it CA_FILL.

2. Select the Polygonal Lasso tool (L).

NOTE: The Polygonal Lasso tool is one of three Lasso tools. The others are the Standard Lasso and the Magnetic Lasso tools. By pressing Shift + L, you can move through the Lasso tools to pick the desired one. The Polygonal Lasso is best for extracting pieces of images that have reasonably straight edges or a semi-polygonal shape, while the Magnetic Lasso is best for complicated figures. To use the Polygonal Lasso, click specific points around an image, and Photoshop will draw straight lines from point to point. Also, if you hold down the Shift key while clicking, you can create straight lines and 45° angles. To undo / redo a point, use the Del / Delete key. For this image, I will have you use the Polygonal Lasso.

3. With the Polygonal Lasso tool, make a selection around the lower left twig. (You do this by periodically clicking the mouse as you move around the object.)

4. Holding down the Shift key for each of the areas that you want to remove, repeat this process so that when you are done you will have a series of selections that looks like this (**Figure 3.2.2**).

5. Go to Edit > Fill (Shift + F5 key) and select Content-Aware from the Fill dialog box's Content pull-down menu (**Figure 3.2.3**).

6. Click OK. Click Command + D / Control + D to deselect the selection (**Figure 3.2.4**).

NOTE: If you need to touch up an area that you missed or there are areas where there is a noticeable edge after you run Content-Aware Fill, simply use the Clone Stamp tool or the Spot Healing brush to touch it up.

FIGURE 3.2.2 *The selection of areas to be removed*

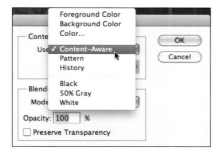

FIGURE 3.2.3 *Choose Content-Aware in the Fill options*

FIGURE 3.2.4 *The image after the unwanted areas are removed*

Step 3: Extending the Dynamic Range of Focus While Maintaining a Shallow DOF

I chose the base image because I liked the way the leaf in the upper part of the composition (the central focal point) related to the overall image. But the image was shot at f/5.6, so its DOF is fairly shallow, and the mid and foreground are out of focus. I chose this DOF for aesthetic reasons; I wanted just the leaf cluster to be in sharp focus. As I have already discussed, stopping a lens down increases the area of acceptable out-of-focus, but it does not increase the number of elements that are actually in focus. Therefore, if I had chosen a base image in which I had stopped the lens down when I made the capture, I would have brought unwanted objects into acceptable out-of-focus, which would have taken the viewer's eye away from the leaf cluster.

Even though this series of images was captured with a camera on a stable tripod, whenever you change the focus, you readjust the position of the elements within the lens. Depending on the lens, this may move the image slightly to the right or left. You will correct for that by replacing the mid-ground leaves with the in-focus leaves from Image 2 (**Figures 3.3.1** and **3.3.2**).

FIGURE 3.3.1 *Out-of-focus leaves to be replaced*

FIGURE 3.3.2 *In-focus leaves that will be used instead*

FIGURE 3.3.3 *MID_LEAVES layer set to 50% opacity to compare the alignment of the two layers*

FIGURE 3.3.4 *MID_LEAVES layer set to Difference*

FIGURE 3.3.5 *After moving the MID_LEAVES layer to better align with the BASE layer*

There are two ways to align an image: 1) manually, by changing the layer you want to move to the Difference blend mode, selecting the Move tool (V), and moving the layer to the placement you want with the arrow keys, or 2) by using Auto Align Layers. Auto Align Layers is the first tool to which I go when I want to align images for a composite. When it works, it works wonderfully. But frequently, it changes the orientation of the image in a way that I find unacceptable. Also, if there are too many blurred areas and too few hard edges, it will not work at all. In this lesson, you will work around Auto Align Layers' penchant for wanting to rotate the entire image, as well as looking at the Difference blend mode approach when Auto Align Layers will not line things up. Both approaches are contained in the 100ppi version of the file that I created while writing this chapter.

Approach 1: Manual Aligning of Image Structure Using the Difference Blend Mode

1. Make the MID_LEAVES layer (the one with the middle leaves in focus) active. Lower the opacity to 50% to compare the BASE and MID_LEAVES layers (**Figure 3.3.3**). Set the opacity back to 100% and select the Difference blend mode from the Blend Mode pull-down menu at the top of the Layers panel. Notice that the image has significantly changed in appearance (**Figure 3.3.4**).

2. Zoom into the central area of the image, select the Move tool (V), and click on that area with the left arrow key to move the image layer until the image is mostly dark (approximately 25 clicks for this image). Then, with the down arrow key, further fine tune the image alignment by clicking on it (approximately 2 clicks for this image) (**Figure 3.3.5**).

3. Select the Normal blend mode from the Blend Mode pull-down menu at the top of the Layers panel. Create a layer mask and fill it with black. Select the Brush tool, set the opacity to 100 percent (0) with a brush width of 70 pixels and brush in the mid-leaf area. Review the image map (**Figure 3.3.6**), the layer mask (**Figure 3.3.7**), the image before (**Figure 3.3.8**), and the image after (**Figure 3.3.9**).

FIGURE 3.3.6 *The image map*

FIGURE 3.3.7 *The layer mask*

FIGURE 3.3.8 *Before the brushwork*

FIGURE 3.3.9 *After the brushwork*

Approach 2: Using Auto Align Layers

Auto Align Layers was very good in CS4, but it is great in CS5. However, it still has some limitations. First, if you select multiple layers to align, it will do just that, which means that it may change the orientation and relationship of all of the layers. That translates into potentially having to crop the image, which is to be avoided whenever possible. What happens when you align the layers is shown in **Figure 3.3.10**. You can work around this limitation by aligning your chosen elements in a separate file, then bringing those elements back into the original file after the alignment is done. This is the next thing that you will do.

1. Select the Move tool (V) and make sure that the rulers are visible (Command + R / Control + R).

2. Make the CA_FILL layer the active and visible one (the eyeball is turned on). (Make sure that the MID_LEAVES layer is not a visible layer.)

3. Click on the top ruler and drag a guide line to just below the lower front leaf. Repeat this process for the top and sides of the mid-leaf area. When you are finished, it should look something like this (**Figure 3.3.11**).

FIGURE 3.3.10 *The result of the Auto Align Layers function in CS5*

FIGURE 3.3.11 *The guides in place for the lower front leaf*

FIGURE 3.3.12 *Drawing a selection using the Marquee tool*

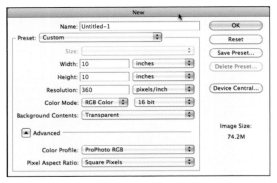

FIGURE 3.3.13 *Creating a new file*

FIGURE 3.3.14 *The MID_LEAVES_B group copied into the new file*

4. Select the Marquee tool (M) then click and drag from the top left corner of the area that you have outlined with guide lines to the lower right corner. You should see the "marching ants" indicating your selection (**Figure 3.3.12**).

5. Copy this selection to its own layer (Command + J / Control + J) and name it BLUR_MID.

6. Command- / Control-click on the BLUR_MID layer inside the Layers panel. This makes a selection of the contents of the layer.

7. Turn on and make active the MID_LEAVES layer. Copy the selection to its own layer (Command + J / Control + J) and name it MID_SHARP.

8. Create a layer group and name it MID_LEAVES_B.

9. Click on the MID_SHARP layer and drag it into the MID_LEAVES_B layer group.

10. Click on the MID_BLUR layer and drag it into the MID_LEAVES_B layer group.

NOTE: You are doing these steps in this order because Photoshop always places any layer that you drag and drop into a layer group at the bottom. If you want it to be at the top, you have to actively place it there.

11. Create a new file (Command + N / Control + N). Make both the width and height 10 inches and the resolution 360ppi. (**Figure 3.3.13**) (Also, make sure that the file is in the ProPhoto color space and 16-bit.) Click OK.

12. Making sure that you are in Standard screen mode, Shift-drag the MID_LEAVES_B layer group into the file that you just created (**Figure 3.3.14**).

13. Holding the Shift key down, make both the MID_SHARP and MID_BLUR layers active.

14. Go to Edit > Auto Align Layers.

15. When the Auto Align Layers dialog box comes up, make sure Auto is selected in the Projection part of the dialog box and click OK (**Figure 3.3.15**). After you click OK, you should see this (**Figure 3.3.16**).

16. Rename the MID_LEAVES_B layer group MID_LEAVES_A.

17. Click on the GREEN_LEAVES_16BIT.psd file to make it active. Drag the MID_LEAVES_B layer group to the trash. Make the CA_FILL layer active.

18. Go to the file in which you just auto aligned the layers and turn off the MID_BLUR layer. Holding down the Shift key, drag and drop the MID_LEAVES_A layer group to the GREEN_LEAVES_16BIT.psd file.

19. Select the Move tool and, using the arrow keys, fine tune your placement so that the stem of the top leaf of the layers that you just aligned lines up with the stem of the top leaf of the CA_FILL layer.

20. Create a layer mask on the MID_LEAVES_A layer group and fill it with black. Follow the image map (**Figure 3.3.17**) to brush in the new leaves that are in focus on the layer mask (**Figure 3.3.18**). Compare the image before (**Figure 3.3.19**) and after the brushwork (**Figure 3.3.20**).

21. Save the file.

22. Close the file that you created to auto align the layers and do not save it.

FIGURE 3.3.15 *The Auto-Align Layers dialog box*

FIGURE 3.3.16 *The image after using Auto-Align*

FIGURE 3.3.17 *Image map*

FIGURE 3.3.18 *Layer mask*

FIGURE 3.3.19 *Before*

FIGURE 3.3.20 *After*

Step 4: Leaf Swapping

The next step is to replace the base image's out-of-focus foreground leaf with the in-focus leaf from the FRONT_LEAF layer. The issue with this leaf is that the camera position was moved from where it was when the base and mid-leaf images were captured, so that the sensor-plane-to-subject relationship was changed. When you change the angle between the camera and the subject, you also change perspective, and the distortions that were caused in relation to the base image need to be corrected. (For this reason, this is something to avoid if at all possible.) In this case, a correction is needed and you will do this using Free Transform and then the Warp tool that were both new in Photoshop CS2. Ben Willmore, in his book, *Photoshop CS2: Up to Speed* (Peachpit, 2005) wrote, "The new Warp feature allows you to bend and distort images almost as if they were printed on Silly Putty."

NOTE: New to CS5 is the Puppet Warp tool that takes the Warp tool to a new level of controllability. But the simplest way is usually the best way, and for this image, just warping will do.

You have undoubtedly noticed that everything you do to an image is a bit of a dance. For everything you do, there will be some change elsewhere in the image that you may or may not like. As in almost everything you do in Photoshop, the global moves you make will need granular corrections until there is no more work to be done.

1. Turn on and make the FRONT_LEAF layer active.

2. Select the Marquee tool then click and drag a selection around the front leaf (**Figure 3.4.1**).

3. Copy it to its own layer and name the new layer FG_LEAF.

4. Turn off the FRONT_LEAF layer.

5. Change the blend mode of the FG_LEAF layer to Difference. You should see this (**Figure 3.4.2**).

6. Select the Move tool (M).

7. Click on the FG_LEAF layer and move the leaf until its front tips are as closely aligned to each other as they can be (as in the previous step, you want as little lit area as possible) (**Figure 3.4.3**).

FIGURE 3.4.1 *Making a selection with the Marquee tool*

FIGURE 3.4.2 *The FG_LEAF layer set to Difference*

8. Zoom into the FG_LEAF area and fill the screen.

9. Select the Free Transform tool (Command + T / Control + T). Move the Reference point to the tip of the leaf. (**Figure 3.4.4**)

10. Click on the top anchor point and move it until the upper part of the stems are more or less aligned (they will appear to be dark with no lightness around the edges) (**Figure 3.4.5**).

11. Click on the right anchor point and move it until the right parts of the leaf are more or less aligned (they will appear to be dark with no lightness around the edges) (**Figure 3.4.6**).

FIGURE 3.4.3 *Moving the FG_LEAF layer to align it with the layer below*

FIGURE 3.4.5 *Moving the top anchor point to align the stems*

FIGURE 3.4.4 *Moving the Reference point to the tip of the leaf*

FIGURE 3.4.6 *Moving the right anchor point to align the leaf*

12. Click on the bottom anchor point and move it until the tips of the leaf are more or less aligned (they will appear to be dark with no lightness around the edges) (**Figure 3.4.7**).

13. Click on the left anchor point and move it until the left parts of the leaf are more or less aligned (they will appear to be dark with no lightness around the edges) (**Figure 3.4.8**).

14. Control-click on the Free Transform box. This will bring up the Free Transform dialog box. Select Warp and the Warp grid will come up (**Figure 3.4.9**).

15. Click on the right corner control handle that rests on the top of the Warp grid box (one grid line to the left), and move it until the right side of the leaf mostly lines up. (**Figure 3.4.10**).

FIGURE 3.4.7 *Moving the bottom anchor point to align the leaf*

FIGURE 3.4.9 *The Warp grid*

FIGURE 3.4.8 *Moving the left anchor point to align the leaf*

FIGURE 3.4.10 *Moving the right corner handle to align the right side of the leaf*

16. Click on the upper left second control handle, (one grid line to the right, and one grid line down from the top), and move it until the left side of the leaf and stem mostly lines up (**Figure 3.4.11**).

17. Click on the lower left second control handle, (one grid line to the right, and one grid line up from the bottom), and move it until the front of the leaf mostly lines up (**Figure 3.4.12**).

18. Click on the upper right second control handle, (one grid line to the left, and one grid line down from the top), and move it until the right top side of the leaf and stem mostly lines up (**Figure 3.4.13**).

19. Press Return / Enter and you should see this (**Figure 3.4.14**).

FIGURE 3.4.11 *Moving the upper left second control handle to align the leaf*

FIGURE 3.4.13 *Moving the upper right second control handle to align the leaf*

FIGURE 3.4.12 *Moving the lower left second control handle to align the leaf*

FIGURE 3.4.14 *Finishing the warp and the resulting layer*

FIGURE 3.4.15 *The layer after changing the blend mode to Normal*

FIGURE 3.4.16 *The image map*

FIGURE 3.4.17 *The resulting layer mask*

20. Switch the blend mode from Difference to Normal (**Figure 3.4.15**).

21. Create a layer mask and fill it with black. At 100% opacity, using a brush diameter of 100 pixels, brush in (with white) the leaf that you just warped following the image map (**Figure 3.4.16**) as a guide. The layer mask should look like **Figure 3.4.17**. Compare the image before (**Figure 3.4.18**) and after (**Figure 3.4.19**).

22. Save the file.

FIGURE 3.4.18 *Before the new layer*

FIGURE 3.4.19 *After the new layer*

Step 5: Matching the Base and Image 4 Colors

You are going to use the BG_PARTS layer to put some image structure elements in the upper right corner of the background, but the leaves in BG_PARTS look bluer than the ones in BASE IMAGE, so you must first match the colors of the two layers.

NOTE: The colors in the images are very subtle. I suggest you open the Histogram palette, set it to All Channels View, and see what happens when you repeatedly click the visibility icon for this layer.

1. Make the BG_PARTS layer active, and select Image > Adjustments > Match Color.

2. In the Match Color palette, select GREEN_LEAVES_16BIT. psd from the Source menu, and select BASE IMAGE from the layer menu (**Figures 3.5.1 and 3.5.2**). Click OK.

FIGURE 3.5.1 *GREEN_LEAVES_16BIT.psd*

FIGURE 3.5.2 *BASE IMAGE*

Step 6: Adding the Background from Image 4

In the final step of the assembly, you will use some of the background details from the BG PARTS layer.

1. Using the Marquee tool (M), select the leaf in the upper-right corner. Copy the selection to its own layer (Command + J / Control + J) and name the new layer BG_LEAF (**Figure 3.6.1**).

2. Create a layer set and name it BG_PARTS.

3. Turn off the BG_PARTS layer, and move the BG_LEAF layer into the BG_PARTS layer set. Choose the Move tool (V), and drag the BG_LEAF layer up and to the upper right corner (**Figure 3.6.2**).

FIGURE 3.6.1 *The new BG_LEAF layer*

FIGURE 3.6.2 *Drag the BG_LEAF layer up and to the right*

FIGURE 3.6.3 *Selecting the Transform tool on BG_LEAF*

FIGURE 3.6.4 *Rotating the layer 45°*

4. Add a black-filled layer mask, making sure the foreground color is white and the background is black. Select a soft 175-pixel brush, and paint in just the area of the leaf. (Make sure that no hard edges remain after brushing.) This layer will be one of the two main building blocks you will use to fill in the aesthetic details.

5. Duplicate the BG_LEAF layer. Move the new layer midway down the right side of the image. Choose Edit > Transform > Rotate. Rotate the layer 45° clockwise, and then move it slightly to the right. Press Return / Enter to apply the transformation. Name this layer BG_LEAF_45 (**Figures 3.6.3** and **3.6.4**).

You now have the two building blocks you need to construct the background. Bear in mind—and make use of—layer order and different levels of opacity.

6. Duplicate the layer BG LEAF. Move the new layer to the upper-left corner of the BG_LEAF layer so that only the bottom half of the leaf is showing. Reduce the opacity to around 80%.

7. Duplicate the BG_LEAF 45 layer. Move the new layer to the upper right of the BG_LEAF 45 layer. Lower the opacity to 80%. Duplicate this layer and move it to the upper left of BG_LEAF 45 and lower the opacity to 50%.

8. Duplicate the layer BG_LEAF copy. Move that layer so that the upper-right part of the layer is just below the lower-left part of the layer BG_LEAF 45 copy. Lower the opacity to 50%.

9. Duplicate the BG_LEAF layer copy 3. Move the new layer so that the upper right of the duplicated layer is below the lower right of the BG_LEAF 45 copy layer. Lower the opacity to 50%.

10. Duplicate the BG_LEAF 45 layer. Move the new layer to the upper left of the BG_LEAF copy 2 layer so that only the bottom half of the leaf is showing. Lower the opacity to 50%. Duplicate this layer and move it to the upper left of BG_LEAF 45 and lower the opacity to 50%.

The composite image is now complete. The focal points on the various leaves are all correct, and the upper-right corner has the desired background detail (**Figures 3.6.5** and **3.6.6**).

Figure 3.6.5 *Before*

Figure 3.6.6 *After*

You now have the main image that is the sum of all of the harvested parts. Before starting the next set of aesthetic corrections, you need to clean up the file structure before merging all active layers into one while keeping all the previous layers intact, i.e., doing "the Move" (see Chapter 1).

11. Click the top layer (BG_PARTS) to make it active, but do not make it visible. Holding down the Shift key, click on the BASE layer. (This will select the BASE layer and all of the layers below it.)

12. Click-and drag the selected layers and layer groups to the Create Layer Set icon located at the bottom of the Layers panel. Name the new layer set MASTER_ALL.

13. What you do next depends on which version of Photoshop you have. For CS2 and above, press and hold Command + Option + Shift + E / Control + Alt + Shift + E. For CS and below, press Control + Alt + Shift / Command + Option + Shift, then type N and then E.

In both cases, the result is a master layer that contains all the previous layers. Name it MASTER_1 (**Figure 3.6.7**).

NOTE: When you do "the Move" in CS2 and above, the name "Merge Stamp Visible" appears in the History palette.

Figure 3.6.7 *The new master layer MASTER_1*

FIGURE 3.7.1 *The image after changing the blend mode to Difference*

FIGURE 3.7.2 *Three sample points on the image*

Step 7: Removing the SLR Sensor Color Cast

As you have done in the previous two chapters, you will now deal with the image's color cast attributable to the SLR sensor. This color cast is caused by data interpolation errors of the CCD or CMOS image's Bayer array data in the post-processing of the capture, and occurs in all digitally captured images. (For a complete discussion of color cast correction, see Chapter 1.)

1. Create a new layer set and name it BP/WP/MP.

2. Create a Threshold adjustment layer. Select the Sample Point sampler from the tool bar. Move the slider all the way to the left, then slowly to the right until you see meaningful black. Shift-click a sample point.

3. Move the Threshold slider all the way to the right, then move it slowly to the left until you see the first or second white pixel. Shift-click a sample point. Click Cancel.

4. Create a new layer.

5. Go to Edit > Fill > Fill with 50% gray and click OK.

6. Select the Difference blend mode. You should see this (**Figure 3.7.1**).

7. Select the Threshold adjustment layer and move the slider fully left.

8. Move the slider to the right until you first see black dots. (I went to a threshold setting of 4.) Zoom in to that area and place a sample point.

9. Discard the Threshold adjustment layer.

10. Discard the 50% gray Difference blend mode layer. You should now have an image with three sample points, one each for black, white, and midpoint (**Figure 3.7.2**).

NOTE: If you have not already done so, set the black eyedropper in the Black Point Curves adjustment layer to R:7 G:7 B:7 and the white eyedropper in the White Point Curves adjustment layer to R:247 G:247 B:247. You set these values by double-clicking the eyedropper.

FIGURE 3.7.3 *The image before the color cast correction*

FIGURE 3.7.4 *The image after the color cast correction*

11. Zoom in to the area where you placed the first sample point. Create a Curves adjustment layer. With the black eye-dropper, click the sample point and click OK. Name this layer BP.

12. Zoom in to the area where you placed the second sample point. Create a Curves adjustment layer. With the white eye-dropper, click the sample point and click OK. Name this layer WP.

13. Zoom in to the area where you placed the third sample point. Create a Curves adjustment layer. With the white eye-dropper, click the sample point and click OK. Name this layer MP.

14. Save the file.

Compare the image before (**Figure 3.7.3**) and after the color cast correction (**Figure 3.7.4**).

Side Step 7.5: Creating the Image Map for the Aesthetic Aspect of This Image

Now that you have one image with which to work, it is time to map out what aesthetic manipulations you want to make. At the moment that this image took me, I began pre-visualizing it as I wanted it to become, i.e., I asked myself what I might need to do to create the image that I saw in my mind's eye. I captured, or harvested, images the way I did so that when I sat down at the computer to work, I could create the vision that I had in mind.

As I have previously discussed, there is a very specific way that the eye sees and moves across an image. In this picture, you want the eye to go first to the top leaf, then to the leaf in the middle, then to the foreground leaf, then to the back set of leaves, and finally, to the background.

NOTE: I suggest you try mapping some of your own images. Start practicing at practicing.

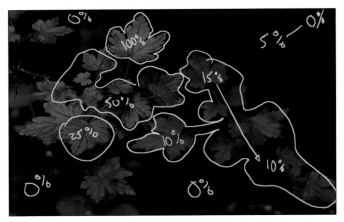

FIGURE 3.7.5 *The image map*

1. Select the Pen tool, make the brush size 8 pixels, and choose a yellow color from the color picker. Create a new layer and name it GF_OVER_ALL_IM.

Here is the image map that I created (**Figure 3.7.5**).

Step 8: Making Lemonade Out of Color Cast Lemons

If you look at all three of the of the corrections you just made, you should observe that the BP adjustment adds a little coolness to the image (**Figure 3.8.1**), WP lightens and slightly warms up the image (**Figure 3.8.2**), and the MP adds even more warmth (**Figure 3.8.3**). Also, take a look at what all three corrections look like combined (**Figure 3.8.4**).

FIGURE 3.8.1 *The image with the BP adjustment*

FIGURE 3.8.3 *The image with the MP adjustment*

FIGURE 3.8.2 *The image with the WP adjustment*

FIGURE 3.8.4 *The image with all three adjustments*

Because you are trying to replicate the reality of the light (shadows are bluer than lit areas, warm colors appear to move forward, and cool colors appear to recede), minimize the cumulative and possibly multiplicative effects of image manipulation artifacting, and undo some of the limitations of the technology that was used, you will use the color cast of the file to your advantage.

1. Fill the WP Curves adjustment layer with black.

2. Select the Brush tool (B), set the opacity to 100% and the brush width to 100 pixels, and brush the upper leaf.

3. Set the opacity of the brush to 50% and brush in the mid-leaves area. Bring up the Fade effect dialog box and increase the amount to 72%.

FIGURE 3.8.5 *The image before the brushwork*

FIGURE 3.8.6 *The image after the selective brushwork*

4. Brush in the front leaf at 50%.

5. Brush in the leaf cluster to the lower right of the image, bring up the Fade effect dialog box, and lower the opacity to 27%.

6. Brush in the leaf cluster below the front leaf, bring up the Fade effect dialog box, and lower the opacity to 15%.

7. Brush the upper right corner of the image (where you added the background image structure), then bring up the Fade effect dialog box, and reduce it to 15%.

8. Now, re-brush over the area closest to the right set of leaves, bring up the Fade effect dialog box, and reduce the opacity to 20%.

9. Holding down the Option / Alt key, click on the layer mask you have just created and drag it to the MP layer mask. When Photoshop asks if you want to replace the layer mask, click OK.

10. Do "the Move" and name this layer MASTER_2.

11. Save the file.

Compare the image before (**Figure 3.8.5**) and after the brushwork (**Figure 3.8.6**). Also look at the resulting layer mask (**Figure 3.8.7**).

FIGURE 3.8.7 *The layer mask for the brushwork*

Step 9: Removing the Blue Cast

Objects photographed in sunlight tend to have a blue cast, and if they are in shadow, they are even bluer. You will use the Nik Software Color Efex Pro 3.0 Skylight filter to color correct the Green Fairy image. This filter removes the blue cast and makes the colors more realistic.

1. Create a layer set and name it SKYLIGHT/CONTRAST/SHARPEN.

2. Duplicate the MASTER_2 layer (Command + J / Control + J) and convert it to a Smart Filter. Duplicate the layer that you just converted so that you have two Smart Filter layers.

FIGURE 3.9.1 *Before the Skylight filter*

FIGURE 3.9.2 *After the Skylight filter*

3. Turn off the second Smart Filter layer (the one you just made) and make the first Smart Filter layer (MASTER_2copy) active. Name this layer SKYLIGHT.

4. Go to Filter > Nik Software > Color Efex Pro 3.0 Versace Edition. Select Skylight from the three plug-in options and click OK. For this image, the default of 25% appears to be best.

5. Holding down the Option / Alt key, click on the layer mask of the MP Curves adjustment layer and drag it to the SKYLIGHT layer. This will copy the layer mask from the MP layer and add it to the SKYLIGHT layer. Compare the image before the Skylight filter (**Figure 3.9.1**) and after (**Figure 3.9.2**)

6. Do "the Move." Make a master layer and name it COLOR. Select the Color blend mode from the Blend Mode pull-down menu at the top of the Layers panel (**Figure 3.9.3**).

7. Place this layer above the MASTER_2copy2 layer.

NOTE: You create this layer to preserve the color decisions that you have made to this point. In the next series of steps, you will address issues of contrast and sharpness using the Luminosity blend mode that may affect the image's saturation. By creating this layer with the Color blend mode, the color choices you made will be preserved.

8. Save the file.

FIGURE 3.9.3

Being Selective with Contrast, Tonal Contrast, and Sharpening

Let me reiterate. The human eye goes first to patterns it recognizes in light areas and then in dark ones. The eye also tracks from high to low contrast, in-focus to blur, high to low sharpness (which is different than in-focus to blur), and then high to low saturation of color. In this next step, you are going to play with contrast and sharpness.

Contrast is often confused with contrast ratio. Contrast is the difference in brightness between the light and dark areas of a picture. If there is a large difference between those two, the image has high contrast. Contrast ratio is the ratio of the luminance (brightness), as measured on a meter, of the whitest pixel divided by the luminance of the blackest pixel. By adjusting that ratio, you can increase or decrease the contrast in an image.

Sharpening (or specifically in Photoshop, Unsharp Masking) is the increase of apparent edge contrast accomplished by increasing contrast on either side of the pixels' edges. In this way, contrast and sharpness are related. It is worth noting, however, that contrast is normally spoken of on a global scale, and sharpness is highly localized.

NOTE: When an image is sharpened using Unsharp Masking, Photoshop does not really sharpen the image. Rather, it creates an illusion of sharpening by increasing contrast at the edges of objects within the image. This illusion (called the Craik-O'Brien-Cornsweet Edge illusion) is created when an edge of an element in an image is modified by lightening one side and darkening the other. After this is done, the area next to the darkened side of the edge appears darker in tone and the area next to the lighter side appears lighter. (For a visual example of this, go to http://en.wikipedia.org/wiki/Cornsweet_illusion.)

The technique of Unsharp Masking is not a new one. It actually had its origins in, and derived its name from, a darkroom printing technique developed in the 1930s. This technique involved printing a normal negative sandwiched with a blurred positive copy of that negative. The result was a print in which the edges of the image elements had the illusion of higher contrast and, therefore, sharpness. Photoshop does this mathematically by manipulating pixels.

Though contrast and sharpness (or more specifically, Unsharp Masking) are technically similar in digital imagery, they differ in the way they can interact in an image. This is why you will be addressing the issues of selective aesthetic contrast and sharpness on two different layers. I will have you start with selective contrast.

Step 10: Selective Tonal Contrast

1. Duplicate the MASTER_2copy2 twice. Turn off the two layers you just copied and make the MASTER_2copy2 active.

2. Name this layer TONAL_CONTRAST.

3. Set the layer blend mode to Luminosity.

4. Select Filter > Nik Software > Color Efex Pro 3.0 Versace Edition. When the Nik filter dialog box appears, select Tonal Contrast.

5. If you have not already, select Split View.

6. Zoom in so that you have a view that shows part of the top and mid-leaves area (**Figure 3.10.1**).

7. For this image, first move the Contrast slider to +70, and then the Shadow slider to +40. Leave the Highlight at the default of +30.

FIGURE 3.10.1 *Zoom in to the upper left leaves in Tonal Contrast*

8. Lower the layer opacity to 63% and click OK (**Figure 3.10.2**).

9. Holding down the Option / Alt key, click on the layer mask of the SKYLIGHT layer, and drag it to the TONAL_CONTRAST layer. Compare the image before and after the Tonal Contrast layer (**Figures 3.10.3** and **3.10.4**).

NOTE: When copying layer masks to layers where sharpening and contrast are applied, you may see things that were not apparent before copying and applying the layer mask. This is what happened when I first worked with this image. Just tighten up the layer mask with the techniques that were discussed in Chapter 1.

FIGURE 3.10.2 *The image after applying Tonal Contrast globally*

FIGURE 3.10.3 *Before the Tonal Contrast layer*

FIGURE 3.10.4 *After the Tonal Contrast layer*

FIGURE 3.11.1 *Zoom in to the main leaf area*

FIGURE 3.11.2 *The shadows are blocked up*

FIGURE 3.11.3

Step 11: Adding Contrast Using the Contrast Only Filter

1. Turn on and make the MASTER_2copy3 layer the active one.

2. Name this layer CONTRAST_ONLY.

3. Select the Luminosity blend mode.

4. Select Filter > Nik Software > Color Efex Pro 3.0 Versace Edition. When the Nik filter dialog box appears, select Contrast Only. Zoom in to an area that has the main leaf and mid-leaves (**Figure 3.11.1**).

5. From the default setting of 50%, move the Brightness slider to 20%. You should see that the contrast is good, but the shadows are blocked up (**Figure 3.11.2**). Open the Protect Shadows and Highlights dialog box and set Protect Shadows to 50%. Raise the contrast to 55%. Lastly, adjust the Saturation slider to about 20%. (Even though you are working in Luminosity mode, by correcting for saturation, you add back some image structure that may be lost by boosting the contrast. I prefer this approach to contrast, because it offers me a level of control not found in other techniques.) This is what the dialog box should look like (**Figure 3.11.3**).

6. Click OK.

7. Holding down the Option / Alt key on the layer mask of the TONAL_CONTRAST layer, drag it to the CONTRAST_ONLY layer.

8. Move the CONTRAST_ONLY layer beneath the TONAL_CONTRAST layer.

9. Reduce the opacity to 74%.

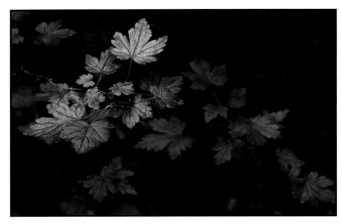

FIGURE 3.11.4 *Before the Contrast Only layer*

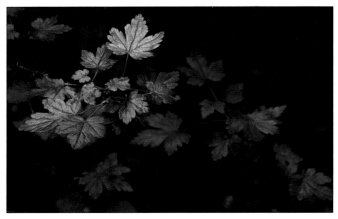

FIGURE 3.11.5 *After the Contrast Only layer*

NOTE: There is a bit of a dance between Contrast Only, Tonal Contrast, and Sharpening. Every image is different and, frequently, that difference determines what the layer order should be. The reason for separating Contrast, Tonal Contrast, and Sharpening into separate layers has to do with the multiplicative nature of artifacting. If you add sharpening to a layer that has any form of contrast applied to it, you will cause serious artifacting that will show up as noticeable halos around the edges of the objects in the image and will also aggravate any noise in the image. By separating out the different forms of sharpening and contrast, you can use layer opacity to blend them together.

You can also increase contrast with the Brightness/Contrast sliders (Image > Adjustments > Brightness/Contrast) or with Curves adjustment layers, a better choice than Photoshop's Brightness/Contrast. You increase contrast with a Curves adjustment layer by creating such a layer and clicking on the center point of the curve to lock it. You then place the mouse pointer over the curve, two grid lines up and right, and you drag that point up and to the left to increase the contrast until it is visually pleasing. Don't drag too far; you need but a small correction. Click OK. Create a layer mask filled with black, and do the appropriate brushwork. In my opinion, however, the Nik Software algorithm is superior to the one in Photoshop and you now own it.

10. Save the file. Compare the image before (**Figure 3.11.4**) and after the Contrast Only layer (**Figure 3.11.5**).

Step 12: Selective Sharpening

Some believe that you should sharpen an image only to allow for an increased output size. Others believe that sharpening is the last thing you do before printing. In my experience neither is always true. What I have experienced is that most people do not know how to correctly sharpen an image once, let alone how to do it correctly multiple times.

Whether TIFF, JPEG, or RAW, all digitally captured files require some form of sharpening. This is due to the interpolation process that occurs when the data is converted from its original form to the form on which you will work.

In addition to sharpening the original digital capture, another consideration is aesthetic, or selective, sharpening that you are going to do in this step. There is also sharpening for output, which is one of the last things you will do to an image, but not always the very last. So an image may be sharpened as many as three times.

It is important to understand some of the problems associated with sharpening. As I discussed at the beginning of this section, Unsharp Masking does not really sharpen an image. It adds visually appealing artifacts that create the illusion of increased sharpness. There are other issues. When you view an image on your monitor, you view a file that is 240 to 360ppi (pixels per inch) on a 72ppi screen. Such images will be printed at either 720, 1440, 2880, or 5760dpi (dots per inch). So what looks right on the screen is probably under-sharpened for output, and what looks over-sharpened on the screen is probably about right. How do you know how much to over-sharpen? You do not—and that is a problem.

There is more: flat planes, lines, foliage, blur, and skin tones all need to be sharpened differently, because each requires different amounts of sharpening at different values in order to minimize artifacting and image noise, and to maintain a pleasing visual experience. In addition, viewing distance, paper type, printer output resolution, printer type, and the amount of dot gain (the expansion of the ink droplet on the paper) are all factors that affect sharpness. Because of this, I generally sharpen using Approach 1 below, because the Nik software is able to detect if something has been sharpened more than once and adjusts accordingly. You should be aware, however, that I also use some or all of the types of sharpening in the Photoshop Only approach.

In this step, I will show you two ways to sharpen an image: one with third party software and one with Photoshop. Both are contained in the 100ppi version of the file that I created while writing this chapter. I recommend that you explore both approaches.

NOTE: If you do not have the Nik Software, you can download a fully functional demo at www.niksoftware.com. Also, if you do not want to play with this software, skip to Approach 2: Sharpening with Photoshop Only.

Approach 1: Using the Nik Software Sharpener Pro 3.0 Filter

1. Make the MASTER_2copy4 layer active and name it NIK_SHARPEN.

2. Set the layer blend mode to Luminosity.

3. Go to Filter > Nik Software > Sharpener Pro 3.0 (2) Output Sharpen.

4. In the Output Sharpening pull-down menu, select Inkjet (**Figure 3.12.1**).

FIGURE 3.12.1

FIGURE 3.12.2

FIGURE 3.12.3

FIGURE 3.12.4

FIGURE 3.12.5

5. When the Output Sharpening choices update for the sharpening type you selected, leave the Viewing Distance set to Auto. You are creating a fine-art print, so select Textured & Fine Art for the Paper Type. I normally use Epson Somerset Velvet or Epson Cold Press Natural paper. The printer resolution for these papers is 2880 x1440 (**Figure 3.12.2**).

6. In the Creative Sharpening dialog box, start with Structure and move the slider until you have a bit more correction than you think you need. I chose 40% (**Figure 3.12.3**).

7. Next, move the Local Contrast slider until you have a bit more correction than you think you need. I chose 33% (**Figure 3.12.4**).

8. Move the Focus slider until you have a bit more correction than you think you need. I chose 45% (**Figure 3.12.5**).

9. Leave the Output Sharpening Strength at the default of 100%.

10. Click OK.

NOTE: Sharpener Pro also has control points and the ability to sharpen by color. But this image does not require that level of granular control, because it is highly monochromatic. (It is all green.)

11. Holding down the Option / Alt key, click on the layer mask of the CONTRAST_ONLY layer and drag it to the NIK_SHARPEN layer.

Before moving on, compare the image before the NIK_SHARPEN layer (**Figure 3.12.6**), after the NIK_SHARPEN layer (**Figure 3.12.7**), and then after adding the layer mask (**Figure 3.12.8**).

There are two reasons that it is critical to make the layer mask as tight as possible, as well as to make sure that any unwanted areas of sharpness are removed. First, whenever you sharpen an image, you add contrast to the edge of pixels that tends to enhance noise. Second, you do not want to sharpen areas that you want blurred. In this next step, you will tighten up the layer mask.

FIGURE 3.12.6 *Before the NIK_SHARPEN layer*

FIGURE 3.12.7 *After the NIK_SHARPEN layer*

FIGURE 3.12.8 *After adding the layer mask to the NIK_SHARPEN layer*

12. Making sure that the newly added layer mask is active, click on the backward slash key (\), which puts the layer mask in Quick Mask view mode. You should now see this (**Figure 3.12.9**).

13. Select the Brush tool, make the foreground color black, and the background color white. Set the brush opacity to 100% with a width of 300 pixels. Brush in the upper right corner (the area in which you added background detail) just up to the lower leaves (**Figure 3.12.10**).

14. Reduce the brush size to 30 pixels, and brush in the area around the upper leaf and any areas in the mid-leaf part of

FIGURE 3.12.9 *The image in Quick Mask view*

FIGURE 3.12.10 *Cleaning up the mask on the upper right*

FIGURE 3.12.11 *Tightening up the layer mask in the midleaf area*

FIGURE 3.12.12 *The final layer mask*

FIGURE 3.12.13 *The image after lowering the opacity to 59%*

the image through which areas of unwanted sharpening show (**Figure 3.12.11**).

15. Now it is time to fine tune the individual leaves even further. Zoom into the left leaf just below the upper leaf. Option-/ Alt-click on the leaf. Even though you see the screen in red, this action will sample the gray of the layer mask. Brush in the leaf.

16. Repeat this process until you have completely refined the layer mask to your liking (**Figure 3.12.12**).

17. Clicking on the backward slash key (\) takes you out of the layer mask in Quick Mask view mode. Lower the opacity to 59% (**Figure 3.12.13**).

18. Save the file.

Approach 2: Sharpening with Photoshop Only

In this approach, you will sharpen using three different methods: High Pass, LAB, and Smart Sharpen for lens blur.

Sharpening Using the High Pass Filter

1. Inside SKYLIGHT/CONTRAST/SHARPEN, create a layer group and call it CS_SHARPEN.

2. Duplicate the MASTER_2 layer, and place the duplicate into the CS_SHARPEN layer set. Take the duplicate you just placed into the CS_SHARPEN layer set and duplicate it twice more. You should now have three layers.

3. Change the top layer's (MASTER_2 copy 2) blend mode to the Color blend mode. Name this layer COLOR.

4. Turn off the COLOR layer.

5. Turn off the second duplicate layer (MASTER_2 copy 1), make the first layer (MASTER_2 copy) in the layer set active, and name it HIGHPASS.

6. Desaturate the HIGHPASS layer (Command + Shift + U / Control + Shift + U) (**Figure 3.12.14**).

7. Convert the HIGHPASS layer to a Smart Filter.

FIGURE 3.12.14 *The HIGHPASS layer desaturated*

FIGURE 3.12.15

FIGURE 3.12.16

FIGURE 3.12.17 *The image after applying the High Pass filter*

8. Go to Filter > Other > High Pass.

9. If it is not there already, move the Radius slider all the way to the left, or to a radius of 0.3 (**Figure 3.12.15**).

10. Move the slider to the right until you start to see just the edges of the image structures, in this case the leaves. I chose a radius of 6.3 (**Figure 3.12.16**).

11. Click OK and change the HIGHPASS layer blend mode to Softlight (**Figure 3.12.17**).

12. Holding down the Option / Alt key, click on the layer mask of the CONTRAST_ONLY layer and drag it to the HIGHPASS layer.

If you did not do Approach 1, do steps 12 through 18 from Approach 1: Using the Nik Software Sharpener Pro 3.0 filter. If you did Approach 1, just copy the layer mask from the NIK_SHARPEN layer.

13. Reduce the layer opacity to 55%.

14. Turn the COLOR layer back on.

NOTE: High Pass sharpening is good for sharpening only the edges in an image, but not the image structures in which the noise tends to be found. Because you need to use the Overlay or Softlight blend modes to do this type of sharpening, using the Luminosity blend mode to avoid sharpening color is not a option. When sharpening with the High Pass filter you should always desaturate the layer first.

Sharpening in Lab

To sharpen in the Lab space requires converting the file from the RGB space to the Lab space.

NOTE: I learned this sharpening technique and the specific approach to increasing saturation in Step 10 from Dan Margulis. I highly recommend his book, *Photoshop* LAB *Color: The Canyon Conundrum and Other Adventures in the Most Powerful Colorspace* **(Peachpit, 2005).**

Many of the limitations of sharpening have to do with the light artifacts it inserts, rather than the dark ones. The following action separates the two functions; the darkening is on the middle layer and the lightening on top, and the action automatically cuts the lightening in half.

1. Duplicate the image file on which you are working by going to Image > Duplicate.

2. When the Duplicate Image dialog box comes up, rename the file GREENLEAVES_16BIT_LAB.

3. Turn off all the layers above the SKYLIGHT layer, so that only the SKYLIGHT layer is visible.

4. Flatten the image. Click OK when the Flatten Image dialog box comes up asking you to discard hidden layers.

5. Go to Image > Mode and select Lab Color (**Figure 3.12.18**).

Figure 3.12.18 *Converting the image to Lab color*

6. Duplicate the BACKGROUND layer.

7. Name it SHARPEN and change the blend mode to Luminosity.

8. Create a layer set and name it LAB_SHARPEN. Drag the SHARPEN layer into the LAB_SHARPEN layer set.

9. Go to Filter > Sharpen and select Smart Sharpen.

10. In the Smart Sharpen dialog box, select Gaussian Blur from the Remove pull-down menu and set the Amount to 500% and the Radius to 0.1 (**Figure 3.12.19**). (This approach is know as "He-Man Sharpening.")

11. Move the Radius to the range of sharpening you desire. I chose 1.5 pixels (**Figure 3.12.20**).

Lower the Amount of sharpening until you remove the crispyness (or hardness) and halos around the edges of the image. I chose 229% (**Figure 3.12.21**).

12. Click OK.

NOTE: You are working only on the L channel, even though you did not explicitly select it, because Luminosity mode excludes the A and B channels. (More about A and B channels in a little while.)

13. Do "the Move" and name this layer LAB_SHARPEN.

14. Holding down the Shift key, drag the LAB_SHARPEN layer to the layer set folder CS_SHARPEN in the GREENLEAVES_16BIT file. Set the layer blend mode to Luminosity.

15. Turn off the LAB_SHARPEN layer set in the GREENLEAVES_16BIT_LAB file and save the file. (You will be revisiting this file in a moment.)

16. Copy the layer mask from the HIGHPASS layer.

17. Reduce the layer opacity to 55%.

18. Save the file.

FIGURE 3.12.19 *Starting He-Man Sharpening with High Pass*

FIGURE 3.12.20 *Setting the Radius to 1.5 pixels*

FIGURE 3.12.21 *Lowering the Amount to reduce halos*

NOTE: The Gaussian Blur Removal option is a good call if the image on which you are working is slightly out of focus. This is very similar to the regular unsharp masking technique.

Sharpening Using the Smart Sharpen Lens Blur Filter

1. Turn on MASTER_2copy2 and make it the active layer.

2. Change the blend mode to Luminosity and convert the layer to a Smart Filter. (This layer should be the top layer in the CS_SHARPEN layer set folder.) Name this layer SMART_SHARPEN_LENS.

3. Go to Filter > Sharpen and select Smart Sharpen.

4. In the Smart Sharpen dialog box, select Lens Blur from the Remove pull-down menu and set the Amount to 500% and the Radius to 0.1.

5. Move the Radius to 1.7 and set the Amount to 229% (**Figure 3.12.22**).

FIGURE 3.12.22 *Using Smart Sharpen Lens Blur, Radius at 1.7 pixels and Amount at 229%*

6. Click OK.

7. Copy the layer mask from the HIGHPASS layer.

8. Reduce the layer opacity to 55% (**Figure 3.12.23**).

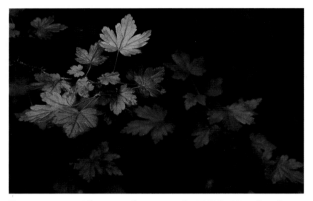

FIGURE 3.12.23 *The image after copying the HIGHPASS mask to the SMART_SHARPEN_LENS layer*

Making One Sharpening Effect Out of the Three

Each type of sharpening sharpens the image in a slightly different way and each has a benefit. However, if you were to do all three types of sharpening to the same layer at the amounts that you just did in the steps above, this is what it would look like (**Figures 3.12.24.1** and **3.12.24.2**). The artifacting that you see here is not only cumulative, it is multiplicative as well. Let me give you an extremely hypothetical example. If you were to make an adjustment to a layer, and it caused a 5% image quality decrease due to artifacting, and then you made a second adjustment to that same layer that caused another 5% quality decrease, the total decrease in quality would not be merely 5 + 5 = 10%, it would be 5 + 5 = 10 x 5 for a 50% quality decrease. It has been my observation that the multiplicative effect of artifacting tends to be a larger issue when dealing with adjustments to contrast and sharpening.

By separating the different forms of sharpening into different layers and then by using opacity to blend them together, you get the benefits of each, but without undue exacerbation of the artifacting (**Figures 3.12.25**). Also, this approach allows you the ability to change the order of the sharpening(s) as well as the individual amounts.

FIGURE 3.12.24.1 *The same three sharpening methods applied to one layer*

FIGURE 3.12.24.2 *A close-up of the same three sharpening methods applied to one layer*

FIGURE 3.12.25 *All three sharpening methods applied to different layers to reduce artifacting*

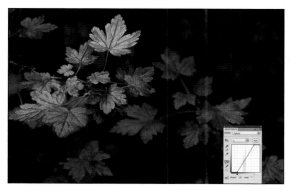

FIGURE 3.13.1 *Adjusting the Curves to increase saturation while in Lab color mode*

FIGURE 3.13.2 *Adjusting the "b" channel to increase saturation*

Now That That is Done...

Whichever way you go—using just one approach to sharpening or combining High Pass, Lab, Smart Sharpen, and/or Nik Software Sharpener Pro—do the following.

1. Make the SKYLIGHT/CONTRAST/SHARPEN layer set active.

2. Do "the Move" and name the new layer MASTER_3.

3. Turn off the SKYLIGHT/CONTRAST/SHARPEN layer set. (This will speed up both the opening and saving of this file.)

Step 13: Increasing Saturation in the LAB Color Space

1. Make MASTER_3 the active layer and, holding down the Shift key, drag it to the file GREENLEAVES_16BIT_LAB. Create a new layer set and name it LAB_COLOR. Place the MASTER_3 layer into the LAB_COLOR layer set.

2. Create a Curves adjustment layer. (If you do not have the small grid on the Curves adjustment layer, Option- / Alt-click on the grid to switch it to Fine Grid mode.) Select "a" and move both the top and bottom anchor points over two grid lines (**Figure 3.13.1**).

3. Select "b" and move the top anchor point over two grid lines and the bottom over one grid line (**Figure 3.13.2**).

4. Do "the Move" and name this new layer LAB_COLOR.

5. Save the file.

6. Shift-drag the LAB_COLOR layer into the GREEN_LEAVES_16BIT.psd file.

7. Set the layer blend mode to Color.

8. Save the GREEN_LEAVES_16BIT_LAB file.

9. Close the file.

10. In the GREEN_LEAVES_16BIT.psd file, lower the opacity to dial in the color. I chose 56% (**Figure 3.13.3**).

NOTE: The "L" of Lab is the Lightness or Luminance channel, "A" is Red to Green, and "B" is Yellow to Blue. Keep in mind that the settings used here are only for this image. As a rule, I never move the anchor points more than three grid points to the left or right, depending on whether it is to the top or bottom of the curve. As much as possible, I try to keep movement to one grid point. The positive values, or the top of the curve, address warm colors, and the negative values, or bottom part of the curve, adjust cooler colors.

FIGURE 3.13.3 *The image after the layer opacity is lowered to 56%*

Step 14: Using Multiple Curves Adjustment Layers for Selective Dark-to-Light and Light-to-Dark

In this step, you are going to create the dappling of light that occurs when sunlight travels through the leaves of a tree. You will do this by using two Curves adjustment layers and by changing the blend modes to Multiply and Screen.

Dark-to-Light Curves Adjustment Layer Using the Multiply Blend Mode

You are now at the point in this workflow to add dark into this image. You should begin with the Curves adjustment layer set to the Multiply blend mode. You will add more darkness than lightness, so it makes sense to cover the most ground first. Also, by addressing the "dark" issues, it will be easier to see where the additional areas of light should go to create the dappled light effect.

1. Make the MASTER_3 layer active, make a new layer set, and name it L2D/D2L/LIGHTING. (The latter set should be between the LAB_COLOR layer and the MASTER_3 layer.)

2. Create a Curves adjustment layer and name it D2L_MULTI.

3. Change the blend mode of this layer from Normal to Multiply.

4. Lower the opacity until you can see some of the background leaves. I chose 70%.

NOTE: Notice that the lighting of the image has begun to look the way you want it. That is because everything you have been doing up to this point is to reinforce, through the use of color , sharpness, and contrast, the image in your mind's eye. What you will do next is to remove everything that is not your vision of the image.

5. Select the Brush tool (B), and set the opacity to 100% and the brush width to 100 pixels. Brush the top leaf. Compare the image before (**Figure 3.14.1**) and after the brushwork (**Figure 3.14.2**), and the resulting layer mask (**Figure 3.14.3**).

FIGURE 3.14.1 *The image before brushing in the D2L_MULTI layer*

FIGURE 3.14.2 *The image after the initial brushwork*

FIGURE 3.14.3 *The beginning layer mask for D2L_MULTI*

6. Set the brush opacity to 50% and the brush width to 200 pixels, and brush the area of the mid-leaves. Bring up the Fade effect dialog box and increase the opacity to 69%. **Figure 3.14.4** shows the resulting layer mask.

7. Brush in the leaf cluster that is in the lower right of the image. Bring up the Fade effect dialog box and lower the opacity to 33%. **Figure 3.14.5** shows the resulting layer mask.

FIGURE 3.14.4 *The layer mask after more brushwork*

FIGURE 3.14.5 *Brushing in the leaf cluster in the lower right*

8. Brush in the background in the upper right corner. Bring up the Fade effect dialog box and lower the opacity to 10%. Compare the image before the brushwork (**Figure 3.14.6**), the image after (**Figure 3.14.7**), and the final layer mask (**Figure 3.14.8**).

FIGURE 3.14.6 *Before the brushwork*

FIGURE 3.14.7 *After the brushwork*

FIGURE 3.14.8 *The final layer mask*

Light-to-Dark Curves Adjustment Layer

1. Create a Curves adjustment layer and name it L2D_SCREEN.

2. Change the blend mode of this layer from Normal to Screen.

3. Create a layer mask and fill it with black.

4. Select the Brush tool (B), and set its opacity to 50% and its width to 100 pixels. Brush in the leaf in the lower left corner, just below the mid-leaf cluster that is right under the foreground leaf on which you did the warp work. Use the Fade effect command to lower the opacity to 28%. Look at the layer mask (**Figure 3.14.9**) and the image after the initial brushwork (**Figure 3.14.10**).

FIGURE 3.14.9 *The layer mask for the L2D_SCREEN layer*

FIGURE 3.14.10 *The image after initial brushwork*

5. Brush in the area at the bottom of the image between the leaf you just brushed and the leaf cluster to the right. Use the Fade effect command to lower the opacity to 39%. View the layer mask (**Figure 3.14.11**) and the image after the brushwork (**Figure 3.14.12**).

6. Brush in the lower bottom left corner of the image and bring up the Fade effect dialog box. Use the Fade effect command to lower the opacity to 39%. View the layer mask (**Figure 3.14.13**) and the image after the brushwork (**Figure 3.14.14**).

FIGURE 3.14.11 *The layer mask*

FIGURE 3.14.13 *The layer mask*

FIGURE 3.14.12 *The image after brushwork*

FIGURE 3.14.14 *The image after brushwork*

7. Brush in the upper left leaf at 50% opacity, and then brush in the middle of the lower right leaves. Bring up the Fade effect dialog box and lower the opacity to 16%. Brush in the corner. Bring up the Fade effect dialog box and lower the opacity to 39%. Lastly, lower the overall layer opacity to 71%. View the layer mask (**Figure 3.14.15**) and the final image after the brushwork (**Figure 3.14.16**).

8. Save the file.

FIGURE 3.14.15 *The layer mask after all brushwork*

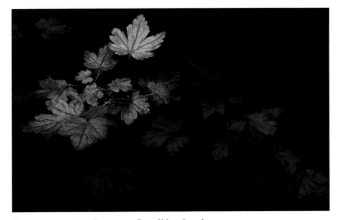

FIGURE 3.14.16 *The image after all brushwork*

Step 15: Adding a Ray of Sunlight

To add the final touch to this image, you will create the effect of a dappled ray of sunlight hitting the various leaves. But first, there is one problem you need to address. The file on which you are working is in 16-bit, and the Render Lighting Effects filter works only in 8-bit.

You do not need the Render Lighting Effects filter to light this image because you have already done that. You will use the Render Lighting Effects filter because it creates ambient light by adding gray to the haze in a image. This quality is what is needed to finish the look of light coming through tree branches in a forest.

It seems a shame to have come all this way in 16-bit ProPhoto RGB only to have to go to 8-bit Adobe RGB. So here is a work-around for this issue.

1. Make MASTER_3 the active layer.

2. Select All (Command + A / Control + A).

3. Deselect the section. Select the Crop tool (C) and click on the image.

4. Copy the MASTER_3 layer to the Clipboard (Command + C / Control + C).

5. Create a new file (Command + N / Control + N).

6. Make sure that the color space is ProPhoto and that you change the bit depth to 8-bit in the Title dialog box. Name the file RENDER_LIGHT_GREENLEAF.

7. Click OK.

8. Paste the image that you copied to the clipboard into this file.

9. Name the newly created layer RENDER_LIGHT and convert it to a Smart Filter.

10. Go to Filter > Render > Lighting Effects.

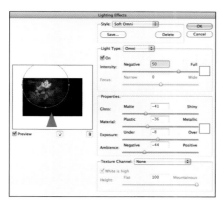

FIGURE 3.15.1 *Moving the light to the upper leaf*

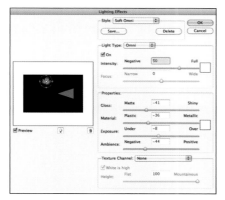

FIGURE 3.15.2 *Reducing the size of the light*

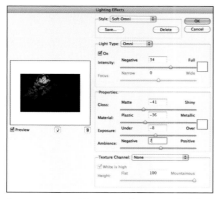

FIGURE 3.15.3 *Adjusting the Intensity and Ambience*

11. When the Render Lighting Effects dialog box comes up, select Soft Omni from the Light Type pull-down menu.

12. Click on the center handle and move the center point to the middle of the upper leaf (**Figure 3.15.1**).

13. Click on the right handle and reduce the size of the light until it is around just the leaf (**Figure 3.15.2**).

14. Lower the Intensity to 34 and increase the Ambience to 7 (**Figure 3.15.3**).

15. Click OK.

16. Do "the Move." Make a master layer and name it RENDER_LIGHT.

NOTE: You now have two layers named RENDER_LIGHT. One is a Smart Filter layer—the one you can readjust should the need arise, and one that is a snapshot of the Smart Filter layer. You are doing this because the Render Lighting Effects filter works only in 8-bit. Therefore, the Smart Filter would not transfer over.

17. Save the file.

18. Shift-drag the RENDER_LIGHT layer to the GREENLEAF_16BIT file and place it in the L2D/D2L/LIGHT-ING layer group so that it is below the two Curves adjustment layers.

19. Close the RENDER_LIGHT_GREENLEAF.psd file.

20. Add a layer mask to the RENDER_LIGHT layer.

FIGURE 3.15.4 *The layer mask after brushwork*

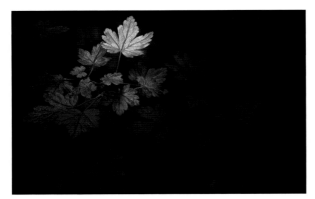

FIGURE 3.15.5 *The resulting image after brushwork*

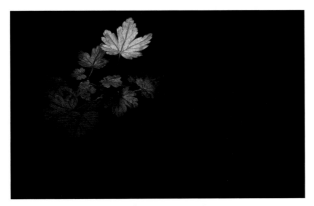

FIGURE 3.15.6 *The image before the opacity adjustment*

21. Turn off the D2L and L2D Curves adjustment layers.

22. Brush the front leaf at 33%, the lower right leaf of the mid-leaf cluster at 22%, the lower left corner at 43%, the area at the bottom between the mid-leaf cluster and the lower right leaves at 43%, and the upper right corner at 20%. View the resulting layer mask (**Figure 3.15.4**) and the image after the brushwork (**Figure 3.15.5**).

23. Turn on the D2L and L2D Curves adjustment layers. Make a L2D/D2L/LIGHTING layer group and lower the opacity to suit your eye. I chose 66%. Compare the image before (**Figure 3.15.6**) and after the layer opacity adjustment (**Figure 3.15.7**)

24. Make the LAB_COLOR layer active.

25. Do "the Move" creating a master layer that you will name FINAL.

26. Save the file.

FIGURE 3.15.7 *The image after the opacity adjustment*

Expanding Your Vision

I am always doing things I can't do; that's how I get to do them.

—Pablo Picasso

Image harvesting, or ExDR, is a way to recreate what you originally saw in spite of, and by understanding, the limitations of camera technology. The real limitation is not the camera; it does what it does. You are limited only by your imagination, but if you are open to the impossible and view it merely as an opinion, you can do anything.

Is the image that you just created a believable improbability or a believable probability? Is your answer the same as it was at the beginning of this lesson? If your opinion has changed, you will realize that your feeling for any image may change as you work with it, and that is okay as long as it suits your vision and retains your voice.

In the next chapter, you will further explore the concept of ExDR for focus, blur, exposure, and image structure. The goal will be not only to recreate your original vision, but to cause shape to become the unwitting ally of color in your pursuit to guide the viewer's unconscious eye.

FIGURE 3.16.1 *The final image*

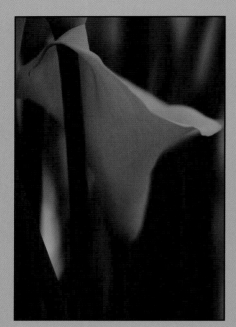

FIGURE 4.0.1 *Before*

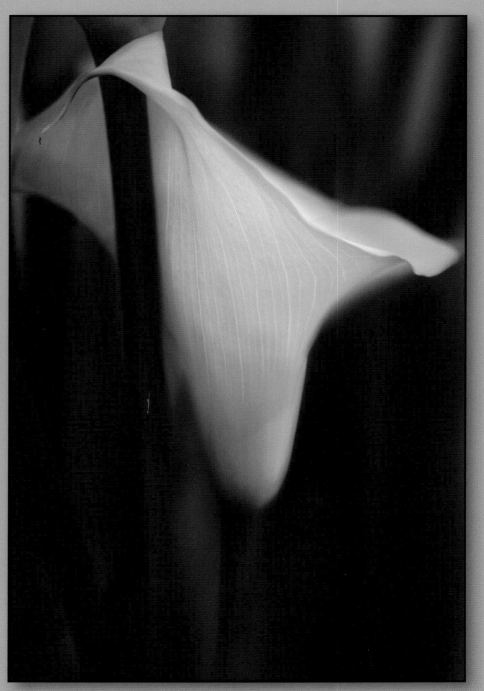

FIGURE 4.0.2 *After*

The Unwitting Ally 2.0

Light, gesture, and color are the key components of any photograph.
Light and color are obvious, but it is gesture that is the most important.
There is gesture in everything. It's up to you to find the gesture that is most telling.

—Jay Maisel

In this chapter, you will go beyond exposure and apply the concepts of Extended Dynamic Range photography (ExDR) to focus, blur, and image structure by using image harvesting. You will apply this to the image editing process in order to support the aesthetic choices you make regarding light, shape, gesture, and color when you first take the picture. Picasso said, "Art is the lie that tells the truth." With that in mind, you will also apply techniques to create an aesthetically satisfying final image rather than a historically accurate one. Additionally, you will use the approach introduced in Chapter 1, and expanded on in Chapters 2 and 3, to guide the viewer's unconscious eye through the image. Finally, you will explore the changes in workflow that you need to make when working with large megapixel files. (The files for this lesson were captured with a Nikon D3x, which is a 24.5MP camera.)

The concepts behind this lesson are the outcome of conversations that I have had over the years with two great photographers: Jay Maisel, who has forgotten more than I will ever know about light, gesture, and color, and who first introduced me to those concepts; and my uncle, photographer CJ Elfont, who taught me photography and, most importantly, how the eye "sees." The writings and images of poet-photographer Ernst Haas have also strongly influenced me by teaching me how to allow the eye to see the feeling of the moments in my images; to be taken by the photograph rather than take the photograph. When you master this lesson, you will have grasped the heart of what I have discovered about how it all works. The real journey begins now.

On Light, Color, Shape, and Gesture

The late painter and designer Josef Albers said that "shape is the enemy of color." By that he meant that when shape is in the presence of color, we tend to remember the shape and not the color. But if you understand how to control color—regardless of whether the photograph is color or black and white—you will have complete mastery of the images you create. The key is to find a way to cause shape to become color's unwitting ally, and thereby make color a shape that the viewer will remember.

This is easier said than done, of course. What you need is a catalyst to make shape and color work in harmony. And this is where pattern comes in.

Patterns are shapes we tend to see in things, sometimes when they are not really there. Patterns tend to manifest themselves as shapes. Whether it is light coming through tree leaves, a paper bag in a subway trash can, or raindrops on a windshield, everything can form or be perceived as a pattern. Patterns are interesting, but a pattern interrupted is more

FIGURE 4.0.3 *A universal gesture*

FIGURE 4.0.4 *Do you see the green or the magenta?*

interesting. If you interrupt a pattern, you are on the path to finding a way to use shape as the unwitting ally of color.

Jay Maisel says that light and color are obvious, but it is gesture that is most important. In the photograph of my niece, the gesture is obvious. The pattern we recognize first is her face, and the finger stuck in her nose interrupts that pattern (**Figure 4.0.3**).

Here is an example of an image where gesture is not as plain as the nose on my niece's face. Look at the image of the flower and the leaves, then look away (**Figure 4.0.4**). Which color do you remember? Most people will say magenta or red. Even though 90% of the image is made up of greens, you tend to remember the part with the most shape. The shape has become an unwitting ally of the color. The color is further reinforced because the magenta/red flower's shape and circular pattern is interrupted by the linear pattern of the green blades. Further, the magenta flower appears to be moving away from the green blades, and this pattern holds the gesture that is most telling.

Of light, gesture, and color, light is the most frequently taken for granted. You see it, it is there, end of story. But rather than merely accepting its presence, why not consider viewing it as an object? Treat it as if it were a solid and a part of the experience being expressed in the photograph.

Take, for example, these images from the original Seattle Sequence series (**Figures 4.0.5, 4.0.6, 4.0.7, 4.0.8, 4.0.9,** and **4.0.10**). The light tells the story of the moment in each image, whether black and white or color. (If you can see something, it has color. The artist Matisse said, "Black is the queen of all colors.")

NOTE: The 12 images that are the original Seattle Sequence were shot in 45 minutes. My skill as a photographer had nothing to do with how quickly I shot; I had forgotten to charge the battery in my camera. I saw the charge eroding as I watched one of the prettiest displays of light that I have ever seen. Shafts of light broke through the clouds of a departing rainstorm, while a new rainstorm was moving in.

FIGURE 4.0.5

FIGURE 4.0.6

FIGURE 4.0.8

FIGURE 4.0.9

FIGURE 4.0.7

FIGURE 4.0.10

Knowing that I had little time to record these images, fear became my caffeine, and I shot until my battery died. Among the images that came from those 45 minutes were 12 that I thought were particularly outstanding. The lessons that I learned were to just shoot the image—don't think about shooting the image—and carry an extra battery.

In each instance, no matter how brief, I perceived the image in its final form as I photographed it, and that perception determined how I harvested the images. In each capture, the light informed the image, made the patterns and interrupted them. In each instance, light was as physical and tangible a thing as the flowers, and for each I considered (no matter how momentarily) how I would use dark, intermediate, and light isolates.

Using Dark and Light Isolates

The Isolate Theory, conceived by CJ Elfont, is a way of looking at composition and explains the interrelationship of the elements (or isolates) in a photograph and how these can be used to evoke meaningful, emotional responses in viewers. (See the sidebar for a very brief overview of this theory.) This compositional theory formed the basis for how I see and remains one of the cornerstones of my vision today.

In the next image of Calla lilies, the primary isolates are the two flowers that are slightly to the right of center. The gesture that is most telling is the spiral that starts from the upper right in the dark isolate. This is the darkest area in which there are definable structures, and it continues to the center of the photograph, where the primary light isolates exist. This particular pattern occurred by happenstance, but I reinforced it (**Figures 4.0.11, 4.0.12,** and **4.0.13**).

By using selective contrast and sharpness, I gradually created the dramatic effect of motion in a still image. I also interrupted the pattern of the background with the spiral of light-to-dark and, in this way, found the most telling gesture. All of this was already present in the image, but it had to be brought out; I had to remove from the file everything that was not my vision.

If gesture is the expression of the photograph, and light is its language, then colors are its words, and contrast, saturation, and sharpness are the alphabet. Without words and language, expression has no meaning. Without the alphabet, there are no words.

FIGURE 4.0.11 FIGURE 4.0.12

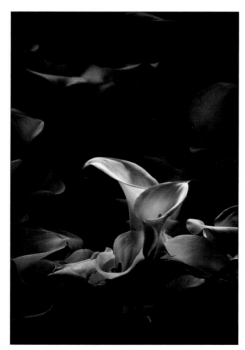

FIGURE 4.0.13

If the words of color are lost in a cacophony of shapes, the image will be less than it could be. The better you support color and its expression, the better your images will be appreciated. And just as in a street fight, the only rule is that there are no rules. Everything you do is in service of the print, which will always be in service of what is ultimately most important: your voice and vision.

Seattle Sequence Re-Sequenced

Stop taking pictures. Be taken by your pictures.

—Ernst Haas

In the first edition of this book, I used a series of images that I captured one morning at sunrise in Cades Cove (in the Great Smoky Mountains National Park). Without planning what I would shoot, I had gotten up extraordinarily early hoping to shoot in the fog at sunrise. I actually saw the field of flowers after all the fog had burned off and I was about to leave. I just found the images, or maybe they found me (**Figure 4.0.14**). With this set of images, I began to be aware of the difference between taking a picture and being taken by one.

As I crawled around on my hands and knees among the flowers in the dew, the light moved and changed. I tried to approach the light the same way I approached the flowers, as if it were a solid object. I made sure to get as many captures as I could using as many options as I could. Moments like those happen; you cannot make them re-happen.

If you look at the images that I shot, you can see the evolution of my vision as I experienced the flowers. It is in that journey that I discovered the destination.

For this rewriting of *Welcome to Oz*, I decided to change the image for this lesson so that I could go beyond using my *first* epiphany (or Eureka!) moment images in order to more deeply explore the concept of ExDR and how to manage the huge amounts of data and the large files that are generated when using high-megapixel DSLRs.

FIGURE 4.0.14　*Cades Cove flowers*

If you look at the images that I captured of the flowers that were randomly placed in buckets in a crowded market (**Figure 4.0.15**), once again, you can see the evolution of my vision as I experienced the flowers. Each was a part of the journey on which the flowers took me (**Figures 4.0.16, 4.0.17** and **4.0.18**).

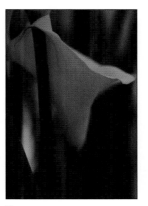

FIGURE 4.0.16

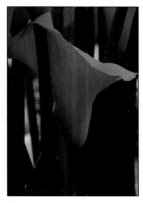

FIGURE 4.0.17

FIGURE 4.0.15　*Images captured of flowers in a bucket in a market*

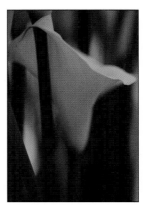

FIGURE 4.0.18

The lessons to be learned using the images that make up this lesson are not just about the bokeh of the lens, they are also about using sharpness and defined image structures to selectively extend the areas of focus in an image that is mostly about blur.

If you look at the image as some photographers might shoot it and call it a day (_VAV072122_SHRP.tif), it is boring, but historically accurate; something you might see on a seed packet. If you look at _VAV0722BASE_LITE.tif, it is a far more interesting image due to the bokeh or blur. Though more visually appealing, it still does not realize the vision that I had when it took me. To recreate that vision, I needed an expanded exposure range so that multiple areas, at different distances and at different levels of sharpness, were all in focus, while existing in a shallow DOF. As I discussed in the previous chapter, that cannot be achieved in one capture using a fixed optical/sensor plane system. To achieve the end that I had in mind for this image, I had to practice preemptive Photoshop and capture all of the image elements that I thought I might need to extend the dynamic range of each of them. Simply put: Real pixels are always preferable to computer-generated ones.

Up to this point, you have been working with images that were captured with cameras that were no larger than 5.5 megapixels. In this lesson, you will be working with images captured from a Nikon D3x, a 24.5 megapixel camera. You will see how to adapt your workflow to the needs of the file. A 24.5MP RAW file, when opened in 16-bit in the ProPhoto color space, is about 149 megabytes. This means that if you harvest four images, you will have a file that is almost 600 megabytes before you do anything.

Once you have chosen the images with which you want to work, you can begin making structural and aesthetic choices. (Because the fulfillment of your vision starts with the choices you make at the time of capture, you should let them guide you in choosing how and what to photograph. The more you get right in your captures, the better off you will be when you begin building the image in Photoshop.)

Here are some initial considerations:

- You will need to align all the images, so that they will blend together as seamlessly as possible.
- Because the lightness of the images differ, you must make aesthetic choices that you can accomplish without leaving chalk marks. More specifically, do not make choices that require technical adjustments that will be obvious to the viewer once your work on the image is complete.
- Aesthetically, you want to support the image's yellows rather than its greens.
- The gesture of this image is the way the top of the flower wraps around the stem and flows downward to the right before tapering to the center bottom where it attaches to the stem. However, you want the viewer's eye to travel in the opposite direction: from the lower right, up through the middle, to the flower embracing the stem, because it makes for a stronger visual journey and therefore a more successful image. This movement should be repeated as long as the viewer is looking at the image (hang time). You will use sharpness, contrast, saturation, and focus to cause the viewer's eye to travel through the image along a path you create, and you want to use blur to give the eye a place to which it can retreat.

Creating a Single Image

Disregard for details is the first sign of doom.

—Kai Krause

Step 1: Many Parts to Assemble the Whole

As in the previous chapters, you will approach the creation of this image going from global to granular. The following steps will show you how I removed everything that was not my vision from the Seattle Sequence 2.0 flower images and how I practiced preemptive Photoshop at the point of capture. I chose the lens I used for its bokeh, because, in my vision of this image, it is the quality of the blur in relationship to the area(s) of focus that I find aesthetically appealing.

1. Open these three files:

 _VAV0719BASE_DRK.tif

 _VAV0722BASE_LITE.tif

 _VAV072122_SHRP.tif

2. Starting with the file _VAV0722BASE_LITE.tif, double-click on the icon of the image in the Layers panel. (It should say "background" when the Layer dialog box comes up.) Name this layer BASE_LITE which unlocks it—something that needs to be done before you align all of the layers.

3. When you select Save As, create a new folder (located in the lower, left corner of the Save As dialog box) and name the folder SEATTLE_LILY. Now, rename the _VAV0722BASE_LITE.tif file SEATTLE_LILY_16bit, and save it as a Large File Format (.psb). (This is located in the Format pull-down menu in the Save As dialog box and is the second option just below Photoshop Document.)

NOTE: You should save the file as a .psb file rather than in a Photoshop Document format (.psd) because the .psd file size is limited to two gigabytes. A .psb file, on the other hand, does not suffer from this size limitation.

4. Duplicate this file, and rename it SEATTLE_LILY_ALIGN_16bit.

5. Once you have saved the file, create a layer group, and name it ALIGNED_PARTS.

6. Click on the _VAV0719BASE_DRK.tif, making it the active file. Click on the BACKGROUND layer of this file and, holding down the Shift key, drag the background layer to the destination file, SEATTLE_LILY_16bit.psb. Name the newly created layer BASE_DRK. Do the same with _VAV072122_SHRP.tif and rename this new layer SHRP_DRK. Once you have placed all of the files into the SEATTLE_LILY_ALIGN_16bit file, close them. You should have two files open, SEATTLE_LILY_ALIGN_16bit.psb and SEATTLE_LILY_16bit.psb. The layer order in the ALIGN_PARTS layer group in the SEATTLE_LILY_ALIGN_16bit file should be BASE_LITE, BASE_DRK, and SHRP_DRK.

7. Save the file.

FIGURE 4.2.1

FIGURE 4.2.2 *Selecting SEATTLE_LILLY_ ALIGN_16bit. in the Source pull-down*

FIGURE 4.2.3 *Selecting BASE_LITE in the Layer pull-down*

Step 2: Creating a Lighter Version of a Darker Flower

In this step, you will use Match Color to make a lighter version of a layer. It would have been lighter had I done this in the camera, but while I was shooting this part of the harvest, the clouds moved, changing the lighting. Normally, when I am working this way, once I have established focus, I do things in manual mode, which affords me greater control over exposure and DOF. The trade off is that the camera cannot automatically readjust exposure for changes in light. So even though I wanted a brighter image, I did not get it. Using Match Color is one way to match both the color and the brightness of one file to another. There is a caveat—when the Match Color adjustment works, it works really well, and when it does not, it is useless. Match Color works best when you harvest images of the same thing at the same location. It might not work if you try matching color from two different locations and/or of two different objects.

1. Duplicate the SHRP_DRK layer (Command + J / Control + J).

2. Rename this newly duplicated layer (which Photoshop will have automatically named SHRP_DRK copy) to SHRP_LITE.

3. Make SHRP_LITE the active layer, and go to Image > Adjustments > Match Color (**Figure 4.2.1**).

4. In the Source pull-down menu, select SEATTLE_LILY_ ALIGN_16bit and, in the Layer pull-down menu, select BASE_ LITE (**Figures 4.2.2** and **4.2.3**).

5. The image is brighter, but not quite enough. In the Options part of the Match Color dialog box, move the Luminance slider to the right to 133, and move the Color Intensity slider to the right to 115.

6. Click OK.

Compare the image before the Color Match adjustment (**Figure 4.2.4**), after the Color Match adjustment (**Figure 4.2.5**), and after the Luminace and Color Intensity increases (**Figure 4.2.6**).

Figure 4.2.4 *Before the Color Match adjustment*

Figure 4.2.5 *After the Color Match Adjustment*

Figure 4.2.6 *After the Luminance and Color Intensity increases*

NOTE: These choices were made because you want the viewer's unconscious eye to go first to the flower and to see the yellows before the greens. Because the eye first goes from light to dark, you lightened up the layer that contained the most defined image structures. However, you had to increase the color intensity because when you lighten an image, color saturation decreases. Conversely, when you darken an image, color saturation increases.

7. Save the file.

Step 3: Aligning the Almost Aligned

No matter how good your tripod, tripod head, and camera fastening system, whenever you touch the camera during the capture process, even to refocus, you introduce some form of camera movement. This next step addresses this first part of the alignment problem.

I have observed that when using the Auto Align Layers feature in Photoshop CS5, the order of the layers in the layer stack and which layer you click on first (top or bottom) has an effect on how the layers will be aligned. Therefore, you must decide which is the primary layer (the BASE_LITE layer is the primary layer in this image) and make sure it is at the top of the layer stack.

1. Click on the BASE_LITE layer and make it active. Holding down the Shift key, click on the SHRP_LITE layer. This will make all of the layers between the two active.

2. Go to Edit > Auto Align Layers. For the Projection, select Auto. Generally, this one works best. Click OK.

You will notice that the alignment process has resulted in an image that is no longer full frame (**Figure 4.3.1**). You could crop the open areas, but that would change the image, and perhaps risk losing parts of it. This next step addresses this second part of the alignment problem.

3. Holding down the Shift key, click on the ALIGNED_PARTS layer group and drag it to the SEATTLE_LILY_16bit file.

4. Save the SEATTLE_LILY_16bit.psb file.

5. Close and do not save the SEATTLE_LILY_ALIGN_16bit.psb file.

NOTE: You are not saving this file so that you give yourself an exit strategy. Because the aligned layers are now in the SEATTLE_LILY_16bit.psb file, there is no need to have two copies of them. Should you feel the need to re-align the layers later, you have a file that is already set up for that in which the layers are not aligned.

FIGURE 4.3.1 *After the alignment, the image is not full frame*

Step 4: The Sum is Greater Than the Parts: Creating One Image from Four Layers

In this step, you will not only extend the range of exposure, you will also extend the range of the sharpness and blur. I have found that real pixels are always better to use than attenuated ones. By using pixels unmodified in Photoshop, you reduce the amount of overall artifacting. You can also control the amount of detail in any specific area. Essentially, you can have your blur and see the image, too. In the first part of this next step, you will add dark, and in the second part, you will add light and sharpness.

All the decisions that you make from this point forward are about how the viewer's eye will move through the image, how to reinforce the gesture of the image, and how to cause shape to become the unwitting ally of color.

You will begin by making sure that the viewer sees the yellows before the greens, so that their unconscious eye moves from the lower left of the image to the center, then to the upper part of the flower where the top of the lily intertwines with the stem, and then to the top of the lily that goes out of the frame.

Adding Dark

1. You have two layers named BASE_LITE: one inside the ALIGNED_PARTS layer group, and one outside it. Rename the BASE_LITE layer in the ALIGNED_PARTS layer group BASE_LITE_M (for Base Lite Modified). This is the image map for the BASE_DRK layer (**Figure 4.4.1**).

2. In the ALIGNED_PARTS layer group, turn off all the layers except BASE_DRK and make it the active one. You should now have the BASE_LITE layer turned on (the one outside the layer group) and the BASE_DRK layer (the one inside the layer group) turned on.

3. Add a layer mask to the BASE_DRK layer and leave it white.

4. Select the Brush tool (B), make the foreground color black

FIGURE 4.4.1 *The image map*

FIGURE 4.4.2 *The layer mask*

FIGURE 4.4.3 *Before brushwork*

FIGURE 4.4.4 *After brushwork*

and the background white, set the brush opacity to 100% and the width to 400 pixels, and brush in the entire flower and the area inside the stem. View the layer mask (**Figure 4.4.2**), and compare the images before (**Figure 4.4.3**) and after the brushwork (**Figure 4.4.4**).

5. With the foreground color black and the background white, and a brush opacity of 50% and a width of 250 pixels, brush in the entire stem next to the flower. Bring up the Fade effect dialog box and move the slider right to 74%. Brush in the back part of the flower at 50%. Bring up the Fade effect dialog box and move the slider left to 44%. View the layer mask (**Figure 4.4.5**) and the image after the brushwork (**Figure 4.4.6**).

FIGURE 4.4.5 *The layer mask*

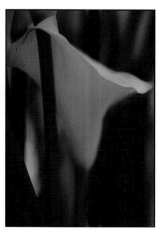

FIGURE 4.4.6 *After more brushwork*

FIGURE 4.4.7 *The layer mask*

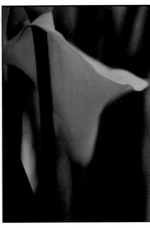

FIGURE 4.4.8 *After more brushwork*

FIGURE 4.4.9 *The layer mask*

FIGURE 4.4.10 *After more brushwork*

6. With the foreground color black and the background white, and a brush opacity of 50% and a width of 600 pixels, brush in the entire area to the lower right of the flower. Bring up the Fade effect dialog box and move the slider left to 34%. View the layer mask (**Figure 4.4.7**) and the image after the brushwork (**Figure 4.4.8**).

7. With the foreground color black and the background white, and a brush opacity of 50% and a width of 600 pixels, brush in the two stalk areas above the leaf on the right side of the image. Do one first, then bring up the Fade effect dialog box and move the slider left until the adjustment is most visually appealing, which for this image is at 47%. Then do the second and move the slider left to 47% as well. (They both require the same setting because you want both stalks to match. The Fade effect tool allows you to address only the last thing that you did, so you can do only one thing at a time; it's the same type of adjustment that you made in Chapter 1 when brushing in Challen's eyes.) In the lower left corner of the image, brush in the lower corner to the left of the stem, bring up the Fade effect dialog box and lower that opacity to 47%. View the layer mask (**Figure 4.4.9**) and the image after the brushwork (**Figure 4.4.10**).

8. Save the file.

Adding Light and Sharpness and More Dark

What you have done thus far is to manually extend the dynamic range of the dark aspect of this image without using tone mapping software. Also, you used real pixels created at the point of capture to darken the image. This approach leads to more realistic looking colors and shadows, and you did not introduce the potential artifacts and color shifts that can result from using Curves and Levels adjustment layers.

In the first part of this step, you created an image that is all about the bokeh or the quality of the blur of the lens that created it. In the next steps, you will selectively add lightness to extend the dynamic range of the exposure even further. You will accomplish this using the layer on which you did the

FIGURE 4.4.11 *The Sharpen Lite image map*

FIGURE 4.4.12 *The Sharpen Dark image map*

Match Color adjustment. Specifically, you are going to add sharpness from an image that was shot at a greater DOF. (In Step 2 of this lesson, Creating a Lighter Version of a Darker Flower, you matched the color and brightness of that image to the present one.) You will also add sharpness from the original image (before you applied the Match Color adjustment) that was captured at about the same exposure level as the BASE_DRK layer that you have just brushed in.

Here are the image maps for the three things that you will be doing to this image: The Sharpen Lite image map (**Figure 4.4.11**), the Sharpen Dark image map (**Figure 4.4.12**), and the Lily Tip Sharp image map (**Figure 4.4.13**).

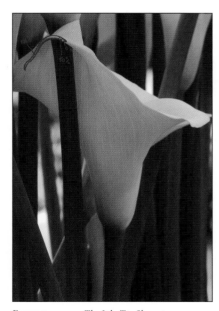

FIGURE 4.4.13 *The Lily Tip Sharp image map*

FIGURE 4.4.14 *The selected area*

1. Make the SHRP_LITE layer active.

2. Select the Marquee tool, make a selection of the lily leaf tip (**Figure 4.4.14**), copy it to its own layer (Command + J / Control + J) and name that layer TIP_SHRP_LITE. Create a layer mask and fill it with black.

3. Make the SHRP_LITE layer active, create a layer mask, and fill it with black. With the foreground color white and the background black, brush in the area of the front part of the lily with a brush opacity of 100% and a width of 600 pixels.

4. Set the opacity to 50% and brush in the lily's stem. Bring up the Fade effect dialog box and lower the effect to 22% by moving the slider to the left. View the layer mask (**Figure 4.4.15**) and the image after the brushwork (**Figure 4.4.16**).

5. Make the SHRP_DRK layer active, create a layer mask, and fill it with black. With the opacity still set to 50%, and the foreground color white and the background black, brush in the back part of the lily. View the layer mask (**Figure 4.4.17**) and the image after the brushwork (**Figure 4.4.18**).

FIGURE 4.4.15 *The layer mask on SHRP_LITE*

FIGURE 4.4.16 *After brushwork on SHRP_LITE*

FIGURE 4.4.17 *The layer mask on SHRP_DRK*

FIGURE 4.4.18 *After the brushwork on SHRP_DRK*

6. Make the TIP_SHRP_LITE layer active. Making sure that the layer mask is also active, zoom in to the tip area. Make the brush opacity 100% and the brush size 40 pixels. Brush in just the tip. View the layer mask (**Figure 4.4.19**) and the image after the brushwork (**Figure 4.4.20**).

FIGURE 4.4.19 *The layer mask on TIP_SHRP_LITE*

FIGURE 4.4.20 *After the brushwork on TIP_SHRP_LITE*

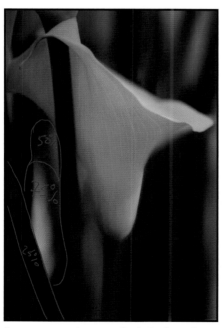

FIGURE 4.4.21 *Image map for the Darken and Lowered Contrast Curves adjustment layer*

Breaking the 11th Commandment... Yet Again

In the lower left corner of the image, there is an area of light that pulls the eye's focus away from the flower. To address this issue, you will first use a clipped curve that you will also darken. Here is the image map for the Darken and Lowered Contrast adjustment layer (**Figure 4.4.21**).

1. Create a Curves adjustment layer, and if it is not already, put it in the Fine Grid mode (Option- / Alt- click on the grid in the Curves dialog box). Lower the top handle of the curve six grid points. Click on the center handle and move it so that it is on the first and second grid line from the bottom. The output should read about 107 (**Figure 4.4.22**).

FIGURE 4.4.22

2. Fill the layer mask with black, and with the foreground white, select the Brush tool. Set the opacity to 50% and the brush width to 400 pixels. Brush in the area from below the bottom of the upper part of the left side of the lily (between the two stems) up to the stem that crosses the bottom of the lower left corner. Then re-brush over the brightest part of the area on which you just did brush work. (Remember that since 50% of 50% is 25%, you have just re-brushed this area at 75%.) Now, brush the stem in the lower left corner, bring up the Fade effect dialog box, and reduce the amount by moving the slider to 25%. View the layer mask (**Figure 4.4.23**) and the image after the brushwork (**Figure 4.4.24**).

3. Click on the ALIGNED_PARTS layer group, create a master layer, and name it MASTER_1.

4. Save the file.

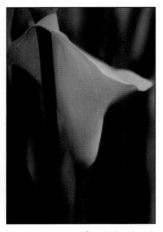

FIGURE 4.4.23 *The layer mask* FIGURE 4.4.24 *After the brushwork*

Step 5: The Registration Problem

You will notice that there is a light band that runs across the bottom of the image. This occurred during the alignment process. Also, there may be some parts of the aligned image that may fall outside the canvas of the original BASE_LITE image (the image onto which you dragged the ALIGNED_PARTS layer group). In this step, you will address both issues.

1. Select the Crop tool (C) and drag it from the top left corner to the lower right one so that the entire image is within the Crop box (**Figure 4.5.1**).

2. Press the Return or Enter key to accept the crop.

3. When the Crop processing has finished, make the MASTER_1 layer active, and zoom in to the lower left corner of the image.

4. Select the Marquee tool (M), then click and drag the marquee selection so that it is slightly bigger than the light area at the bottom of the image. Drag it from the right to the left edge of the image.

5. Go to Edit > Fill and, in the Contents part of the Fill dialog box, from the Use pull-down menu, select Content Aware. Click OK.

6. Save the file.

NOTE: New to CS5 are Content Aware Fill and Content Aware Spot Healing. Both of these are implementations of PatchMatch technology. These algorithms work by copying multiple patches to stitch together from the surrounding background and fitting them inside the area of the fill selection or the area of the Spot Healing brush. This is an improvement over the old Spot Healing proximity match approach that used only one patch from the background. By stitching together multiple areas, you get a much more convincing and seamless patch. The PatchMatch algorithm works not only for small areas, but for large ones, as well, as you have just seen.

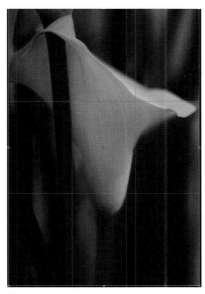

FIGURE 4.5.1

Step 6: Harvesting from Within

As I discussed earlier, a pattern is interesting, but a pattern interrupted is more interesting. Currently, the image on which you are working has a pattern of greens and yellows in the background with one area of pinkish red. You want to interrupt that pattern while reinforcing the yellows over the greens. And there are still light areas that need to be toned down so that they do not pull the unconscious eye away from the main focus of the image, the lily. For that, you need some darker shapes to conceal the lighter ones and then some red/pink shapes to interrupt the pattern of greens and yellows. Simply darkening the image by using Curves would not accomplish this. Whatever you do, when you are finished with this next step, the image must look as if it was originally captured that way. To accomplish this, you will harvest image structures from within the image. Here are the image maps for the two things you are about to do. View the Stem Parts image map (**Figure 4.6.1**) and the Reds image map (**Figure 4.6.2**).

FIGURE 4.6.1 *Stem Parts image map*

FIGURE 4.6.2 *Reds image map*

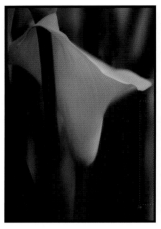

FIGURE 4.6.3 *Copying the lower right corner to its own layer*

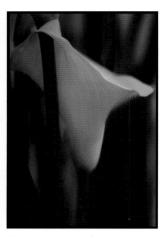

FIGURE 4.6.4 *Duplicating the stem area*

FIGURE 4.6.5 *Moving the new STEM_PART layer to the lower right*

FIGURE 4.6.6 *Stretching the selection upwards*

1. Create a layer set and name it INNER_HARVEST.

2. Make the MASTER_1 layer active. With the Marquee tool (M), make a selection at the edge of the lower right corner that contains the reddish/pink area, and copy it to its own layer. Name this layer REDS. Drag REDS into the INNER_HARVEST layer set (**Figure 4.6.3**).

3. Again, make the MASTER_1 layer active. With the Marquee tool (M), make a selection of the stem area below the front part of the lily and copy it to its own layer. Name this layer STEM_PART. Add a layer mask. Drag the STEM_PART into the INNER_HARVEST layer set. Duplicate the STEM_PART layer (**Figure 4.6.4**).

4. Turn off the STEM_PART copy layer (the one that you just created) and make the STEM_PART layer active.

5. Select the Move tool (V) and move the STEM_PART layer to the lower right corner (**Figure 4.6.5**).

6. Select Free Transform (Command + T / Control + T), click on the top, center control handle, and stretch the selection upward to just above the front part of the lily. Click Return / Enter (**Figure 4.6.6**).

7. Select the Brush tool. Fill the layer mask with black. With the foreground color set to white, set the brush opacity to 50%, and brush in the right side of the image (as shown in the STEM_PART image map). Bring up the Fade effect dialog box and increase the amount by moving the slider to 71%. Compare the image before the brushwork (**Figure 4.6.7**), and after the brushwork (**Figure 4.6.8**), and look at the resulting layer mask (**Figure 4.6.9**).

8. Copy the STEM_PART copy layer so that you have a new layer, STEM_PART copy 2. Turn on the STEM_PART copy 2 layer. Select the Move tool (V) and move the STEM_PART copy 2 layer to the upper right corner, above the lily and over the light area between the two stems (**Figure 4.6.10**).

FIGURE 4.6.7 *Before brushwork*

FIGURE 4.6.8 *After brushwork*

FIGURE 4.6.9 *The layer mask*

FIGURE 4.6.10 *Adding STEM_PART copy 2 above the lily*

9. Select Free Transform (Command + T / Control + T). Holding down the Option / Alt key, click on the left, center control handle and expand the selection to the left. Click Return / Enter (**Figure 4.6.11**).

10. Select the Brush tool and fill the layer mask with black. With the foreground color set to white, set the brush opacity to 50% and the brush width to 400 pixels. Brush in the upper right side of the image (as shown in the STEM_PART image map) leaving the slider set to 50%. View the image after the brushwork (**Figure 4.6.12**) and the resulting layer mask (**Figure 4.6.13**).

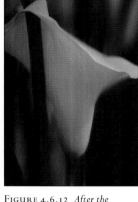

FIGURE 4.6.11 *Expanding the selection left*

FIGURE 4.6.12 *After the brushwork*

FIGURE 4.6.13 *The layer mask*

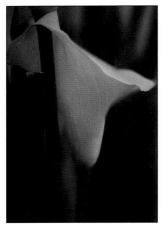

FIGURE 4.6.14 *Adding the STEM_ PART to the bright area on the left*

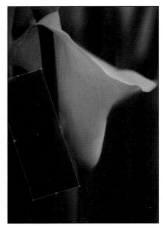

FIGURE 4.6.15 *Transforming the selection*

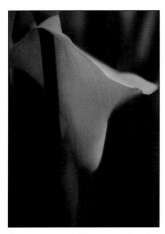

FIGURE 4.6.16 *The image after the brushwork*

FIGURE 4.6.17 *The resulting layer mask*

11. Turn on and make the STEM_PART copy layer active, and move it so that it is over the bright area in the left corner of the image (**Figure 4.6.14**).

12. Select Free Transform (Command + T / Control + T) and move the curser to the lower handle. When the rotation arrows appear, click and drag it to the right, and holding down the Option / Alt key, click on the left, center control handle. Expand the selection as you move it to the left. Click Return / Enter (**Figure 4.6.15**).

13. Select the Brush tool. Fill the layer mask with black. With the foreground color set to white, set the brush opacity to 50% and its width to 250 pixels. Brush in the light area in the lower left corner (as shown in the STEM_PART image map). Bring up the Fade effect dialog box and move the slider to 86%. View the image after the brushwork (**Figure 4.6.16**) and the resulting layer mask (**Figure 4.6.17**).

14. Save the file.

Getting the Red In

You should now have an image in which the central focus is the lily. There should be no light areas to pull the eye away from that. You have used both image structures and colors that were inherent in the image. In this next step, you will add reds into the image to interrupt the pattern of the greens and yellows in the background, and to introduce visual depth. By introducing red elements, I think that all the aspects of the image become more appealing, which means that the viewer will look at it longer. Look again at the Reds image map (**Figure 4.6.2**).

1. Turn on, and make the REDS layer active. Select the Move tool (V) and move it to the center of the image.

2. Duplicate the REDS layer twice.

3. Flip the REDS layer copy 2, horizontally (Edit > Transform > Flip Horizontal). Move the layer that you just flipped to the right (**Figure 4.6.18**).

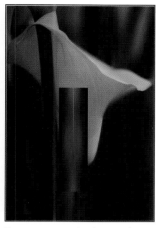

FIGURE 4.6.2 *The Reds image map*

FIGURE 4.6.18 *Duplicating the REDS layer twice and flipping the REDS layer copy 2*

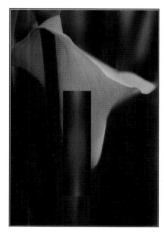

FIGURE 4.6.19 *Aligning the two new layers with the Move tool*

FIGURE 4.6.20 *Selecting Content-Aware and turning off Sample All Layers*

4. With the Move tool selected (V), click the left arrow key until the two layers overlap (**Figure 4.6.19**).

5. Merge this layer to the layer below it (Command + E / Control + E).

6. Select the Spot Healing tool from the Tool options bar and select Content Aware. Make sure the Sample All Layers checkbox is turned off (**Figure 4.6.20**).

7. With a brush width of 70 pixels, and holding down the Shift key (this locks the brush so that it will move in a straight line), start at the top of the pink area and drag the brush down to bottom of the pink area. Then release it (**Figures 4.6.21** and **4.6.22**).

8. Name this layer REDS_DUO and add a layer mask to it.

9. Duplicate the layer (the new layer will be named REDS_DUO copy), and move it to the upper right corner above the lily between the two stems. Turn off the REDS_DUO and REDS layers (**Figure 4.6.23**).

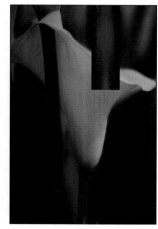

FIGURES 4.6.21 AND 4.6.22 *Brushing in the gap to correct it and the result*

FIGURE 4.6.23 *Moving the REDS_DUO above the lily*

FIGURE 4.6.24 *Activating the Free Transform tool*

FIGURE 4.6.25 *Expanding the width*

FIGURE 4.6.26 *Rotating the selection*

FIGURE 4.6.27

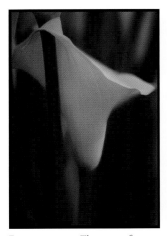

FIGURE 4.6.28 *The image after brushwork*

FIGURE 4.6.29 *The layer mask*

10. Select Free Transform (Command + T / Control + T) and, holding down the Option / Alt key, click on the left control handle and expand the size. Click near the lower, left handle, which will bring up the Rotate arrows, and rotate the image slightly clockwise to match the angle of the two stems that border this selection. Press Return / Enter (**Figures 4.6.24, 4.6.25, 4.6.26,** and **4.6.27**).

11. Make the layer mask active and fill it with black. Select the Brush tool, set its opacity to 50% and its width to 300 pixels, and brush in the area between the two stems. Bring up the Fade effect dialog box and reduce the opacity to 38%. View the image after brushwork (**Figure 4.6.28**) and the resulting layer mask (**Figure 4.6.29**).

12. Duplicate the REDS_DUO layer (the new layer will be named REDS_DUO copy2), and move it to the lower right corner to the right of the lily stem (**Figure 4.6.30**).

13. Select Free Transform (Command + T / Control + T), and holding the Option / Alt key, click on the left control handle and expand the size. Click near the lower, left handle which will bring up the Rotate arrows and rotate the image slightly clockwise to match the angle of the two stems that border this selection. Press Return / Enter (**Figures 4.6.31**, **4.6.32,** and **4.6.33**).

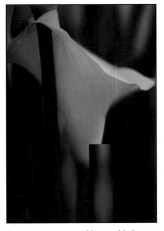

FIGURE 4.6.30 *Adding red below the lily*

FIGURE 4.6.31 *Free Transform tool*

FIGURE 4.6.32 *Expanding the width*

FIGURE 4.6.33 *Rotating the selection*

14. Make the layer mask active and fill it with black. Select the Brush tool, set its opacity to 50% and its width to 500 pixels, and brush in the area between the two stems. Bring up the Fade effect dialog box and reduce the opacity to 38%. View the image after the brushwork (**Figure 4.6.34**) and the resulting layer mask (**Figure 4.6.35**).

15. Turn on and make the RED_DUO layer active. Move it to the lower left corner between the two stems (**Figure 4.6.36**).

FIGURE 4.6.36 *Adding red to the left side*

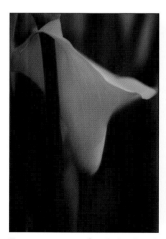

FIGURE 4.6.34 *After the brushwork*

FIGURE 4.6.35 *The layer mask*

FIGURE 4.6.37 *Selecting the Free Transform tool*

FIGURE 4.6.38 *Expanding the selection*

FIGURE 4.6.39 *Rotating the selection*

16. Select Free Transform (Command + T / Control + T), and holding down the Option / Alt key, click on the top, center control handle and expand the height. Click near the lower, left handle to bring up the Rotate arrows and rotate the image slightly counterclockwise to match the angle of the two stems that border this selection. Holding down the Option / Alt key, click on the left, center control handle and expand the selection slightly. Press Return / Enter (**Figures 4.6.37, 4.6.38,** and **4.6.39**).

17. Make the layer mask active and fill it with black. Select the Brush tool, set its opacity to 50% and its width to 500 pixels, and brush in the area between the two stems. Bring up the Fade effect dialog box and reduce the opacity to 31%. View the image after the brushwork (**Figure 4.6.40**) and the resulting layer mask (**Figure 4.6.41**).

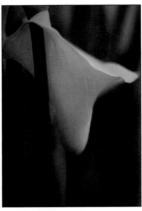

FIGURE 4.6.40 *The image after the brushwork*

FIGURE 4.6.41 *The layer mask*

The Emery Board Step

In this last part of the "inner harvesting" step, you will smooth out any places where the transition from sharpness to blur occurs more abruptly than you would like. Also, this is a good time to increase the colors' intensities and the lightness of the background to further fine tune the image. You will use the Base Layer to accomplish all these tasks. Look at the Base Lite Brush Back image map (**Figure 4.7.1**).

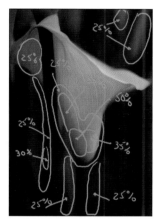

FIGURE 4.7.1 *Base Lite Brush Back image map*

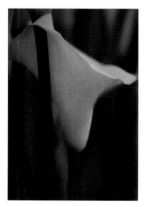

FIGURE 4.7.2 *The image after the brushwork*

FIGURE 4.7.3 *The layer mask*

1. Duplicate the BASE_LITE layer and move it so that it is the topmost layer in the INNER_HARVEST layer group. Rename this layer BASE_LIGHT_BB (BB = Brush Back).

2. Create a layer mask and fill it with black.

3. Make the layer mask active. Select the Brush tool. With the foreground color set to white, set the brush opacity to 50% and its width to 400 pixels. Using the image map diagram as your guide, brush in the lower part of the lily. Bring up the Fade effect dialog box and reduce the opacity to 41%. Brush in the left stem. Bring up the Fade effect dialog box and reduce the opacity to 36%. Brush in the right stem. Bring up the Fade effect dialog box and reduce the opacity to 31%. In the upper right corner, brush the right-most yellow base of the background lily. Bring up the Fade effect dialog box and reduce the opacity to 28%. Finally, brush in the lily's base next to where you just brushed. Bring up the Fade effect dialog box and reduce the opacity to 31%. Look at the image after the brushwork (**Figure 4.7.2**) and the layer mask (**Figure 4.7.3**).

4. Make the INNER_HARVEST layer group active.

5. Create a Master layer and name that layer MASTER_2.

6. Save the file.

7. Select Save As (Command + Shift + S / Control + Shift + S), and when the Save As dialog box comes up, rename the file SEATTLE_LILY_MASTER_CNTRST_SHRP_16bit. Click off the layers radial button and save it in the Large Document file format (.psb).

NOTE: The reason for doing this is that the current file size of what you have just done is 2.1 gigabytes. That is a lot of file to have to move. Everything you just did was to create one image from many. Every decision that needed to be made, has been made. By breaking the image workflow up into different files, you save time while preserving an exit strategy.

The Dance of Aesthetics

Directing the unconscious eye

Every act of creation has to start first with an act of destruction.

—Pablo Picasso

As I indicated in the previous chapter, the human eye is an amazing biological optical system. But this eye is by no means conscious. True, the eye evolved from migrated brain tissue, but it does not think. It sees what it sees and does so in a very specific, predictable manner.

But I believe that humans are in possession of another eye, the conscious one; the one that gives meaning to what we see. The unconscious eye records, while the conscious eye interprets what is recorded.

To this point, you have made decisions on how to manipulate an image so that it will speak to the conscious eye of the viewer. You have done that by causing the unconscious eye to go where you wanted it to go, so that the story would be seen the way you determined it should. You did this by using the alphabet of the photograph: contrast, saturation, and sharpness and by the recognition that the unconscious eye first recognizes light areas and then moves to dark ones, sees high contrast before low contrast areas, records areas of high sharpness before low sharpness, notices areas in focus before those that are blurred, and focuses on highly color-saturated areas before moving to less-saturated ones. Thus, you overrode the tendency of the unconscious eye to wander and sent it on a path of your own choosing.

By controlling the sequence of things that the unconscious eye sees is another facet of control by which you cause shape to become the unwitting ally of color. Previously, you created a pattern interrupted to control the unconscious eye. Now you will do that by working from dark-to-light to remove the light that does not belong and light-to-dark to add brightness where it should be. Also, you will further control the unconscious eye through use of contrast and several forms of "unsharp" sharpening.

At this point in the lesson, you realize that the image you now have was created from conscious decisions that were made at the time of capture. You did not fix this image in Photoshop; rather, you used Photoshop to re-create the vision that you had at moment of capture using fragments of the image itself. No tone mapping software was used to extend the exposure's dynamic range.

It is at this point in an image's workflow that you would probably do a color cast correction, as you have in the previous three chapters. You will not do that for this image, because here, the color cast works to your advantage. Remember, the cleanest file that exists, the one with the least amount of artifacts, is the original RAW file, and a non-destructive workflow endeavors to minimize artifacting, as well as assuring an exit strategy. The important lesson is that workflow is dynamic and image specific. You will never do the same things, and in the same order, all of the time.

Step 7: Setting Up for Things to Come

1. If you have not already done so, close the SEATTLE_ LILY_16bit.psb file. (If Photoshop asks you if you want you to save the file before closing, click OK.)

2. Open the SEATTLE_LILY_MASTER_CNTRST_ SHRP_16bit.psb file.

3. Rename Layer 1 and call it MASTER_BASE.

4. Save the file.

5. Duplicate the file (Image > Duplicate) and name the new one SEATTLE_LILY_LAB_SAT_SHARPEN.

6. Convert this file to LAB (Image > Mode > Lab color).

7. Save the newly created LAB file and leave it open.

8. Make SEATTLE_LILY_MASTER_16bit.psb the active file.

9. Duplicate the MASTER_BASE layer twice.

10. Make the MASTER_BASE copy 2 (the top-most layer in the layer stack) into a Smart Filter. Add a layer mask and duplicate this layer twice.

11. Create a layer group and name it CONTRST/SHRPN.

12. Inside the layer group that you just made (CONTRST/ SHRPN), create a new layer group and name it CS_SHARPEN.

13. Drag the MASTER_BASE copy and MASTER_BASE copy 2 layers into the CS_SHARPEN layer group. (MASTER_BASE copy 2 should be the top layer in the layer stack at this time.)

14. Turn off the MASTER_BASE copy 2 layer and make the MASTER_BASE copy layer the active one.

15. Save the file.

Part One: The Dance of Sharpness and Contrast

Step 8: Aesthetic Sharpening Using CS Only

As I discussed in Chapter 3, each type of sharpening sharpens the image in a slightly different way and each has a benefit. By separating your sharpening steps into different layers and then using opacity and layer masks to blend them together, you get the benefits of the different types of sharpening without the cumulative effect of artifacting.

Sharpening Using the High Pass Filter

In this step, you will selectively enhance sharpness using High Pass sharpening. Look at the Image map (**Figure 4.8.1**).

1. Rename the MASTER_BASE copy layer HIGHPASS.

2. De-saturate the HIGHPASS layer (Command + Shift + U / Control + Shift + U).

FIGURE 4.8.1 *High Pass Sharpening image map*

3. Make the HIGHPASS layer into a Smart Filter and add a layer mask.

4. Go to Filter > Other > High Pass.

5. If it is not already there, move the Radius slider all the way to the left, or to a radius of 0.1. You should see nothing but gray.

6. Move the Radius slider to the right until you start to see just the edges of the image structures (in this case the veins in the lily) at 13.5 pixels for this image (**Figure 4.8.2**).

7. Click OK and change the HIGHPASS layer blend mode to Softlight. Compare the image before High Pass (**Figure 4.8.3**) and after High Pass sharpening (**Figure 4.8.4**).

8. Make the layer mask active, fill it with black, select the Brush tool, and set its opacity to 100% with a width of 500 pixels. Brush in the front lily area. View the layer mask (**Figure 4.8.5**).

9. Set the brush opacity to 50% and brush in the back part of the lily. Then, reduce your brush size to 70 pixels and brush in the tip of the lily. View the layer mask (**Figure 4.8.6**).

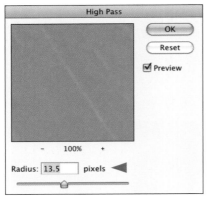

FIGURE 4.8.2 *High Pass Sharpening set to a radius of 13.5 pixels*

FIGURE 4.8.5

FIGURE 4.8.6

FIGURE 4.8.3 *Before High Pass sharpening*

FIGURE 4.8.4 *After High Passs sharpening*

FIGURE 4.8.7

FIGURE 4.8.8

10. Set the brush opacity to 50% and the width to 400 pixels, and brush in the lower stem of the lily. Bring up the Fade effect dialog box and reduce the opacity to 34%. Brush in the long stem around which the lily tip wraps. Bring up the Fade effect dialog box and reduce the opacity to 44%. Brush in the lower left corner stem. Bring up the Fade effect dialog box and reduce the opacity to 24%. View the resulting layer mask (**Figure 4.8.7**) and the image after the brushwork (**Figure 4.8.8**).

11. Save the file.

Sharpening in LAB

1. Make the SEATTLE_LILY_LAB_SAT_SHARPEN.psb file the active one.

2. Duplicate the layer, destaturate the layer you just duplicated, name it LAB_SHARP_WORKING, and make it into a Smart Filter.

3. Go to Filter > Sharpen and select Smart Sharpen.

4. In the Smart Sharpen dialog box, select Gaussian Blur from the Remove pull-down menu, and set the amount to 500% and the radius to 0.1.

5. Zoom in on the veins of the lily.

6. Now, move the radius first to the desired range of sharpening (2.6 pixels for this image).

7. Lower the amount until you remove the crispiness or hardness and the halos around the edges of the image. I chose 258%.

FIGURE 4.8.8

FIGURE 4.8.9

8. Click OK.

9. Do "the Move" and name this layer LAB_SHARPEN. Set the layer blend mode to Luminosity. Compare the image before (**Figure 4.8.9**) and after LAB sharpening (**Figure 4.8.10**).

10. Turn off the LAB_SHARP_WORKING layer.

NOTE: Files save more quickly and open faster if Smart Filter layers are turned off.

11. Save the file.

12. Holding down the Shift key, drag the LAB_SHARPEN layer to the CS_SHARPEN layer set folder (so that it is above the HIGHPASS layer) in the SEATTLE_LILY_MASTER_16bit.psb file. Add a layer mask and fill it with black.

13. Select the Brush tool and set its opacity to 50% and its width to 400 pixels. Brush in the sharp area of the lily and the back part of the lily including the tip. Do not brush in the blurred areas of the lily. View the image map (**Figure 4.8.11**), the image after the brushwork (**Figure 4.8.12**), and the layer mask after the brushwork (**Figure 4.8.13**).

14. Save the file.

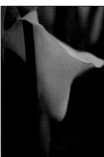

FIGURE 4.8.11 FIGURE 4.8.12 FIGURE 4.8.13

Sharpening Using the Smart Sharpen Lens Blur Filter

1. Turn on the MASTER_BASE copy2 and make it the active layer. Change the blend mode to Luminosity. (This layer should be the top layer in the CS_SHARPEN layer set folder.) Name this layer SMART_SHARP_LENS.

2. Go to Filter > Sharpen and select Smart Sharpen.

3. In the Smart Sharpen dialog box, select Lens Blur from the Remove pull-down menu and set the amount to 500% and the radius to 0.1.

4. Move the radius to 1.7 and the amount to 258%. Click OK.

5. Copy the layer mask from the LAB_SHARP layer.

6. Make a master layer and name it CS_SHARP.

7. Turn off the CS_SHARPEN layer group.

8. Save the file.

Step 8.1: Aesthetic Sharpening Using the Nik Software Sharpener Pro 3.0 Filter

These next steps require that you have Nik Software Sharpener Pro 3.0 or that you have downloaded the free 15-day demo. For this image, you will use control points to define the sharpening. When I use control points for sharpening, I zoom in to the area of most importance and use the global sliders to get the look I want. Then, I drop the control points to either sharpen the areas I want or to define those I do not want sharpened. Below is the workflow I employed for this image.

1. Make the MASTER_BASE copy3 layer active, duplicate this layer, and name it NIK_SHARPEN.

2. Set the layer blend mode to Luminosity.

3. Place this new layer above the CS_SHARPEN layer. (Set it so that it is outside of the layer set.)

4. Go to Filter > Nik Software > Sharpener Pro 3.0. (2) : Output Sharpening.

5. In the Output method pull-down menu, select Inkjet.

6. For the sharpening type you selected, leave the viewing distance set to Auto and the paper dimensions to what comes up in the dialog box. You are creating a fine-art print, so select Texture & Fine Art. Set the printer resolution to 2880 x1440.

7. Zoom in to the center part of the lily (**Figure 4.9.1**).

8. In the Creative Sharpening dialog box, start with Structure and move the slider to a little more than you think you need. I chose 44%.

9. Next, move the Local Contrast slider to little more than you think you need. I chose 21%.

10. Next, move the Focus to little more than you think you need. I chose 21%.

11. Zoom out of from the center of the image (Command + 0 / Control + 0).

12. Select the Select tool (located next to the Magnify Glass tool) in the upper left of the dialog box. Make sure that Selective Sharpening is checked on and Control Points is selected in the pull-down menu (**Figure 4.9.2**).

13. Click on Control Points and find the place in which you

FIGURE 4.9.1 *Zoomed in on the center of the lily in Sharpener Pro 3.0*

want to drop the control point. (I put this first one in the center part of the lily.) When you click, the Control Point is placed. Then, click directly on the Control point to make all of the handles visible (**Figure 4.9.3**).

14. Click on the S (Structure) handle and move it to 44%, then click on the LC (Local Contrast) handle and move it to 21%, and then click on the F (Focus) handle and move it to 21% (**Figure 4.9.4**).

15. Click on Control Points and place the second point. (I dropped the second one in the upper right corner on the red area between the two stems.) You will see the sharpness that was applied from the first control point disappear, but the sharpness in the lily remains (**Figure 4.9.5**).

FIGURE 4.9.2 *Selecting Control Points in the Selective Sharpening pull-down menu*

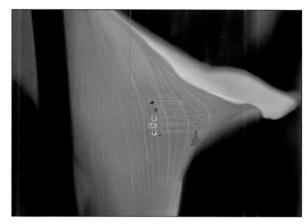

FIGURE 4.9.4 *Adjusting the sliders for the control point*

FIGURE 4.9.3 *Making the Control Point active*

FIGURE 4.9.5 *Placing the second control point*

16. Click on Control Points and place the third point in the lower right corner on the red area between the two stems (**Figure 4.9.6**).

17. Click OK. Compare the image before (**Figure 4.9.7**) and after (**Figure 4.9.8**).

FIGURE 4.9.6 *Placing the third control point*

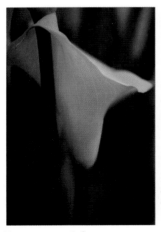

FIGURE 4.9.7 *Before*

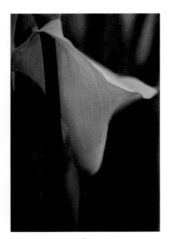

FIGURE 4.9.8 *After*

18. Make the layer mask active and fill it with black. Select the Brush tool, and with the foreground color set to white, the brush opacity set to 50%, the brush width set to 400 pixels, brush in the center part of the lily (using the image map diagram as your guide). Leaving the brush opacity set to 50%, reduce your brush size to 250 pixels, and brush in the upper part and back of the lily. Again, leaving the brush opacity set to 50% reduce the brush width to 80 pixels, and brush over the flower tip. Increase the brush width to 400 pixels, brush in the stem of the lily, bring up the Fade effect dialog box, and move the slider to 35%. Brush in the lower stem to the right of the lily, bring up the Fade effect dialog box, and move the slider to 20%. Brush in the upper stems to the right of the lily, bring up the Fade effect dialog box, and move the slider to 20%. Brush in the long stem to the left of the lily, bring up the Fade effect dialog box, and move the slider to 10%.

Look at how the image evolved by looking at the image map (**Figure 4.9.9**) the layer mask after the brushwork (**Figure 4.9.10**) the image before brushwork (**Figures 4.9.11** and **4.9.12**), the image after the brushwork (**Figures 4.9.13** and **4.9.14**), and the image after the brushwork is combined with the CS_SHARPEN layer (**Figures 4.9.15** and **4.9.16**).

19. Save the file.

NOTE: Because I used a combination of both the Nik Sharpener and CS Sharpen approaches, I put both of those layers into a layer group called SHARP_COMBO.

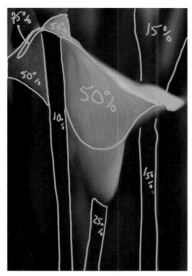

FIGURE 4.9.9 *The image map*

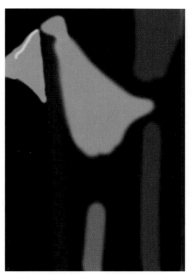

FIGURE 4.9.10 *The layer mask*

FIGURES 4.9.11 AND 4.9.12 *Before brushwork and detail*

FIGURES 4.9.13 AND 4.9.14 *After brushwork and detail*

FIGURES 4.9.15 AND 4.9.16 *After brushwork and combined with CS_SHARPEN and detail*

FIGURE 4.10.1 *Setting the Protect Shadows and Highlights to 15%*

FIGURE 4.10.2 *Before*

FIGURE 4.10.3 *After*

Step 9: Selective Contrast

In this next series of steps, you will create two contrast layers: a Tonal Contrast layer and a Contrast Only layer.

Adding Tonal Contrast with the Nik Software Tonal Contrast Filter

1. Create a new layer set (above the NIK_SHARPEN or CS_SHARP layer depending on which way you went with the aesthetic sharpening of this image) and name this new layer set CONTRAST.

2. Turn off the Sharpen layer(s).

3. Drag the MASTER_BASE copy 3 layer into the CON-TRAST folder. Set this layer to the Luminosity blend mode and duplicate it. (This newest layer should be MASTER_BASE_copy 4.) Name this layer CONTRAST_ONLY and turn it off.

4. Make the MASTER_BASE_copy 3 layer active (turn it on if it is not already) and rename it TONAL_CONTRAST.

5. Select Filter > Nik Software > Color Efex Pro 3.0 Versace Edition. When the Nik Software filter dialog box comes up, select Tonal Contrast.

6. If you have not already, select Split view.

7. Zoom in so that you have the upper middle part of the lily in the preview screen.

8. First, set the Mid Contrast slider (I chose +56), and then the Shadow slider (I chose +17). Set the Highlight at +29. Set both the Protect Shadows and Protect Highlights to 15% (**Figure 4.10.1**).

9. Click OK. Compare the image before (**Figures 4.10.2**) and after (**Figures 4.10.3**).

10. Select the Brush tool. With the foreground color set to white, the brush opacity set to 50%, and the brush width set to 400 pixels, brush in the center part of the lily using the image map diagram as your guide. Leaving the slider set to

50%, reduce the brush size to 250 pixels, and brush in the upper part and back of the lily. Again, leaving the slider set to 50%, reduce the brush size to 175 pixels, and brush over the blurred part of the lily. Bring up the Fade effect dialog box and move the slider to 27%. View the image map (**Figure 4.10.4**), the resulting layer mask (**Figure 4.10.5**), and the image after the brushwork (**Figure 4.10.6**).

11. Lower the layer opacity to 57%.

FIGURE 4.10.4 *Image map*

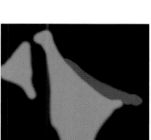

FIGURE 4.10.5 *Layer mask*

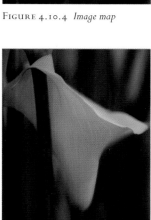

FIGURE 4.10.6 *Image after brushwork*

Adding Contrast Using the Nik Software Contrast Only Filter

1. Turn on and make the CONTRAST_ONLY layer active.

2. Select Filter > Nik Software > Color Efex Pro 3.0 Versace Edition. When the Nik filter dialog box comes up, select Contrast Only. Zoom in to approximately the same area that you used for the Tonal Contrast adjustments.

3. From the default setting of 50%, move the Brightness slider to 40%. Open up the Protect Shadows and Highlights dialog box. Set Protect Highlights to 34% and Protect Shadows to 27%. Lower the Contrast to 40%. Lastly, adjust the Saturation slider to about 50% (**Figure 4.10.7**).

4. Click OK.

FIGURE 4.10.7 *Setting the Tonal Contrast sliders*

5. Holding down the Option / Alt key, click on the layer mask of the TONAL_CONTRAST layer, and drag it to the CONTRAST_ONLY layer.

6. Reduce the opacity to 57%.

7. If they are not already, turn on the sharpen layer group(s) and/or layers.

8. Make the CONTRST/SHARPN layer set active.

9. Create a master layer and name it CONTRAST/SHARP.

10. Turn off the CONTRST/SHARPN layer.

11. Save the file.

12. Go to Save As (Command + Shift + S / Control + Shift + S) and, when the dialog box comes up, rename the file SEATTLE_LILY_MASTER_COLOR_16bit. Click off the Layers radial button and save the file in the Large Document file format (.psb).

NOTE: Remember that there is a bit of a dance between Contrast Only, Tonal Contrast, and Sharpening. Every image is different and, frequently, that difference determines the layer order. For this image, it was best to have Sharpening beneath Contrast—and to have Contrast Only above Tonal Contrast. The reason for this former choice was that when Sharpening was beneath Contrast, it minimized the noise that sometimes comes with sharpening. I placed Contrast Only over Tonal Contrast to further lower the noise and to brighten the areas that I wanted the eye to go to first. So not only did I help move the way the unconscious eye tracks across the image, I enhanced light-to-dark and high-to-low contrast just by layer placement.

View the image with the Contrast Only adustment only (**Figure 4.10.8**), the image with the Tonal Contrast and Contrast Only combined (**Figure 4.10.9**), and the Sharpening, Tonal Contrast, and Contrast Only combined (**Figure 4.10.10**).

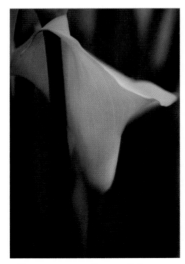

FIGURE 4.10.8 *Contrast Only adjustment*

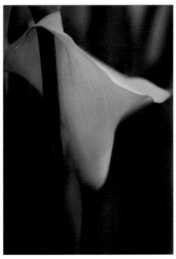

FIGURE 4.10.9 *Tonal Contrast and Contrast Only*

FIGURE 4.10.10 *Sharpening, Tonal Contrast and Contrast Only*

Step 10: Enhancing Warmth
Using the Nik Software Skylight Filter

1. Close the SEATTLE_LILY_MASTER_CNTRST_SHRP_16bit. psb.

2. Open the SEATTLE_LILY_MASTER_COLOR_16bit.psb.

3. Rename Layer 1 SHRP/CNTRST_BASE.

4. Duplicate the SHRP/CNTRST_BASE layer and make it into a Smart Filter.

5. Add a layer mask.

6. Create a new layer set and name it SKYLGHT/WHT_NTRL/ LABSAT.

7. Drag the SHRP/CNTRST_BASE copy layer into the SKYL-GHT/WHT_NTRL/LABSAT layer set.

8. Rename this layer SKYLIGHT.

9. Go to Filter >Nik Software > Color Efex Pro 3.0 Versace Edition. Select Skylight from the three plug-in options and click OK. For this image, I thought the default of 25% appeared to be the best choice.

10. Change the layer blend mode to Color.

NOTE: The Color blend mode affects only the color of the image; it does not change the highlights or the shadows. When you last used the Nik Software Skylight filter, you saw that the image brightened and the colors warmed when you ran the plug-in. When you changed the blend mode to Color, the colors did warm up, but the shadows and highlights remained unaffected.

I generally prefer to switch to the Color blend mode for the last step in my process—when I am finished with my adjustments to sharpness, color, and contrast. When I use the Luminosity blend mode, however, I frequently use it when I do an adjustment to sharpness or contrast, because I do not want to affect the color of the image.

11. Select the Brush tool. With the foreground color black, set the brush opacity to 50% and its width to 400 pixels, and brush in the center part of the stem and the upper part of the lily using the image map diagram as your guide. Bring up the Fade effect dialog box and move the slider to 24%. Now, rebrush the top part of the lily and just left of its yellow center. Leave the amount set to 50%, reduce the brush size to 250 pixels, and brush in the upper part and back of the lily. Bring up the Fade effect dialog box and move the slider to 27%. View the image map (**Figure 4.11.1**), the layer mask (**Figure 4.11.2**), and the image after the brushwork (**Figure 4.11.3**)

FIGURE 4.11.1 *Image map*

FIGURE 4.11.2 *Layer mask*

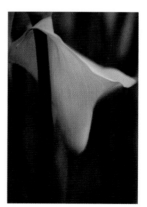

FIGURE 4.11.3 *After brushwork*

FIGURE 4.12.1 *Selecting Yellows from the Colors pull-down*

FIGURE 4.12.2 *Lower Saturation slider*

FIGURE 4.12.3 *Lower Hue slider*

Step 11: Neutralizing Whites

In this step, you will visually neutralize the whites using a Hue and Saturation adjustment layer that will specifically target the yellows of the image. First, you will reduce the saturation, then you will add some blue with the Hue slider, and finally, you will lighten everything without removing all the color.

NOTE: Obviously, if there is any color in a white, it is not white. This is where having a calibrated monitor is important. If you do not have one, what you see on the screen is not what you will print.

1. Create a Hue and Saturation adjustment layer and rename it NTRLIZE_WHITES.

2. Select Yellows from the Colors pull-down menu (**Figure 4.12.1**).

3. Lower the Saturation to –72 (**Figure 4.12.2**).

4. Lower the Hue to –6 (**Figure 4.12.3**).

NOTE: This warms the remaining colors a bit, and will make for a smoother transition from the adjusted to the non-adjusted areas when you do the brushwork on this layer.

5. Increase the Lightness to +6 (**Figure 4.12.4**).

6. Select the Brush tool and fill the layer mask with black. With the foreground color white, set the brush opacity to 50% and the width to 400 pixels. Using the image map diagram as your guide, brush in the center part of the lily, the upper blurred part of the lily, and the upper part of the lily to the right of the stem that separates the back and front of the lily. Bring up the Fade effect dialog box and reduce the amount to 19%. Next, rebrush the top of the lily, just to the left of its yellow center. Bring up the Fade effect dialog box and reduce the amount to 19%. Just brush the center top and blurred background. Bring up the Fade effect dialog box and reduce the amount to 27%.

7. Leaving the opacity at 50%, reduce the brush size to 250

pixels, and brush in the upper part and upper blurred back of the lily. Bring up the Fade effect dialog box and move the slider to 27%. Brush the top and back part (to the left of the main stem). Bring up the Fade effect dialog box and move the slider to 27%. View the image map (**Figure 4.12.5**), the resulting layer mask (**Figure 4.12.6**), and the image after the brushwork (**Figure 4.12.7**).

8. Do "the Move."

9. Save the file.

FIGURE 4.12.4 *Increasing Light-ness to +6*

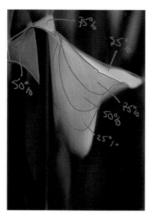

FIGURE 4.12.5 *The image map*

FIGURE 4.12.6 *Layer mask*

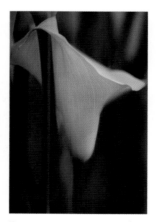

FIGURE 4.12.7 *The image after the brushwork*

Step 12: Increasing Saturation in the LAB Color Space

1. Holding down the Shift key, click and drag the newly merged layer (Layer 1) to the SEATTLE_LILY_LAB_SAT_ SHARPEN.psb file. (This file should still be open.) Make sure this layer is at the very top of the layer heap.

2. Rename this layer TEMP_COLOR.

3. Create a Curves adjustment layer and name it LAB_ BOOST. (Make sure that you are in fine grid mode. To do this, Option / Alt click on the grid in the Curves dialog box.)

4. Select the "a" channel from the Channel pull-down menu.

5. Click on the top point of the Curve line and move it two grid lines left. Then, click on the bottom point on the Curve line, and move it two grid lines right (**Figure 4.13.1**).

6. Select the "b" channel from the Channel pull-down menu.

7. Click on the top point of the Curve line and move it one grid line left. Then, click on the bottom point of the Curve line and move it one grid line right (**Figure 4.13.2**).

FIGURE 4.13.1 *Clipping the "a" Curve at the bottom point*

FIGURE 4.13.2 *Clipping the "b" Curve at the top point*

8. Do "the Move" and rename this layer LAB_SAT.

9. Save the file.

10. Holding down the Shift key, drag the LAB_SAT layer into the SKYLGHT/WHT_NTRL/LABSAT layer set.

11. Drag the Layer 1 layer to the trash.

12. Add a layer mask to the LAB_SAT layer and change the blend mode to Color.

13. Fill the layer mask with black.

14. Select the Brush tool. With the foreground color white, set the brush opacity to 50% and the width to 400 pixels. Using the image map diagram as your guide, brush in the red area in the lower, left corner between the two stems. Leave the opacity at 50% and brush in the red area at the lower right corner of the image. Bring up the Fade effect dialog box and move the slider to 69%. Brush in the red area midway to the right corner. Leave the opacity at 50% and brush the red area at the top right corner between the two stems.

15. Brush in the lily stems in the upper, left corner. Bring up the Fade effect dialog box and move the slider to 28%. Brush in the yellow parts of the area that you just brushed, both at 50%. Brush the long stem below the front of the flower in the lower right corner. Bring up the Fade effect dialog box and move the slider to 28%. Brush the stem of the main lily (the stem that is at the base of the flower in the bottom middle). Leave the opacity at 50% and brush in the upper part of the lily next to the stem following the yellow to the base and including all of the yellow area in the base. Bring up the Fade effect dialog box and move the slider to 17%. Brush just the yellow parts of the lily's base and move the slider to 27%.

16. Reduce your brush to 80 pixels and brush the tip of the lily. Bring up the Fade effect dialog box and move the slider to 77%. Brush in the top part of the lily and leave the opacity at 50%.

17. Reduce the layer opacity to 57%.

View the image map for the planned work (**Figure 4.13.3**), the resulting layer mask (**Figure 4.13.4**), and the image after the brushwork (**Figure 4.13.5**).

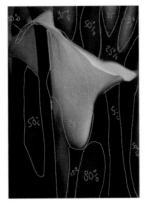

FIGURE 4.13.3 *The image map*

FIGURE 4.13.4 *The layer mask*

FIGURE 4.13.5 *The image after brushwork*

Seeing the Light of Traveling at the Speed of Dark

In my view you cannot claim to have seen something until you have photographed it.

—Emile Zola

Everything you have done on your journey through this image has been to get to this point—controlling the viewer's eye by the use of isolates (you might want to review the Isolate Theory sidebar at the beginning of this chapter). As I have discussed in the previous chapters, dark is as important to an image as is light. And as you have already seen, there is more to adding dark than merely adding dark. How you darken an image affects its color. Therefore, the blend modes that you choose to use, and where you use Curves adjustment layers with regard to the layer stack, become important in the creation of the dark aspects of any image.

What is true for the dark aspects of the image is also true for the light ones. You will see, as you create dark-to-light and light-to-dark Curves adjustment layers, that how you create and place the light aspects of the image are also important.

Just as was the case when you used Curves adjustment layers to remove color cast, there is no one Curves adjustment layer that will do everything in one swift move. It will take a number of steps to create just the right balance of light-to-dark isolates to take the viewer's eye on the path you intend.

Step 13: Traveling at the Speed of Dark: Using Curves to Create Dark-to-Light Areas

In this step, you will first work on the dark and intermediate isolates in the image by using two Curves adjustment layers. The final goal that you seek for this image is to cause shape to become the unwitting ally of the color yellow, which includes the yellow-tinged white areas of the lily as well. Your aim is to direct the viewer's eye in such a way that they first see, and

remember, the yellow, even though the image is mostly green. Also, by building the dark-to-light and light-to-dark relationships in the next series of steps, you will add an almost three dimensionality to the image by enhancing the warm colors (that tend to move forward in a image). Here is the image map of the brushwork that you will do (**Fig 4.14.1**).

1. Create a new layer group and name it L2D_D2L.

2. In the L2D_D2L layer group, create a Curves adjustment layer.

3. Name this new layer D2L_NORM.

4. Leave the blend mode set to Normal.

NOTE: You are leaving the blend mode as Normal because, when you darken a color, you increase its saturation. You will not use the blend mode Multiply because you will need more granular control of the darkness than Multiply will afford.

FIGURE 4.14.1 *Brushwork image map*

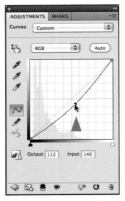

FIGURE 4.14.2 *Dragging the center point down*

FIGURE 4.14.3 *Before brushwork*

FIGURE 4.14.4 *The layer mask*

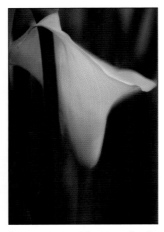

FIGURE 4.14.5 *The image after the brushwork*

5. Click on the center control point and drag it downward toward the right corner so that it is in the middle of the grid box that was to the right of the center point. The output should be about 112 and the input be about 140 (**Figure 4.14.2**).

6. Fill the layer mask with black, set the foreground color to white, and select the Brush tool. Set the brush opacity to 50% and the brush width to 400 pixels. Following the image map, brush in the stem in the upper right corner above the main lily. Leave the opacity at 50%. Do the same to the stem in the upper right corner above the lily that is at the center of the image—again leave the opacity at 50%. Brush in the red area between the two stems that you have just brushed. Bring up the Fade effect dialog box and increase the opacity to 60%. Brush in the upper left corner, the area above the left top of the lily, and the long stem around which the flower wraps. Leave the opacity at 50%.

7. Brush in the stem in the lower right corner that starts beneath the main lily. Leave the opacity at 50%. Brush in the red area to the left of the stem that you just brushed. Brush right up to the lily. Bring up the Fade effect dialog box and increase the opacity to 60%. Brush in the red area to the right of the lower stem. Bring up the Fade effect dialog box and increase the opacity to 60%. Brush in the red area to the left of the lily between the two lower left stems. Bring up the Fade effect dialog box and increase the opacity to 60%.

8. Brush in the yellow area of the main lily and the lower background to the left of the main lily's stem. Make sure not to brush the main lily's stem. Leave the opacity at 50%. Brush the lower edge of the upper part of the lily. Leave the opacity at 50%.

Compare the image before the brushwork (**Figure 4.14.3**), the resulting layer mask (**Figure 4.14.4**), and after the brushwork (**Figure 4.14.5**).

9. Duplicate the D2L_NORM Curves adjustment layer, rename it D2L_NORM_2 and fill the layer mask with black.

The goal of the next D2L Curves adjustment layer is to both deepen the yellow of the lily base (due to the increase of color saturation that occurs when you darken an image) and to cause the white part of the image to become more prominent by increasing the relationship of light-to-dark (part of the ABC's of how the eye sees). This is the image map of the areas that you will brush in the D2L_NORM_2 Curves adjustment layer (**Figure 4.14.5**).

NOTE: The reason that you are duplicating this Curves adjustment layer is first, by simply duplicating the layer, you do not need to go through all the work of darkening over again (workflow efficiency) and second, you will have more granular control. This granular control comes when you fill the layer mask with black and do brush work on it. In some cases where you have already done brush work on the L2D_NORM Curves adjustment layer (that you have just duplicated), you will further fine tune the layer's opacity.

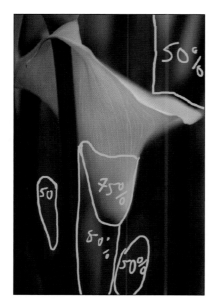

FIGURE 4.14.5 *Image map for D2L_NORM_2*

You did not duplicate the layer twice after filling the layer mask with black in Step 6, because this is what I did when I created this image for the first time. You are seeing my "thought workflow." It was after doing the brush work on the first L_2_D_NORM Curves adjustment layer that I realized that I wanted to apply more targeted "darkness" in certain areas. I liked what I had done in the first L_2_D_NORM Curves adjustment layer, and because I did not want to change that, I chose to create a new layer rather than to paint more on the existing one.

10. Making sure that the layer mask is active, set the foreground color to white. Select the Brush tool and set its opacity to 50% and its width to 400 pixels. Following the image map, brush in the upper right corner, just brushing the lily stem to the top of the main lily. Bring up the Fade effect dialog box and decrease the opacity to 46%.

11. Brush in just the red area at the bottom right of the stem of the main lily. Bring up the Fade effect dialog box and increase the opacity to 62%.

12. Brush in just the red area at the bottom left between the two stems to the left of the main lily. Bring up the Fade effect dialog box and increase the opacity to 62%.

13. Brush in just the yellow part of the base of the main lily. Leave the opacity at 50%.

14. Brush in the stem of the main lily, the yellow part of the base of the lily, and to the left of the base stem.

15. Save the file.

Look at the image before (**Figure 4.14.6**), the image after brushwork (**Figure 4.14.7**), and the resulting layer mask (**Figure 4.14.8**).

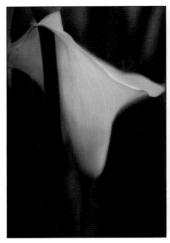
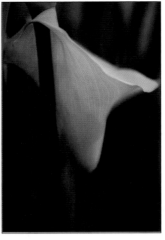

FIGURE 4.14.6 *Before the brushwork* FIGURE 4.14.7 *After the brushwork*

FIGURE 4.14.8 *The layer mask*

Step 14: Let There Be Light... Isolates

What you did in the last step was to set the stage for the primary light isolate, to which you want the eye to be drawn, by adjusting the supporting dark and intermediate isolates. (See the Isolate Theory sidebar at the beginning of this chapter.) These supporting isolates will be the areas that allow the eye places in which to wander and begin to recognize the subtle nuances that support the primary isolate and draws the eye to it. To accomplish this you will use three Curves adjustment layers, two blend modes, and placement above and below the two D2L Curves adjustment layers.

This approach is based on a renaissance painting technique called *sfumato*, which is the intricate mixing of thin layers of pigment, glaze, and oil to yield the appearance of lifelike shadows and light. In his work, of which *Mona Lisa* was a prime example of *sfumato*, Leonardo da Vinci used upwards of 30 layers of paint with a total thickness of less than 40 micrometers, or about half the width of a human hair. You can accomplish a similar effect using opacity and blend modes with both pixel-based layers, as well as adjustment layers. This approach works amazingly well in the creation of realistic looking atmospheric effects, from misty haze to inner glow, which, in addition to creating a primary light isolate, is the goal of the next series of steps.

These are the image maps for the brushwork you will do on the three Curves adjustment layers layer masks:

◆ L2D_SCREEN (**Fig 4.15.1**)
◆ L2D_SCREEN_2 (**Fig 4.15.2**)
◆ L2D_NORM (**Fig 4.15.3**)

Creating a Glow from Within

1. In the L2D_D2L layer set, create a Curves adjustment layer, name it L2D_SCREEN, and place it below the D2L_NORM Curves adjustment layer. (Starting from the top, the layer order should be L2D_SCREEN, then D2L_NORM, and then D2L_NORM_2.) Change the blend mode to Screen and fill the layer mask with black.

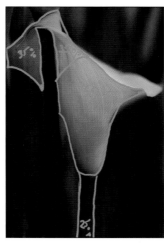

FIGURE 4.15.1 *L2D_SCREEN image map*

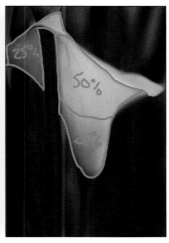

FIGURE 4.15.2 *L2D_SCREEN_2 image map*

FIGURE 4.15.3 *L2D_NORM image map*

2. Making sure that the layer mask is active, set the foreground color to white. Select the Brush tool and set its opacity to 50% and its width to 400 pixels. Following the image map, brush in the lily stem to the top of the main lily. Bring up the Fade effect dialog box and decrease the opacity to 22%.

3. Brush in the front part, the upper top, and top left of the main lily. Bring up the Fade effect dialog box and increase the opacity to 31%.

4. Brush in the lower base and about two-thirds up the front part of the main lily. Bring up the Fade effect dialog box and increase the opacity to 19%.

5. Lower the L2D_SCREEN layer to an opacity of 82%. View the resulting layer mask (**Figure 4.15.5**) and the image after the brushwork (**Figure 4.15.6**).

6. In the L2D_D2L layer set, create another Curves adjustment layer, name it L2D_SCREEN_2, and place it above the L2D_SCREEN Curves adjustment layer. (Starting from the top, the layer order should be L2D_SCREEN, then L2D_SCREEN_2, then D2L_NORM, and then D2L_NORM_2.) Change the blend mode to Screen and fill the layer mask with black.

FIGURE 4.15.5 *The layer mask*

FIGURE 4.15.6 *After brushwork*

7. Making sure that the layer mask is active, set the foreground color to white. Select the Brush tool and set its opacity to 50% and its width to 400 pixels. Following the image map, brush in all of the main lily. Bring up the Fade effect dialog box and decrease the opacity to 22%.

FIGURE 4.15.7 *Layer mask*

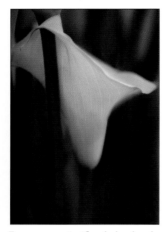

FIGURE 4.15.8 *After the brushwork*

FIGURE 4.15.9 *Tweaking the Curves adjustment*

8. Brush in just above the lower base at the edge of the yellow front part of the main lily. Bring up the Fade effect dialog box and increase the opacity to 31%.

9. Lower the L2D_SCREEN_2 layer to an opacity of 33%. View the resulting layer mask (**Figure 4.15.7**) and the image after the brushwork (**Figure 4.15.8**).

10. In the L2D_D2L layer set, create a Curves adjustment layer, name it L2D_NORM, and place it above the D2L_NORM_2 Curves adjustment layer. (Starting from the top, the layer order should be L2D_SCREEN, then D2L_NORM, and then D2L_NORM_2 L2D_NORM). Leave the blend mode set to Normal.

11. Click on the center control point and drag it upward toward the left, upper corner so that the center control point is in the middle of the grid box that was to the left of the center point. The output should be about 142 and the input should be about 119 (**Figure 4.15.9**).

12. Fill the layer mask with black.

13. Making sure that the layer mask is active, set the foreground color to white. Select the Brush tool and set its opacity to 50% and its width to 400 pixels. Following the image map, brush in just the center part of the main lily. Bring up the Fade effect dialog box and increase the opacity to 79%.

14. Lower the L2D_SCREEN_2 layer to an opacity of 33%.

15. Make the L2D_D2L layer set active, create a master layer, and name it MASTER_FINAL.

16. Turn off all of the layer sets. (This will speed up opening and saving because this file contains Smart Filters.)

17. Save the file.

View the resulting layer mask (**Figure 4.15.10**), and the image after the brushwork (**Figure 4.15.11**).

If you now analyze the color image of the Seattle Lily using the Isolate Theory, you can see that all of the elements come together to create a composition where the lily (the primary isolate) is reinforced and brought to the foreground so that it appears to be almost three-dimensional. The subtle appearance of the green stalks and reddish background, rendered as dark to intermediate isolates, surround the lily and allow it to pop out of the image and start the viewer's seeing process. As the viewer becomes more involved with the image, he/she begins to see and feel the subtle supporting isolates that add to his/her emotional response and appreciation of the entire composition—and this is what you set out to do at the beginning!

FIGURE 4.15.10 *The layer mask*

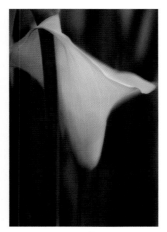

FIGURE 4.15.11 *After the brushwork*

Step 15: Disbanding the Potential Banding Issue of Blur

If you make a print and find that areas of high blur exhibit a stepping pattern that looks like a topographical map, you are seeing banding and possible posterization. Banding has a tendency to occur in the very blurry areas of an image, because the computer is trying to linearize the randomness of the blur. There are several ways to address this issue, but the quickest one is to add noise to the affected areas. The noise breaks up the banding. Generally, you want to use Monochromatic Gaussian noise.

The size of the image file determines how much noise to add. I have found that the range is between 2 and 8, but as a rule, it is better to add as little noise as possible. The smaller the file, the less noise you should add. For the purposes of teaching this technique, I am going to have you do this step at this point in this image's workflow rather than doing it after sharpening for output, which is when I generally do this. This step is best done after output sharpening because the last thing you want to sharpen is noise.

1. Make the MASTER_FINAL layer active.

2. Holding the Option / Alt key, create a new layer.

3. In the Name box, type NOISE. Then, from the Mode pull-down menu, select the blend mode Soft Light, and check the Fill with Soft-Light-neutral color (50% gray). Click OK (**Figure 4.16.1**).

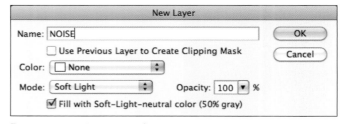

FIGURE 4.16.1 *Creating a new layer*

FIGURE 4.16.2 *Adding noise to the image*

FIGURE 4.16.3 *The image map*

FIGURE 4.16.4 *The layer mask*

FIGURE 4.16.5 *The image detail after the brushwork*

4. Make the NOISE layer into a Smart Filter.

5. Go to Filter > Noise > Add Noise. In the dialog box, select Gaussian Noise and check Monochromatic. (Remember that the size of the image file determines how much noise to add.) Zoom into a blur problem area and move the noise amount slider until any banding issues go away. For this image, I chose 6. Click OK (**Figure 4.16.2**).

NOTE: When you look at the 100ppi version of this file, it appears to be much noisier than the original, because the amount of noise that you apply to an image is dependent on the size of the file. For example, if the file size was 100ppi instead of the original file size of 300ppi, the amount of noise that that you would apply would be around 2 or 3. I have turned off the NOISE layer in the 100ppi reference file, but you should turn it on and play with it to see how adding noise works.

6. Add a layer mask to the NOISE layer. For this image, leave the layer mask white. Following the image map, set the brush width to 400 pixels at an opacity of 100%, and with the foreground color set to black, completely brush the main lily. Now, brush in the main lily stem, bring up the Fade effect dialog box, and reduce the opacity to 50%.

7. Lower the NOISE layer to an opacity of 86%.

8. Save the file.

View the image map (**Figure 4.16.3**), the resulting layer mask (**Figure 4.16.4**), and the image after the brushwork (**Figure 4.16.5**).

Children Play, They Don't Take Notes. Adults Take Notes and Don't Play as Much as They Should.

I hope you are now convinced that there is more to dynamic range than just bracketing your exposures. I also hope that you have found that there is a much bigger high to be had by exploring and exploiting the power and subtlety of image harvesting for the purpose of extending the dynamic range of all aspects of an image. You have also had a master class in directing the viewer's unconscious eye.

I believe that once you understand how to control color, you will have complete mastery of the images that you create. I also believe that you have to learn the rules before you can effectively break them. But if you make all of this a game, the playfulness and spontaneity that you bring to the process will be inherent in the image. It is from this sort of spontaneity that the truth of your experience will be captured.

FIGURE 4.0.1 *Initial image*

FIGURE 4.0.2 *Final image*

From Here to There: Where We Are On the RGB Road

You don't make a photograph just with a camera. You bring to the act of photography all the pictures you have seen, the books you have read, the music you have heard, the people you have loved.

—Ansel Adams

I have covered a lot of territory up to this point. So I am going to review some of the things that I have discussed in previous chapters.

- A still photograph is called a still photograph because the picture does not move, not because the objects in the picture were not in motion at the time of capture.
- Visualize the finished image in your mind's eye as you are making the capture. Do not go out with a camera with preconceived notions of what you will capture; be open to possibilities.
- Do not take pictures; be taken by them.
- Photoshop is not a verb. It is a noun.
- Photoshop should be used as an emery board, not as a jackhammer. "Did you do that in Photoshop?" should be a question, not an accusation.
- Get it right in the camera. If it doesn't look good through the lens, it will not look good coming out of the printer.
- Because the printer is a "default" device, the print is only as good as the file you send to it.
- RGB is not a color; it is a formula to mix color.
- If you can see something, it has color. Gray is a color and "black is the queen of all colors."
- Practice doesn't make perfect. Perfect practice makes perfect. Perfect practice comes from practicing at practicing.
- Workflow starts at the point of capturing the image.
- Workflow is a dynamic experience. No two images are the same; therefore, no two workflows are the same. Be adaptive: always pro-act rather than react
- The more you know about the middle, the more informed your decisions can be at the beginning, because everything you do is in service of the print (the end), and the print is your voice.

- A believable improbability is better than an improbable believability.
- The human eye is an amazing biological optical system that can see motion; a digital still camera cannot.
- An image is more about quality of blur, or bokeh, than it is about focus.
- When using a fixed sensor/film plane system such as an SLR or DSLR, it is optically impossible to have two objects at different distances to be in focus at the same time.
- Stopping a lens down does not ensure that objects at different distances from the sensor/film plane will all be in focus at the same time.
- If you want to have multiple objects in focus you need to have captured a separate image for each object that you want in focus.
- The expansion of the dynamic range of exposure through multiple captures (HDR) is a small part of the extension of dynamic range (ExDR).
- Shape is the enemy of color.
- A pattern is interesting, but a pattern interrupted is more interesting.
- If you want the eye to remember color over shape, you need to cause shape to become the unwitting ally of color.
- The viewer looks at a photograph with two "eyes"; the unconscious (the biological optical recording device) and the conscious one. The conscious eye interprets the image that the unconscious eye sees.
- The unconscious eye "sees" in a predictable manner. It first recognizes light areas and then moves to dark ones, sees high before low contrast, records high before low sharpness, notices focus before blur, and focuses on high color saturation before low.
- CJ Elfont's Isolate Theory explains the interrelationship of the elements (or isolates) in a photograph and, when correctly applied, causes the unconscious eye to move across an image in a way that the photographer intends.

- Consider light a tangible thing, so that what you photograph is not the subject, but the light as it falls on the subject.
- Three of the four key components of any photograph are light, gesture, and color.

Note: In the third book of this series, I will discuss the fourth key component: time. In the original *Welcome to Oz*, the chapter discussing this was the last. During the rewrite, I expanded the discussion of time so that it became too large to include in this book.

These are some of the key points in this book. But there is more to creating an image than the four lessons contained within these pages. There is also why and how to process RAW files, how to scale images, why and how to color manage an image and calibrate your monitor(s), and what to do to an image before printing it.

To further address these considerations, there is a PDF that is located on the download page, titled *The Why to of My How*. Here is where I concisely explain my personal workflow. The PDF also includes the bullet points that precede these paragraphs. Covered in the PDF are my reasons for the way I convert RAW files, how I use color management, and how I scale an image, specifically: Fractal scaling vs. Bi-cubic, Bi-cubic Smoother, Bi-cubic Sharper, and 10% stepping for up-scaling.

Note: There is a full resolution file that shows the outcome of each of these approaches to scaling so that you can see what looks best and what looks less than best.

In the PDF, I also discuss the provided Photoshop action for how to make a print "Snap!" off the paper. Lastly, there is an overview of the Wacom "Welcome to Oz 2.0" presets for 21" Cintiqs, Intuos 4, and Intous 3 tablets, as well as the presets for you to download. These presets are set up for both left and right handedness, as well as for Windows 7 and Mac OS X operating systems.

I chose to make this section a PDF, rather than a chapter, because it is a lot easier to have a quick reference on your computer than to carry a book around.

The End of the Beginning

A picture is a poem without words.

—Horace

Before you ever press the shutter, there must be something that moves you to do so. If you are not moved, you will not move others. Do not try to make a memorable image out of a capture made casually, even if it was a happy accident. Do not simply take a picture. Let the picture take you. Let the experience that is happening in front of your camera, pull you through the lens and not the other way around.

If you have read all that has preceded this, you know that a still camera's limitations are also its power. John Paul Caponigro has said, "The camera is what I use to hold the world still." And this isn't "hold" in the sense of tying something down. That is too often the case with people who feel that all photographs must be posed and the subject must stay completely still. "Sit, move your head to left... No, too much, okay, hold that. Place your hand under your chin... Stop... Hold that, don't move." Shooting that way produces images so devoid of life and time that they are eminently forgettable.

You should want to create images that feel as if they are about to move or were caught as if they were already in motion; as if the moment of capture is like a breath held expectant, waiting to exhale and breathe the next moment. I will say it one more time: A still photograph is called a still photograph because the picture does not move, not because the objects in the picture are not in motion. You can capture motion with stillness and, in that moment, hold time still, but yet experience the feel of its passing.

Make images that move the viewer the same way you were moved. Make images that communicate the fullness of your life, and your images will be just that: full of life.

Afterword

When Vincent asked me to write this piece, I protested that I am anti-Photoshop and anti–post-shot manipulation, and generally I think it's all an excuse for slovenly thinking and seeing. Vincent said, "Fine, it's important for readers to know about all sides of the question."

He wrote a book, I get 500 words to express my opinion.

Photography is about vision. There is one major thing to remember after reading this book. Photoshop and other post-shot manipulations are corrections and addendums to your vision.

When I teach, I tell my students that the one phrase I don't want to hear is, "I can fix it in Photoshop." You are responsible for every square millimeter of your image at the time you shoot it.

I've often thought that the reason the grass always looks greener on the other side of the fence is because it's backlit. Truth then, depends on where you're standing and is thus quite subjective. Without getting into an intricate philosophical evaluation of truth, I'd like to quote the French painter, Georges Braque: "Truth exists, only falsehood has to be invented."

There may be times when your original concept will call for and include the use of post-shot manipulation. When that is a conscious decision made before the image is taken, you are no longer using it to correct an inferior or badly thought-out image. You are then using post-shot manipulation as an integral part of the process of seeing, and seeing and vision are of course the essence and reason for photography.

It is incumbent upon you to make sure you are getting what you want at the moment you take the picture. It would be best for you to spend more time thinking of the quality of your pictures and less time thinking about the quality of your pixels. The parameters of your vision are more important than the expertise you have with levels and curves or whatever you get involved with after you take the picture.

Your responsibility and obligation as a photographer lies with your concept and execution at the instant of exposure. I have seen so many demonstrations that dealt with the correction of an inferior image that I want to shout out, "Screw the corrections, do it right in the first place or do it over until you get it right." Don't depend on post-shot manipulation as a crutch. It will only make you sloppy in your execution of the image.

The American playwright Arthur Miller said that he tried to create the poem from the evidence. I wish you to see not how clever you can be, but how observant you can be. The reality that is out there is rich and varied and worthy of investigation. The search into the real world can, with insight, lead not merely to replication, but revelation.

This is not to say that you cannot enhance the vision that you have, rather to reiterate that you must discipline yourself to be responsible to and have faith in your original vision.

Ernst Haas once said, "We do not take pictures, we are taken by pictures." He also said something else that took me a long time to understand. I don't remember the exact words, but it was something like, don't work so hard to take a picture. Years later I understood, and wrote a poem for my students that I think encompasses what he meant about working so hard to make it work and also illustrates the passion I think is of utmost importance:

If it doesn't excite you,
the thing that you see,
then why in the world
would it excite me?

—Jay Maisel

Afterword

It feels at times as though photographers are the red-headed step-children of the art world. For all the talk about how democratic this relatively new art form is, we get very little respect, in part—I think—because we ourselves trifle with the forms and conventions as though they didn't matter. Photography is an aesthetic art, the technical means by which we achieve our work are only details; the sooner we make our vision, and its expression, more important than the particular tools and conventions of our expression, the sooner our art will grow out of its childhood and towards maturity.

Imagine a long line of artists all sitting together in the great Afterward; there are Caravaggio, Raphael, Rembrandt, Picasso, Monet, and hundreds of others. The crazy one, Van Gogh, is there too, but probably muttering in the corner. And they've gathered to talk about their work. Do you think for a moment that they would spend eternity discussing the merits of one brush over another? I suspect not. I suspect they'd argue instead—in loud voices, no doubt—about light and lines, depth, and texture. They would talk about paintings and painting, but probably never talk about the paint itself. We photographers, however, in our brief history, have talked so long and so often about the means of our expression— cameras and lenses and so on—that we've collectively forgotten this one fundamental possibility: photography can be much more about aesthetics than about technique and gear. It can be expressive and powerful and it can open the eyes and hearts of people who were never there to see Yosemite the way Adams saw it, Paris as Cartier-Bresson did, or Italy with the humur of Elliott Erwitt.

It would be a mistake, however, to ignore the role of technique and process in the creation of our work. There are purists in every discipline and they seem to draw lines in the sand not based on what is "pure" but on where they are most comfortable. Let the purists go back to daguerreotypes if they like, or to painting mammoths on the wall of the cave; they are missing the chance, in embracing new technology and technique, to better tell our stories—to more compellingly bring the viewer of our work into the emotion we felt when we pressed the shutter button. While gear and technique really are not the point, they do matter a great deal inasmuch as they are the means through which we tell our story.

I believe deeply in the possibilities inherent in photography. We have in our hands the most democratic art form since the pen; a means by which we can all go out and create a compelling visual story without the years needed by a painter, for example, to get to the same basic level of competency. That doesn't mean it's easy, or that one can master the techniques and forms of photography in less time. It just means the initial doors are wide open and more easily walked through. And so we've created an art form with incredible diversity and no small measure of anarchy, having had no long line of traditions from which to draw, or to which we feel bound. Why I bring this up is because that freedom—combined with embracing new technologies and processes not unlike new brushes and paints—can take us into incredible places if we allow it to. The moment we abandon the so-called rules of the purists and allow ourselves to, as an example, blend multiple frames to do what our optics or our shutter could not, we take our craft a little closer to the possibility of being art—a story that transcends the means by which it is told, something that makes us feel something, see the world a little differently, or experience something in two dimensions that we've never experienced in three.

My belief in photography as a means of expression and an agent of change tell me that—ethical considerations of a discipline like journalism aside—the rules were meant to be

stretched, broken, disregarded entirely. To do otherwise is to make the rules more important than the vision and message of the photograph itself. And that's the point of it for most of us. The vision. We didn't get into this simply to haul around a bunch of expensive gear or spend hours in front of a computer. We do it because we want to create something. Something new. Something that comes even remotely close to expressing the thing we feel inside when we see something breathtaking and experience wonder. We do it because the act of creation is hardwired into us and we can't not do it. In light of that longing, it seems myopic at best, ignorant at worst, to suggest there is a way we should and should not do things.

When I first read *Welcome to Oz* in 2007, a switch was thrown for me. It was as though Vincent was giving me permission to tell my stories my way. I didn't need Vincent's permission, per se, but it was good to hear it all the same. I don't do things exactly the way Vincent does. You'd be wise not to either. Vincent tells his stories in his way; you and I will tell our stories in our own ways. But it would be a shame not to absorb the way in which Vincent crafts his images and

the reasons he does what he does, and to allow those to inform our own processes. There is no photographer or artist of any discipline over whose shoulder we cannot look and learn. But this Afterword isn't about Vincent. It's a simple recognition that what Vincent brings to the table with *Welcome to Oz* is important and useful in learning to express ourselves and make outward our inner vision. That's what it's all about. Learning to see, and then using any tool that fits in our hand, to sculpt that vision into something with which we, first, and then the world, resonates.

We do not need more overworked digital images, or one more book on how to make our images better with Photoshop. But there is a limitless hunger for beauty and wonder, and stories that connect us to the world around us—and the better we understand the possibilities that lie within the tools at our disposal, the closer we come to feeding that hunger for truth and beauty.

—David duChemin

Index

Notes

Notes